# S. Andrea in Mantua

# S. ANDREA
# IN MANTUA

*The Building History*

Eugene J. Johnson

The Pennsylvania State University Press

University Park and London

Library of Congress Cataloging in Publication Data

Johnson, Eugene J    1937–
    S. Andrea in Mantua: the building history.
    Bibliography: p. 118.
    1. Mantua.   Sant'Andrea (Basilica)   I. Title.
NA5621.M34J63          914.5'28          74–30085
ISBN 0–271–01186–6

Designed by Glenn Ruby

Printed in the United States of America

In Memory of My Parents

# Contents

# List of Illustrations

## Plates

## *Figures*

# Preface

A few years ago, I mentioned to a very distinguished art historian that I was working on S. Andrea in Mantua. He instantly replied, "How could you possibly find anything new to say about that old saw?" When I assured him that I had indeed found something new, his disbelief was painfully clear. This particular scholar was expressing a widely held belief in our profession that the "key monuments" are so well studied that there is nothing left for a new generation of scholars to do with them, except to contemplate their splendors. Such an attitude is, I believe, misguided. To enumerate all those things we still do not know about the great monuments of early Renaissance architecture, for instance, is to demonstrate that our ignorance roughly equals our knowledge of the field. Every one of the great buildings of Brunelleschi and Alberti still needs further study. For primary source materials for these buildings, we have all relied on the publications of certain nineteenth-century archivists. I hope that this book will demonstrate that we should not be so trusting.

The chief aim of this monograph on S. Andrea is to answer a number of questions raised over the last fifteen years about the fidelity of the present church to Alberti's original design of 1470. To that end, the bulk of the text is devoted to a rather detailed study of the building history of the church, based on documentary and archaeological evidence. In addition, I have assembled all the documents, published as well as unpublished, in a series of appendixes. The documents are arranged chronologically in groups that relate to the various phases of construction.

The book does not limit itself, however, to a discussion of the building history alone. The last two chapters deal with some more general problems. Even so, the work does not attempt a broad discussion of Alberti as an architect, or his position in Renaissance architecture. For the modest scope of this study, I offer no apology. Some day in the future we may have learned enough to attempt a book called *The Architecture of Alberti*, but clearly the time is not yet ripe.

When this study began over ten years ago, I had no idea that it would not see the light of day until shortly after the five-hundredth anniversary of Alberti's death and, coincidentally, the five-hundredth anniversary of the laying of the cornerstone of S. Andrea. I was first introduced to the study of Alberti in a seminar offered jointly by Richard Krautheimer, Wolfgang Lotz, and Richard Pommer at the Institute of Fine Arts, New York University, in the fall of 1962. I thank them heartily for having made the introduction, and for innumerable other kindnesses as well. Professor Krautheimer generously helped me over the rocky dissertation road, the subject of which was S. Andrea. The primary research was made possible by a Fulbright grant to Italy, and subsequent work has been underwritten by grants from the Class of 1900 Fund of Williams College and aided by a leave of absence from the same institution, which allowed me to go back to Italy to redo those things I did badly while researching the dissertation.

Among scholars who generously gave me time and counsel, I would especially like to thank L. H. Heydenreich, Erich Hubala, Ulrich Middeldorf, Ercolano Marani, and Chiara Perina. The work would literally not have been possible, however, without the cheerful and willing assistance of the ex-Parroco di S. Andrea, Rev. mo Monsignore Osvaldo Mantovani. His patience and understanding were as monumental as his church. In the Archivio di Stato, Mantua, I received invaluable and astute assistance from Gilberto Carra, who kindly taught me how to deal with fifteenth-century documents. The Mantuan photographers Calzolari, Giovetti, and Rizzi also gave me much-appreciated aid and, in the case of the

first two, generous permission to reproduce some of their fine work. Closer to home, Ronald Malmstrom has worried over numerous problems with me, offering a string of helpful suggestions for which I am deeply grateful. Whitney Stoddard, among other things, generously went out of his way to go to Mantua to do some handsome photography. Michael Wurmfeld, a practicing architect, gave me much-needed counsel on structural problems and provided some keen visual observations. To them both, my deepest thanks, as well as to Susan Downey and Mary Fuqua, who extricated me from thickets of Latin syntax, and to Roger Widmer, who tried to do the same for me in English. Also thanks are due Walter Riley, Allan Goodrich, and Robert Clark for the redrawing of the Ritscher plan and sections, and Howard Levitz, for technical work on my own photographs. Finally, there is the case of my wife. When we met, she was singing "Vissi d'arte." It now goes "Vissi d'architettura." To her, I offer the last words of Verdi's *Otello*.

*E. J. J.*

*Author's Note:*    While this book was in press, three important volumes appeared: Ludwig H. Heydenreich and Wolfgang Lotz, *Architecture in Italy 1400–1600* (Harmondsworth and Baltimore, 1974); Carroll William Westfall, *In This Most Perfect Paradise, Alberti, Nicholas V, and the Invention of Conscious Urban Planning in Rome, 1447–55* (University Park, Pa., and London, 1974); and Ercolano Marani, ed., *Il Sant'Andrea di Mantova e Leon Battista Alberti, Atti del convegno di studi organizzato dalla Città di Mantova con la collaborazione dell'Accademia Virgiliana nel quinto centenario della basilica di Sant'Andrea e della morte dell'Alberti 1472–1972, Mantova, 25–26 aprile 1972* (Edizione della Biblioteca Comunale di Mantova, Mantua, 1974). The last named volume, despite its title, contains articles which range beyond the church of S. Andrea alone. The reader's attention is particularly called to the contribution of Ercolano Marani concerning the three churches of S. Andrea which have stood in Mantua (p. 71f.).

# S. Andrea in Mantua

# I

# Introduction

A casual visitor to Mantua today discovers a small city, half-surrounded by lakes, rising out of the flat Lombard plain. Dominated by architectural relics, which cast their red-brown, brick pall over the flashing movements of motor scooters and little cars, Mantua seems only partially of the present. A feeling of age and weariness hangs over its center, a feeling that new storefronts, artfully filled with brightly-lit samples of the latest, most colorful styles, cannot quite dispel.

Mantua is a city not particularly well treated by time. In 1630 it was cruelly sacked by Austrian troops, and since that great event (in Mantuan histories one speaks of The Sack as a temporal watershed second only to the Birth of Christ) the city has never fully recovered.[1] It has endured as an agricultural center, outside the mainstream of history, the scene of a way of life that moves little more swiftly than the waters of its encircling lakes.

If one turns back time to the days before the Sack, one recovers quite a different Mantua. From the middle of the fifteenth century to the early years of the seventeenth, the Gonzaga family presided over a brilliant and cultivated court. While marrying into the best families and raising the finest horses in Europe, the Gonzaga surrounded themselves with great minds and talented artists, amassed a vast collection of works of art,[2] and commissioned noble buildings. Of these Gonzaga buildings, noblest and most important was the church of S. Andrea (pl. 1), designed in 1470 by Leon Battista Alberti for the Marchese Lodovico II.[3]

The history of Alberti's S. Andrea, like that of most major architectural works of the quattrocento, still remains clouded by multiple uncertainties. The basic question modern scholarship has raised about S. Andrea, however, can be stated quite simply: Does the present church faithfully reflect Alberti's original design of 1470?

Up until some fifteen years ago, scholars (at least in public) tended to assume that the vaulted Latin Cross basilica that confronts us today largely represented the realization of Alberti's intentions, providing one stripped away the eighteenth-century dome and some other details. At the 1960 Alberti Congress in Munich, however, two scholars found serious fault with this point of view. Indeed, it seems to have been the general consensus of the Congress that only the present nave, and probably the west porch, could surely be held to be by Alberti.[4]

The studies that raised such fundamental questions about S. Andrea were based on the chronology of its building history proposed by Ernst Ritscher in 1899.[5] That chronology can be summarized briefly as follows:

> 1470
> first design for S. Andrea submitted to Lodovico Gonzaga, marchese of Mantua, by Leon Battista Alberti

> 1472
> cornerstone laid in June, following Alberti's death in Rome in early April

1472–1494
first campaign: construction of nave and west porch under the supervision of Luca Fancelli, the Florentine architect and sculptor

1597–1600
second campaign: construction of the transepts, choir, and large crypt below the crossing

1697–1704
third campaign: vaulting of transepts and choir

1733–1785
fourth campaign: construction of dome according to a design of Filippo Juvarra

c. 1780
restoration and decoration of interior under Paolo Pozzo

At the Munich Congress, Erich Hubala suggested that the design for the whole east end of S. Andrea should be viewed as contemporary with the late-sixteenth-century date for its construction proposed by Ritscher.[6] Hubala's analysis of the church led him to the conclusion that the eastern and western parts of the building are not of a piece, but rather that they represent two quite distinct stylistic moments. Hubala's late-sixteenth-century dating for S. Andrea's Latin Cross plan reverses the hitherto largely accepted relationship between S. Andrea and Vignola's Roman church of the Gesù (fig. 12), begun in 1568, and consequently diminishes the extraordinarily important role that S. Andrea had seemed to play in our conception of the development of the vaulted Latin Cross basilica in post-medieval architecture. According to Hubala's thesis, only the nave of S. Andrea influenced the design of the Gesù. In turn, he contended, the Latin Cross plan of Vignola's church (and its followers) engendered a modification, around 1597, of Alberti's original plan, transforming S. Andrea from a relatively simple structure (porch and nave terminated by an apse) into the present more complex cruciform shape.[7]

On an entirely different basis, Richard Krautheimer raised equally disturbing questions.[8] He set out to explain Alberti's famous remark—"questa forma de tempio se nomina apud veteres etruscum sacrum"—contained in the cover letter Alberti sent with his design for S. Andrea to Lodovico Gonzaga in 1470.[9] By juxtaposing Vitruvius's description of an Etruscan temple (a difficult passage for Alberti, who had never seen an Etruscan temple) with the remains of other types of ancient building known to Alberti, Krautheimer was able to explain Alberti's own description of such a building in *De re aedificatoria*.[10] Krautheimer was also able to reconstruct Alberti's *templum etruscum*:[11] a vaulted space terminated by an apse and flanked on either side by three smaller transverse spaces, the whole preceded by a portico (fig. 4).[12]

Between Alberti's *templum etruscum* and the nave and west porch of S. Andrea a clear typological relationship exists. The whole east end, however, with its crossing, transepts, and chancel, is alien to this type of *templum*. Moreover, when he wrote *De re aedificatoria* around 1450, Alberti felt transepts to be appropriate not for *templa* but rather for *basilicae*, i.e., buildings with a secular function.[13] On the basis of these observations, then, Krautheimer left open the question of Alberti's authorship of the Latin Cross scheme of S. Andrea.[14] Indeed, the question of the form of its original plan is one of the most important problems confronting modern students of Italian Renaissance architecture.

Before attempting to come to a solution to this problem, it is first essential to know the building as it stands today, as well as its history prior to 1470. Very much as they did in the fifteenth century, the main façade and porch of S. Andrea rise on the north side of Piazza Mantegna (formerly Piazza S. Andrea), a small urban space adjoining the main market and civic square of the city, Piazza dell'Erbe (pls. 2 and 3). The great arched opening in the center of the façade is flanked on either side by pairs of widely spaced pilasters that rise from high bases to support a pediment. These pilasters form side bays, each containing a door, a roundheaded niche, and a roundheaded window, arranged vertically. Between the levels of the

niches and the windows runs a broad entablature, which rests on the small order of fluted pilasters at the corners of the central opening. From this point, the entablature turns east to run around the walls of the central bay of the porch beyond. Except for the stone details of the capitals, bases, small order, and door surrounds, the entire façade is covered with a pale yellow stucco, relieved by terra-cotta details. To the left of the façade, abutting it at an oblique angle, rises a brick campanile (pl. 3) of clearly earlier date.

Directly above the central section of the portico stands a peculiar structure consisting of two parallel walls rising perpendicular to the plane of the façade and supporting a barrel vault. This structure projects out from high neutral walls behind it (the west walls of the nave) almost to the plane of the façade itself. The purpose of this construction, known locally as the "ombrellone," is to shade the large oculus on the west end of the nave from direct sunlight.

To return to the façade proper, its three openings lead into a rather grand porch. Behind the two side openings are relatively low bays capped by barrel vaults poised transversely to the axis of the higher and larger barrel over the central bay. All three vaults are richly encrusted with white stucco coffers filled with rosettes of a variety of shapes. The central bay terminates in a flat wall decorated by an elaborately carved, rectangular door frame, which leads directly into the church itself. There are two lesser portals flanking the central one, reached through the side bays of the porch.

A momentary shock overcomes almost every visitor passing from the porch into the nave of S. Andrea (pls. 4 and 5). The size of the interior space before him, vast in itself, is exaggerated by the smaller scale of the porch. Indeed, the interior seems larger than the out-of-doors just left behind. Gradually, the visitor becomes aware that he is in a different world, a specially created environment, a series of sharply carved, monumental spaces bathed in a dim, diffuse, silvery light, a light that seems to be generated by the building itself. The visitor, in short, has undergone an architectural experience of rare power.

Some very simple relationships between the exterior and the interior form the basis of this experience. The visitor brings with him the memory of having just passed under a high barrel vault, flanked by a pair of lower transverse vaults. He enters a space covered by an enormously wide (18.6 meters) and high (27.9 meters) barrel running in the same direction as that of the porch. The nave vault, in turn, is flanked on either side by three lower transverse vaults, essentially identical in height and span to the central vault of the porch. The nave space is one and one-half times as high as the central bay of the porch, and two and one-half times as wide, a ratio that repeats the dimensional relationship of the central bay of the porch to its flanking bays.

Furthermore, the articulation of the walls which bound the nave is strikingly similar to the articulation of the façade (pls. 2 and 5). Except for seemingly minor variations in detail, the nave walls can be thought of as composed of three overlapping façades on each side (pl. 45). There are the same pairs of pilasters, raised on high bases, which support the great cornice above. There are also three smaller elements arranged vertically between these pairs of pilasters, as well as a small order of pilasters from which the arches of the flanking chapels spring.

The periphery of the nave, then, is marked off by large, round arched openings separated by piers. In the lower faces of the piers (which are largely hollow) are doors that lead to small, domed chapels (pls. 71 and 72); in their upper faces are round windows through which light enters the nave (pl. 4).

At the east end of the nave there is a slight narrowing of its width. Two additional pairs of pilasters project out from the crossing piers (fig. 2, pls. 4 and 5). These piers contain pairs of overlapping circular staircases reached by doors in both their nave and transept faces. The nave then opens into a square crossing covered by a dome on a high drum that rises from four pendentives. From the crossing radiate three arms, all square in plan. Two large chapels face each other across each transept arm. The transept arms terminate in flat walls articulated by four pilasters and pierced by a great oculus, repeating the scheme of the inner west wall of the nave. The choir, in contrast, is flanked by two vaulted sacristies, separated from it by heavy walls, and its space is increased by the addition of a semicircular apse.

Beneath the crossing is a large crypt, reached by the staircases in the four crossing piers. This crypt is cruciform in plan (pl. 41), the arms of its cross extending outward to a point approximately

in line with the outer edges of the crossing piers. The western arm of this crypt, however, is exceptional. It is continued by a semicircular apse that reaches beneath the floor of the nave to a point roughly equal to a line drawn between the centers of the two large nave chapels next to the crossing piers. The arms of the crypt join in the center to form an irregular octagon, the vault of which projects through the pavement of the crossing above (pl. 59). This vault is covered with a red marble revetment and protected by a balustrade.

The surfaces of the interior as it stands today are richly decorated with frescoes and terra-cotta ornament. Most of the chapels have been embellished with large pictorial compositions on their walls[15]— those along the nave dating mainly from the sixteenth century, while those in the east end belong to the seventeenth and eighteenth centuries. The giant order of pilasters bears a set of frescoed candelabra, produced by a group of neoclassical painters of the 1780s, and the vaults of the nave, transept, and choir were painted to appear coffered during the same years.[16] The only ornaments of any real three-dimensional character are the coffers of the vaults of the large chapels (pl. 11). These, highly polychromed, hold wooden rosettes. The leaves of the Corinthian capitals of the great order are made of terra-cotta, while the channeling of the capitals of the small order is the result of some rather convincing *trompe-l'oeil* work in fresco (pl. 7).

From the south transept there is no access to the outside, but from the north transept one can exit onto a brick porch that is almost identical in dimension to the porch attached to the western end of the nave (pls. 8 and 32). This porch, however, is not finished off with stuccoed walls and stone details. As seen from the present day Piazza L. B. Alberti, which runs along the north side of the church, this north porch appears incomplete: a clearly temporary roof rests on the walls just above the apex of the central arch.

The structure of the nave confronts the basic problem of transmitting the continuous load and lateral thrust of the great barrel vault into a system of supports and buttresses that is not continuous. The solution to the problem is beautifully, if metaphorically stated by the articulation of the nave walls (pls. 6 and 7). The vault rests on a continuous entablature, which is, in turn, visually supported by the arches of the large chapels and the pairs of pilasters attached to the faces of the piers. Thus the continuous horizontal is related to an alternating series of arches and of vertical supports below it. While the structure itself is more complex, and far more three dimensional than the articulation of the nave, that articulation still reveals the essence of the structural system.

Because the structure is worked out in rather elaborate three-dimensional terms, it is essential to refer constantly to the plan (fig. 2, pl. 15) and both the longitudinal (fig. 1, pl. 45) and cross sections (fig. 3, pl. 14). Even with these aids, the task of comprehending the whole system is not a simple one. The plan reveals that along the side of the nave run two types of wall. One set is parallel to the nave; the other stands at right angles to its axis. In addition, these walls are of three distinct thicknesses. The thickest ones (2.65 meters) flank the nave directly and are pierced by the low doors that lead into the little chapels. A second set of walls, about 2 meters thick, runs at right angles to the first and separates the large and small chapels from each other. These walls are not evenly spaced. Where they are wider apart, they create the large chapels, and where closer together, they form the little chapels (fig. 2). This alternating rhythm is clearly mirrored in the spacing of the giant order of pilasters. The third type of wall, only 1.5 meters thick, runs again parallel to the axis of the nave and encloses the church on the outside, forming the exterior walls of the chapels.

The cross section shows the vertical extent of these walls (fig. 3). The thickest, or first set of walls, rises up to the point from which the nave vault springs (pls. 6 and 7). Their vertical extension is marked by the cornice of the entablature under the vault. The third, or exterior walls reach a slightly lower point, marked on the exterior by the rising of the side roofs (pl. 9). The second set of walls, those that separate the chapels, however, continue from ground level up through the side roofs and terminate as a series of exterior buttresses, which rise high above the springing of the nave vault (fig. 3, pl. 9).

The various arches and vaults covering the spaces of the church spring from the walls just described.

The transverse barrels covering the large chapels are faced by arches decorated with a band of poly-chromed terra-cotta ornaments. These arches, in turn, spring from two small pilasters that rise alongside the pilasters of the large order of the nave. The small pilasters and the arch offer a visual equivalent for the actual structural system. In reality, the arches of the large chapel openings (over 2.5 meters thick) transmit the continuous load of the nave barrel into the thick walls that separate the nave from the small chapels. These walls are not solid but are pierced by doors at ground level and by oculi rather high up on their faces (pl. 6 and 7). These openings are stabilized by two relieving arches, one over the door, the other over the oculus. The relieving arches over the oculi, then, perform a function similar to that of the barrel vaults covering the large chapels, i.e., the redirection of the continuous load of the nave barrel into those few points of vertical strength along its length. There is no visual manifestation of this aspect of the structure in the nave articulation; even so, the oculus does offer an echo of the shape of the relieving arch above it to those who know that the relieving arch exists.

The second type of vaulting that one finds in the church is a series of hemispherical domes over each of the little chapels (fig. 3). These domes are too low to buttress the nave vault directly, but they do provide lateral stabilization for the great buttressing walls that separate the chapels. Above these little domes, the structure is essentially exposed to the open air through enormous, round arches cut through the upper exterior walls (pl. 9, right side). These outer arches, in turn, also lend lateral stability to the outer ends of the buttress walls between the chapels.

The side roofs of the church are held up in an ingenious manner. They rest directly on pairs of ramping, segmental vaults, which rise from the exterior walls to meet the inner wall just above the springing of the nave vault (fig. 3). These ramping vaults are supported midway in flight, as it were, by a diaphragm arch, parallel to the main axis of the nave, which springs from the buttresses between the side chapels. These ramping vaults are only one brick thick (pl. 48). Thus it would seem that they serve neither to buttress the main vault nor to stabilize the buttress walls. Their purpose is to provide a structurally continuous, fireproof means of supporting the outer roofs. Also, the roofs over the west porch are supported by a series of ramping, segmental vaults identical to those that support the side roofs along the nave. Similarly, the roof over the main vault rests directly on the masonry of the vault itself.

The nave vault is flanked on either side by a series of flange buttresses, which are, as noted earlier, upward extensions of the walls that separate the chapels (pl. 9). In addition to these walls, another group of buttresses rises from the apexes of the barrels covering the large chapels. As a group, the buttresses are not equidistant from each other, so that on the exterior they move in a slightly syncopated rhythm (pl. 9), alternating with roundheaded, semicircular niches (pl. 10) hollowed out of the masonry flanking the nave vault. These niches are placed to serve several functions. First, they lighten the load of masonry high on the building. Second, they transmit the continuous thrust of the barrel into the noncontinuous system of flanking buttresses at a point on the structure above the springing of the nave vault itself. Finally, the half-domes of the niches help to poise a large mass of masonry continuously along the haunch of the nave vault to prevent it from splaying by transforming some of the lateral thrust of the vault into vertical load.

Essentially, then, the walls and vaults along the periphery of the nave are designed to bear the load of the main vault, counter its lateral thrust, cover the auxiliary interior spaces, and carry the exterior roofs.[17] At the same time, this system of walls and vaults is so designed that it stabilizes itself, somewhat in the manner of a honeycomb, but utilizing a far greater variety of forms and means.

Although very large in size, S. Andrea is not a cathedral. Nor is it simply a parish church fortunate enough to have been aggrandized under the patronage of a great family. Rather, S. Andrea was built to perform a very specific and singular function: the housing of two vases containing the Most Precious Blood of Christ, which are now conserved in an altar in the center of the crypt. An understanding of the history of this relic and of the function of the church is crucial to an understanding of its form.[18]

According to tradition, two vases containing the Blood of Christ mixed with earth from Calvary were brought to Mantua by St. Longinus, the Roman centurion who was converted during the hours of the

Crucifixion itself. Before he suffered martyrdom near the city, Longinus is said to have buried his precious vases for safekeeping in a Mantuan hospital. There the relics lay until the year 800, when St. Andrew, in a dream, miraculously revealed their location to a local resident. In 804 Pope Leo III dedicated a small basilica built to house the relics.[19]

In the difficult times following the collapse of Carolingian power, the relics were buried anew. Once again, in 1049, St. Andrew appeared in a dream, which led to their recovery. An altar was immediately built to mark the spot where they were found, and by 1056 at least part of a new church had been erected, presumably around the altar, under the august patronage of Boniface and Beatrice, parents of the famous Countess Matilda of Tuscany.[20] Of this second Mantuan church dedicated to St. Andrew we know very little more than that it occupied the site of the present building,[21] that it was of large size,[22] and that it was served by a Benedictine monastery.[23]

The disposition of the relics in Romanesque S. Andrea was far from convenient. They were buried *sub pavimento* in a location to the right of the high altar. When the Emperor Charles IV wished to venerate the contents of the vases while visiting Mantua in 1354, the pavement of the church had to be torn up to accommodate his request. Moreover, the location of the vases in the church was so closely guarded a secret that the emperor made his visit under cover of darkness, and saw the vases only after the doors of the church were locked. Afterward, of course, the pavement had to be put back to conceal the hiding place again.[24]

With such secrecy surrounding the conservation of the Blood, there must have been little, if any, chance for an average communicant to view the relics with his own eyes. In 1401, however, this situation was changed markedly. In that year, by order of Francesco Gonzaga, the vases were relocated in a more accessible place, which could be opened with relative ease by eight keys entrusted to eight different people. More important, however, at the same time Francesco instituted an annual public display of the Blood on Ascension Day.[25] According to a contemporary account, the relics were shown on three separate occasions to accommodate the large crowds of faithful who wished to view the Blood, and on the third showing some 10,000 people are said to have been present in the church.[26] The event began to attract throngs of pilgrims, as a local author, writing about eighty years later, testifies:

> Many witnesses are still living, who remember the coming of Ascension Day, when the Blood is shown. There were so many foreigners that they could scarcely be contained in the city, and it seemed as if one were in Rome at the time of the Jubilee.[27]

The reordering of the relics is but one aspect of a renewed interest in the church that manifested itself in the first years of the fifteenth century. The then abbot of the monastery, Antonio Nerli, compiled the first known history of S. Andrea, and began a new façade, incomplete at his death in 1406.[28] This new façade (or part thereof) was joined in 1413 by the still extant tower[29] that abuts the present façade (pls. 1 and 3). In 1450, the front of the church was further embellished by the addition of a six-column portico, and thirty-two new columns were ordered for the cloister of the monastery.[30] Thus by mid-century the old church presented a relatively modern face to the pilgrims who came to venerate the relics within, even if the eleventh-century interior (perhaps partially rebuilt after a fire[31] in 1370) did not.

As far as we know, the old church of S. Andrea had little formal connection with its successor of 1470. To be sure, the old tower remained, and the very recent portico of 1450 found an echo in the present porch.

In 1459 Pope Pius II, in convening the ill-fated Council of Mantua,[32] perhaps set in motion those events that led directly to the new S. Andrea as it now stands. The Council, called to raise a crusade against the threatening Turkish hordes, brought to Mantua not only the papal court, but also distinguished visitors from all over Europe. One of Pius's courtiers was Leon Battista Alberti, perhaps on his first visit to the city.[33] During the tedious course of the Council the Most Precious Blood became a center of interest and devotion, perhaps in part because the Pope is said to have fallen ill and to have recovered

his health only after praying before the relics.[34] At this very time, however, the authenticity of the relics was being seriously questioned, and a learned debate was held under papal auspices to decide the issue. Significantly for the future history of S. Andrea, the chief defender of the relics was Francesco della Rovere, who was to become Pope Sixtus IV, and one of the Gonzaga's strongest allies. The debate resulted in an affirmation of the genuine nature of the relics, and·through this debate they doubtless achieved a certain enlarged notoriety.

To the dignitaries who gathered for the council, S. Andrea must have presented a less than pre-possessing appearance, with some of it apparently in precarious structural condition.[35] This state of the church may have weighed more and more on the mind of Lodovico Gonzaga, the proud, ambitious, and cultivated marchese of Mantua. By the fall of 1470 he had clearly decided to build a new church, not simply out of Christian devotion, but, as he put it, "for our honor, and the honor of this city."[36] To the history of this new church we now turn.

# II

# The First Campaign

## *1470–c. 1494*

On 20 or 21 October 1470, Leon Battista Alberti sent Lodovico Gonzaga a letter (pl. 12), accompanied by a sketch, in which he briefly explained his conception of the new church of S. Andrea.[1] The letter is a model of brevity and diplomacy:

> Also I understood in these days[2] that Your Highness and these your citizens were thinking of building here at S. Andrea. And that your principal intention was to have a great space where many people would be able to see the Blood of Christ. I saw that model of Manetti's. I liked it. But to me it does not seem suited to your intentions. Ponder and imagine this which I send you. This will be more capacious, more lasting, more worthy, and more felicitous.[3] It will cost much less. This type of temple was known among the ancients as the Etruscan. Should you like it, I will see to drawing it up in proportion.
>
> *Your Servant*
> *BAPTISTA DE ALBERTIS*

The letter is the single most important known document for our understanding of Alberti's intentions at S. Andrea. It demonstrates that he instantly grasped the major functional problem: the necessity for a great space in which the Blood of Christ could be shown to large crowds. The form, structure, and scale of the church grow directly out of this single requirement.

Clearly Lodovico had already commissioned a design from (Antonio [?]) Manetti, since a large part of the Alberti letter is aimed directly against this project. Although Alberti said that he had seen Manetti's model and had liked it, the latter remark must have been offered as a gratuitous compliment to Lodovico's sensibilities as a patron for, in the following sentence, he criticized the plan as unsuitable to the purposes of the church, and to the intentions of Lodovico and his citizens. Instead, he offered a concept of his own, which he urged Lodovico to ponder and to imagine in his own mind ("pensai et congettai"). Alberti praised his design in an exquisitely balanced appeal to his patron's pride, discrimination, and pocketbook. Finally, to drive his point home, he closed with a typically learned reference to the ancient past, expressing himself in Latin ("etruscum sacrum") to underline the antique antecedents of his design. He chose, moreover, a peculiarly appropriate nomenclature to describe his church. According to local tradition, surely well known both to Alberti and to Lodovico, Mantua was founded by Etruscans.[4] Thus his "etruscum sacrum" would be singularly well suited for the city in which it was to rise. If ever an architect's letter were carefully composed to fetch a commission, this note of Alberti's to Lodovico is surely one. In every way that could have mattered to a cultivated fifteenth-century prince, Alberti proclaimed this design superior to that of his rival.

The letter gives us no particulars of the plan. Those were indicated on the drawing that accompanied the letter. This drawing, now lost, could only have been a freehand sketch,[5] for Alberti clearly indicated that he had not drawn the plan up in proportion, a laborious process that he was prepared to undertake only if the design pleased Lodovico.[6]

The marchese did not immediately bite at Alberti's cleverly offered bait. But he did find the lure sufficiently tantalizing to reply that, upon his return to Mantua from the country, he would talk the matter over with Alberti. The design must have puzzled Lodovico, for he told Alberti that he had not really been able to understand it well.[7] Finally, Lodovico, who fancied himself something of an architect,[8] promised to share with Alberti what he called his own "fantasia" on the subject.

It is out of this relationship that the design for S. Andrea must have grown. Unfortunately we have no further preserved correspondence between Alberti and Lodovico in which the church is mentioned. What ideas may have been exchanged, and what changes may have been made in the original design, we will probably never know. Nor is it likely that we will know if Lodovico exerted any real influence on the final plans. But we must, at least, leave open the possibility that some modifications in Alberti's thinking took place before the final project was settled upon.

This project may have been ready as early as the following January, for in the middle of that month Luca Fancelli, the Florentine sculptor-architect who directed the first campaign at S. Andrea, was already busy acquiring supplies for the new building.[9] For ten years and more (1460f.) Luca had supervised the construction of Alberti's other Mantuan church, S. Sebastiano,[10] and so it is hardly surprising to find him involved in preparations for the new church at a very early moment. He was the logical candidate for the position of supervisor at S. Andrea.

The gathering together of supplies was accompanied by a major effort to raise money to begin the building of the church. A fund drive was held on Ascension Day (23 May), when the Blood of Christ was shown. At that time Lodovico made an offering of 300 ducats, while Cardinal Francesco, his son, offered 200. In a letter of 27 April 1471, Lodovico urged his chief steward to encourage others to make "some nice offerings" as well.[11] Lodovico apparently did not plan for work to start immediately, however; or, if he had planned at one time to begin construction in 1471, something must have gone wrong, for on 18 May of that year, in a letter to Carlo da Rodiano, his agent, he remarked that "we will not work on the church until God knows when."[12]

The fund drive at Ascension was successful, as we are told explicitly by the contemporary chronicler Schivenoglia:

> On 6 February 1472 they began to tear down the church of S. Andrea . . . and this beginning was made from money that had remained from the offerings made on Ascension Day. And it was estimated and said that work on the said church would last twenty-two years and that it would be finished in the year 1494.[13]

Schivenoglia's optimism makes us smile today. Had he lived until 1494, he would not have seen the church in quite the state of completion expected.

The delay in beginning work on S. Andrea from the spring of 1471 until February of the following year may have been caused in part by the necessity of getting papal permission to destroy the old church. On 2 January 1472, Lodovico wrote to Cardinal Francesco, requesting his services in speeding up that permission.[14] The letter is important in many respects, for it reveals the importance Lodovico attached to the project and contains also the only knowledge we have of the relationship between the old church and the new.

Lodovico wanted to start on the building "to which construction we have turned our heart," not only for reasons of necessity, because the old church was falling down, but also "for your honor and ours and that of the city."[15] Lodovico expected the campaign to go rapidly. He pointed out to his son, who was probably concerned lest in the future he should have an economic albatross of a large unfinished church around his neck, that "according to a model that has been made it will not require the expense or the time that used to be thought"[16] (cf. Alberti's "it will cost much less").

Demolition of old S. Andrea was to begin "at the well which, as you know, has been ready to collapse for a good while."[17] Located toward the other end of the church from the piazza, this "well" was clearly

connected with the old place where the relics had been exhibited since 1401, a fact that is established in four additional documents.[18] That the destruction of the "well" had to be specifically mentioned in the razing permit emphasizes its more than ordinary significance. The church, moreover, was to be torn down in two phases: "from the well toward the door and the piazza [Piazza Mantegna] all that part, and it will be torn down before the other part is razed."[19] Thus the old choir of the church was to be maintained so that services could be continued, although it probably did not stand for many more years, or even many more weeks.

The urgency for immediate permission to begin work was underlined by Lodovico for a very practical reason: it was winter and there was a large pool of idle farmers and laborers handy to do the work. Lodovico intended to mobilize as many of them as possible to raze the old building quickly. This passionate desire to get work under way, coupled with the availability of labor, doubtless accounts for the fact that work began, unusually, in February, a month in which the Mantuan climate makes going out-of-doors almost unbearable.

The destruction of old S. Andrea must have proceeded rapidly, for by the end of April, just prior to Ascension Day (7 May),[20] the site was in such a state of confusion that almost no one connected with the project was sure if the Blood of Christ would be shown. Two letters of 30 April, one from Luca Fancelli[21] and the other from Lodovico,[22] show clearly that both men were determined to see the ceremony carried out, for Ascension Day was the very day on which offerings were made to the building fund. Not to show the Blood could have had adverse effects on the treasury of the Fabbrica, as both Lodovico and Luca were well aware. To facilitate the showing, Luca had filled in the "well" with rubble from the site, so that, according to custom, someone could stand on it to show the Blood.[23] Lodovico was pleased with this solution but expressed concern about the heat of the day, since the roof of the old church had already been removed.[24]

These letters and the chronicle of Schivenoglia are all the evidence we have from those fifteen months between Alberti's first submission of a design and the commencement of construction. We have no document that actually links Alberti's name to the final project, that is, to the "model that has been made" that Lodovico mentioned in his letter of 2 January 1472.[25] Even so, no one has seriously questioned Alberti's authorship of at least the west porch and the nave. The monument itself speaks more authoritatively in this instance than fragmentary documentary evidence.

Alberti, as is well known, never actually directed the construction of one of his buildings. That rather ungentlemanly task was always handed over to a craftsman. In Mantua, Luca Fancelli was the man best suited by experience to oversee the building. As we have seen, only three months after Alberti had sent Lodovico his sketch, Luca was already engaged in gathering building supplies for the new church. Surely he had direct discussions with Alberti about the design before Alberti's departure from Mantua, which took place before 23 March 1471, when we know Alberti was in Florence, involved in Lodovico's project of the choir of the SS. Annunziata.[26] Alberti died in early April 1472,[27] two months after the razing of the old building began, and two months before ceremonies were held to commence the new work. Luca Fancelli then became the direct link between Alberti's concept of S. Andrea and its realization. With the aid of newly discovered evidence of both a documentary and an archaeological nature, the work that was actually completed under Luca's direction can now be clearly established.

Toward the end of May the razing of the old church, or at least that part which was to be destroyed first, must have been completed, for, according to the seventeenth-century Mantuan chronicler Donesmondi, "On the twelfth of June [1472] the marchese with great solemnity placed in the foundations the first stone religiously blessed ...."[28]

Lodovico was constantly interested, and occasionally even meddled in the construction, as we learn from a letter of 6 July of this first year of work. Luca protested gently to Lodovico about a scaffolding that the latter had ordered erected "up from the pavement of the choir" in his absence. Another part of the letter, not immediately understandable, reads:

Your excellency has been to S. Andrea and ordered that a scaffolding be made up from the pavement of the choir. And, considering that how the walls are to go is not decided, and I doubt that they will know how to decide without me. But it seemed to me that the walls should not go higher until I am there.[29]

The scaffolding that Lodovico had ordered clearly was to be used for the building of walls, but the exact form these walls were to take had not been decided. Moreover, it turns out that this activity took place before most of the foundation walls had been laid (see below). Lodovico, then, was in a hurry to see these new walls rise up from the floor of the choir, walls that seem to have had no connection, indeed, with the new foundations being laid at that very moment around the perimeter of the new nave.

If we assume, with Ritscher,[30] that the old choir was left standing until the late sixteenth-century, then it is very difficult to understand the purposes of these new walls. Ritscher based his assumption of the continued existence of the old choir of the church on a drawing of 1580 (pl. 13) by Cesare Pedemonte,[31] on which one finds the inscription: "the old chapel outside the church in the construction." A careful analysis of the drawing leads to the questioning and the probable rejection of Ritscher's position. It can be demonstrated that the "old chapel" mentioned in the drawing was not the still-standing medieval choir but a temporary structure hurriedly built in the 1470s.[32] In this case, Luca's letter to Lodovico makes perfect sense. Lodovico wanted this temporary choir built as soon as possible—the cornerstone had only been laid a month before—so that services could be continued on the site without difficulty.

This same letter of 6 July closes with the information that Luca had ordered some workers and kilns to begin a foundation of bricks, which were not available at that time. Bricks were to be made right on the site, apparently, and the time had arrived, I would think, to lay the upper courses of the foundation.

A letter from Lodovico to Luca on 22 July shows Lodovico in almost a frenzy of anxiety over the foundations, as he delivered a lecture to Luca on the necessity of their being extremely firm.[33] The advice was doubtless gratuitous, and not a little annoying to a professional such as Luca, but Lodovico seems to have thought that ultimately he could trust no one but himself to get the building built properly.

The letter was occasioned by an abrupt trip Luca had made to Mantua, the purpose of which he had tried to disguise as flying to his ailing wife's bedside.[34] Lodovico's excellent information system, however, brought him word that the trip was actually caused by troubles with the foundations of S. Andrea.

This exchange of letters brings sharply into focus a grave problem we face in attempting to reconstruct the building history from such documents. Even if all the letters concerning S. Andrea exchanged by these two men, and by others, were preserved, they would not tell us the full story. Sometimes, clearly, the full story was deliberately not told in the letters. When this difficulty is coupled with the facts that many decisions were made by word of mouth, and that letters were exchanged only when Lodovico and Luca were in different locales, it becomes clear that only a small fraction of the decisions made about S. Andrea are actually known to us.

On 6 August, Luca was able to report to his master that considerable progress had been achieved at the church.[35] Indeed the progress seems miraculous. Toward the monastery, he wrote, half of the foundation had been laid, beginning from the campanile and proceeding toward the sacristy (surely the old sacristy, which must have been still standing). These foundations had been raised to the same level (not indicated) as those in the other side, toward the shops.[36] He wrote, then, as if the southern foundations were already completed and raised to a certain height. "The other part," he continued, "is being made with great care."[37] By "the other part" I take him to mean the north side, only half complete, because of the difficulties encountered in finding firm footings. The excavations had to be made deeper in that part, and this hardship was intensified by the finding of many old foundations. He complained of not having enough men for this particularly difficult work, especially since it had been necessary to shore up the walls and the excavations against the continual slippage of the ground. But, he assured the anxious marchese, good work had been done.[38]

Braghirolli, unfortunately, published only the first part of this extremely important letter, which closes with the following remark: "And one digs for the foundation of the façade and the foundation is begun, and I estimate that this coming week all the foundations will be laid to the level of the one Your Excellency has made."[39] In other words, while work was going on the foundation of the nave, the workmen began to excavate and lay the foundations of the façade. This letter, then, should put to rest those suspicions that the present west porch might have been a later addition to the nave.[40] Clearly, the two were built together from the ground up.

Luca's letter also contains a curious passage that describes injuries sustained by two of the workmen. The first of these broke his left arm "between a wall and the ground."[41] Perhaps he fell into a trench in which foundations were being laid. The other, however, received his injury at a point much higher up, "above vaulting outside the sacristy," when a part of a wall gave way and threw a large board into his side.[42] What this man was doing laying a vault high outside the sacristy only two months after the cornerstone had been laid is not clear. The only reasonable explanation at this point is that he must have been working on the temporary choir that Lodovico had been so anxious to begin a month earlier. The choir must have gone up very rapidly (and in a very shoddy fashion?) for a mason to find himself at a level where vaults were being built.

From Luca's complete letter of 6 August we now know that, despite difficulties, in a period of about two months approximately three fourths of the foundations of the present nave were laid, the foundation of the façade was begun, and a temporary choir was rising rapidly to the east of the nave. The quickness of execution attests convincingly to the excitement and purpose with which the building was begun.

By mid-September work had rushed forward at such a pace that it had outstripped the supply of materials. Indeed, from the middle of September until the middle of October Lodovico was engaged in an effort to find more materials for the Fabbrica. On 17 September, in response to a plea from Luca for more money and supplies, he wrote two letters. The first was a reply to Luca in which he noted that no bricks or mortar were available, but that the requested 100 ducats could be found.[43] The second, accompanied by Luca's correspondence, was addressed to his treasurer, Albertino Pavesio. In this letter he reiterated his response to Luca and pointed out that the help of Cardinal Francesco (luckily in Mantua) would be needed to secure the 100 ducats. Albertino was clearly instructed that work had to go on at S. Andrea, come what might.[44]

This small flurry of correspondence was caused by the request Luca must have made for funds and supplies to raise the walls to a height of 3 *braccia* (roughly 1.5 meters), a height that had been agreed upon earlier.[45] From the wording of Lodovico's reply to Luca's letter, it is clear that both men were anxious to "see" the plan realized, to get a sense of the actual scope of the building.[46]

Although a height of 1 *braccia* had not been reached on 17 September,[47] by the twenty-sixth of the month Luca, in a previously unknown letter, was able to report that "up to this hour there is erected a *braccia* and a half of the surrounding walls, and similarly, the parts under the chapels," and that work was continuing "with great care."[48] This surge in the work was financed through an arrangement made by Cardinal Francesco, which he reported to Lodovico on this same 26 September. Francesco had assumed a debt of 300 ducats, which a certain Niccolo Tosabezzo owed to the Fabbrica of S. Andrea. In return, Francesco received the deed to Niccolo's house. Francesco immediately had 100 of these ducats paid to his father, and promised to pay the rest in bricks in the early spring (when work would begin again).[49] Lodovico replied that he was happy with the solution, but quickly told Francesco to have the 100 ducats paid not to him, but rather to "those in charge of the works."[50] Lodovico was always very careful to keep himself above suspicion in the handling of the building funds of S. Andrea.

Work continued at least until 15 October, when Luca reported to Lodovico that he had gone from Revere to Mantua to look after things at S. Andrea. This previously unknown letter does not supply us with any informative details, but it does reveal a great deal about the relationship between the two men. The closing phrase reads: "and this [letter] is only so that Your Lordship should not become excited and

also may know where I am."[51] Luca apparently had learned in the previous July that hurried trips into Mantua could well arouse "excitement" on Lodovico's part.

Toward the end of the month there still seemed to be a possibility of reaching the 3-*braccia* level before the building season came to an end. On 22 October Albertino Pavesio informed Lodovico that he would "have very well his intent" (the 3 *braccia*), if Lodovico would pay to the Fabbrica the 100 ducats he still owed[52] (those same 100 ducats Francesco had provided?). We have no further correspondence from this year dealing with S. Andrea, and so it is impossible to say at what level work finally stopped. Albertino's closing sentence—"the [work], God granting through his grace, we will finish in our time"[53]—gives us a clearer insight than any we have previously had into the general excitement and hopes that the beginning of work at S. Andrea aroused in those concerned. Everyone seems to have been driven by a desire to see the building rise in the shortest possible time. Thus the campaign in that first year drove forward at a dizzying pace.

It is interesting to contemplate what factors in Alberti's design allowed work to progress at such a rapid rate, a rate that must have reinforced Lodovico's belief that "it will not require the expense or the time that was once thought," and that bears out Schivenoglia's seemingly foolish statement that the church would be completed by 1494. Alberti, it would seem, had good reason to write that the church would cost "much less."

Within five months the site for at least the nave had been cleared—that is, a fairly large church had been razed and its debris removed. In the documents, however, there is never any mention of other buildings being torn down or additional land being purchased. It is dangerous, I know, to consider a lack of evidence as evidence in itself. But it is very tempting to hypothesize that Alberti deliberately designed the new church in such a way that little or no additional land would have to be purchased and no buildings razed other than the old church itself, at least for the construction of the nave and west porch, with which we are specifically told the work began ("from the bell tower . . . toward the sacristy"; see n. 36). How clear a cost-cutting and time-saving procedure this would have been, and also how sensitive to the preservation of the local cityscape.

S. Andrea is constructed entirely of brick, except for a few decorative details. The bricks of the church were produced in kilns set up on the site, saving both the delays and expense involved in transporting them from factory to Fabbrica. Further, there is no wooden truss system to support the roof, which rests directly on, and is even an integral part of the great brick barrel vaults that cover the whole interior space. No large timbers were available locally—they would have had to be imported at great expense from the Tyrol. This fact must have been taken into account in the design.

The simplicity of the plan and structure, however, is probably the most important factor here. The huge nave, over 50 meters long and over 18 meters wide, is completely unencumbered, and thus better able to hold great throngs of people, every one of whom could see the relics when they were displayed. The only structural members rise along the periphery of the nave—a series of walls parallel and at right angles to its axis. Indeed, the major part of this space is left open also to form a group of side chapels, six to each side. For the size of the church, then, there was actually very little to be built, and what had to be built was very simple in nature: brick walls intersecting each other at right angles. No footings for columns had to be sunk, nor were complicated, careful measurements necessary to locate such footings, nor did columns have to be quarried, carved, and set in place. It was only necessary to lay out a few straight lines parallel to each other, and a few others that intersected these at right angles. For the actual building, no stone had to be cut and joined together in regular fashion. Bricks were made and laid as quickly as the masons could put them up. In this light the miracle wrought at S. Andrea in the first year becomes no less a miracle, but it does become a different kind of miracle, one of design as well as one of will.

From this information, also, I think we are able to conclude that there was a very carefully laid plan for the whole building campaign, accompanied by almost equally careful estimates of cost and material

requirements, as Lodovico's remark in his letter of 2 January to Francesco Gonzaga bears out: "... there will be placed in the work two million bricks according to our calculations."[54] The speed of the work attests to careful preparations prior to the actual phase of construction. Actually, the work seems to have outstripped the preparations—witness the difficulties that arose in reaching the agreed height of 3 *braccia*.

During the ensuing winter lull in building, a bitter conflict arose among the men responsible for carrying out the work, a conflict that could have had the effect of bringing everything to a complete halt. The disagreements seem to have centered around the character of Luca Fancelli, which, if we are to believe his accusers (chief among whom was Albertino Pavesio), was far from admirable. In February 1473, Albertino and two others addressed an extremely long letter to Lodovico, detailing Luca's transgressions of the past year. The charges included the hiring of incompetents and loafers, the appointment of master masons without the consent of the board of overseers, favoritism, graft, and theft from the works. Moreover, Luca apparently forced anyone who wanted a job at the works to work part time at his own house.[55] The list is long and tedious, and Luca's reply to the charges is far from convincing. For instance, he admitted to having stolen from the Fabbrica, but only just a little.[56] Moreover, he seems to have had a most evil temper with the workmen, as a letter from the canons of S. Andrea to Lodovico attests.[57] How the conflict was finally resolved we are unable to say, but resolved it must have been, for in the spring of 1473 work began again in earnest.

By 13 May Luca was able to report that within a few days it would be time to "raise the great door of the entrance of the church, once the chapels have been built up to the level of the scaffolding." (The exact height of the scaffolding is not given.) At that moment, he informed Lodovico, he was working with a force of twenty-seven masons ("cazole," literally trowels).[58]

The work by this point must have reached a level of over 5 meters. The height of the "great door" Luca mentioned is 5.6 meters and so, assuming that a uniform height was being maintained all around, that height must be close to the level that the walls of the chapels had reached. Assuming also that each new level of the scaffolding would allow the walls to be raised something less than 2 meters, the walls could then have reached the height possible from two levels of scaffolding above floor level—something less than 6 meters. At this time, of course, it would have been necessary to suspend work while a third level was added to the scaffolding. This point seems, then, a normal one at which to make a report on the progress made.

A very rough estimate of the rate of work, based on this information, is now possible. We know that in the fall of 1472 the walls were 1½ to 3 *braccia* high before the building season came to an end. When work began again in the spring of 1473, less than a meter and a half was the previous height reached, at best. Assuming that work did not begin again before March, or possibly a couple of weeks later, the walls must then have gone up at a rate of something close to 2 meters a month. It would be tiresome to break these figures down into bricks laid per day by each of the twenty-seven masons, but it is safe to say, I think, that the building must literally have grown before the eyes of the citizens of Mantua.

By 7 August Luca could write to Lodovico that he had brought the building up to a height of almost 20 *braccia* (about 10 meters), a point in the neighborhood of the capitals of the small order of pilasters of the nave.[59] As Schivenoglia indeed commented, in 1473 work was carried on "fortemente" at S. Andrea.[60] At this rate the walls should have been completed up to the cornice and ready to receive the great barrel vault by the summer of 1475 at the latest. Given such rapid progress, does not Schivenoglia's estimate of twenty-two years to complete the church seem too long? Or was there more to be built than just the nave and west porch?

This pace, however, faltered. From 1474 to 1476 no documents have come down to us that indicate any specific progress at the works.[61] Indeed, we do not hear any more about new levels reached until the end of the building season of 1477, when a sudden flurry of correspondence, dated between 15 and 28 September, arose.[62] The letters revolve around new controversies at the works between Luca and the others on the job, specifically a certain Johannino de Bardelone. The only really solid pieces of evidence

to come out of all this letter writing are that during the month of September Luca vaulted "this third chapel,"[63] that at the same time he sent to Florence for some stone-carvers,[64] and that various ornaments, doubtless of terra-cotta, were being manufactured.[65]

From this evidence it is clear that work had not progressed very rapidly over the preceding four years. In 1473 work had reached almost the point of the springing of the vaults of the large chapels, but by 1477 only three of those chapels had been vaulted. One major reason for the delays is undoubtedly to be found again in the character of Luca Fancelli. In these letters of 1477 he speaks as if all the workmen in and around Mantua were ill at the same time and unable to work.[66] It may well have been that all of the workmen decided to quit working under Luca and gave illness as their most reasonable excuse. (Johannino de Bardelone and Luca were engaged in a running battle over several years—another controversy between them arose in 1480 and took all of Francesco Gonzaga's considerable diplomatic and persuasive powers to solve.[67]) Faced with this mutiny, Luca sent back to his native Florence for four stonecutters, probably in the hopes of getting artisans who would be both highly skilled and faithful to him. If there were stone to be carved at this time, it could only have been for the capitals of the small order of the façade (there was no other stone ornament on the original building except for the main portal).[68]

Although Lodovico wanted it made clear to Luca that his conduct was not entirely to be forgiven, he stated that "this work cannot be done without Luca, for there is no other except him who understands it."[69] Luca was indispensable, and for that reason alone he seems to have been allowed his evil temper and his petty graft. Luca was the only sure link with Alberti; therefore he had to be saved and humored at all costs,[70] even in the face of rising expenses and the prolongation of the work to an unconscionable length.[71] To Lodovico the only other alternatives must have been to have the work done improperly, or not at all. With this exchange of letters concerning a typical imbroglio among his hirelings,[72] Lodovico passes from the picture. He died in the following year, to be succeeded by his son, Federigo, who seems to have turned much of the supervision of work at S. Andrea over to his brother, Cardinal Francesco.[73]

Work plodded on, characterized by at least one more major quarrel in 1480[74] (and doubtless many more), until, by the spring of 1480, ten of the twelve chapels flanking the nave had reached a sufficient state of completion for consecration, a ceremony carried out on 20 May by Francesco.[75] Since the last two chapels at the eastern end of the nave were not included in the ceremony,[76] we may conclude that they had not yet been completed. A month later, on 22 June, Federigo wrote to Francesco that the church was ready to receive the vault. He suggested a clever scheme for raising money for this project: persuading the pope to donate part of the funds that had been collected and deposited by Pius II in Mantua for the latter's proposed crusade against the Turks. Federigo was well acquainted with the exact terms under which the money, some 2300 ducats, was to be spent: "against the Turk or rather for pious causes." He continued in a splendidly rational vein:

> The church of S. Andrea here will have great need of a subsidy, it being necessary to spend a considerable sum there almost at one time to cover it. And it would be a most pious work to aid this Fabbrica.

Actually, we find out, Federigo intended to indulge in a form of blackmail. He did not think, he informed the cardinal, that he would let the funds out of his hands until he got a response to his proposal, at which point, sure of his ultimate victory, "immediately the remainder will be sent according to the command of His Beatitude."[77] One suspects that indeed he did get his pious offering for the church.

On 14 July 1482, the last chapel "on the left side from the entrance of the church" was consecrated and dedicated to St. Bonaventure.[78] We have no record of the dedication of the sixth chapel on the right (it is now the chapel of St. Longinus, and probably always has been[79]) but, assuming that the building was ready to be vaulted, it must have been dedicated at much the same time. Apparently the procedure of building from west to east, which began with the laying of the foundations, was followed throughout the campaign to complete the nave.

Before the chapel of St. Bonaventure was ready for dedication, however, another chapel in S. Andrea was consecrated to the Blood of Christ on 22 August 1481.[80] Although the document does not pinpoint the location of this chapel in the church, there is only one reasonable place for it to have been: below pavement level in a crypt. We know the dedications of all except one of the side chapels, and are reasonably sure of the dedication of that one to St. Longinus. Furthermore, until 1401 the relics had always been preserved below ground, and after they were moved into a new reliquary at the beginning of the quattrocento, the tradition of their subterranean keeping was maintained by showing them annually above the "pozo" frequently referred to in the documents cited above.[81] One would expect this tradition continued in the new church. It was also necessary in new S. Andrea to give the relics their own particular and important location, preferably, one would think, along the line of the main axis of the building. There was, finally, the necessity of providing a place where they could be safely kept, yet remain accessible. The inclusion of a crypt in the Alberti plan would satisfy all of these needs well.

The physical location of a crypt at the lowest level of the church obviously required that work on it begin during the earliest phases of construction, that is, during the laying of the foundations. We are now in possession of a document that specifically tells us that during the first year of the fifteenth-century campaign, work was carried out on the accesses to this crypt. In Albertino Pavesio's lengthy list of the sins of Luca Fancelli during the building season of 1472, he mentioned a workman who had made a number of mistakes, "mostly concerning the circular stairs."[82] The only circular stairs built during the fifteenth-century campaign are those in the western crossing piers,[83] and it is through these stairs in the crossing piers that one still reaches the crypt today. What is perhaps even more important in this respect is the fact that access to the stairs that lead to the crypt is and always has been through the door on the transept face of each pier (pls. 5 and 15).

Keeping this enormously important point in mind, let us now take a careful look at the western crossing piers. The archaeological evidence they provide is crucial for our understanding of the history of S. Andrea. Since these piers are mirror images of each other, for the sake of clarity we shall discuss only one. The exterior faces of the pier present a modified appearance from their original state. During the third campaign, 1597–1600 (as I will demonstrate below[84]), additional pairs of salient pilasters were added to each face. The addition of these pilasters caused the relocation of the pier doors closer to the crossing.[85] The frames of the original nave doors are still to be seen behind the later masonry, and the relative positions of the two sets of doors can be grasped from a look at the Ritscher plan (pl. 15). The old door is in the same plane as the doors of the other piers of the nave. The distance from the center of the earlier door to the center of the adjacent large chapel in the nave is equal to the distance from the center of that large chapel to the midpoint of the door in the next pier to the west, thus maintaining the rhythm of the articulation of the nave. On both faces of the pier, moreover, part of the original pilaster farther from the crossing is seen to emerge from behind one of the later, projecting pilasters (pl. 6). The old door opening on the transept side of the pier has undergone more radical modifications[86] and its original frame is no longer visible.

A further penetration into this crossing pier reveals that the inner space is partially occupied by pairs of overlapping circular staircases (*scale a lumaca*). On entering the pier from the nave door, one immediately ascends a long, straight flight that leads to the circular stairs that carry the visitor up to the roof and the dome. Through the transept door the modern visitor enters a curving corridor that quickly leads to a short flight descending to a landing. At this landing one discovers a gate (pl. 16) raised above the landing level, through which are visible the fifteenth-century circular stairs that the present system replaced. From here one makes a 90-degree turn to complete the descent to the crypt.

A walk up the circular stairs reveals that the pier was articulated originally by pairs of large oculi (pl. 17) at the same height and of the same size as the oculi in the other piers that line the nave.[87] One oculus faced into the nave, and the other faced east into the transept. These oculi were later partly walled up at the same time that the faces of the piers were modified by the additional pairs of pilasters.

Finally, the oculi were completely closed off. The purpose of the oculi, beyond that of continuing the articulation of the piers of the nave, was to allow light to enter the staircases, which at present are plunged into a Stygian darkness.

Each crossing pier also once had two additional openings that occurred at a level between that of the oculi and that of the doors. These openings, rectangular cuts in the masonry capped by round arches (pl. 18), also faced in two directions—into the nave and into the transept. They too admitted light from the church itself into the staircases within the pier. These rectangular openings suffered the same fate as the oculi above them, i.e., they were partially walled up at the time the additional pairs of pilasters were added to the faces of the crossing piers, and then later completely closed off.

If, then, each face of each of the two western crossing piers was once subdivided into three stories articulated by three openings—door, roundheaded window, and oculus, what does this new information tell us about the original articulation of the faces of the piers that line the nave? Today there are doors at ground level, and oculi at the third level. In the intermediate zone, however, the faces of the piers are flat, offering rectangular fields for the frescoes (c. 1780) that now adorn them. I suggest that originally these intermediate zones of the piers were not simply planar, but rather were carved out with roundheaded niches, corresponding to the roundheaded windows in the crossing piers.[88] Thus, all of the nave piers, in their original form, would have resembled the two outer bays of the west façade (pl. 19) more closely than they do now, and, as well, the walls of the interior of the church would have enjoyed a greater richness of relief.

A further point about the crossing pier can be made if one turns again to the plan of the church (fig. 2). The staircases in the pier are not centered but pushed back into the corner away from the crossing. This disposition of the staircases allows the larger part of the mass of the pier to flank the nave and transept directly. A similar situation obtains for the locations of the small chapels in the nave piers. These are placed against the periphery of the building, leaving a large mass of masonry next to the nave to support the great barrel vault (pl. 14). Clearly, then, when the staircases were placed in the crossing pier it was intended that that pier support not only the vault of the nave (pl. 6), but the vault of a transept as well.

All of this evidence, then, allows us to reconstruct rather clearly the original design of the crossing piers. They were identical to the nave piers on two sides, except for the fact that there were roundheaded windows in the middle stories of the crossing piers, instead of the roundheaded niches in the nave piers. The corner of the transept must have been turned in a very simple manner. The corner pilasters came together at a right angle, separated only by a thin molding, just as the two pilasters on the southwest corner of the west porch come together still (pls. 1 and 64).

More important, our new documents and newly observed archaeological evidence make it plain that a transept was planned at S. Andrea in 1472, when work on the church began. The planning of a transept, in turn, implies the planning of the crossing and the choir beyond, or, in other words, the laying out of S. Andrea according to a Latin Cross scheme.

Finally, another piece of archaeological evidence assures us that the fifteenth-century plan called for a church of the present size, with transept arms as deep as they are wide. On the exterior corner of the west wall of the north transept one can observe a horizontal discontinuity in the masonry at a level approximately 7 meters above ground (pl. 32). This line runs directly above the second of two small oculi cut into the brickwork. These oculi, and the rectangular windows above them, light one of a pair of superimposed staircases located in this corner of the transept. Oculi of this size and function occur in only one other place in the building, the staircases flanking the west porch of the church (pls. 1 and 64). These staircases and oculi are clearly of the quattrocento campaign. For this reason it seems logical to assign the oculi, and the masonry surrounding them, to the same time. If we return to a photograph of the north transept (pl. 32), we will observe that the line of discontinuity continues around the corner of the wall and across the north face of the transept, to be lost in a portion of wall reworked at a later

date. From these observations we are entitled to conclude that during the fifteenth-century campaign the western part of the north transept was laid out to its full depth and up to a height of about 7 meters before work on it was abandoned.[89]

In addition, it is possible that at least a small portion of the north porch was also begun during the first building campaign. A look at the west wall of the north porch (pl. 33) reveals a striking incongruity. The round arched doorway at ground level and the roundheaded niche above it do not line up along a vertical axis. Indeed, the doorway is not centered in the wall but rather is displaced toward the right. A similar situation obtains for the round arched side doors of the west porch (pl. 1). Thus, in the case of both porches, the side doors are located in the centers of the short interior end walls, but not in the centers of the exterior walls (pl. 15). On the exterior of the south side of the west porch, the niche and window above the door are lined up on a vertical axis that corresponds to a line drawn vertically through the center of the door itself (pl. 1). These observations lead to the hypothesis that the roundheaded niche above the door on the west wall of the north porch is not coeval with the door but is to be assigned to a later period in the building history of the church. Since the north porch was completed around 1550, as I will demonstrate in the following chapter, it would seem logical to date the niche to that campaign, and to assign a first-campaign date to the door below, or at least to the lower parts of the door. The masonry at this point in the building is difficult to read, and so it is probably unwise to try to define the precise limits of the construction that may have taken place here during the fifteenth-century building period. Clearly, however, the moldings on the dado to the left of the doorway belong to the mid-sixteenth century—they do not correspond to the moldings on the west façade—thus it seems unlikely that construction on the north porch during the fifteenth century could have reached a very significant height.

For the remainder of the history of the building of S. Andrea during the quattrocento few documents seem to have survived. The façade must have been completed by 1488, for Andrea Mantegna frescoed the roundel of the tympanum (pl. 2) in that year.[90] The vaulting of the nave must have been under way during those very years, for on 15 September 1490 the "Presidentes Fabbricae S. Andreae" petitioned Marchese Francesco Gonzaga for funds that he owed the Fabbrica so that the "third part" of the church could be vaulted.[91]

Francesco, in contrast to Lodovico and Federigo, seems to have used the funds for S. Andrea for his own purposes, giving, as the letter informs us, 200 ducats to the work at Ascension, and then immediately taking them back with a promise to repay the funds within a month, a promise that was not fulfilled. Moreover, he had borrowed 110 ducats as far back as 1485, the year after he succeeded Federigo, and still had failed to complete the repayments.[92]

The situation hardly improved instantly, for on 30 May 1494 the "presidentes" again wrote to Francesco, reminding him that he was about 400 ducats in debt to the Fabbrica, 100 of which would cover the expense of vaulting the "third part" of the church.[93]

We hear no more of these difficulties with Francesco, for whom the completion of the building seems to have meant very little. Whether we can assume that he carried out the suggested method of paying off the Fabbrica 10 ducats a week, up to the 100 needed to do the work, is difficult to say. Perhaps he gave in, after possibly holding up the completion of the vault for almost ten years. I think we can assume, however, that around the end of the fifteenth century that "terza parte" was indeed vaulted. The writers of the letter made it clear, in any event, that they had decided to do the work in 1494, if Francesco would help them. This, it might be noted, was the year in which Schivenoglia predicted the church would be completed, and perhaps by that point the nave was.

Before moving on to later development at S. Andrea, we should pause to consider in some detail one particular part of the church that was erected wholly in the fifteenth century—the west façade and porch. The impression the porch gives today, however, is somewhat different from the impression a visitor to the church in the late fifteenth century would have received. This difference can be attributed partly to the natural ravages of time, but it is due largely to a drastic restoration of the façade and porch

carried out in the nineteenth century. Fortunately, a careful record of these efforts, which were ac-
complished between 1828 and 1832, has been preserved in the Archivio di S. Andrea.[94] From these
documents it becomes clear that a major part of the architectural decorations of the portico is actually
nineteenth century. Also, and more to the point for our purposes here, the documents describe in some
detail the state of the porch as it was found in 1828, a state that seems to be datable to the late fifteenth
century.

Originally, the façade was very poor in stone. Only the frame around the main portal, the channeled
pilasters from which the central arch springs,[95] and the capitals of this small order were of stone.[96] Four
fragments of the original capitals of this small order are preserved in Palazzo Ducale (pls. 20 and 21).
Leandro Ozzola, who attributed these fragments to Luca Fancelli, suspected that they might have come
from S. Andrea, removed during the restoration of the church carried out by Paolo Pozzo.[97] Ozzola
seems to have been unaware of the nineteenth-century restoration of the façade, and of the fact that
the fragments were actually removed at that time.

These four fragments form a homogeneous group, even if they were carved by more than one hand.
They fit precisely the dimensions of the small order of the façade.[98] The decorations of the capitals
combine foliate ornament with grotesque heads. The foreshortening of various features of the heads
shows a rather sophisticated respect for the effect the heads would have had on a viewer below it (pl. 21).
The relief of the central palmette is so high as to be almost in the round. The capitals still bear traces
of a colored ground, probably red, against which the relief decorations, probably blue, were played off.
The present capitals, more or less identical to each other (pl. 19), are composites of elements found in the
various fragments. It is worth noting that the half-pilasters that abut the outer wall of the nave (pl. 26)
were originally of terra-cotta, as were their capitals.[99] Stone was used, in general, only where another
material would decay from direct exposure to the weather.

The stylistic sources for these capitals can at least be suggested. In form, the central palmettes and
scrolls are very close to the capitals and consoles of the square piers of Mantegna's S. Zeno altarpiece
in nearby Verona, painted in 1459.[100] There is an equally strong connection, however, with some
decorative carvings on impost blocks and consoles of the upper order of the garden loggia of the Badia
Fiesolana near Florence, forms that are roughly contemporary with the Mantegna altarpiece.[101] The
use of the masks on the capitals was occasioned by the necessity of turning corners, which the masks
do quite well. Masks on the corners of capitals go as far back as Donatello's Annunciation tabernacle
in S. Croce in Florence of the early 1430s.[102] Such masks are, however, far from common in the
architectural vocabulary of the fifteenth century.

In discussing the capitals of the large order of the façade (pl. 19) one must proceed with far greater
caution. We are told by a document of 1832 that "the present capitals are of simple stucco made with
lime and crushed brick, and they appear almost worn away."[103] These badly weathered capitals were
then replaced with the present ones of white marble. If we assume, for the sake of argument, that the
present capitals follow at least the rough outlines of the original capitals, then we can also attempt to
suggest sources for these designs.

As Rudolf Wittkower noted, there is a clear relationship between the exterior capitals of the large
order and those of the small order,[104] a relationship that increases the unity of the façade (pl. 19). One
hopes that this idea originated in the fifteenth century. The exterior capitals of the large order (pl. 23)
may also be related to the pilaster capitals of the small shrine that Alberti designed for the Rucellai
family in S. Pancrazio in Florence.[105] In both cases a palmette rises from two scrolls that move up and
out across the ground of the capital to become the volutes at the corners. These volutes, in turn, rest
on acanthus leaves that rise from the neck to meet the end scrolls of the volutes. The S. Pancrazio
capitals, however, lack the lower row of two acanthus lobes found at S. Andrea. These lower lobes,
which relate the outer capitals to the rather straightforward Corinthian capitals of the inner pilasters,
find a parallel in the capitals of the pilasters of Bernardo Rosselino's Tomb of Leonardo Bruni (d. 1444)
in S. Croce in Florence.[106] In the Bruni Tomb three acanthus lobes are arranged in a lower row beneath

a volute-scroll design somewhat analogous to the one at S. Andrea. The type of Corinthian capital of the inner pair of pilasters (pl. 22) was current in Florence from the Old Sacristy at S. Lorenzo of Brunelleschi onward (pl. 81).[107]

All of the motifs of these capitals, then, can be derived from earlier Florentine prototypes, a fact that would tend to place their design in the circle of Alberti and Fancelli (perhaps with some intervention on the part of local sculptors, if one wishes to draw a parallel between the scrolls of the capitals of the small order and the consoles that once formed part of the cassone of Paola Gonzaga [c. 1477], now in Klagenfurt).[108] Whether the S. Andrea capitals were designed by Alberti himself is impossible to say. Hubala preferred to find Alberti only in the total composition of the façade, rather than in the details, and I am inclined to agree with him.[109]

Also, it is now possible to give a partial answer to the question that Heydenreich raised about the date of these capitals: Should they be assigned to the 1470s or the 1490s?[110] It is safe to assume that the capitals were in place when the roundel in the typanum of the façade was frescoed in 1488, a fact that had not come to light when Heydenreich raised his question.[111] The designs of the capitals are possible around 1470, as Hubala pointed out.[112] Luca Fancelli, it will be remembered, sent to Florence for stone-carvers in 1477,[113] and perhaps the carving of the capitals is to be associated with the call for these Florentine artisans.

The stone bases of the large pilasters are also of nineteenth-century origin (pls. 19 and 25). They replaced bases that were described as "in carved terra-cotta, with the ornaments damaged for the most part."[114] The remaining terra-cotta ornament of the façade probably maintains at least fragments of its original moldings and decorative motifs. Also the original pavement of the porch in brick[115] was replaced by the present Veronese marble pavement (see drawing of about 1830, pl. 27).

The elaborately carved frame of the main portal (pl. 26) is possibly roughly contemporary with the capitals of the façade. Chiara Perina has convincingly questioned the old attribution of this portal to the Mola brothers, intaglio artists at work in Mantua in the first decades of the sixteenth century.[116] She prefers to connect the rhythmically curving foliage of the portal to ideas current in the circle of Mantegna roughly between 1490 and 1510.[117]

Actually, curving tendril motifs as part of a decorative scheme are quite common in Mantua from around 1480 to after 1520—that is, between 1482, the date of the frescoes in the vault of the sacristy of the cathedral of Mantua,[118] and the early 1520s, when the ceiling of Isabella d'Este's second *Grotta* in Palazzo Ducale was painted.[119] The date of the S. Andrea portal appears to be much closer to the former than to the latter. Although the *Grotta* ceiling employs the vegetable forms in rhythmic patterns, the forms themselves are much thinner and more delicate than those of the portal of S. Andrea.[120] The decorations on the sacristy ceiling, on the other hand, have that same heaviness of the vine tendril and rather heavy-handed geometry of the rosettes that one finds in the S. Andrea portal, even though the ceiling lacks the rhythmic impulses of the doorframe. The double tendrils at S. Andrea, moreover, find a rather close parallel in the decorations of the doorframe of the Colleoni Chapel, Bergamo, the façade of which bears the date 1476.[121] There is also a somewhat analogous doorway, datable after 1474, now in the Victoria and Albert Museum, but originally from the palace of Federigo da Montefeltro in Gubbio.[122] If all of this evidence points to a date of about 1480 for the door frame, then such a date would connect fairly closely with Luca Fancelli's calling of Florentine stone-carvers to Mantua in 1477.[123]

If the façade and porch were originally rather poor in stone, this poverty found a certain compensation in a fairly rich application of color, most of which is now lost. For instance, the vaults of the porch are now decorated with rather heavy white stucco ornaments. The documents from the nineteenth-century restoration make clear, however, that these white decorations replaced polychrome decorations in wood and fresco.[124] Indeed, the original encrustation of the porch vaults must have resembled very closely the decorations of the vaults of the large chapels inside the church, where the original painted wood and fresco decorations seem to have been, for the most part, preserved (pl. 11). We should also remember that the remaining fragments of the original capitals of the small order of

the façade bear traces of paint. In addition, the west façade (pl. 19) even today (p. 21) bears faint traces of shell decorations in fresco in the two niches. On the south side of the façade even more interesting and better preserved evidence is to be found (pl. 64). Not only is there the remnant of a shell decoration in the niche, but one can also make out a row of painted palmettes in the lower frieze and a kind of frescoed rustication of the wall surface.[125] All of this decoration on the south side came to light only after World War II.[126] At that time the house that abutted the south side of the porch of S. Andrea (pl. 3) was destroyed by a stray bomb. This house had been built around 1500, covering up almost immediately the newly executed decorative frescoes on the south wall of the adjacent porch. Thus these frescoes escaped the weathering that has destroyed almost entirely the similar painted decoration on the façade. It is quite probable that other parts of the façade and porch were also given colorful painted decorations. The large pilasters on the interior are covered with frescoed candelabra, but it has always been thought such decorations were not applied to the pilasters until around 1780. It can be demonstrated, however, that these eighteenth-century frescoes, in large part, simply replaced earlier decorations, which probably can be dated to the late fifteenth or early sixteenth century. Moreover, on the right-hand pilaster of the west wall of the first large chapel to the right of the entrance a small section of the eighteenth-century decoration has recently been removed, revealing a fragment of Mantegnesque decoration beneath.[127] This evidence suggests that many of the surfaces of both the interior and the exterior were covered with painted ornament at the time the west porch and nave were physically brought to completion. Also preserved, at least in part, are the four pictorial decorations that were placed, respectively, in the roundel of the tympanum, in the roundel over the central doorway, and in the two roundels at the north and south ends of the porch. The tympanum roundel bore a fresco depicting SS. Andrew and Longinus. Over the portal appeared the Ascension, while the north roundel showed the Holy Family and the south the Entombment. Clearly, these four frescoes were conceived as parts of a single program.[128] In any event, the generally pale, monochromatic appearance that the façade and porch now present is the result of the neoclassical face-lifting they were given around 1830. The surfaces were far livelier and more colorful originally.

Finally, there is the persistently bothersome question of the "ombrellone," the large barrel-vaulted canopy that rises above the west façade to shield the great west window of the nave from direct sunlight (pl. 28). Since Wolfgang Lotz's publication of a drawing of 1515 by Hermann Vischer the Younger, which shows the "ombrellone" in place, we have known that it must have been erected during the fifteenth-century campaign.[129] Thus we must deal with it as an original part of the building, and not a later addition. But original or not, it still raises disturbing questions. Its function is clear: Alberti, as is well known, stated firmly in *De re aedificatoria* that churches should be dimly lit.[136] Moreover, in two churches previous to S. Andrea he arranged things in such a way that no light entered directly into a church through the window of the façade.[131] The "ombrellone" of S. Andrea clearly fits this pattern, but it has almost universally appeared to critics of the church as an awkward solution.[132] The "ombrellone" makes its presence felt on all observers, and disappears from view only when one is quite close to the façade.

An investigation of the masonry of this feature of the church brings new light to bear on the question.[133] In both of the rising walls that support the barrel, at a point .87 meter behind the rear edge of the pediment roof, there is a break in the brickwork that runs up from a point about 1 meter above the segmental arch of the small door pierced through the rising wall (pl. 29). This break continues in a straight line to a point about 1.5 meters below the egg-and-dart molding that marks the springing of the vault. The break then moves in an irregular diagonal line, away from the façade, up to vault level.

The masonry of the small portal also reveals that certain changes took place in that area after the initial phases of construction. The lower half of the left jamb appears to be composed of rudely broken bricks, probably the result of tearing out a wall that had already been built westward from the rear of the pedimental structure (with its extraordinary niches; pl. 30). The right jamb, on the other hand, appears to have been built with the idea of adding additional masonry to its east face at some later point.

Indeed, the break in the rising wall above the door seems to be a continuation of the masonry pattern established in the right jamb, although the continuity is broken from a point below the springing of the segmental arch to a point about 1 meter above that arch. An analogous situation obtains for the door opposite this one.

On the basis of these observations of the masonry of the "ombrellone" one may note that the rising walls were constructed in two distinct phases up to the level of the springing of the vault. In the first phase, the wall stopped short of the rear of the pedimental structure by about .85 meter except for its lower courses of brickwork, which were to have been bonded into a low wall connecting to the pedimental structure, a wall that seems to have been ripped out to make way for the present door.

The second phase of construction must be contemporaneous with the completion of the pediment, for the masonry of the rising wall and of the pedimental structure above the broken portion to the left is continuous and in bond. Thus it would seem possible that a shallower canopy was first planned. For some reason, as the pediment itself was being completed, that scheme was modified to continue the "umbrella" out over the eastern third of the pediment roof (pl. 28). Such a course of action may have been taken to increase the shadow of the canopy or to protect the area behind the pediment somewhat more thoroughly. What seems clear, and most important for our purposes here, is that according to the first scheme, the "ombrellone" would have been slightly less obtrusive than it now is.

But even if the earlier design called for a slightly shallower canopy, this canopy would still have been clearly visible from the piazza in front of the church, and it would still have appeared an awkward solution to a difficult problem. The problem itself is relatively easy to understand. The size of the façade is dictated by at least two considerations: one being the small scale of the piazza in front of the church (pls. 2 and 3). A façade covering the whole west end of the nave would have overpowered the space in front of the church. Second, the scale trick that is accomplished between the space of the porch and the space of the interior would not have been possible had there not been a one-to-one correspondence between the dimensions of the central bay of the porch and the dimensions of the large chapels on the interior. Also, to retain the identical proportions of width and height on the façade in an enlarged version could have meant either hiding part of the façade behind the old campanile, or tearing that campanile down. Even if the "ombrellone" still seems awkward, it allowed Alberti to scale his façade to the city before it, to create the powerful spatial experience of entering the church, and to preserve the old tower.[134]

# III

# The Second Campaign

## c. 1530–c. 1565

It has generally been assumed that no construction was undertaken at S. Andrea between about 1495 and 1597, when Duke Vincenzo Gonzaga ordered work carried forward once again.[1] Evidence exists, however, that in this seemingly dormant century there occurred an important building campaign.

Ritscher noted that in the main vault of the north porch of the church one can read, scratched into the plaster of the vault, the date 1550 (pl. 31). Puzzled, he accepted this date for the porch but felt the transepts had been completed later.[2] Hubala, on the other hand, dismissed the date for lack of corroborative evidence (and because the date did not conform to the arguments he advanced to fit S. Andrea into a particular stylistic mold).[3]

Until recently, however, no one had noted an inscription, "BERNARDINO GIBERTO," which accompanies this date of 1550.[4] This inscription can be identified as the signature of one Bernardino Giberto (or Gilberto), referred to in documents as a "muratore," or mason. From leases of 1533, 1536, and 1546, still preserved in the Archivio di S. Andrea,[5] we know that Bernardino rented the house that formerly stood immediately to the south of the west porch of the church (pl. 3). Bernardino must have taken part in the construction of the north porch, perhaps as director of the operation, but unfortunately he signed his name in such a way that posterity completely lost track of him. Had the signature been recognized at an earlier point in the study of the church (it offers us Hubala's desired corroborative evidence), then some mistaken views of the church's building history would never have been formed.

The inscription, then, gives us a firm date around which to place the second campaign at S. Andrea.[6] By putting together bits and pieces of evidence (much of it already available), we can reconstruct with some certainty the course of events at the church during this time.

Although we have no exact date for the beginning of this campaign, something was in the wind as early as 1526. In that year two houses belonging to the church were leased, with clear provisos that parts of those houses, at a future date, would be taken over for the construction of the church.[7] We cannot pinpoint the location of these houses, but we know that one of them adjoined the cemetery of S. Andrea.[8] From another lease of the same month we discover that the cemetery of S. Andrea was near Piazza Broletto,[9] which lies south and east of the church (pl. 66). The house in question was, then, south, or east, or both, of the present crossing, and therefore on land needed for the south transept or choir. Since both leases were renewed in 1527,[10] work probably had still not begun in that year.

On 20 July 1528, Federigo Gonzaga ordered his Treasurer General to see to the election of a certain Francesco de Donino as one of the "presidentes" of the Fabbrica of S. Andrea.[11] The marchese's desire to pack the board, as it were, with his own men probably means that a moribund organization was being brought to life in preparation for the new building campaign. In 1530 Federigo informed these "presidentes" that, at the request of Federigo himself, the pope had granted a plenary indulgence

to anyone visiting the church and that all donations made as a result of these visits were to be used only for the building itself.[12] Such indulgences were a clear "gimmick" to raise money. That they were being granted must mean that work was either imminent or already under way. Thus c. 1530 seems a reasonable date to assign to the commencement of this building campaign.

Probably the main potential source of revenue for the building of the church was a construction tax, levied throughout the Gonzaga domains. Since this tax had not been paid conscientiously in the past, on 29 August 1532 Federigo (now raised to the title of Duke) issued a letter to all his stewards and deputies ordering them to begin immediate collection of these funds. The firmness of Federigo's intention to see this taxation carried out is vividly reflected in the closing sentence of the letter: "We do not intend that anyone be exempt."[13] The urgency conveyed here suggests that financial difficulties may have been causing a delay in the construction.

A terminal date for this campaign is offered us by a hitherto unknown piece of evidence—the record of an apostolic visit to the church made in 1575.[14] At that time the apostolic visitor was told that no work had been done at the church for ten years and more.[15] Assuming he was given reasonably correct information, work had come to a complete halt before 1565.[16]

We have, then, a building campaign of more than thirty years duration—c. 1530 to c. 1565—to insert into the history of S. Andrea. Even if work progressed at a deathly slow pace, the north porch alone, as Ritscher suggested, could hardly have been the sole accomplishment of so many years' labor.

To define the extent of this campaign we must turn to the exterior masonry of the church, for no known documents discuss the specifics of this work in any way. The masonry reveals that the entire east end of the church (except the lower 7 meters of the west wall of the north transept, possibly the lower reaches of the west wall of the north porch, and part of the semicircular apse) was completed at the time. On the north side of the east end the masonry is essentially continuous from its intersection with the nave around to a point just beyond the springing of the semicircular apse. On the opposite side, except for most of the south wall of the south transept, the masonry is equally continuous from the nave to a point near the springing of the apse. The exceptions we have noted here are of major importance, and other minor incidents occur in the masonry that we should take time to note.

The juncture of the north transept with the nave is only partially visible today (pls. 32 and 34), the lower reaches being hidden by later constructions. Above these structures one can clearly make out a section, between two openings, where the brickwork of the nave wall was left ready to receive that of the transept (pl. 34). Above this point the walls have been so heavily reworked that a clear reading of the masonry no longer seems possible. The nave cornice, on the other hand, turns the corner and runs along the top of the transept walls, with only minor interruptions (pl. 32). From this observation it would seem that the old fifteenth-century molds must have been used to turn out the cornice during the second campaign.

The lower portions of the west wall of the north transept, as discussed earlier,[17] were completed during the first campaign. One should note, however, the masonry around the window that gives light into the west chapel of the transept. Originally this was a "thermae" window (pl. 34). The characteristic pair of vertical members within a half-circle are still visible and clearly form part of the original masonry of the transept. At some later date the window was filled in to create the present relatively small oculus. It should also be noted that above the level of the cornice a vertical buttress similar to those lining the nave was begun.

On the north wall of this transept, the continuity of the masonry seems broken where the porch has been joined to it (pl. 32). The break above the present roof of the porch is easily explicable: the upper part of the porch was torn down around 1700, leaving the scar that one now sees.[18] Below the roof line, however, the masonry would seem to indicate that the porch was constructed as an independent until after the walls of the transept had been erected. A glance at the plan (fig. 2) will make clear that this porch follows in most essentials the structural system of the west porch. That is, where they are pierced by the two side doors, the inner walls are thick to support the vaults of the side bays of

the porch, whereas the wall through which the central portal is pierced is quite thin, a simple curtain with no supporting function.

The masonry continues without significant interruption around the east side of the transept, along the north flank of the north sacristy, and then across the east wall of that sacristy (pl. 35). The north side of the curved wall of the apse is bonded into the exterior masonry of the sacristy up to a level somewhat above that of the oculus carved out of the masonry of the apse wall (pl. 37). In part because of the subsequent remakings of the apse window, and in part because adjacent buildings conceal the apse wall, it is difficult to specify the precise point at which work laterally on the arc of the apse was halted. As I will demonstrate below, the southern part of the arc was not built until 1597–1600. The vertical extension of the work of this second campaign of the mid-sixteenth century, however, is demonstrated by the line of discontinuity in the masonry, which can be observed above the oculus in pl. 37. It would seem, also, that during this second campaign the east wall of the sacristy reached a higher quota than the wall of the apse proper, for the apse masonry above the line of discontinuity is not bonded into the masonry alongside the sacristy.

It is more difficult to be specific about the masonry of the south transept, since the houses surrounding it have all been built up to encroach directly upon its flanks (pl. 38). The visible masonry, however, seems to correspond to the type of masonry found on the north transept. A view of the southeast corner of the south transept shows that the history of this part of the building has been somewhat complex (pl. 40).[19] The lower visible reaches of this pier are divided into two parts, the smaller of which is located toward the oculus, while the larger continues around the corner of the building. Above this lower part there is a step back in the masonry, and upward from this level the wall seems to belong to the fourth campaign of 1697ff.[20] The mid-sixteenth-century masonry then continues on along the south flank of the south sacristy and turns north along its east flank, coming to a halt before the springing of the apse. Along the south flank of the south sacristy there are walls of three different dates—the lower section 1530ff., a narrow middle band dating from 1597–1600,[21] and a wide top section dating from 1697ff.

These limits for the masonry of this campaign are in accord with what we know of the later building history of the church. From documentary sources we know that the crypt, the vaults of the transepts and of the choir, and the dome were all built later.[22] The completion of the apse, as demonstrated by the masonry, is also to be assigned to a later campaign. Thus we have, between roughly 1530 and 1565, the construction of both transepts up to the level of the inner cornice (with the exception of the south wall of the south transept), the north porch, the choir, the sacristies flanking the choir and part of the apse. Such a great amount of work does not seem unreasonable for a campaign that lasted over thirty years.

Having established the dates and physical limits of this campaign, let us now turn to a closer inspection of the work that was done. The transepts were built according to the size that had been prescribed for them during the previous building period.[23] Across the arms of the transepts large chapels face each other, two to each arm. Apparently these chapels were to be lit by "thermae" windows, for the verticals subdividing such windows are still visible on both sides of the north transept (pls. 34 and 35). These windows probably mark a deviation from the fenestration of the nave, the large chapels of which originally seem to have been lit by oculi.

The choir was laid out equal in size to the transept arms, with the addition of the apse to the east. In distinction to the arms of the transepts, however, the choir bay is not flanked by two large chapels opening directly onto it, but rather by a pair of sacristies. These are far deeper than the chapels flanking nave and transept, and, consequently, their exterior walls run directly into the areas of the windows of the adjoining transept chapels (pl. 35). On the north side, part of the wall above the sacristy had to be carved away to make room for the present fenestration. One would surmise, from this evidence, that the sacristies were added to the plan during the second campaign, indicating thereby a modification of the fifteenth-century design.

Another possible addition to the plan at this time may have been the semicircular apse. The purpose of the apse, at least in some respects, is clear. It adds more room to the east end, at the same time stressing further the longitudinal aspect of the interior space. On the other hand, the apse breaks the symmetry of the three arms radiating from the crossing and interrupts the consistent articulation of the flat interior faces of the end walls of the cross. Such consistency is further broken by the three windows concentrated toward the center of the apse. For these reasons, the apse (pl. 62) strikes this observer as perhaps an alien element in the design. Without any hard evidence at our disposal at this point, the question of the date of its design must be left open.

The work done during the second campaign at S. Andrea, by and large, lacks the finesse of the work during the preceding century. The architectural details of the north porch are crude, and there is the seemingly mistaken placement of niche and window above the door in the west wall of the north porch (pl. 33). Perhaps the placement of niche and window in the center of the exterior side wall of the porch represented an attempt at mid-sixteenth century to "regularize," or to "correct" errors it found in the fifteenth-century design. Finally, there is the awkward conjunction of the sacristy wall with the window of the transept chapel. A large amount of building was carried out, but it was not carried out with the greatest care.

Ultimately, the man responsible for this second campaign must have been Federigo Gonzaga, who vigorously concerned himself with problems of fund raising and staffing. The actual work was supervised by three of the leading citizens of Mantua. Two of these were not what might be called artistic types, but the third turns out to have been a certain "domino Julio Romano,"[24] a figure hardly unknown in the history of art. Giulio came in late 1524 from Rome to Mantua, where he quickly became the virtual artistic dictator of the city.[25] Below these men must have been Bernardino Giberto, the *muratore* who signed his name to the vault of the north porch. He was probably the man on the site directly in charge of the work, like one of the *suprastanti* of the fifteenth century.

We have long known that under Giulio's direction an extensive program of decoration was carried out in the nave chapels of S. Andrea by such of his followers as Rinaldo Mantovano.[26] Only now, however, can his name be connected with the *architectural* aspects of the building, although these connections turn out to have been rather remote. There is no evidence of Giulio's very distinctive, one should really say idiosyncratic, style in the architecture of the church today.[27] On the contrary, the single most salient fact about this second campaign is that it rather docilely followed in the footsteps of the fifteenth-century campaign. It accepted the transepts as begun in the fifteenth century, and then proceeded to copy almost literally the quattrocento porch, making only some changes in details. Athough such a copy of a fifteenth-century work in the sixteenth century is not unknown elsewhere (one thinks of Antonio da Sangallo the Elder's "copy" of Brunelleschi's Ospedale degli Innocenti), it is decidedly rare. We can be relatively sure that Giulio would have been consulted fully on such an important and costly project as the continuation of S. Andrea, and perhaps the decision to continue it according to the earlier design was Giulio's responsibility.[28] One would hope that the awkwardness of the mid-sixteenth century additions to the plan is not to be attributed directly to him. It may even be that the sacristies were added to the plan only after his death in 1546.

In the years following the termination of the second campaign, the building fell into neglect and disuse, a fact that is vividly sketched for us in the account of the apostolic visit of 1575.

We discover, for instance, that light was cut off from the chapel of St. Sebastian by walls built up close to it,[29] and that the windows of all the chapels were covered with cloth, which the visitor ordered replaced with glass.[30] The other windows, presumably the oculi in the piers, were glazed, but were so cracked and covered with dust that the visitor had to order them replaced and washed.[31]

The visitor further ordered that, for all of the windows, "each eye should not lack glass, but should in every part be covered by glass."[32] Using the word "occulum," he seemed to have been referring to all of the windows, which might be taken to mean that the church at this point had only round windows. In relation to this observation, there are two notices of 1595 that refer to the "ochio" of the chapel of

St. Longinus,[33] the last large chapel on the right of the nave. Presumably at that time it was lit by an oculus.

Not only was the building in a sad state, but the visitor was told that there was no hope of completing it, since there was no revenue for the building fund other than alms and oblations rendered on Ascension Day. The visitor was not permitted to look at the building accounts, for they were under the immediate protection of the duke himself.[34] The drawing of Cesare Pedemonte[35] of 1580 (pl. 13), discussed in the preceding chapter, attests to the general decay of the building in these years, or at least to the need for further repairs to admittedly temporary parts of the work. Clearly, in 1580 there was no thought of continuing the building in the immediate future. Had such an intention existed, time and money would not have been wasted on repairs to a temporary aspect of the church, the wooden wall at the east end of the nave.

# IV

# The Third Campaign

## *1597–1600*

In 1589, roughly twenty-five years after the end of the second campaign, Duke Vincenzo Gonzaga took up the problem of continuing the work at S. Andrea. On 4 February of that year the architect Carlo Lambardo sent a terse note to Vincenzo from Rome, informing the duke that he had begun the designs of S. Andrea.[1] Unfortunately, no further description of these designs was included in the letter.

It was not until the end of July 1597 that Vincenzo, upon leaving Mantua to support the Austrians in their war against the Turks, ordered that work on the choir of S. Andrea should be "taken up again and carried forward according to the ancient design of Marchese Lodovico the second." Work began on 27 August, under the direction of Vincenzo's trusted adviser, Tullio Petrozzani, *primicerio* of S. Andrea.[2]

The major source of information about the new work at S. Andrea comes from the first systematic history of Mantua, that of Ippolito Donesmondi. According to Donesmondi, who witnessed the actual construction, by 1600 the church had been brought to "that end of perfection which it at present [1616] has."[3] The third campaign, then, is securely dated between 1597 and 1600.

Included in Donesmondi's history of the city is a rather lengthy and detailed description of the church as he knew it:

> The temple is all of brick, in the form of a cross, with a single vault, which forms the lower part of it, placed above the nave of the church: 104 *braccia* long and 40 *braccia* wide, without any chain of iron, or wood to sustain it. It is all of the composite order, having in the disposition of this body, as supports, three large chapels on each side, and three other small ones, made in the piers, with the columns, the socle of which is about 1 *braccia* high. Their pedestals are the third part of these columns; the architrave, frieze, and cornice with due proportion are the fifth part of the height of the columns, including the bases and capitals. The entablature runs around the upper part of all the church, cupola, and choir. The floor of the chapels is almost three feet higher than that of the nave, and in each arm of the cross there are two chapels, one opposite the other. The crossing, where the cupola must be built, is nearly 40 *braccia* wide, and in the corners of the squares around the crossing there are four piers of the same width, with their internal spaces properly proportioned. Beyond the crossing there is the choir in oval [*ovale*] form, 52 *braccia* long, and as wide as the nave, which, with the aforesaid crossing in the year of our Lord 1600 was furnished up to the top of the entablature, according to the ancient model. Because of its strength, the whole construction bespeaks timelessness— the piers that hold up the whole machine being of the width and thickness already mentioned, with the lights for the chapels carved out of them above the little chapels. Moreover, there are their lovely and artful ornaments, especially in the façade, where there is a most beautiful loggia with three arches, with columns and pediment in proportion, and with three doors, the largest of which, in the middle, is decorated with gray marble, also carved.[4]

Donesmondi was a trustworthy observer. Those parts of the church that he described still appear the same today. His only apparent error lay in neglecting to mention that the south wall of the south transept was, at this point, still incomplete—a fact we know both from a rather crude map of Mantua of 1625 (pl. 39) and from an exhaustive account of the state in which the building was found at the end of the seventeenth century just prior to the commencement of the fourth campaign.[5]

There are some seeming peculiarities in Donesmondi's measurements, however. He gives the width of the nave as 40 *braccia*, in contrast to the width of the crossing, which he calls "nearly 40 *braccia*" [*presso a quaranta*]. Further, he gives too short a length for the nave, 104 *braccia*, excluding the crossing piers from his measurement. Donesmondi, therefore, must have considered the crossing to be distinct from the nave. The added pairs of pilasters on the crossing piers transform the piers in such a way that the space from pier to pier is slightly narrower than the width of the nave (fig. 2, pl. 2). Moreover, this change in articulation of the crossing piers removes them from an association with the piers of the nave and groups them together in a distinct unit, which reads plainly as the crossing. Donesmondi's text, then, makes clear that the second pairs of pilasters had been added to the crossing piers by 1616.

All evidence tends to date these new pilasters to the third campaign (1597–1600). All four crossing piers underwent the same modification. Since the western piers were built in the first campaign, and the eastern piers in the second, the earliest possible date for the additional pilasters is the third campaign. (There is also no sign of the additions in the Cesare Pedemonte drawing of 1580 [pl. 13].) Stylistically, this distinction between the nave and crossing also seems to fit best into the second half of the sixteenth century. In two of the best known churches of this period—the Gesù in Rome, begun in 1568, and St. Michael's in Munich, begun in 1582, both of whose designs were influenced by S. Andrea as it stood by 1565—there is a clear break in the articulation of the nave walls at the crossing (pl. 43, figs. 12 and 13). The abrupt change in rhythm emphasizes the crossing as a separate spatial entity. This new idea of the later sixteenth century appears to have been employed at S. Andrea to bring it up to date, to make it look more like those churches which it had, in part, sired.[6]

The additions to the piers may also have been intended to serve a structural purpose. In his description of the church, Donesmondi speaks of a cupola still to be built[7]—perhaps a more ambitious dome than originally planned. The dome of St. Peter's was newly completed at this point, and one might suppose that Vincenzo wanted something more in this vein for his most important church. A newly designed dome of large scale might well have required a strengthening of the piers, such as the additional pilasters.

To turn from the crossing to the choir (pl. 62), we know from Donesmondi that it was completed up to the level of the cornice during the third campaign, following Vincenzo Gonzaga's order that work on the choir be "taken up again and carried forward according to the ancient design of Marchese Lodovico the second."[8] Donesmondi's statement, which indicates previous construction in this area, is precise, for we know that the north and south walls of the choir, as well as part of the apse, were built during the second campaign. We cannot infer from Donesmondi's statement, however, that he had actual knowledge of the fifteenth-century designs, in whatever form they may have taken. All the information he needed to make the observation that he made existed in the masonry of the building as it stood before 1597.

Donesmondi also informs us that between 1597 and 1600 the crypt of S. Andrea was enlarged.[9] The history of this crypt forms a puzzling chapter in the story of the church. It is cruciform in shape, with the uniformity of the four arms broken by a semicircular apse attached to the *western* arm (pl. 41). (One would expect to find such an apse, if at all, at the end of the eastern arm.) The vaulted arms are divided into naves separated by columns from narrow side aisles, all of which meet in the middle to form an irregular octagonal core (pl. 42).

We know from Vincenzo's will that he planned the crypt to be a Gonzaga pantheon of sorts, with twenty-four monuments to the twelve Gonzaga rulers and their wives.[10] This scheme, although never

carried out, is typical of Vincenzo's thinking: for instance, the representation of himself accompanied by his wife and dead parents on Peter Paul Rubens's altarpiece for the Jesuit church in Mantua;[11] or the decoration of his own catafalque, which showed one great deed of each of his eleven predecessors, matched by eleven comparable deeds of his own.[12] The fact that Vincenzo had a grandiose use in mind for the crypt, however, does not necessarily allow us to credit him with originating the idea for such a large subterranean area. We now know that a crypt was in use as early as 1481 and that the apostolic visitor of 1575 went down into this area in the company of a number of other people.[13] Throughout this time, access to the crypt was gained through the two western crossing piers. But stairs leading to a subterranean level were installed in the eastern crossing piers during the second campaign. These stairs suggest the existence of a plan for a crypt similar in extent to the present one. Thus, although the crypt was enlarged during the third campaign, the concept of such a large space must date from an earlier moment. We shall return to the question of dating this plan at a later time.

The design of the crypt as it stands has traditionally been given to Antonio Maria Viani, a Cremonese artist who was Vincenzo's court architect.[14] In his biography of Viani, however, the rather precise Donesmondi never mentions the crypt, and elsewhere, whenever he mentions the crypt, he fails to mention Viani. While these facts might simply be incidental, they probably mean that Donesmondi did not think that Viani had anything to do with the design of the crypt.[15] I am inclined to follow Donesmondi's lead, while agreeing with Marani's attribution of the altar in the north arm to Viani.[16] This altar bears Gonzaga and Medici arms, and we know from Donesmondi that Vincenzo and his bride, Eleanora de' Medici, were buried in the crypt of S. Andrea.[17]

While the crypt was being enlarged, the stairs leading to it underwent considerable remodeling. The addition of the pairs of pilasters to the crossing piers shifted the entrance to the crypt toward the crossing, necessitating the realignment of the upper reaches of the staircases. Short curved passages were cut into each western pier, leading to a new, straight flight of steps. These steps descended to a landing, where a long flight leading to the level of the crypt joins at a 90-degree angle (pl. 16). These new steps replaced the original circular stairs, which were cut off approximately at the level of the floor of the nave. The old curving stairs offered a difficult descent, and one assumes that Vincenzo wanted easier access to his Gonzaga pantheon.

In the case of the eastern piers, the southern one underwent a transformation essentially similar to that of the western piers, while the interior of its partner to the north suffered more drastic modifications. Here a curving corridor was cut through the pier to link the north sacristy directly to the transept (fig. 2, pl. 53). The circular staircase leading to the crypt was completely destroyed and replaced by a single straight flight running without break from the corridor down to the eastern arm of the crypt (pl. 41). Above the vault of the corridor, parts of the stairs that had led from the choir to the roof were ripped out and replaced by a wooden ladder.

Also during this campaign an important practical step must have been taken, namely, the placing of a temporary roof over the entire east end. No contemporary document speaks directly of this roof, but other sources assure us of its existence. The 1625 map of Mantua shows roofs over the crossing, choir, and south transept (pl. 39). These roofs are also specifically mentioned in the carefully kept records of the fourth campaign (1697–1704), during which time they were removed to make way for the transept and choir vaults.[18] Moreover, the western chapel in the north transept was decorated in the first decade of the seventeenth century, and we can be sure such action would not have been taken if the chapel had not been protected from the elements.[19] With the entire east end covered, it was no longer necessary to maintain the wooden wall at the east end of the nave that is recorded in the Pedemonte drawing of 1580 (pl. 13). This wall, and the narrow piers to either side of it, must have been razed, together with the temporary chapel that Lodovico Gonzaga had erected in the very first year of building activity on the site.

Even if this third campaign was rather modest in scope, it did produce certain modifications in the church: the additions to the faces of the crossing piers, the changes to the staircases within

the piers and the enlargement of the crypt. Whereas the plan for a rather large crypt seems to have existed earlier, the other two changes are probably to be credited to Vincenzo's campaign. We have suggested that the crossing piers were remodeled to bring S. Andrea up to date with such recent churches as the Gesù in Rome and St. Michael's in Munich (fig. 13). Antonio Maria Viani came to Mantua in 1590–1591 direct from Munich,[20] where he had just completed two large altarpieces in St. Michael's.[21] During his stay in Munich, he had married the daughter of the court architect of the Wittelsbachs, Friedrich Sustris, who in turn was deeply involved in the final phases of the building of St. Michael's. This church, it will be recalled, was erected in two major campaigns. The first, beginning in 1582, was carried out on the basis of a design that called for a barrel-vaulted nave flanked by three chapels on either side and terminated by an apse, thereby recalling both the Basilica of Maxentius and the nave of S. Andrea. Sustris seems to have been responsible for the second plan for St. Michael's, which added the present transepts and deep choir to the preexisting nave.[22] Viani must have been in on the planning of this second design, the carrying out of which was begun during his last year in Munich. The modification of the faces of the crossing piers, then, may reflect Viani's experience with the similar crossing piers at St. Michael's. If such be the case, the relationship between S. Andrea and St. Michael's is more complex than we have previously suspected.

# V

# The Fourth Campaign

## *1697–1702*

Between 1616, the year in which Donesmondi's description of the church was published, and the end of the century, when the fourth major building campaign began, we have only two documents concerning S. Andrea, both from 1677. These documents deal with land still required to complete the church. On 8 February of that year the Porri heirs were commanded in the name of the duke to present reasons within fifteen days for the continued possession of land that was needed for the building.[1] Then, on 16 July, they were ordered to give up that land, which consisted of "some sites of walls, little courtyards, and other places located in their houses, and shops contiguous to the Collegiate Church of S. Andrea."[2] Although the exact location of the Porri property cannot be determined, it is safe to assume that the needed land lay adjacent to the south transept. Since the entire area now covered by the church, except for the southern end of the south transept, had already been enclosed by the end of the sixteenth century, the only direction in which the church could have moved was south, toward Piazza dell'Erbe (pls. 66 and 68).

In 1692, the temporary roofs that had been erected over the eastern parts of the church were leaking so badly that the duke was asked to have them repaired.[3] Perhaps this condition of the temporary covering precipitated the actual work of vaulting the whole east end, excluding the dome. Although the work was not begun until 1697, we know that it had been planned for some time previously, for in December 1696 the duke donated to the Fabbrica of the church enough earth to make 500,000 bricks.[4]

For this period in the history of S. Andrea we are fortunately supplied with rich documentation, concerning both the work accomplished and the major remodeling scheme envisioned by a Bolognese architect, Giulio Torre.[5] Luckily Torre's plans were, for the most part, unrealized, but, as we shall see, some important changes were made in the original parts of the structure under his direction.

Let us first analyze the preserved records of Torre's project to modernize the church and bring it to completion. We have a written description of his designs, which was accompanied by a plan, a longitudinal section, an elevation of the east end, an elevation of the three façades, and a design demonstrating the structure of the roof supports. Of these documents, only the written description survives.[6] The longitudinal section seems to have been known as late as 1901, when Bellodi published a drawing (pl. 44) that purports to show Torre's ideas.[7]

Bellodi's section shows a drastically altered building (compare pl. 45). The façade is doubled in height, with new construction rising upward from the level of the apex of the central arch. This work would have necessitated the destruction of the present pediment. On the interior, Alberti's careful balance of horizontal and vertical elements is replaced by a series of strong verticals. The articulation of the pier surfaces between the pilasters gives way to four rectangular elements arranged vertically without a single horizontal counter movement. The great cornice is cut away above the large chapels, the oculi in the exterior walls become oval, and all horizontal bands are removed from the wall surfaces. Above the cornice, pairs of crossbands rise from the pilasters to reach across the great vault. Between these bands large windows are opened up in the vault itself, in a manner reminiscent, for instance, of the nave vault of the Gesù (pl. 43). The narrower intercolumniations on the crossing piers are strongly emphasized by the application of tall, narrow elements to the surface between the pilasters, and the doors of these piers are made smaller and lower. The inner face of the end wall of the transept is blank, except for a

rather heavy central portal, a large, rectangular window surrounded by an ornate frame, and a heavy blind arch rising from the corner pilasters. The walls and vault of the choir receive the same treatment as those of the nave, and two rectangular windows flanked by pilaster bundles are pierced through the curved sides of the apse.

The dome rises on a tall drum, the lower part of which is concealed on the exterior by the newly raised roof line. The upper, and larger, part of the drum is lit by eight windows, with alternating segmental and triangular pediments, separated by paired pilasters, from which spring the pairs of ribs articulating the single-shell, pointed dome, capped by a lantern. Had Torre's scheme been executed, S. Andrea would have become a (not totally) pedestrian replica of myriad other seventeenth-century churches.

In the written statement that accompanied his drawings, Torre felt it necessary to explain some aspects of his designs. The first of these explanations is baffling. He wrote that the designated pilasters of the nave "are all to be moved; that is, some are to be narrowed and some widened. But all are to be cut at the openings of the chapels to widen them."[8] No such narrowing, widening, moving, or cutting, however, is evident from the section published by Bellodi, nor does that drawing show the letters that would have demonstrated those parts with which Torre intended to meddle.[9] Torre next spoke of the "pilastrate" of the "pilastroni" of the cupola, by which he must have meant the pilasters of the crossing piers. These "pilastrate" were to be cut at the "lasene" (also pilasters) marked by a letter "B," to make the "lasene" larger.[10] Although no letter "B" appears on our section, Torre's intention is nevertheless clear. He wanted to enlarge the small pilasters on the eastern sides of the easternmost nave chapels by trimming away parts of the adjacent giant pilasters on the crossing piers, as a careful look at this part of the section (pl. 44) will show. He also planned to enlarge the small pilasters next to the eastern crossing piers to produce mirror images. Such action would have subtly increased the distinction between the crossing and the nave, but whether it would have been worth the effort remains questionable.

Torre's second explanation deals with the articulation of the choir walls. According to him the pilasters at the opening of the choir did not project sufficiently from the walls. To rectify this situation, he proposed cutting away some of the choir wall surface. He found this method preferable to that of building up the pilasters, for any additions would have restricted a space he found already too narrow.[11] This work may well have been done, at least along the north and south walls of the choir, for a glance at the plan reveals that the circular staircases within those walls are not centered, but lie slightly closer to the area of the choir than to the flanking sacristies.

His third piece of advice was to fill up the whole crypt,[12] a scheme highly insensitive to the function of the church, for it would have required the relocation of the relics of the Most Precious Blood. Nevertheless, Torre felt it necessary to fill in the crypt and those parts of the staircases leading to it to provide firmer footings for his planned dome.[13] He also argued that it was improper in a sacred place to look up from the crypt through the light holes in the floor of the church and see people who in turn could not see their observers.[14]

Torre's fourth explanation describes his design for the dome, a design for which he displayed a certain pride. His new design for a "Cupola"[15] (the pointed dome of the section) he opposed to a previous one for a "Catino" (probably referring to a hemispherical dome).[16] His cupola would make, he assured his readers, "a better show than any Catino could."[17] By designing a balustrade for the inside of the drum immediately above the crossing arches, he concealed the fact that his drum was to be built slightly larger than the crossing in order that its weight might rest on the centers of those arches. In this way, he argued rather shrewdly, the dome would be wider, more original, more stable, and the circular stairs above pavement level would not have to be filled in to strengthen the piers.[18] Further, the platform of the balustrade would afford a convenient place to stroll around the interior of the dome.[19]

The dome, whose height would have been more than double that of the nave vault, was to become the new focus of the church. Its vertical thrust would reiterate the new vertical emphasis Torre planned for the nave. Further, the flood of light pouring in from its eight windows would have matched, if not

exceeded, the light that would have entered through the great openings he planned in the nave, transept, and choir vaults.

The last three explanations Torre offered were brief. Organs were to be located over the doors of the sacristies,[20] presumably over the doors in the north and south walls of the choir. The Bellodi section (pl. 44), however, contradicts this idea, showing neither doors nor organs, but rather chapels like those along the flanks of the nave. The sixth explanation announced his intention to destroy the old campanile,[21] while the seventh signaled his plan to replace it with a new one of his own design.[22] Although we do not know his design for the tower, it is probably fortunate that the handsome old late Gothic campanile was allowed to survive.

Appended to the written description is a highly technical account of Torre's plan to make windows in the old vault of the nave.[23] He must have encountered or anticipated serious objections to this part of this plan, for otherwise there would have been little reason to defend this rather delicate task at such great length. The old nave was obviously far too gloomy for late baroque taste; consequently, for Torre, adding the windows was essential to bring the church up to date.

Two points in this document have been consistently misused: Torre's rejection of an earlier scheme for a "Catino" over the crossing, and Torre's intention to build three façades for the church.[24] Although Torre's description has not previously been published, it was apparently known to several scholars who rashly used it to reconstruct Alberti's S. Andrea with three façades and a hemispherical dome.[25] By itself, however, this document offers insufficient evidence for a sound reconstruction of Alberti's plan. From it one can only observe that Torre knew a previous design (of undetermined date) for a "Catino," and that he himself wished to build a third façade to the south. We shall return to these points later.

When we consider the actual account of the building campaign that Torre directed, we find that few of his major changes were carried out. According to a document of 1731, compiled by a certain Antonio Ardenna from a now lost "Libro Maestro della fabrica,"[26] work began in 1697.[27] Ardenna diligently summarized the records of the individual years of this fourth building campaign at S. Andrea, and it seems advisable to follow his chronological method as we analyze this document.

First, the choir was vaulted, an apparently simple procedure completed by 17 August 1697.[28] The vault was made with large semicircular openings on either side (pls. 35 and 37), just as Torre promised in his project. These openings, walled up about eighty years later, are still visible from the exterior. As soon as the work on the choir was completed the workmen moved into the south transept to restore the wall toward Piazza dell'Erbe (pls. 38 and 46), which had previously been constructed up to a height of 8 *braccia* (approximately 4 meters). This wall was in large part remade from the foundations up and continued to the level of the cornice at 30 *braccia*.

We are then told that the piers to the sides of this wall were increased, another pier of the "great well" (Pillone del Pozzone) was refounded, and still another pier, next to the shop of a Sig. Moro, was built from the foundations.[29] From this description it would seem that the first two refer to those along the southern wall of the transept and the third and fourth refer to the southern crossing piers. To accept this interpretation, however, is to deny the archaeological evidence, as well as evidence that appears later in this very document. From the masonry of the church, from Donesmondi's description of the building as he knew it, and from the Mantuan map of 1625 (pl. 39) we know that most of the south transept had been completed long before this fourth campaign. Thus it seems impossible to believe that one of the crossing piers was actually refounded and the other built up from the foundations, as the document would have us believe. Also, one might add that it seems rather unlikely that one of the crossing piers could have been next to a shop, whereas the piers along the south wall actually do abut nearby stores.

The language of the document, then, must be mistaken. The piers said to be at the sides of the south wall must actually have been the crossing piers, which had only to be built up ["accresciuti"], and the other two piers ["rifondato" and "fatt'... da fondamenti"] were actually the ones to the south.[30] The

pier of the "Pozzone" of the document may have been the one at the southeast corner of the transept, for a circular well 1.9 meters in diameter runs up its entire height. The one next to the shop could then have been the pier at the southwest corner. The stair that the document mentions in connection with this pier could be the one at the southwest corner that appears on the Ranieri map of 1831 (pl. 66), but not in Ritscher's plan (pl. 15). Indeed, in the account of the second phase of work on this transept, both of these southern piers are described as having "Pozzoni nelli cantoni" (great wells in the corners).[31]

In the second year of the campaign, work continued on the south transept. All four piers and the wall of the south façade were increased in height. The two exterior walls above the chapels were then erected with large arches built into them (pl. 49). These arches were designed to allow light to pass through the walls and into the windows that were later to be built into the vault. The old cornice was then taken out and replaced by a new entablature, from which the vault rapidly rose. Finally, the rather mean frontispiece now seen from Piazza dell'Erbe was erected and capped by a marble pedestal (pl. 69), which was intended to bear a cross.[32] This cross, however, has never been put in place.

The exterior arcades above the chapels and the walled-up remains of windows in the vault attest to the fact that Torre vaulted the transept in the same style in which he had vaulted the choir and to which he planned to convert the nave. On the other hand, by the second year of the new campaign his scheme for a third façade to the south, to match the other two already existing, had been abandoned. This scheme may still have been a possibility in the first year, for three exterior doors were included in the south wall,[33] following the models of the end walls of the nave and north transept. The erection of the present frontispiece to the transept seems, however, to have meant that the plan for the third façade was by then discarded.

In the third year work moved to the north transept (pls. 32 and 35), which was found intact up to the level of the cornice and, in some places, even beyond. The old cornice and a piece of wall above it (probably the north wall) were removed, the new cornice was placed, and the upper side walls toward the façade (now almost completely hidden behind the volutes) were erected. The pilasters and cornice of the inner north wall were then torn out, indicating that these elements (pls. 59 and 60), later replaced during the Pozzo restoration,[34] formed part of the original articulation of that wall.

The four corner piers of the transept were increased in height, the exterior walls erected with arches to let light into the vault windows, and the "frontispiece" of the façade begun. The plan for this façade included tearing down part of the north porch so that more light could be admitted into the "giant window" of the transept. For this purpose, the roof of the porch was removed, the pediment razed, and its walls lowered to a level just above the apex of the central arch.[35] Thus, the porch as it presents itself today (pls. 32 and 35) is not actually unfinished but is partially destroyed and never refinished. Reduced in height and robbed of its pediment, the porch seems to have been treated in the manner indicated for the west porch in the Bellodi section (pl. 44). Since it is not improbable that Torre planned the two porches to be identical, the fragments of Torre's north façade give us a good indication of what he planned for the western "frontispiece."

The third year of construction also saw the vaulting of the north transept (also with large openings in the vault, pl. 50) and the re-roofing of the two transept chapels. We are told that when the vault had been completed, an earlier roof over the transept was removed.[36] Presumably this roof dates from the third campaign, for it must have been in place around 1600–1610, when the west chapel of the transept was decorated.[37]

During the fourth year of this campaign there was no new construction,[38] but in the fifth work commenced in the crossing. The first act was to remove the old cornices under the first arch leading into the choir. These cornices must have been at the summits of crossing piers. An arch 14 *teste* (or 7 *braccia*) thick was erected over the new cornice to span the space between these piers. At the same time the other two arches of the crossing were built up to a height of about 10 *braccia* in order to bond them better into the work. Presumably the lower parts of the pendentives were begun at the same time.

The old covering of the crossing was removed and replaced by a new one, which rested on eight piers built over the choir arch and eight over the nave vault. This new roof was made large enough to include under it the four crossing piers.[39]

From all of the information we have just investigated, it becomes clear that the crossing in 1697 was virtually complete up to the level of the cornice. When work was carried out on both transepts, the crossing piers were raised up beyond the level of the cornice to their present height under the drum of the dome. But there is never any indication, in this rather meticulous account, that any work was done on the pilasters of the interior faces of the piers. We are told in detail of the removal of old pilasters from the interior of the north wall of the transept, but we are never told that any elements of the crossing piers other than the cornices were modified. This evidence, negative though it may be, strengthens the attribution of the modification of those piers to the period 1597–1600.[40]

In the sixth year, 1702, the interior face of the west wall of the nave was modified to conform to the inner faces of the end walls of the transepts. The old cornice was torn out, along with the pilasters (called "Colonati" in this instance) between the main door and the two smaller doors flanking it. A blind arch was placed under the great arch of the vault, and the round window was converted into a rectangular one 8 *braccia* wide and 18 *braccia* high. Vestiges of the bottom of this window are still visible on the exterior (pl. 51). The interior wall was reduced to a smooth plane from the top to a point above the previously walled-up window of the main door. At the same time niches "very high above the small doors" were also walled up.[41] The outlines of these niches are still visible on the exterior of the church (pl.52). These niches pierced the end wall above the cornice and offered faint sources of light. Their presence in the great lunette at the end of the nave would clearly have modified its appearance.[42]

The only other work of importance about which the documents inform us was the relocation of the stairs that led from the level of the nave to that of the choir. These stairs were transferred from a position near the chapel of St. Longinus (last on the right) to the western edge of the choir,[43] where they now lie (fig. 2). In the process of moving the stairs the floor level of the crossing was lowered to that of the nave. This action produced a very strange effect, in that the top of the vault over the central octagon of the crypt was uncovered. Torre's plan to lower the crossing must have been tied to his desire to fill in the crypt, in which case the center of the vault over the octagon of the crypt could easily have been removed. The top of the vault must have looked very peculiar, popping up from the center of the crossing, until it was finally given a rather heavy-handed revetment of red marble in the nineteenth century (fig. 1, pl. 59). The result of this mix-up is that literally the most important point in the church is inaccessible to the visitor and to those who perform the services.

The document compiled by Antonio Ardenna is not absolutely complete, however, in that it fails to mention that some work was done in preparation for piercing the nave vault with six large windows. On both the north (pl. 9) and south flanks of the nave, the next-to-last eastern buttresses were enormously increased in width and height. The original buttresses, still visible, were encased in new masonry. This masonry is easily identifiable with the other masonry of the Torre campaign both by its strong pink color and by its characteristic *cavetto* molding.

Actually what one sees above the side roofs is only part of the new buttressing system that was begun. Below the roof heavy, steeply sloping arches were added to either side of the continuation of the wall that separates the last large chapel from the small chapel adjacent to it (pl. 48). These arches supported the new weight above them and were doubtless intended to form part of a system that would receive the thrust of the vault when the windows were opened therein. These new pieces of masonry were of such a great width that they projected out into the round arched opening that gives onto the open space above the dome of the little chapel (pls. 9 and 47). To regularize the opening, and presumably to strengthen the outer walls, the hole was partially closed by new masonry, including a low segmental arch. It appears, then, that the plan to remake the nave vault, a splendid late baroque idea but a gross disservice to Alberti's original design, was almost realized. One wonders what put a stop to this work, which was, in essence, quite far along.

S. Andrea found itself in the first decade of the eighteenth century a rather strange compromise between the way it had been before 1697 and the way in which Giulio Torre had wished to transform it. Only the north porch, the choir and transept vaults, and the inner faces of the end walls of the nave and transepts bore the stamp of his designs. The old cornice, as far as we can tell from the documents, was not completely replaced, for there is no mention in Ardenna's account of transformations to the cornice in the nave proper. On this basis it is probably safe to assume that the cornice we find in the nave today is the original one, and those around the transepts and choir and across the interior of the west wall of the nave are Paolo Pozzo's copies of the original parts that he found.[44]

# VI

# Eighteenth-Century Developments

*Juvarra's Dome—Pozzo's Restoration*

When one approaches Mantua from the northeast, and enters by the Ponte S. Giorgio, it is the eighteenth-century dome of S. Andrea that shapes the whole image of the city and makes it appear to rise like a volcanic island out of the surrounding lakes (pl. 54). The dome of S. Andrea is to Mantua as Brunelleschi's dome is to Florence, or Michelangelo's to Rome. But, because Mantua is far smaller, the dome's predominance over the city is increased.

Apparently the construction of Giulio Torre's design for the dome was not begun until shortly before 1733. However, both Niccolo Tasca, the energetic *primicerio* of S. Andrea, and Andrea Galluzzi, the current architect of the Fabbrica, were dissatisfied with the Torre design.[1] For this reason, in the winter of 1733 Tasca began a dogged campaign to secure the services of Filippo Juvarra, the renowned chief architect of the House of Savoy.[2] Tasca must have opened his campaign with an appeal to Cardinal Alessandro Albani, the Roman agent for the Piedmontese rulers, for on 31 March 1733, the cardinal wrote to Turin on Tasca's behalf.[3]

According to Albani's letter, the chief concern of the *primicerio* seems to have been the stability of the existing works. Tasca ostensibly wanted Juvarra to determine whether the crossing piers were strong enough to sustain the great weight that was to rise above them. It is also clear from the cardinal's letter that Tasca, whose supply of funds was greatly limited (the dome was partially financed by a lottery,[4] partly by outright begging in high places[5]), was trying to avoid paying Juvarra anything more than personal traveling expenses. One suspects, however, that the *primicerio* hoped to get more than advice on the crossing piers from the architect of the House of Savoy. Foremost in his mind was undoubtedly the idea that if he could only bring Juvarra to Mantua, he could then persuade the architect to make a new design for the dome. There were surely plenty of people capable of giving sound opinions on the piers, but only one Juvarra to create a new dome.

The trip to Mantua did not take place immediately. Juvarra was ill in March[6] and busy with other projects throughout the spring and summer.[7] He was also probably leery of the trip, fearing that even his traveling expenses might not be met. Cardinal Albani, however, persisted in his request for Juvarra to go to Mantua,[8] and this persistence paid off. On 19 August the minister D'Ormea, with whom Albani carried on this correspondence, reported to the cardinal that Juvarra had returned the day before from Mantua. There, not only had his expenses been paid, but he had also been given a present.[9] Moreover, Tasca's scheme to obtain a Juvarra design met with success. The *Gazzetta di Mantova* reported on 21 August 1733 that Juvarra had recently visited the city and left behind a "most beautiful drawing with various instructions" which, the newspaper promised, would result in one of the most beautiful domes in the world.[10]

Only two years before, Juvarra had made a series of projects for the dome of the cathedral of Como. Besides the finished project drawings, a sketch has come down to us that is extremely close to the design of the dome of S. Andrea (pl. 56). In this sketch the key elements of the Mantuan dome (pl. 55) first appear in Juvarra's work: the extremely high drum, the four massive buttresses articulated with paired

columns, the triple fenestration between the buttresses, the oval projection into the springing of the dome proper, and the tall lantern. It would seem that Juvarra recollected one of the rejected designs for Como and reused it for S. Andrea. He must have been in Mantua only a few days, was probably cajoled into doing a design only at the end of his stay, and quickly drew upon his memory to come up with a project that he had at least partially worked out two years before. The gift he received in Mantua, then, must have been a payment for the design and whatever instructions were left behind for its realization.

Work on the design, however, was far from rapid. On 21 April 1758, some twenty-five years after Juvarra's visit, a contract was finally let for the gilded ball capped by a cross that crowns the lantern.[12] And on 7 September 1780, Paolo Pozzo wrote that the full completion of the dome according to the designs left by Juvarra lacked only the ornaments and the stuccoing of the exterior, part of the interior ornament, and the four circular stairs planned for the four buttresses.[13]

A previously unpublished document in the Archivio di S. Andrea gives us an even more precise indication of what was still left to be done. Presented eight days before the Pozzo letter was written, the document lists the expenses and materials still necessary to finish the work. This work included eight pilasters and sixteen half pilasters of the drum, probably almost all of the moldings, eight candelabra over the columns, and four vases over the round windows. Neither the candelabra nor the vases were ever put in place,[14] but the other work was done rapidly, for on 23 October 1781 the cupola was pronounced "at present completed."[15]

The structure of Juvarra's dome is remarkable not only for its striking height, but also for the way in which it allows light to flood through the tall drum into the interior of the church. The entire weight of the lantern and most of the stress of the dome is borne by pairs of ribs that spring upward from the four great buttresses placed diagonally over the crossing piers. The intervening walls between the buttresses are almost entirely opened up into three tall windows. These walls are really thin screens that anchor the glass of the windows and support the thin single shell of the dome between the ribbing. The design ingeniously gathers all of the major elements of weight and support into four compact areas, so that the rest of the drum may be left free for the passage of light.

Curiously, Juvarra seems to have derived his principal inspiration for the exterior of this dome from an English prototype that he had seen only a few years before (pl. 57). When Juvarra left the services of the Portuguese royal house in 1720 to return to Turin, he apparently took a circuitous route via London and Paris.[16] In London, he must have seen the Greenwich Hospital, then being built. The twin domes (completed 1728) that crowned Sir Christopher Wren's plan[17] seem to have made an impression on the mind of the Italian artist, for they stand directly behind Juvarra's "pensiero" for Como of 1731, which in turn developed into his design for S. Andrea. This visual evidence, then, lends weight to the proposition that Juvarra had visited London and also provides us with one of those rare instances in which the work of an English architect has a direct echo not just across the channel but also south of the Alps.

On the interior of the drum the articulation is absolutely regular (pl. 58). The pattern of the windows is interrupted only by niches of identical size and shape, which contain colossal statues of dubious merit. Above these, the round windows in the dome proper alternate with aediculae of an open, free design, which contain colossal busts. Foliate ornament in stucco adds a certain richness of texture and relief at this point.[18] The lower part of the drum may reflect the earlier Torre project (pl. 44), although the balustrade, a simple iron one, is probably located higher in the drum than Torre intended his to be.

It has been universally noted, even as early as the 1780s,[19] that Juvarra's design violates the spirit of the interior of the church. The brilliant light that pours into the crossing makes it appear a world apart from that of the somber, indirectly lit nave. But, we should remember, the brilliance of the light in the crossing was very much in tune with the flood of light Torre had already introduced into the eastern parts of the church. In Juvarra's day all three arms were lit by pairs of enormous lunettes in their vaults (pl. 50). In addition, the choir was lit by three tall windows in the apse, and the

transepts by giant rectangular openings high up in their end walls (pl. 51). To Juvarra, the nave must have appeared very somber and old-fashioned indeed, whereas the vaults of the eastern arms, built during the very years he was beginning to form his own style, were characterized by those large, light-filled perforations that Juvarra himself frequently employed.[20] He must have found this part of the church far more congenial, and rightly so. We have erred in condemning him too roundly for violating Alberti's nave, largely because we have insufficiently understood the state of S. Andrea as Juvarra knew it.

We have tended to assume that S. Andrea fared little better under the loving hands of a very sympathetic admirer, the Veronese architect Paolo Pozzo, than it had under Torre and Juvarra. While the late baroque dome was in the final stages of construction, Pozzo directed an extensive restoration and remodeling (he would have called the whole campaign simply a restoration) of the interior of the church. He seethed with righteous outrage over the fate suffered by the church at the hands of those artists who had intervened in the building between Alberti's time and his own: those "false architects, who, longing for licentious novelty, have until this time deformed it in many places and deprived it of its exquisite ornaments."[21]

The sense of history Pozzo possessed in relation to the building clearly relates to that developing taste for classical historical styles that began to flower in the last third of the eighteenth century.[22] Pozzo spoke of S. Andrea as the church that had served as "the sole model for the other Catholic temples erected after it."[23] While such naïveté about architectural history may seem amusing to us today, Pozzo took his own position very seriously and felt himself to be conserving, as he indeed more or less was, one of the great monuments of the past.

Pozzo seems to have begun the work of restoration as early as April 1778.[24] By June he was restoring the bases of the pilasters of the façade, which at that time were made of terra-cotta (the present stone bases date from around 1830). In a letter of that month he pleaded with the local authorities for support in his campaign of restoration, citing the historical reasons discussed above. The next day, apparently persuaded by his impassioned plea, the authorities assured him that he was free to do whatever he thought necessary "as much for the stability as for the elegance and dignity proper for the magnificence of the temple."[25]

In accordance with this decision Pozzo, at the end of July 1780, proposed a much more costly step in his reconstruction—the remaking of the great cornice on the interior "by almost half."[26] During the fourth campaign, it will be remembered, the cornices of the transepts and choir were remade according to the design of Giulio Torre; it was undoubtedly these baroque cornices that Pozzo found "too heavy, and licentious in form."[27] The nave cornice, never mentioned in the documents relating to the Torre campaign, had probably been undisturbed, and Pozzo could have used it as a model for the cornices of the east end.

Actually Pozzo intended to do more than remake half of the cornice, as we learn from some sheets of estimates for expenses. Among the most important changes he intended to make were the reinstallation of the six pilasters that had formerly articulated the inner faces of the end walls of the nave (pls. 59 and 60) and the two transepts, as well as the remaking of round windows in the lunettes above these pilasters.[28] The Torre campaign, one remembers, had taken out the original pilasters and changed the windows from round to rectangular. A drawing (pl. 61), probably in Pozzo's own hand, reveals the care with which Pozzo designed his quattrocento-like decorations for the window and its surrounding lunette. These windows, however, are probably larger than the originals. Had the fifteenth-century windows been this size, they would have dwarfed those small niches that rose originally over the cornice directly above the side doors of the west wall of the nave (pl. 52). An intentional juxtaposition of two such disparate scales seems unlikely in terms of the fifteenth-century proportions of the church.

The document also tells us of Pozzo's plans to "replace the three rectangular windows in the choir, as well as three other round ones,"[29] a project that was clearly carried out, as a look at the exterior

masonry of the apse will verify (pls. 37 and 63). The outlines of the original apse windows (third campaign) are still visible. Under their round arches Giulio Torre had inserted a low segmental arch. Pozzo, in turn, abandoned the original axes of the two side windows, moving them laterally toward the choir, to make the side windows equidistant from the springing of the apse and the central window. The result of this change in the disposition of the apse windows is clear on the interior (pl. 62). By relocating the side windows he was able to obtain an even rhythm of openings, which he could then enclose in an "Albertian" system of arches and pilasters of his own invention. The apse as it stands today, then, is a Pozzo essay in the vocabulary of an earlier period. As such, it is not without success.

In Pozzo's cost estimates two sets of mysterious "nichie" (niches) crop up. The document speaks of "the formation of eight new niches with Corinthian columns,"[30] and also of opening "the four niches in the end walls."[31] To take the former group first, there is no evidence in the church today of eight niches with Corinthian columns. Nor is it clear where eight new such niches could have been placed. The most logical positions might have been the eight faces of the crossing piers, which originally had round headed openings at a level below their oculi. Subsequently, these were greatly reduced in size and finally closed up entirely. The "four niches in the end walls" are equally difficult to place precisely. There were, of course, three "end walls," those of the transepts and of the nave. We know that the west wall of the nave contains niches that were walled up during the fourth campaign. Perhaps Pozzo intended, to open new niches in the end walls of the two transepts, following the pattern of the niches at the end of the nave. These he could well have planned to open without mention of them in the cost estimate. If such a scheme were in his mind in 1780, it had been abandoned by 1782, for his drawing for the lunettes of the "end walls," dated 24 September, shows no niches (pl. 61). The great windows and decorations of the lunettes were carried out largely according to the ideas set forth in this drawing.

Still another project on the same list was never realized: the razing of the barrel vault that shields the great west window of the nave. Pozzo wished to remove this structure "to obtain a direct light in the temple," and planned either to convert the area over the porch into a terrace or to cover the whole space with a new roof.[32] Why the "ombrellone" was allowed to survive, we do not at present know. Clearly Pozzo's sense of light was very different from Alberti's.

An important aspect of Pozzo's work at S. Andrea, although it is not mentioned in the known documents, was the closing up of the lunettes that Torre had inserted in his vaults of the east end of the church (pl. 50). The brickwork that fills these enormous openings is characteristic of Pozzo's time (compare the masonry fill under the west window of the nave) (pl. 51). Moreover, Pozzo undoubtedly had access to the records of the fourth campaign, and it would have been an easy task for him to identify these great openings as the result of misguided thinking—mistakes he luckily was in a position to rectify. With these openings filled in, the transepts and choir lost that brilliance of light Torre had given them, but they still did not become quite as dark as the nave. Had Pozzo built two "ombrelloni" over his new windows at the ends of the transepts he would have given those spaces a far more Albertian mood than they now possess.

To the modern visitor to S. Andrea the most immediate and, one might add, most disturbing contribution of Paolo Pozzo to the interior is the extensive program of fresco decorations on the surfaces of the architectural members. The candelabra painted on the giant order of pilasters have inspired, in addition to one pious monograph dedicated to them alone,[33] general condemnation by modern critics (pls. 6, 7, and 65). A more careful reading of the eighteenth-century documents, however, forces us to reevaluate our position on these ornaments. In another sheet of cost estimates from 1780 we find an item of particular interest in this respect: "To paint N. six new pilasters with candelabra corresponding to the old ones."[34] The six new pilasters are clearly those Pozzo built at the ends of the nave and the transepts. The document continues by calling for the retouching of the pilasters that were already painted,[35] thereby reinforcing the idea that there were some pilasters that had been decorated at an earlier time. We discover, moreover, from the same document, that the barrel vault of the nave was already painted with coffers and only needed retouching, whereas the vaults of the transepts and

choir were bare.[36] The present coffering of these vaults, then, was carried out under Pozzo's direction.

There is further corroborative evidence for the existence of these earlier decorations. An anonymous writer of 1783 praised the salutary influence of Pozzo on the painters who were redecorating the rest of the church:

> Pozzo has contributed much to the beauty of those ornaments, seeing to it that with his counsel and with the example of the still remaining ornaments, the new goes alongside the old: and in fact we now look with pleasure upon all the great cross repainted according to the taste of the remainder.[37]

In Pozzo's mind there was no doubt about the age of the old frescoes in S. Andrea. He wrote: "the old paintings in the Temple, both of ornaments and of figures, were executed by Andrea Mantegna and his pupils."[38] Although in his attribution of the bulk of the figure painting he was patently wrong, he may have been right in giving the architectural decorations to the school of Mantegna. Certainly the local style of the late-fifteenth/early-sixteenth century called for the elaborate decoration of architectural members, and specifically for the painting of candelabra on pilasters. Such decoration we find at its best on the painted pilasters in Mantegna's frescoes in the Camera degli Sposi (completed 1474) and on a cruder level in numerous examples from local domestic architecture, such as the carved portal of 17 via Fratelli Bandiera. One might also cite the now-destroyed paintings in the apse vault of S. Francesco (pl. 77), where flat ribs decorated with candelabra separate figural groups. These frescoes surely were carried out by followers of Mantegna and must date just prior to the period in which the nave of S. Andrea was ready for decoration, that is, after its vaulting in the 1490s.

The church itself offers us equally compelling arguments. Traces of a shell decoration in the niche on the south side of the façade, a row of painted palmettes in the frieze, and a kind of frescoed rustication of the wall surfaces all came to light after World War II (pl. 64). These frescoes were covered up almost immediately after their execution in the late fifteenth century by the building of a house—the very house, in fact, rented to Bernardino Giberto in the 1530s and '40s (pl. 3). Until it was destroyed by a stray bomb, the house protected these decorative details, enabling them to escape the severe weathering that has destroyed almost entirely the similarly painted decorations of the façade proper.[39] In this respect, we should remember that the preserved fragments of the original façade capitals retain traces of red and blue paint. Furthermore, as late as 1830 the vaults of the porch were still partly decorated with painted ornaments,[40] and today the walls of Mantegna's chapel still display their early ornamental and figurative frescoes of the early sixteenth century (pl. 71). Finally, the longer one looks at the great pilasters of the façade and of the nave, the more one becomes convinced that they were designed to be painted. Their terra-cotta moldings literally frame their tall, slender faces, as if to stress the fact that these surfaces were intended as fields for pictorial decorations (pl. 23). Admittedly the paintings one now discovers on the pilasters are hopelessly dry and academic, but their qualities may not be due entirely to the meager talents of Pozzo's painters. Those dry productions were, in all likelihood, based on equally dry originals.

Clearly, as a restorer Pozzo does not deserve quite the low mark he has generally been given for his work at S. Andrea. The same cannot always be said for his work at other places. For instance, he did irreparable damage to the exterior of Giulio Romano's Palazzo del Te.[41] The bizarre attic he removed from it must have seemed hopelessly licentious to him, and in no way worthy of preservation. One suspects that S. Andrea emerged reasonably unscathed, and perhaps even improved by his work, because he was sympathetic to at least some aspects of its original style. For whatever reason, it is fortunate that the "ombrellone" of S. Andrea escaped his wrecking crew. Actually, we should not blame him too harshly for misunderstanding it and wanting to have it removed. After all, distinguished scholars of modern times have found it equally disturbing, and some have even gone so far as to attribute its construction tentatively to the time of our friend Paolo Pozzo.

# VII

# The Fifteenth-Century Plan

## *A Reconstruction and Attribution*

In the building history of S. Andrea, we have seen that during the first major campaign on the site, beginning in 1472 and ending probably before 1500, the west porch, the nave (pl. 96), the nave vault, and the lower part of the west wall of the north transept were built, and a crypt was added below the floor of the east end of the nave. Between about 1530 and about 1565 the north and south transepts, the north porch, the eastern crossing piers, the sacristies, the choir, and the apse were added to the building, although plans to accomplish this work must have existed as early as 1526. From 1597 to 1600 the fifteenth-century crypt was greatly enlarged and the faces and interiors of the crossing piers altered. Beginning in 1697, a fourth campaign saw the vaulting of the choir and the transepts, completion of the south wall of the south transept, destruction of the upper parts of the north porch, and beginning of the north and south crossing arches. The dome was begun in 1732, but in 1733 a new design of Filippo Juvarra was adopted. By 1758 the major work on the dome had been done, but it was only completed as it now stands in 1781. Also in the 1780s the interior was "restored" in a neo-quattrocento vein. Around 1830 the façade and west porch were restored.

Now that a relatively precise history of the construction of the church has been achieved, we must turn to the question of the fidelity of its ultimate appearance to Alberti's original design (or designs) of 1470–1471. There is general agreement that the nave represents the realization of Alberti's ideas. Doubts about the present Latin Cross plan have been raised, however, on three grounds: that of a supposed late-sixteenth-century date for the beginning of work on the entire east end of the church,[1] that of a lack of stylistic concordance between the nave and the rest of the building toward the east,[2] and that of the apparent disparity between the present plan and Alberti's understanding of the *templum etruscum*.[3]

Since we know that the present transepts were erected between about 1530 and about 1565, we can easily discard the supposed late-sixteenth-century date for their design and construction. The proposition that the Latin Cross plan of Vignola's Gesù (begun 1568; fig. 12) influenced the plan of S. Andrea, as suggested by Hubala,[4] must therefore be rejected on simple chronological grounds.

Moreover, recent discoveries and observations of both a documentary and an archaeological nature make it quite clear that some type of transept was planned from the time the foundations of the nave were begun in 1472, and that one side of the north transept was laid out its full length during the first campaign. Thus it seems certain that transepts of the present depth were included in the fifteenth-century plan. To understand the background against which these transepts were designed we should examine the position that S. Andrea was intended to assume in the Mantua of around 1470.

S. Andrea constituted the most noble and important part of a rather ambitious "urban renewal" scheme that Lodovico Gonzaga envisioned for his city.[5] That the building was intended to play a secular role in the *vita urbanistica* of Mantua seems clear from the west porch, that grandiose loggia that forms part of the system of loggias flanking the major streets of the city (pls. 66, 68, and 70).

The integration of the design of the façade with the articulation of the nave walls brings an echo of a public space into the nave and, at the same time, adorns the piazza with the architectural scheme for the interior of the church. This combination of public and "private" space, of secular and Christian elements in one building is one of the most innovative and progressive aspects of Alberti's design. He was reworking what he knew from the Pantheon, for instance, with its public porch and enclosed, even unfenestrated interior; but he surely knew that he had gone beyond antiquity when he gave the whole design a unity of exterior and interior generally unknown in ancient temples.[6]

Lodovico's efforts to give his capital a modern face were in large part concentrated directly south of S. Andrea, in and around Piazza dell'Erbe, which had become the commercial and political center of Mantua by the thirteenth century (pls. 66 and 68).[7] A new portico was attached to the Palazzo della Ragione, probably after the completion, in 1473, of the contiguous Torre dell'Orologio,[8] in itself a key piece of public architecture (pl. 68). Also, from 1462 to 1464 Lodovico had restored the old Palazzo del Comune, or del Podestà,[9] which separates Piazza dell'Erbe from Piazza Broletto (pls. 66 and 68). Along the opposite side of that square, porticoes with a definite Fancellian air (pl. 70) were created between Contrada S. Agnese and the point at which Vicolo Leon d'Oro debouches beneath them into the piazza. This *vicolo* was marked toward the piazza by the interruption of the colonnaded porticoes with a pair of piers articulated by very flat pilasters. Over this part of the portico was constructed the Casa dell'Università dei Mercanti, for which a date of 1450 has been suggested,[10] although I would prefer to think of it as somewhat later, after Alberti had arrived on the scene and had left his stamp on Fancelli's style. The continuation, or renovation of the porticoes along the rest of that side of the square probably dates from the sixteenth century (cf. the severe Tuscan capitals of these loggias, unthinkable as fifteenth-century capitals in Mantua), although the house built on the corner (pl. 3) between Piazza dell'Erbe and Piazza Mantegna (Piazza S. Andrea) was completed in the last years of the quattrocento.[11] Furthermore, at the same time S. Andrea was quickly rising before the eyes of the Mantovani, Lodovico was building the Casa del Mercato,[12] which occupies a site on the south side of Piazza del Purgo at the corner of Contrada dei Magnani (pl. 66).

Almost all of this activity can be dated to that period in which Alberti found himself in Mantua from time to time.[13] One is tempted to think that he instigated the whole idea, or at least helped to clarify and direct Lodovico Gonzaga's ideas on the matter. Although Lodovico's projects were in no way as grand as Pope Nicholas V's for remaking the Borgo and St. Peter's,[14] they still belong on the list of the earliest Renaissance attempts to revive the cityscape of antiquity. One can think only of Pius II's Pienza[15] and the Nicholas V projects as precedents, and they both fall into the category of plans at least loosely connected with Alberti.

The most important building in this part of Mantua is the church of S. Andrea, which naturally became the focal point of the new developments. Yet the church is in no way directly connected to the civic heart of the city. Its site is divorced from Piazza dell'Erbe by a row of old houses, and formerly as well by a narrow street, the Vicolo del Muradello, which ran between the houses and the south flank of the nave of the church (pl. 66).[16] Furthermore, the church faces the old Piazza S. Andrea, a less important adjunct of Piazza dell'Erbe, rather than the main square itself. While the present orientation of the church seems to have been dictated by the direction of its eleventh-century predecessor, we can well imagine that Alberti would have liked to connect his great temple with the main public square, a procedure he strongly advocated in *De re aedificatoria*.[17]

A solution to this problem would have been offered by the addition of a porch like those at the ends of the nave and the north transept to the end of the south transept. The inclusion of such a south porch in the fifteenth-century plan has often been assumed, generally for reasons of symmetry, by students of the church. A somewhat more complex and more convincing case can now be made for this porch.

It is important to remember that around 1550 a copy of the fifteenth-century porch at the west end of the nave was built at the end of the north transept. This north porch, however, was never intended to face a major public space. It gave onto the old monastery, parts of which are still visible on Ranieri's

map of 1831 (pl. 66), although they were removed later in the nineteenth century. Thus the north porch could never have been meant to perform an important role in the Mantuan cityscape. Indeed, it would appear to have been a wasteful and useless piece of construction. Its existence, however, can be justified in the following manner. The north porch was built as a complement to an intended but never erected south porch, which would have performed a key role in the developing urban scene.[18] In other words, the arguments for symmetry still stand, but for different reasons.

Other evidence at our disposal leads to a similar conclusion. We know that when the south transept was erected between 1530 and 1565, its southern wall was completed only up to the height of about 4 meters. This evidence is corroborated by a map of Mantua of 1625 (pl. 39), which shows the end of the south transept still open. The failure to finish the south transept during the extensive second campaign suggests that more was to be built at the south end than a simple curtain wall. In other words, the south wall was left open, so that that wall and the south porch could be built in the future as one unit, a procedure that had been followed in the construction of the north porch during this same campaign. In addition, as late as 1677 the purchase of land for this porch was still being contemplated by the Duke of Mantua. Unfortunately, the property needed for the extension of the church toward Piazza dell'Erbe was located in Mantua's prime commercial area, for that reason probably commanding a high price. Thus the economics of the situation seem to have had the final say. Any intention of adding the south porch was abandoned by 1698–1699, when the south transept was brought to its present mean state of completion.

Precedents for such a grand transept façade in Italy are not common, but one outstanding example, surely well known to Alberti, immediately springs to mind: the twin-towered façade of the thirteenth-century transept of S. Giovanni in Laterano in Rome (now largely covered over by Domenico Fontana's late sixteenth-century benediction loggia). At the Lateran the problem was analogous to the problem at S. Andrea. The main façade of the Lateran faced away from the center of Rome, just as the main façade of S. Andrea faced away from Piazza dell'Erbe. From the center of Rome the main approach to the Lateran was toward the transept. Alberti could well have contemplated a similar approach to S. Andrea.

A south porch would also have served a specific ceremonial function on great feast days when the Blood of Christ was shown. At such times, contemporary sources inform us, the nave of the church was filled with throngs of the faithful, who would have entered through the west porch. From the monastery the north porch provided the clergy with its own entrance. The Gonzaga and their court, on the other hand, had no special means of access. Their palace was located to the east of the church (off the upper right of pl. 66) and can be partly seen in the upper left-hand edge of the aerial view in pl. 67. Coming from there to the ceremonies in S. Andrea, they had to proceed the whole length of the building from east to west—a considerable distance—and then fight their way through the crowds in the nave to gain their positions in the east. If nothing else, a south porch would have solved this traffic problem.

A study of S. Andrea is not possible, actually, without considering its specific relation to the Gonzaga family and their specific reasons for wanting to rebuild the church. In the first place, the relic the church contained was one of the most remarkable of Christendom, and as such, it was visited by thousands annually.[19] The circumstances in which the relic was conserved would reflect either glory or shame on the house responsible for its care. Thus the prestige and pride of the family were tied up in the new building. Lodovico clearly expressed this idea when he said that he wanted to build the new church for the honor of his son, of himself, and of his city.[20]

Gonzaga and Mantuan honor were tied up with the church of S. Andrea not just for the obvious reason that the church happened to be in Mantua, but also because of a specific set of historical circumstances surrounding the relic of the Most Precious Blood of Christ, which was conserved in the church. From as early as the papacy of Clement VI (1342–1352) the Dominicans and Franciscans had been engaged in a theological debate over the Blood of Christ.[21] As Ludwig von Pastor neatly put it:

> The question ... was, whether the blood shed by our Lord in his Passion, and redeemed at His

Resurrection, was during these three days he remained in the sepulchre, hypostatically united with the Godhead, and therefore entitled to worship.[22]

In the years immediately following the Council of Mantua (1459) the debate seems to have reached a new peak of intensity. In 1462 Pius II forbade the preaching of the subject either publicly or privately, on pain of excommunication. Pius's ban, however, seems to have had little effect, for during the Christmas season of 1462 he saw fit to order a three-day disputation on the subject in his presence. The Dominicans, who held the affirmative opinion, carried the day, but Pius, not wishing to offend the Franciscans, withheld a definite public pronouncement. Thus the controversy raged on, and Pius had to renew his ban in 1464.[23] One doubts, however, that the renewed ban caused the question to disappear.

The debate was followed with great interest by the Gonzaga,[24] for the value of their most important relic lay at the very center of the controversy.[25] As one would expect, they also seem to have taken direct action in defense of the Blood. For instance, during the last quarter of the quattrocento three literary works appeared in Mantua in support of the relic.[26] Also during this period at least one propagandistic work of art related to the hypostatic controversy was commissioned: a stone relief, now in Palazzo Ducale, Mantua, which shows Christ as the Man of Sorrows between two angels.[27] Christ is pressing the wound in his right side, from which his blood flows into a chalice. The angels hold symbols of the Passion, but in the case of this particular relief, as Marita Horster has demonstrated, these symbols may also be interpreted as referring to SS. Andrew and Longinus.[28] Thus the connection of this relief with the relic of the Most Precious Blood seems sure, and its connection with the new church of S. Andrea at least highly probable.[29]

The decision to rebuild S. Andrea in a new and magnificent form, then, must be seen against the background both of the hypostatic controversy and of Gonzaga efforts to defend the value of their relic.[30] At S. Andrea, Lodovico Gonzaga and the citizens of Mantua, who jointly undertook to meet the building costs, sought to offer unequivocal, permanent, and public proof of their faith in the importance of the relic entrusted to their protection. In a sense, new S. Andrea was their grandest piece of artistic propaganda. For the Gonzaga and the Mantovani the new church represented an enormous commitment of effort and treasure. In the end, because of their limited resources, they were unable to carry out what they had begun. To paraphrase Browning, their reach exceeded their grasp. But the very fact that they were willing to reach so far bears witness to the importance they attached to the building of this church.

The church and convent also became involved in Lodovico's political maneuverings. An able ruler, Lodovico devoted his life to the careful consolidation of his holdings and his power.[31] Through his efforts, his son Francesco became the first Gonzaga to wear a cardinal's hat. And under the dominion of this trusted son Lodovico sought to consolidate all the local ecclesiastical power in Gonzaga hands. Francesco became Bishop of Mantua in 1466. Sixtus IV, who came to the throne of St. Peter in 1471, made Francesco abbot of the monastery of S. Andrea.[32] Then, in the summer of 1472, surely after a Gonzaga request, Sixtus suppressed the monastery and created the *primiceriato* of S. Andrea, with Francesco as *primicerio*.[33] With this arcane and long-unused title, the head of S. Andrea came under direct papal jurisdiction. In this manner the two most powerful ecclesiastical posts of Mantua came into the hands of the Gonzaga cardinal, whom Sixtus had also chosen for the very important post of legate to Bologna. We are told that Francesco helped to engineer the election of Sixtus to the papacy.[34] Papal gratitude was obviously received with pleasure by the Gonzaga thereafter.[35]

Intimately connected to the church in this variety of ways, the Gonzaga and their court would naturally have played a large role in the great ceremonies that took place there. Thus it seems likely that the church would have been designed with these ceremonial needs in mind. A porch off the south transept would have given the Gonzaga their own monumental entrance to the church off the main public square, an entrance convenient both to their palace and to their places within. It is interesting to note that when plans for this porch seem finally to have been abandoned around 1700, the Gonzaga

dynasty was in serious decline. In 1707 the state was taken away from the tenth duke, Ferdinando Carlo, and placed under direct Austrian control.[36]

In attempting to reconstruct the fifteenth-century plan, another significant question still remains: that of the covering for the crossing. Even though the evidence available to us may not be conclusive, what little we have from Mantuan soil at least tends to lead us in the direction of one form—a hemispherical dome on pendentives. First, there is the evidence available in S. Andrea itself. All of the little chapels in the nave piers are covered by precisely such domes (pl. 72). Stylistic consistency would appear to dictate the maintenance of the same form over the crossing.

Second, there is the evidence of the Cappella dell'Incoronata, adjacent to the Duomo of Mantua. Ercolano Marani has hypothesized that the present chapel, with its central bay covered by a hemispherical dome on pendentives capped by a lantern and flanked by two barrel-vaulted arms (pls. 73 and 74), originally formed the crossing and transept of a kind of miniature basilica. The single nave of that basilica he has identified with the present sacristy of the cathedral—a vaulted, rectangular space that at one time opened directly, through a wide arch, into the domed bay of the present chapel.[37] If his reconstruction of the original structure is correct, and his attribution of the building to Luca Fancelli is as sound as it seems to be, then we have an almost immediate reflection, designed 1477–1478, of the large church from the drawing board of the architect-mason who directed the first campaign at S. Andrea.

Similar forms were found in the now-destroyed east end of the church of S. Francesco in Mantua (pls. 75 and 76). Beyond the Gothic nave two bays and an apse were added, probably in 1478 and probably on the basis of a design of Luca Fancelli.[38] The first of these bays was covered with a barrel vault springing from simple vertical walls. This bay led into a square bay covered by a hemispherical dome on pendentives resting on four arches, the eastern of which led into a semicircular apse capped with a semi-dome. The arches were supported by four large freestanding columns with Corinthian capitals. To the north and south of the dome there were no transepts but rather projections as deep as the arches that supported the cupola. The western columns and arch formed a triumphal arch that led into the domed bay.

Both of these buildings reflect Fancellian adaptations of elements of the vocabulary of S. Andrea to different purposes. Together with the little chapels of S. Andrea, they probably give us the only locally available clues to the intended covering for its crossing: a hemispherical dome on pendentives, possibly with a lantern. Both the Cappella dell'Incoronata and the east end of S. Francesco postdate the plans for the larger church. Furthermore, their very presence in Mantua and their clear connection with the style of Luca Fancelli, as modified under the impact of Albertian forms, lends weight to the argument that the crossing of S. Andrea would have been covered by a hemispherical dome on pendentives.

Finally, there exists a scarcely recognized piece of pictorial evidence from the year 1477 that may well give us at least some of the larger details of the original design for S. Andrea, including the covering of the crossing. The cassone of Paola Gonzaga (pl. 78), made for her marriage to an Austrian nobleman in 1477, shows a building with certain features peculiar only to S. Andrea.[39] The façade of the building has a large arched opening in the center flanked by two pilasters. Above this rises a triangular pediment with one window in the center. The arch opens onto a porch, at the rear of which a doorway is visible. Although details of the design are different, the general disposition of forms and spaces is quite similar to that of S. Andrea. Rising behind this porch we see the smooth, curved outline of a hemispherical, blind dome. It is, of course, extremely rare to find "portraits" of contemporary buildings on a fifteenth-century cassone,[40] but the circumstances under which this particular design for a building came to be employed on this particular chest—a Gonzaga building on a piece of Gonzaga furniture—make it possible that here may be preserved some of the larger outlines of the original fifteenth-century design.

To consider other aspects of the east end, it has long been recognized that the crossing piers were not originally intended to carry their extra pairs of salient pilasters. Stripping those pilasters away, one arrives at a very different manner of turning the corner between the nave and transept. The original

corner pilasters must have come together at right angles, separated by a single molding, just as the two pilasters join at right angles on the south corner of the west porch (pl. 64). The turn from one space to the next would have been as clean and sharp as the present break between the space of the nave and the spaces of the large side chapels (pls. 6 and 7). The oculi of the great lunettes of the end walls of each end of the transept presumably would have been shaded by "parasols," just as the oculus of the west end is still shaded. As noted earlier, the oculi of the transepts let almost as much light into the eastern end of the nave as do the twelve windows of Juvarra's dome. Students of S. Andrea have been right to point out the entirely different atmosphere one finds in this part of the church, but they have not been quite precise enough in isolating the causes of this disparity. Were one to remove the added pilasters and open the oculi and niches of the crossing piers, shield the great transept windows from direct sunlight, and black out the great windows of the dome, one would then have a crossing more faithful to the original plans, and thereby more consistent with the grand scheme of the design of the church.

In the original fifteenth-century parts of the building—the west porch and the nave—one notes a particular propensity for variations and expansions on a theme. Specifically, we should recall the relationship between the central and side bays of the porch (pl. 2). This relationship, which consists of a central vault rising from flanking barrel vaults, is repeated with successive increases in scale as one proceeds down the length of the church (pls. 4 and 5). Continuity is maintained in this progression as the dimensions of the central element in one phase become the dimensions of the adjoining elements in the next. Thus, the central bay of the porch recurs as the six flanking side chapels of the nave. In this phase the nave rises as the new central element, to be succeeded by the (hemispherical?) dome in the next. In this, the final stage, the transept vaults serve as the flanking elements. A similar effect obtains if one enters from the north porch. Here, however, the telescoped leaps in scale produce a more dramatic effect. We may be sure that had a south porch been built, that entrance would have afforded not only convenience, but also a remarkably impressive introduction into the church from the city as well.

If the general outlines of this reconstruction are acceptable, and seen as most possible and appropriate in the Mantua of about 1470, then to whom are we to attribute this design, Alberti or Luca Fancelli? In all probability, the author could only have been Alberti himself. Luca was a perfectly respectable mason and designer of buildings, but there is no evidence anywhere of his ability to think in the grand and sophisticated terms that typify the design of S. Andrea. Indeed, around 1470–72 Alberti was the only architect in Italy who could and did think in such terms.

The chronology of events, moreover, reinforces this thesis. Alberti designed the church late in 1470. Soon afterward, we now know, Luca Fancelli's name appeared in documents related to S. Andrea, a fact that indicates that he was associated with the church from the very beginning and therefore must have had direct conversations with Alberti about the building. In April of 1472 Alberti died in Rome; the cornerstone of S. Andrea was laid the following June. It seems highly unlikely that Luca, who had already been in charge of the building of Alberti's S. Sebastiano, would have changed the plans for S. Andrea during the old man's lifetime. Nor is it likely that he would have altered those plans in the two months between Alberti's death and the beginning of construction. It does seem, then, that the weight of the evidence points to Alberti as the sole author of the plan from which construction of the church was begun in June 1472.

There still remains the question of reconciling such a final Albertian plan for S. Andrea with the first design he submitted, based on his understanding of the *templum etruscum* (fig. 4). As Richard Krautheimer has pointed out, Alberti's *templum etruscum* is typologically analogous to the actual design of the west porch and the nave, but not to the rest of the present church.[41] The answer is that there may well be room for both interpretations. It is clear from the exchange of letters between Lodovico Gonzaga and Alberti that Lodovico intended to have some say in the final product.[42] There is ample reason to suppose that changes, even major ones, occurred in Alberti's design after Lodovico returned to Mantua and discussed the project with Alberti. The final plans need not have been ready for several months, and in that space of time many changes and modifications could have occurred.[43] Alberti's first sketch, which

he sent to Lodovico, may well have envisioned only the nave, and later Alberti may have enlarged the plan to its present dimensions.

Another crucial question is how the Albertian design could have been transmitted to subsequent ages. Our knowledge of fifteenth-century building practices would tend to lead us to the conclusion that no architect of that time could have left a plan readily intelligible to later architects. Brunelleschi, for instance, relied as much on conversations with his workmen as on drawings and models to transmit his ideas.[44] Once he was dead, his fragmentary visual representations were at least partially incomprehensible to the actual builders.[45] Thus S. Spirito, largely completed after Brunelleschi's death in 1446, deviates from the master's original intentions in numerous ways.[46] The kinds of architectural rendering in perspective popular in the 1460s, if the illustrations in the margins of Filarete's *Trattato* can be taken as typical, would have been as difficult for future builders to follow as Brunelleschi's designs.[47]

As early as the writing of *De re aedificatoria*, however, Alberti had conceived a system of graphic representations of buildings in terms of plan, section, and elevation.[48] For architectural drawings, he specifically forbade the tools of the painter, such as light and shade and perspective renderings.[49] Alberti's "nude,"[50] methodical, and reliable method of recording the design of a building, undreamed of by any other architect of the quattrocento, made him the only architect of his day capable of producing a set of plans that subsequent architects could comprehend and follow.[51]

It is important always to keep in mind that Alberti did not practice architecture in the normal fashion of his day. The kind of day-to-day communication with his workmen that Brunelleschi utilized was out of the question for the noble Alberti, who rarely oversaw the construction of his own buildings,[52] and who often kept abreast of developments on the site by correspondence. The craftsman in charge—Luca Fancelli for the Mantuan buildings—took care of the daily problems at the works. If Alberti, then, did not want to see his designs ruined in execution, he had to invent and practice a system of architectural representation that would allow his ideas to be followed with fidelity.

No student of the ancient authors, and Alberti was one of the greatest of their students, can read them without an awareness of their concern with the opinion of posterity. Alberti, we know, shared this concern.[53] He must have been keenly aware, for instance, of the fate of Brunelleschi's unfinished buildings in the period after his death. In his late sixties when he designed S. Andrea, Alberti could hardly have hoped to see a building of such great size completed during his lifetime. Yet he must have wanted to make sure that the church, his crowning achievement as an architect, would rise with every part in its proper place, with the carefully wrought harmonies of its "musica" intact. Obviously the method he had advocated twenty years earlier in *De re aedificatoria* would have served him well in this respect. It is hard to imagine his not having used it.

S. Andrea, then, must be one of the first buildings ever designed that could have been completed according to the original architect's wishes, even long after that architect had passed from the scene.[54] It is extremely unusual to find a church with a building history stretching over 300 years that turns out to resemble in large part the plan of its first architect. The building of new St. Peter's, to take a well-known example, required roughly 100 years. Yet the church went through countless changes at the hands of successive architects in charge and now bears little resemblance to Bramante's original scheme.

The fact that Alberti's plan for S. Andrea fared better than Bramante's for St. Peter's seems the result of at least two historical factors. First, almost half of the church was built during the first campaign, under the direction of Luca Fancelli, who must have received instructions directly from Alberti. Second, a conscious choice must have been made, roughly between 1526 and 1530, to continue the building according to the original scheme rather than to seek to complete it according to a new plan.

Although we may never know why this decision was made, it is an intriguing question on which to speculate. On the one hand, one can argue that in 1530, with a major portion of the building already standing, it was simpler and cheaper to continue construction in the original vein. Although plausible, such a solution is hardly usual. The enormous change in taste and style between 1470 and 1525–1530 would lead us to expect a desire on the part of the sixteenth-century builders to redo things in their own

modern idiom, just as each new generation has always tended to remake and remodel old buildings, no matter how respected they may be. Moreover, we must not forget that Giulio Romano, a man with bizarre tastes and very much in the avant-garde of his day, arrived in Mantua in 1524.[55] Thereafter, any major decision that was made about the future of S. Andrea must have been made with his full participation. As we have already noted, it is both clear and striking that no traces of Giulio's very distinctive style can be found in the architecture of the building. We even know that Giulio was one of the three superiors of the Fabbrica of S. Andrea.[56] Why did he see the building carried out, *grosso modo*, according to the design of the previous century? Was he simply ordered by Federigo Gonzaga to have the building continued along the old lines? Or could it be that he realized the worth and historical importance of the design, at least to some extent? We know that his master, Raphael, had keenly felt the need to preserve the monuments of the ancient Roman past.[57] Could Giulio have extended this feeling to a building of the immediate past? Were the works of Alberti admired by architects of the first half of the cinquecento in a manner parallel to the way they admired ancient works?

There is enough evidence of a widespread interest in Alberti among the members of the Bramante-Raphael circle to make such a question at least a reasonable one to ask. In the first place, the only early-sixteenth-century drawings of Alberti's buildings known to us come from this very group of artists: the elevation of the façade of S. Andrea drawn by Hermann Vischer the Younger in 1515[58] and the plan of S. Sebastiano by Antonio Labacco (of which three versions exist).[59] Such an interest in an architect of the immediate past is hardly common in drawings of this day.[60] In projects of Antonio da Sangallo the Younger, references to motifs first developed by Alberti at S. Andrea are not unknown: a façade project for S. Marco in Florence,[61] a project for a porch for the S. Casa in Loreto,[62] the articulation of the nave arcade of his 1520–1521 project for St. Peter's.[63] In the thirties we find the first church clearly based on the nave of S. Andrea that was actually built: Girolamo Genga's S. Giovanni Battista in Pesaro (fig. 14).[64] Also in the thirties, Giulio himself acknowledged his own respect for Alberti when he borrowed the nave articulation of the earlier church for the south flank and façade of the church at S. Benedetto Po.[65]

In the light of this evidence, then, it is perhaps inadvisable to hold fast to the old opinion that the architects of the first half of the cinquecento cared little for the works of the most distinguished masters of the preceding century, Brunelleschi and Alberti. At least in the case of S. Andrea we must recognize the fact that a conscious choice was made to continue the Alberti design more or less along its original lines. It is to be hoped that further studies will clarify the reasons for this choice.

# VIII

# Conclusion

At S. Andrea Alberti developed a number of ideas he had collected from earlier works: some ancient, some medieval, some quattrocento, and some his own. As a designer, however, he exhibited a very complex, even ambiguous style. In the façade we can see in a most instructive way the interplay of his rich knowledge of the history of architecture with his very sure instinct for form and design.

The façade is traditionally described in terms of the fusion of a Roman triumphal arch with an antique temple front (pl. 79).[1] In the design, each of the two types possesses a form uniquely its own—the triumphal arch the great central opening, the temple front the pediment. They share, however, the pairs of giant pilasters, which not only flank the arch, as in the Arch of Constantine, but also support the pediment, as in a temple front.[2] In sum, the pilasters function in two ways: both in the sense of their historical sources and in terms of their visual effects. Furthermore, each of the ancient types has been forced to sacrifice an integral part of its original form. The arch is deprived of an attic, which is replaced by a pediment. The normally even rhythm of vertical supports in a temple front, on the other hand, has given way to the insertion of a larger bay, the arch proper, in the middle. Each historic type, then, has been forced to accommodate the other, so that neither is quite what it was originally, although the original source easily springs to mind. Throughout the rest of the building we consistently find precisely this kind of complex and ambiguous play with forms and sources. Although this aspect of Alberti the artist in his final work has been noted,[3] it deserves greater stress than it has received. There is an enormous difference between the freedom with which Alberti embraced and made over the past at S. Andrea and the rather handsome imitation he made of Roman monuments twenty years before at the Tempio Malatestiano in Rimini (pl. 83).

Medieval monuments, as well, form an important part of the background of certain aspects of the façade of S. Andrea.[4] When Alberti placed a pediment over a large central arch flanked by narrower side bays, he repeated a recurring motif of the Lombard Gothic, the best example of which for our purposes is probably the early fourteenth-century façade of the Cathedral of Crema (pl. 80).[5] The major elements of the designs are strikingly similar. (Alberti, of course, has distinguished S. Andrea from its nearby predecessors by providing it with a modern set of proportions and a classical vocabulary.) We might even compare details. Alberti seems deliberately to have set his windows and niches (pl. 19) into his wall in a manner that recalls the way windows were set into walls in Lombard Gothic churches, as a comparison between the façade of S. Andrea (pl. 79) and that of Crema Cathedral (pl. 80) will demonstrate. Generally, as we know, Alberti incorporated aspects of local and regional monuments into his own designs. Indeed his fidelity to and interest in local architectural traditions sets him apart from many of his contemporaries.[6]

For many aspects of S. Andrea Alberti seems also to have turned to the architecture of Brunelleschi as a source. That Alberti had great admiration for Brunelleschi even in the early, pre-architectural part of his career is clear from the fact that *della pittura* was dedicated to the older man.[7] While there is evidence of Brunelleschian ideas in Alberti's early buildings, a point that will be developed below, in the specific case of the façade of S. Andrea it is clear that its elevation is deeply indebted to Brunelleschi's handling of the triumphal arch motif, in a rather personal way, on the altar wall of his Old Sacristy in S. Lorenzo in Florence (pl. 81).[8]

In terms of Alberti's own works, the façade of the Tempio Malatestiano (pl. 83) is a prime source for the triumphal arch at S. Andrea, for it was in Rimini, in his first major building, that the Roman triumphal arch first appeared whole in a work of Christian architecture.[9] The temple front, on the other hand, previously appeared in Alberti's own work in the upper story of S. Maria Novella in Florence (pls. 82 and 85).[10] Here, too, the motif was derived directly from a local source, the upper story of the medieval façade of S. Miniato al Monte, reputedly Alberti's favorite church. At S. Maria Novella Alberti took up a form from the ancient past as it had been filtered down through a medieval monument. The temple is poised on the attic story of the rather spread out triumphal arch with which he adorned the lower story. The forms existed, then, one above the other in Florence, before they were fused in Mantua.

Alberti's S. Sebastiano in Mantua (1460) (pl. 84)[11] also has a temple-front façade, but in this case he incorporated into the temple front the ancient form of an arcuated central intercolumniation. Since a number of questions still surround this façade, one must proceed in any discussion of it with great caution. According to Wittkower's reconstruction (pl. 90) of the history of the façade, Alberti in 1460 seems to have intended to articulate it with six evenly spaced pilasters. In 1470, however, he may have reduced this number to the present four, thus changing the rhythm from a regular one, in the ancient manner, to a more synocpated and, one might add, Albertian one.[12]

Every one of Alberti's façades (save Wittkower's S. Sebastiano of 1460) is characterized by the consistent use of an *a b a* rhythm, with the central, or entrance bays distinguished in width from those that flank them. At S. Andrea, the Tempio, and the upper story of S. Maria Novella, the central bay is wider, whereas at S. Sebastiano, and in the lower story of S. Maria Novella, the central bay is much narrower than the flanking bays. Even the seemingly regular bays of the façade of Palazzo Rucellai in Florence (pls. 88 and 89) are differentiated, the two door bays being slightly wider than the others to emphasize their functions as entrances.

Alberti was deeply concerned with the architectural (and spatial) ordering given to the entrances of his buildings. What he did at Palazzo Rucellai is not the exception but the rule. At Rimini (pl. 87) the entrance is recessed under the large central arch, and the portal adorned with a heavy pediment and surrounded by a lavish display of polychrome marble, the only colored stone on the exterior except for a pinkish rope molding that runs around the base (pl. 83). At S. Maria Novella the portal is also recessed as far as possible into a relatively thin wall (pl. 86). This recession is then emphasized by the pairs of pilasters that articulate the inner surfaces of the surrounding arches. The whole richly decorated bay in which the door is placed, moreover, is subtly distinguished from the side bays in that the plane of its wall is pushed back slightly behind the plane of the walls of the flanking bays.

What Alberti intended at S. Sebastiano is again difficult to specify. Clearly, he gave the central bay a vertical thrust (pl. 84), up through the broken entablature, to distinguish it from the surrounding bays, whether there were two or four. There, also, the central opening received a more imposing frame than those of the other bays, but it is difficult to decide if Alberti intended the central cornice to overlap the flanking pilasters. Such a procedure seems highly unusual for him.[13]

Equally complex in its sources is the idea for such a porch at S. Andrea. Such a scheme was anchored, without doubt, in Alberti's conception of the *templum etruscum* derived from Vitruvius, as well as in the firsthand experience of such ancient buildings as the Basilica of Maxentius and the Pantheon. What is more, old S. Andrea, just twenty years before Alberti's design, had received a six-column portico.[14] New S. Andrea, then, replayed an old theme, one that echoes throughout that ring of loggias encircling the heart of Mantua.

Of Alberti's previous churches, only Mantuan S. Sebastiano boasts a porch (fig. 5). In Rimini and Florence Alberti's hands had been tied by the fact that he had to work from preexisting structures. In both cases, the recessed portals served as buffer zones between interior and exterior. With S. Sebastiano, a new foundation, Alberti had a free hand to develop and order more fully the space through which the visitor enters the church proper. Indeed, he "deformed" the pure Greek Cross plan of this church (the first of the Renaissance) by adding the porch to the west arm of that cross.

The subtle manipulation of standard architectural detail in the façade of S. Andrea also continues a major theme of Alberti's designs, especially those in Florence.[15] (Actually, when stacked up against the later churches, the façade of the Tempio seems just a bit immature.) A particularly revealing example, in the case of S. Andrea, is the entablature of the small order of the façade. As the entablature runs around the interior of the central bay, it behaves in a perfectly "normal" fashion (pl. 92). The three fascia of the architrave step out from the wall. Above them the frieze is slightly recessed back to the plane of the wall itself, and then the whole is capped by a projecting cornice. As the entablature swings around the corners of the central bay, resting on its composite capitals, it maintains this correct disposition of parts. Once past the capitals, however, it is abruptly shoved back into the thickness of the wall (pl. 91). The fascia of the architrave are slanted backward, so that none of them projects beyond the thin bands of terra-cotta moldings that enclose the faces of the giant pilasters. The frieze is thrust back into the wall to a totally unexpected depth, and the profiles of the cornice are slanted, like those of the architrave, to prevent them from projecting beyond the plane of the large order. The purpose of all of this, of course, is to allow the pilasters (whose flat surfaces are actually slightly recessed behind the plane of the wall) an unbroken vertical sweep from their bases to the pediment (pl. 19). No thoroughgoing classicist would ever have attempted such a brilliantly unconventional ploy, and few architects apart from Alberti (only Michelangelo and Palladio come immediately to mind) could have carried it off with such quiet success.

Such manipulation of architectural details is surely a further step along a road on which Alberti had already embarked in his Florentine buildings. The slight widening of the door bays in the Rucellai façade is one example (pl. 89). The attic that intervenes between the first and second stories of the façade of S. Maria Novella is another (pls. 82 and 85). An unhurried look at this familiar design reveals a most interesting fact. The axis of the central portal lies slightly to the left of the axis of the great rose window (pl. 85). Alberti conceals this fact, with which he was confronted in the already existing structure, so cleverly, however, that it has not been remarked, at least to my knowledge. Because of this shift in axes, the pilasters flanking the window do not rise directly above the engaged columns below them. The intervention of the attic, with its repetitive motif of dark squares on a light ground, keeps the two orders apart and conceals the disparity. There is no attempt at vertical continuity, for such continuity would have been impossible, and disastrous for the design.

To summarize the points I have attempted to make here, the façade and porch of S. Andrea reveal some peculiarly Albertian characteristics. One is the complex, and often even ambiguous historical sources of the work, and the other is the brilliant visual refinement of many of the members—the accommodation of one part of the design to another for a specific effect.

The nave of S. Andrea can be viewed in the same light (pls. 4 and 96). The major source for this part of the church was generally held to be the Basilica of Maxentius,[16] although this idea has been modified by Krautheimer, who pointed out that a number of smaller Roman structures, to say nothing of Vitruvius's description of an Etruscan temple, probably also stand behind Alberti's design.[17] But if one looks a bit farther afield, Alberti's transformation of the three groin vaults of the nave of the Basilica of Maxentius into a single great barrel becomes an easier step if one sees as the intermediary the large hall of the medieval Palazzo de' Consoli at Gubbio, which has a single pointed barrel resting on three arches to either side.[18] Also, round arches that span great distances are to be found in secular buildings in Mantua, specifically the Arengario.[19]

Contemporary sources for the nave are equally important. If we return to Brunelleschi's Old Sacristy, we discover along the altar side (pl. 81) that combination of closed and open spaces that characterizes the flanks of the nave of S. Andrea. In the Old Sacristy (fig. 6) Brunelleschi placed the chapel containing the altar between two closed spaces entered by doors leading from the main space. Thus, Brunelleschi's articulation of the walls of this part of the sacristy seems to have played a role not only in Alberti's design of the façade of S. Andrea, but also in the disposition of its volumes. Alberti owed, in other words, not only a two-dimensional but also a three-dimensional debt to Brunelleschi. Such an alternation of

closed and open spaces actually occurred in Alberti's own work at Rimini (fig. 8) some twenty years before it appeared at S. Andrea, although the order of the solids and voids along the naves in Rimini is reversed.[20]

The closed spaces flanking the nave are one of the most interesting features of Alberti's plan for S. Andrea. Unlike the closed, barrel-vaulted spaces which flank the open domed chancel at the Old Sacristy, Alberti's open spaces are barrel vaulted, and the closed spaces domed. These hidden domes not only offer an architectural surprise, but also increase through architectural means the sense of importance of these small, auxiliary spaces.

These little hidden domes are not unique in Alberti's work; their forerunners appear at S. Sebastiano ("are concealed in" might be a better phrase). There the western arm of the upper church is flanked on either side by two small chambers, square in plan, which are separated from the arm by heavy masonry walls (fig. 5). Both side spaces were once covered by hemispherical domes; the southern dome, with its lantern, is still preserved.[21] The dome and lantern are completely concealed by the exterior masonry of the church, but the location of the southern chamber, with its dome, can be sensed from the exterior. The south wall of the porch arm of the building is punctured by two rectangular openings, arranged vertically (pl. 84). The lower of these windows lights the square chamber, while the upper illuminates an interior space above the little dome and provides light for the internally hidden lantern.

The intended function of the little domed spaces at S. Andrea and at S. Sebastiano can be suggested. Alberti was opposed to the medieval practice of burial within churches; he spoke out against it strongly in *De re aedificatoria*.[22] Yet, in 1481 the little chapels at S. Andrea were designated as burial chambers,[23] and the first of these to the left of the entrance was given to one of the chief luminaries of the Gonzaga court, the painter Andrea Mantegna, by around 1500. Was it also Alberti's intention that such a disposition of these spaces should be made? The little chapels do indeed exist as almost entirely separate structures, small replicas, one might say, of Brunelleschi's Old Sacristy, which was built not only as a sacristy but also as the mausoleum of Giovanni de' Medici. Even the segmental curves carved out of the side walls of some of the little chapels probably derived from the similar treatment of the side walls of the altar space of the Sagrestia Vecchia. Moreover, the small chapels at S. Andrea are strikingly reminiscent of a remark which Alberti made in *De re aedificatoria* about putting chapels in funerary structures. If chapels are to be adopted in mausolea, then they should be "little models of temples" (*pusilla templorum exemplaria*).[24] Admittedly, one has to reverse Alberti's position to see these small chapels as funerary monuments—they are not part of a mausoleum, but of a large pilgrimage church—but they keep the burial spaces separate from the spaces devoted to the gathering of the faithful, and this is the purpose which also probably stands behind Alberti's desire to have chapels in mausolea separate from the burial space as well. In any event, the little chapels at S. Andrea are surely small temples in their own right. The analogous spaces at S. Sebastiano quite possibly fit the prescriptions of *De re aedificatoria* more exactly, in that they may well have been intended as little chapels inside a larger funerary building.

The structure of S. Andrea is firmly grounded in Roman practices. The honeycomb nature of the construction—the hollowness of the seemingly solid piers—must have been derived from that of the Pantheon, which Alberti knew and admired.[25] The great barrel vault of the nave is surely the largest since antiquity (Alberti knew, without the slightest doubt, that he was rivaling the ancients), while the unitary character of vault and roof again recalls the Pantheon. The coffered transverse vaults of the side chapels, on the other hand, go back to such monuments as the Basilica of Maxentius, and probably the arch of Septimius Severus.

Once again, however, medieval Lombard practices seem to have played an important role in the designing of the church. The roofs of the building are not held up by a system of wooden trusses. Rather, the roofs over the chapels rest directly on a system of ramping, segmental vaults, the thickness of one brick, while the roof over the nave rests directly on the masonry of the vault. A strikingly similar practice is found in a group of churches located in Pavia and Piacenza.[26] In these churches, as at S.

Andrea, the roofs rest directly either on the extradoses of the interior vaults themselves, or on special vaults built only to support the roofs. The areas between the inner vaults and the roofs are closed off, so that the roofs are reachable and reparable only from above.[27] The same situation obtains at S. Andrea. The close parallels between the peculiar structural systems of these churches and that of S. Andrea leads one to believe that the relationship is not entirely fortuitous.

Although the design of arched and vaulted structures was not new to Alberti, when he drew the plans for S. Andrea (he had used thick arches in the flanks of Rimini [pl. 98] and had planned vaults and a dome for S. Sebastiano),[28] the complex structural system we find at S. Andrea is quite new in his career.[29] As far as we know he had never tried his hand at a building of such vast scale as S. Andrea, and it is doubtless the grandness of its size that called forth its technology. Although this structure has been described in some detail in this book, I would like to point out again the contradiction inherent between the barrel vault and the system that supports it. The great vault of the nave is continuous, without a single break between the inner wall of the façade and the piers of the crossing (pl. 45). Such a vault calls for continuous support and buttressing along its entire length. One might expect a supporting system that expressed this requirement visually, such as a series of transverse barrel vaults of identical size moving down the nave in an unbroken rhythm (for example, the background architecture in Donatello's bronze panel of the Miracle of the Ass in Padua).[30]

Instead, Alberti chose a far more complex design for his interior. The giant order of pilasters visually assumes the lion's share of the task of supporting the vault. But the pilasters are not evenly spaced. Rather, they are paired at alternating intervals on the faces of the piers, thus creating the famous "rhythmische travée" (pls. 6 and 96). The unevenly spaced pilasters then support (along with the apexes of the arches of the large chapels) the continuous run of the entablature, from which the continuous vault rises. The two incompatible systems are merged through the ingenious application of decorative detail. To mark the visual points of support along the entablature, Alberti placed a small cherub head in the frieze above each pilaster and above the apex of each large chapel vault. At first glance, these heads appear evenly spaced, but on closer inspection, the alternating rhythm of their placement asserts itself.

The flat pilasters, moreover, are not wholly decorative. *Grosso modo*, they mark off for the viewer the locations of the walls between the chapels, that is, the walls (or piers, if you will) that actually buttress and support the vault. The oculi in the faces of the piers also play a role in explaining the actual structure. They lie in a kind of curtain wall stretched between the two flanking pilasters. Above the oculi, relieving arches carry the load of the vault down into the walls that separate the chapels. This presence of the oculi in the structure in no way lessens its ability to bear the load, and they do admit light at crucial points while revealing the fact that they do not exist in a bearing wall. In other words, their presence visually reinforces the role the pilasters play in explaining the actual workings of load and support in the building.[31] The vault is held up by continuous courses of masonry supported on a series of arches of alternating size, which transmit the load of the barrel onto the walls separating the chapels. These ultimate load-bearing members then extend out from the nave like flanges to act also as the buttresses for the thrust of the vault. The whole system is sophisticated and economical, while at the same time providing Alberti with the opportunity to play with the kinds of visual complexities he found so particularly enthralling.

Such complexities also characterize the relationship between the architectural membering of the nave and that of the west porch (pl. 19). The two are very close but differ in several crucial aspects. On the façade, Alberti seems to have wanted to express a certain independence between the central arch and the flanking bays, whereas on the interior he wanted to stress the continuous movement of those members in unison down the nave. The pilasters of this order no longer stand decidedly free of the giant order, but rather slide partially behind the large members. Moreover, the pilasters of the small order have no bases and no fluting, so that from the nave they have no real identity until one catches sight of their capitals. These are reduced to plain stucco surfaces, on which *trompe l'oeil* channels have

been painted. (Whether the decoration is ultimately original is not known.) The entablature, in turn, is reduced to a single frieze to decrease markedly its horizontal impact. Furthermore, the elaborate game of pushing the entablature back into the wall, which we noted on the façade, is abandoned here. But the same unclassical hand is still at work. The baseless pilasters are inordinately tall, and the whole entablature is replaced by the unorthodox thin band of the frieze.

For all of these aspects of the building that we have just been discussing one would have to search with excessively great diligence to find prototypes in earlier times. They are manifestations of Alberti's own sensibility as a designer—a highly personal application and reworking of motifs he had learned from ancient buildings, which he admired perhaps more than any other man of his age. But in no way can it be said that he was a slavish imitator of the works for which he felt a profound admiration. He was that rare breed of architect who understands the history of architecture in a deeply scholarly fashion, but at the same time is capable of creating works of the highest quality, marked with the indelible imprint of his own personal style.

We should now ask if our reconstruction of Alberti's plan for the whole church can stand up to the kind of analysis to which we have just subjected the clearly original parts. In the case of the Latin Cross plan (fig. 2) we seem to run into difficulties. To my knowledge, there is no pre-Christian prototype for a vaulted Latin Cross basilica with three porches. No matter how one would like to stretch Alberti's description of the *templum etruscum* to make it comply with the plan we propose for S. Andrea, such a procedure is impossible. Moreover, we know that when Alberti wrote *De re aedificatoria* he felt transepts to be proper for secular buildings rather than sacred ones.[32] Recently, however, it has been pointed out that we probably should not take Alberti's statements in that work quite as categorically as we have tended to do in the past.[33] After all, Alberti did not specifically say that transepts should *never* be used in a building with a sacred function. Moreover, as we have attempted to point out, the rebuilding of S. Andrea occurred, at least in part, in response to certain needs and desires of the Gonzaga dynasty. As a visual expression of its relationship to the life of the city around it, the articulation of the interior of S. Andrea is repeated rather closely on its façade, opening up its sacred world to its secular setting. The building, then, is probably too complex in its meanings to allow us a narrow view of its design.[34]

Possible sources for that design from the Christian architectural tradition are less difficult to find. One thinks, for instance, of the Early Christian Basilica Apostolorum (now S. Nazaro) in Milan, as Alberti could well have known it. The plan of the original fourth-century basilica[35] offers striking parallels to the plan of S. Andrea. The church was cruciform in shape, with the arm of the nave longer than those of the transepts. Entrances into the basilica were located at the ends of both transepts, and these entrances were preserved when the present apsidal endings were added during a major reconstruction of the church in the eleventh century. During this reconstruction the cruciform plan was maintained, but details such as the triple arcades separating the nave from the transepts were removed. In the original scheme, moreover, semicircular apses opened off the east and west sides of each transept arm. The western apses were removed in the eleventh century, but those on the east wall exist down to the present. Thus the proposed Albertian transepts of S. Andrea, in an embryonic state, were available for his study.[36] As we have already noted, the large medieval transept façade and entrance of S. Giovanni in Laterano, as well as the great transept façades of the nearby Duomo of Cremona,[37] could also have served as sources for Alberti's plans for Mantua. There is, in addition, the possibility that Alberti could have seen, or heard of, French Gothic transept porches, such as those of Chartres.

Certain aspects of the plan can also easily be seen as growing out of a synthesis of ideas brought forth in the period 1420–1470. We have already noted a certain debt to Brunelleschi's Old Sacristy (pl. 81, fig. 6) both in the façade and in the disposition of the open and closed chapels along the periphery of the nave of S. Andrea. Furthermore, the square plans, hemispherical domes, and shallow niches hollowed out of some of the walls of the little chapels (pl. 71) in the piers of S. Andrea clearly go back to the altar chapel of the Old Sacristy. Even certain relatively minor details of S. Andrea are Brunelleschian in origin. The roundheaded windows above the cornice of the west wall of the nave

echo similar windows in the Old Sacristy (pl. 81) and in the end walls of the transepts of S. Lorenzo. The putti heads in the friezes of the giant orders of porch and nave are similarly to be found, albeit in great profusion, in the frieze of the Old Sacristy. Also, the eastern pilasters of the small order of the porch (pl. 26) seem to disappear into the west wall of the nave in a manner that reminds us clearly of a famous Brunelleschian *leitmotif*.

Underlying much of modern literature on quattrocento architecture is the notion that Alberti was in many ways anti-Brunelleschian, and, conversely, Brunelleschi's most devoted followers of the latter half of the quattrocento were anti-Albertian. While the latter case is clearly demonstrable,[38] the former turns out to be not quite so simple. Indeed, one might argue that Alberti, in the course of his architectural career, actually went through Brunelleschi's stylistic development in reverse. As Heydenreich demonstrated, Brunelleschi's early works, such as the Old Sacristy (pl. 81), are characterized by flat wall surfaces overlayed by a flat system of articulation, while his late style, exemplified by S. Spirito (fig. 9), becomes much more three dimensional in terms of the articulation of the wall surface.[39] Alberti, on the other hand, according to Wittkower's perceptive analysis, moved from an architecture of relatively high relief, as in the façade at Rimini (pl. 83), to a submersion of the orders into a planar pattern on the surface of the wall.[40] Indeed, the façade of Rimini would appear to have taken as one point of departure Brunelleschi's tribunes below the dome of Florence Cathedral, where pairs of columns engaged to the wall alternate with semicircular roundheaded niches. At Rimini, Alberti's original intention was to alternate single engaged columns with semicircular roundheaded niches, although these were later walled up for structural reasons.[41] The tribunes were probably being completed at the very time Alberti was designing the façade of Rimini,[42] so that one can see here a direct movement of a motif from the last works of Brunelleschi into the first work of the younger master, Alberti.

In his last work, S. Andrea, early Brunelleschi designs, specifically the Old Sacristy, seem to have come to the fore in Alberti's thinking, and with good reason. The Old Sacristy was really the first essay in the new style of the fifteenth century in a purely wall architecture. The supporting members, the pilasters, are fused with the wall in such a way that wall and articulations are inseparable. It is exactly this kind of effect that Alberti sought and achieved in the façade of S. Andrea.

Just as Alberti turned to his most distinguished immediate predecessor as a source for his treatment of the wall surface at S. Andrea, so too he turned to Brunelleschi for its plan. S. Spirito in Florence, laid out in the form of a Latin Cross (fig. 9), with a long nave and three square arms radiating from a square crossing, surely was a prototype for Alberti's S. Andrea.[43] He seems to have turned to this late design of Brunelleschi for the solution to a problem that had interested him throughout his architectural career: the integration of centrally and longitudinally planned forms in one church. As we know from Matteo de' Pasti's medal of the Tempio Malatestiano, its nave was to have been terminated by a large, centralized, domed structure.[44] The awkwardness of such a juxtaposition of forms is clear to us from the unhappy manner in which the rotunda of the SS. Annunziata in Florence is joined to the transept of the medieval basilica. Indeed, Michelozzo's proposed addition of a rotunda to the SS. Annunziata must be closely connected, in one way or another, with Alberti's scheme at Rimini.[45] Ten years later, for S. Sebastiano, Alberti proposed essentially a Greek Cross plan, but to this centralized concept he fused a porch, adding to the building a rather weak sense of a longitudinal axis (fig. 5). In S. Spirito Alberti must have found the reasonable solution that, for one reason or another, he had not found in his previous churches.

Such a Latin Cross scheme for S. Andrea is specifically related to the function that the church had to perform: to conserve and to offer a fitting, capacious site for the display of the Most Precious Blood of Christ, a relic of great importance to the Gonzaga dynasty and to the city of Mantua. Alberti's solution for that function finds a parallel in a contemporary Italian church, the S. Casa in Loreto (fig. 10). The history of this building, still not altogether clear, would seem to indicate a date for the first plan as early as 1468, two years before S. Andrea was designed.[46] That Alberti knew of

the church is not certain. Its location on the Adriatic coast south of Ancona places it decidedly off the beaten track. On the other hand, the papacy was intimately involved with the building, and Alberti surely could have known of developments at Loreto from acquaintances at the papal court.

The S. Casa has a large vaulted nave flanked by aisles. These are terminated by an octagonal domed crossing, from which radiate three large arms with triapsidal endings. This disposition conforms splendidly to the function of the church, the conservation of the Holy House, in which the Virgin lived and in which sacred events transpired. According to the legend surrounding the House, it was transported by angels from the Holy Land to Loreto, with intermediate stops on the opposite shore of the Adriatic Sea. The House itself rests under the dome of the church, much as the Blood of Christ is preserved directly under the dome of S. Andrea in the crypt. One might call both churches "reliquary basilicas," in that their function is to preserve and glorify a major relic, while at the same time offering space for throngs of the faithful to congregate to venerate the holy object. Both churches offer a well-planned solution to this particular functional problem. The centralized east ends glorify and emphasize the presence of the relic under the dome, while the vast naves and large spaces surrounding the crossings afford ample room for enormous gatherings on holy occasions.

It is not entirely coincidental that two such similar and sensible solutions to a particular problem appeared so close in time and place. Both S. Andrea and the S. Casa go back to Nicholas V's project to rebuild the western end of St. Peter's.[47] Nicholas's scheme, as we know it in broad outline both from an early-sixteenth-century plan (Uffizi A 20)[48] and from Giannozzo Manetti's description in his *Vita* of Nicholas,[49] envisioned the addition of wider and longer flat-ended transepts to the Constantinian church, as well as a deep choir terminated by a semicircular apse. The new transepts and choir were to be joined together by a square crossing over which a semicircular dome, capped by an apparently quite tall and rather bizarre lantern, was to rise.[50] The tomb of St. Peter was to find itself beneath the dome to the west of the center of the crossing. The Nicholas V plan for remodeling the chief church of Christendom, then, presented at mid-century, even if in somewhat tentative form, a workable arrangement of transepts, choir, crossing, and dome around and above a major relic (fig. 11). This arrangement must have been the prototype for both S. Andrea and the S. Casa.[51] To be sure, the St. Peter's scheme was modified in the cases of both later churches, but it still provided the general outlines of a solution to a peculiar functional problem that all three buildings shared.

Alberti, of course, knew the Nicholas V plan at first hand, and apparently did not find it to his liking. According to Matthia Palmieri, he advised Nicholas to halt construction of the new addition to the church.[52] For that reason alone, it would seem unlikely that Alberti had any role in the designing of this new part of St. Peter's. Unfortunately, Palmieri does not give us Alberti's reasons for counseling a halt in the work. To what aspects of the plan did Alberti object? On the basis of his design for S. Andrea, some twenty years later, it would seem that the general conformation of spaces might well have met with his approval. Further, on the basis of his own clear disposition toward saving parts of old buildings, one doubts that he would have counseled Nicholas to abandon his project in favor of a total rebuilding of the whole church from the ground up. In *De re aedificatoria* he even presents a plan for restoring the walls of old St. Peter's,[53] which had leaned dangerously out of the perpendicular.[54] Perhaps, then, the details of the design displeased Alberti. From what we can glean from Manetti's not-always-clear description, as well as from the Uffizi A 20 plan, the project seems rather crude in conception, still at least half medieval in flavor, and not at all designed in that robust, clearly organized, archaeologically learned style that Alberti himself was practicing in the same years at Rimini. If he used actual local antique models for a relatively provincial church such as the Tempio, what far wider possibilities and opportunities awaited an architect in Rome at St. Peter's? One would think that Alberti would have found the Nicholas V project hopelessly inadequate for its time, for its place, and for the noble ambitions of the great pope. The formal language of the buildings as planned could never have conveyed the message of a resurrected papacy, with all of the ramifications of that idea, a message that Nicholas surely wanted the church to convey. An Alberti

design, knowledgeably utilizing great buildings of the Roman past as sources, would have been capable of conveying just such a meaning. It is for these reasons, I would suggest, that Alberti advised Nicholas to call a halt. Two decades later at S. Andrea[55] Alberti may well have attempted to correct some of the faults he had found in the Nicholas V project for St. Peter's.

In other respects, a contemporary church equally crucial for the design of S. Andrea is the Badia Fiesolana, on the outskirts of Florence. The history of the design of the Badia is one of the most unclear of any of the major works of quattrocento architecture. We know, unfortunately, neither the name of the architect (or architects) of the Badia nor the date of its design.[56] Work on the church, however, is known to have begun in 1461, under the very anxious and watchful eye of Cosimo de' Medici, who died before its completion in 1466.[57] Thus the patronage of the Badia was as high as its architectural qualities and historical importance.

In plan, the Badia is a Latin Cross basilica (fig. 7) with a nave directly flanked by eight square chapels (pl. 97) raised above the pavement of the central vessel. Beyond the nave, there is a square crossing, raised four steps above the level of the nave pavement (pl. 95). From the crossing radiate a long choir and two transept arms as deep as the nave chapels. Both transepts and choir, like the nave, are barrel vaulted and terminated by flat walls. The crossing, like the eight chapels flanking the nave, is covered by a pendentive dome.

The interior of the nave is elegantly undecorated. The round arched entrances to the chapels are articulated by rather plain *pietra serena* moldings, while the springing of the nave vault is marked by a simply profiled cornice, which runs uninterrupted around the whole interior. Between the chapels and this cornice rises a large expanse of bare wall surface. The nave is joined to the crossing by slender fluted pilasters, which wrap themselves around the ninety-degree corner.

It is only at the crossing that highly decorative elements intrude (pl. 95). The pilasters are channeled and bear Corinthian capitals. The intradoses of the crossing arches are richly carved, in a manner reminiscent of the nave arcades of S. Lorenzo. The cornice above the capitals springs out from the surface of the wall as it turns the corner. All of these details join together to emphasize the crossing, and thus the "central" element of the plan. Moreover, the end walls of the nave, transepts, and choir have identical oculi opened up in the lunettes above the cornice. At the ends of the nave and the choir three rather small rectangular windows give additional light, although those in the choir are larger and higher than those of the nave.

By this point, the number of similarities between S. Andrea (pl. 96) and the Badia should become apparent. (There are great differences, to be sure, in vocabulary. The Badia was conceived in a Florentine, Brunelleschian idiom of stuccoed walls accented by *pietra serena* details.) The Latin Cross plan, the barrel-vaulted spaces, the raised vaulted chapels opening directly off the nave, the high round windows at the ends of the arms of the cross, the emphasis on the raised crossing, all are elements first brought together at the Badia and then taken up again in 1470 at S. Andrea.

Furthermore, other extremely important parallels can be drawn between the church in Fiesole and the one in Mantua. In terms of structure, the nave of the Badia is a unique antecedent of S. Andrea (pl. 94). The walls separating the nave chapels rise above the chapel vaults to buttress the nave vault and to support the roof. Before S. Andrea, only at the Badia does a similar structural system appear in quattrocento architecture, to my knowledge.[58] Also, the manner in which one enters the Badia is equally important. The present unfinished façade (pl. 93) preserves the remains of the façade of an earlier, Romanesque church (the nave walls rest on the foundation of the old building). This fragment of the older and smaller church has a decided sense of scale all its own. The scale of the interior, in turn, is much larger than that of the façade, so that a visitor experiences a certain sense of surprise at the size of the interior when he first enters. Walking into the Badia, in that sense, is very similar to walking into S. Andrea. At the Badia, the trick seems too subtly turned to have been accidental. The Romanesque façade was preserved not by default but by deliberate choice. If we knew the name of the man who decided to save the old façade, we would probably also know the name of

the man responsible for the design of the new church. Moreover, there is an intangible quality to the interior space of the Badia, partially a result of the high, small light sources and the consequently rather dim light, which brings S. Andrea to mind. We are, I think, faced with a choice between two equally intriguing possibilities. Either Alberti played some role in the designing of the Badia, or the architect of the Badia exerted a profound influence on Alberti. That Alberti knew the Badia is sure; his relationship to it remains to be clarified.

The plan of S. Andrea differs from that of the Badia, of course, in that the east end is far more decisively centralized. This centralization, in turn, leads to a plan which is more ambiguous than that of the church in Fiesole. At S. Andrea Alberti fused a longitudinal basilica with a Greek Cross in such a way that both forms can be clearly read, and yet each is forced to accommodate the other, just as the triumphal arch and the temple front of the façade are forced to accommodate each other. The dichotomy of forms can still be experienced by comparing the effect of entering the nave through the west porch with the effect of entering the transept through the north porch. Standing at the west end of the nave, one has no real sense of the depth of the transepts (pl. 4). Standing in the transept, one has no sense of the great length of the nave. One sees only the dome, the crossing, and the four apparently identical arms that radiate from it. This ambiguity is inherent in the function of the church as a shrine for the relic of the Most Precious Blood of Christ, as well as a pilgrimage church capable of holding large crowds on the annual occasion of the showing of the Blood. We are too long accustomed to thinking of the church only from the vantage point of the pilgrim who entered from the west. The Greek Cross effect, to have been experienced by the clergy and the court, has ceased to register with us. The experience of this complex building can be far richer if we now see S. Andrea from both points of view.

# Appendix I

1) Carlo Magno Pippini Regis filio imperante, translato ad Germanos in personam ejus Imperio, apud Mantuam hoc eodem loco, quo praesens hodie Monasterium cernitur, parvo tunc Oratorio cum Hospitali domo in jam dictae urbis suburbio constituto, Sacratissimum Sanguinem Dei & Domini nostri Jesu Christi, ex ipsius in Cruce pendentis effusum latere, a beato Longino milite & glorioso Martyre delatum atque reconditum, primum inibi innotuisse patribus nostris tradunt & authenticae literae, & ad nos usque continuata memoria. Admirabilis admodum & recolendae hujus rei crebrescente fama commoti Imperatoris ejusdem precibus beatissimus Leo Papa III a Roma perfectus Mantuam vocanti apud Aquisgranis Augusto quae sitam comperatam tantae revelationis fidem vero dedit testem, Mantuae Annos a Nativitate Dominica Octingentos Quatuor celebrato Concilio, eodemque Oratorio praeter antiquitatem beati Andreae Apostoli titulum sub vocabulos praefati gloriosissimi Sanguinis in novam & parvam Basilicam consecrato. (p. 1073)

2) *Revelatio secunda Sanguinis sacratissimi sub Leone Papa IX & Henrico Imperatore II. Anno Domini MXLIX.* Superabundante iniquitate mortalium jam ad sacratissimum Sanguinem coeperant corda frigere, paulatimque ejus consumebatur tum loci ignorantur, tum temporum vetustate, memoria. Cum ad excitandas sopitas jam fere mentis inaestimabilis illius thesauri, jubente Altissimo, secretum transferri non potuit. Quod quidem usque suscepto divinitatis oraculo, indicatne *beato Adalberto Eleemosynario Bonifacii Marchionis* factum est Anno a Nativitate Dominica Millesimo Quadragesimo Nono, Leone IX. summo Pontefice, & Henrico II Imperatore Romanorum, Mantovana Cathedram regente *Episcopo Martiali*, ejusdem vero Urbis temporalem rem publicam *Bonifacio Marchione*; a prima autem superiori illa revelatione annis fluxis Centum Nonaginta Sex. Rei hujus **coruscantibus** undique miraculis, ad sacras aures **praedictorum** Pontificis & Augusti veriloquâ famâ deductâ, ob eaque ambobusdivinum illud munus Mantuae corporali summa devotione visentibus, inaedificatâ Cryptâ, lapideoque constructo Sacello, idem sacratissimi Dei & Domini nostri Jesu Christi Cruor, celebratis divinis rebus, utriusque sexus, omnisque aetatis adstante multitudine innumerabili, atque celerbritate devota, fideliter & pie reconditur, loco sigillato & desuper posito Altare lapideo. Facta est autem haec resipositio Anno Domini MLIV, ab ipsa scilicet Revelatione anno quinto Inde **autem post,** modico temporis intervallo, Anno videlicet **MLVI** procuratione religiosissimae conjugis olim Bonifacii Marchionis inclytae Beatricis, constructa est Ecclesia, quae nunc cernitur. (p. 1074)

3) Bonus Abbas octavus coepit MCCXXVII
cessavit MCCXXXIX
Construxit autem inter cetera dua latera Claustri, latus scilicet Orientale, & latus Australe. (p. 1077)

4) Albertus Abbas undecimus coepit MCCLXXVII
cessavit MCCCXIII
... quamquam diversis & adversis temporum fatis multifariam conquaffatus, duobus inter cetera ejus praeclara opera coepti olim ab Abbate Bono Claustri lateribus **constructis,** Occidentali videlicet, & Aquilonari, in **aeterna pace** quievit. (p. 1078)

5) Azzo quartus Abbas coepit Anno MCXXIX
cessavit MCLXIX
Fecit his Abbas inter cetera pavimentum tabulatum, quod est circa Altare majus. (p. 1076)

6) Hujus tempore, Anno scilicet Domini MCCCLIV. Carolus IV. Imperator Boëmiae Rex, Mantuam veniens, lectâ diu & auditâ venerandâ memoriâ sacratissimi Sanguinis Dei & Domini nostri Jesu Christi, locum illum sacrum, in quo Anno antea fere trecentesimo primo, temporibus Leonis IX. & Henrici. tanta devotione pie reconditus fuerat, aperire desposuit, quamquam sacra Dei arcana, tanto tempore invisa atque intacta, turpe fit pertractare, Quod sub nocturno silentio clam aggresus, re ad millius deductâ notitiam, solis comitatus Magnificis ambobus fratribus Dominis Ludovico & Francisco tunc Dominis Mantuanis, praefato Abbate Laurentio, & Sacrista, qui postea ipsius Abbatis Laurentii successor factus est, & Magistro Andrea de Godio, Vate egregio, ipsius Imperatoris Protonotario, Magnificorum Dominorum Consillario, ac necessariis lapicidis, foribus Ecclesiae reclusis, jussit pavimentum superius frangi ad latus majoris Altaris dextrum. Quo in loco decenti facto foramine via patuit ad Sacellum, à tempore illius constructionis omnibus prorsus incognita. Hinc descendens Abbas sacratissima vasa tulit, & ea Imperatori sursum palam faciens, thesaurum illum incomparabilem, pretium redemtionis nostrae, futurae beatitudinis munimentum, datae liberatatis initium, servitutis ablatae vexillum, quem Ditis regia ferre non potuit, Imperatoris hominis subjecit imperio, At illum Imperator multa oratione, devotioneque pia, una cum ibi adstantibus supradictis diutius veneratur; certusque visione corporea ejus, quem legerat, audieratque longa fama, & sensibus carneis tractans, quod

tunc spiritum vix persuasisse potuerat, aut literarum, aut referentium inveterate memoria, pauculam capiens, & decenti recondens vasculo, phialam illam vitream, in quam à principio sacratissimum illum Sanguinem gloriosus stillaverat Christi Martyr Longinus, quamvis esset aliquantulum fracta desuper, inter quandam argenteam reclusit pixidem; ligansque illam filo argenteo circumcirca, & sigillatam desuper in antiquo alio suo vitreo majori vase reposuit. Erat & vas aliud vitreum, quo pars quaedam Spongiae cernebatur. Fama est, hanc esse illam Spongiam, quae fluentem gloriosissimum illum Cruorem & Aquam ex sacratissimo in Cruce pendentis latere percusso excepti . . . suus ex coeco mox videns factus, quem facti poenitens Centurio Longinus, pie recollegisse, & recollectum immisisse creditur vase, quo supra. Erat & haec inter duo vasa lamina quaedam plumbea, antiquissimis inscripta literis, quarum sic titulus legebatur, JESU CHRISTI SANGUIS. Facta igitur Imperator oratione sua, jussit vasa ad propria loca referri; nec inde discessit, donec locus diligentissime atque fideliter reconstructus, & validissime reclusus est. Ita ut antea omnibus inaccessibilis redderetur. (p. 1079f.)

7) Antonius Abbas quintusdecimus coepit MCCCXCIII. cessavit autem tra translatus Anno MCCCCVI.
Undecimo [Anno] autem Cathedralis Ecclesiae facies lapidea erigitur. Tertiodecimo. . . . Et his formosus, atque pulcherimi aspectus, & multae eloquentinae, ac Poëta praeclarus, venerabilis Abbas Antonius, in summa reverentia fere omnibus manens, frontispicium Ecclesia Sancti Andreae, & tam Monasterium, quam plateam Salerii satis decoram incipiens, nisi ad Abbatiatus, voluntate inclyti Principis Domini Francisci Gonzagae merito mantuae Domini, translatus fuisset, mirando satis opere protinus complevisset. (p. 1081)

8) Johannes Abbas MCCCCVII–MCCCCXXXI
Septimo [Anno] . . . XI Madii per hunc ipsum Abbatem Campanile Sancti Andreae initiatur. (p. 1082)

Antonius Nerlius, *Breve Chronicon Monasterii Mantuani Sancti Andreae. Ord. Benedict. ab Anno MXVII usque MCCCCXVIII*, in Lodovico Antonio Muratori, *Rerum Italicarum Scriptores* (Milan, 1738), vol. 24, pp. 1071–1084.

9) Mag.ce et excelse dne dne noster sing.le cupientes iuxta mandata vestra omnia dominationi vestre nota fieri, que hic circa reconditionem demonstrationem et venerationem sacratissimi Sanguinis Dei et Domini Nostri Jehsu Christi usquemodo gesta sunt singula eiusmodi Magnificentie Vestre duximus presentibus nuncianda postquam igitur ut alias Dominationi Vestre scripsimus aperto illo sacro loco, prefatum sacratissimum sanguinem honorifice reposuimus secundum nostrum posse, captato opportuno tempore, vasa illa cristalina, de quibus Dominatio Vestra verba fecerat ad locum portavimus, et ibi secrete presente semper tantum Reverendo Patre domino Episcopo man-

tuano de reconditione in eis fienda tam prefati preciosissimi sanguinis quam etiam vitrorum illius vasis, in quo prius reconditus fuerat, quae vitra sine dubio propterea magnam eius adhesionem maxime nobis venerationis visa sunt. Item et spongie devote feramus, et que considerata quantitate substantie rerum illarum sacrarum, vasa illa duo nobis nimis profunda visa sunt, ita ut apparenciam excusatam aliqualiter viderentur efficienter nichil. Filippo venit in mente quod in volta [?] duarum [?] centum essent vasa aliqua cristalina, quare perquisito inter ea reperij gobeletum unum pannum quod Magnificus Dominus frater vester donavit sive Illustris memorie Magnifice Domine consorti vestre, sive inclito nato Vestro. Quod accipientes consideravimus aptissimum fore ad intencionem nostram, quare remoto arsento quo ligatum fuerat superiorem partem ipsius reposuimus in uno ex illis predictis duobus tabernaculis in illo scilicet quod habet de super florem argenteum, et ipso intrante ad fondum eius, et clare demonstrante exterius, quod intus poneretur, quasi circa medium tabernaculi, consideravimus utrumque illud Vas esse aptissimum ad rem nostram, propterea desuper quodam facto cuperculo argenteo tantum albo bene ebrunito in nomine Sanctissime Trinitatis ibi reposuimus sanguinem predictum sacratissimum cum toto pulvere, que in alio antiquo vase reperveramus, quem pulverem non nisi de substantia eiusdem sanguinis esse credimus. Ex quo videntes idoneam valde representationem eiusdem sanguinis sacratissimi et claram visionem fieri extrinsecus, ita ut subtus et supra et ad latera clare videri possit, gratias agentes deo ita dimissimus, non arbitrantes, aliter posse convenientius collocari, prout etiam dominatio vestra excedere domino potuerit intendere. similiter autem et inferiorem partem dicti gobelleti accipientes, remoto extremum omni suo ornamento ipsam immissum in altero Tabernaculo in illo scilicet quod iam alias pro corpore domini Nostri Jehsu Christi fuerat preparatum, et ipsa intrante dumtaxat usque ad medium cristali ipsius tabernaculi consideravimus quod ibi aptissime reponi possint dicta sacratissima vitra et spongia, Quod fecimus nam ad fondem dicti tabernaculi diligenter et apta dicta sacra vitra locavimus, Quapropter ipsorum quantitate et qualitate, aptissime videntur exterius, postea partem illam dicti gobeleti, usque ut diximus medium attingenti dicti tabernaculi de supra posuimus, et in eo loco locavimus spongia ita ut aptissime et dicta sacra vitra et ipsa spongia videantur. Sic igitur dicta vasa ordinata ut nobis visum est convenienter et honorifice reposuimus in loco post altare et ibi ipsa custodientes diligenter, die et nocte usque ad vigiliam Ascensionis stare dimissimus. Igitur adveniente die dicta, et in Ecclesia Sancti Andree super podium ipsius ecclesie preparato et ornato loco convenientibus et congregatis ibidem, Reverendo predicto Episcopo; ceteria venerabilis dominis abbatibus et universo clero, ac etiam laicorum innumerata multitudine facto ofertorio dictis solemniter vesperis, et sermone vulgariter facto ad populum, per quedam venerabilem Magistrum, fratrem Petrum de Roma provincialem fratrum Servorum Beate Virginis provincie Venetarum valen-

tissimum utique virum, qui a casu diebus his Mantuam supervenerat, ad honorem altissimi Dei, et presente inclito nato vestro, omni devotione et cerimonijs debitis observatis preciosissimas dictas reliquas populo ostendimus, nec non et vasa illa antiqua in quibus prius fuerant ipse recondite sigillatim populum de omnibus per dictum Magistrum de omnibus populum certificantes,: In qua quidem demonstratione, tum propter ipsarum rerum inextimabilem pretiositatem, tum propter observatas cerimonias, tum etiam propter disertissimam et devotissimam predicationem dicti Magistri tanta in omnibus apparuit compuncio, ut non esset qui a lacrimis contigeret sermones potius in altos etiam quasi fletus irrumperent publicamus etiam per notarium publicum, privilegium Indulgentie, videntes autem magnam multitudinem, sexui mulierum compassi sumus, quapropter demostrationem quae [que?] in nocte fienda erat, solis mulieribus reservavimus, et hoc fecimus omnibus notum tam per dictum magistrum, quam etiam per preconem; igitur nocte illa, ante campanam diei, existente in ecclesia mulierum multitudine maxima, ita ut non minor videretur, quam virorum et mulierum quae fuerant die precedente, Secundo dictas reliquas Iuxta primum ordinem demostravimus, in qua demostratione, praesens fuit magnifica domina soror vestra. Sic et tercio fecimus mane subsequente per Reverendum predictum episcopum missarum solemnijs celebratis. Qua hora multo maior multitudo utriusque sexus convenit, ita ut communi extimatione, excederent numerum decem milia personarum, predicationem dicti magistri ad populum similiter precedente, his festis quod nundum erat locus deputatus expletus reponentes dicta vasa in loco solito et diligenter custodientes, sumpto precidio, omnes convenimus videlicet Reverendus predictus dominus Episcopus, Venerabilis presentes abbates, Capitulum Sancti Petri: et alij Religiosi, dominus potestas Mantue, Massarius, Sapientes, et nos pro dominatione vestra deputati, et loco completo claudentes nos propter multitudinem cum himnis et canticis sacris indutis vestibus, predictas sacratissimas reliquas, ad suum locum portavimus et intro ponentes capsam quam iam factam scripsimus dominationi Vestre intro posuimus, et in ea presentibus predictis omnibus et clare videntibus, per manus mei Domini Abbatis, et domini Archipresbiteris dicte sacre reliquie suprascripte reposite capsa supra quodam altariolo in dicto constructo reposita et clausa, de dicta expositione rogato publico istrumento, facta autem huiusmodi repositione primum hostium contrarius seras quatuor clausimus, quarum clavium unam habuit Reverendus predictus dominus Episcopus, secundam seram prima hactenus pro dominatione Vestra Terciam dominus potestas. Ego Abbas quartam. similiter clausivimus et seramus habens similiter seras quatuor clavium quarum prima habuit Massarius Communis, secundam Capitolum Sancti Petri, terciam sapientes, quartam sacrista Sancti Andree, confectis superinde sigillatis publicis instrumentis, et stippulatio a singulis promissionibus de bene et fideliter custodiendo etc. Haec igitur omnia ad laudem Dei perfecta sunt manu divina omni devotione et reverentia observatis, fecimus

insuper fieri. hostium unum ferens in ingressu loci illius ubi est altare in medium feriate, ita ut intro videri possit in minima autem interiri; semper autem in dictis demostrationibus, inclitus natus Vester in primam scilicet et secundam, et unam nobilem viam ad baldachinum, et portantes cereos astitentem, quorum cereorum fuit magna multitudo. Datum Mantue xiii maij 1401

Magnifico domino mantue etc.
Per Excellentissime dominationis Vestre
Servitores deputatos in Mantua cum Recommandatione

ASM, AG, 2881, lib. 4, 33r and v

(I am deeply grateful to Gilberto Carra for his careful transcription of this document, and to Mary Fuqua for her invaluable translation of it.)

10) Obligatio collonarum pro porticu ecclesie sancti Andree, et pro alijs pro porticu pienda ad Viam ciconie. In Christi nomine amen. Anno Domini millesimo quadragentesimo quinquagesimo die Martis 27 octobris In Civitate Mantue et in officio factorie monasterii sancti Andree de Mantua.... Ibi magistro Antonius filius quondam domini Maffioli de pusterla de mediolano tayapetra civis et habitator Mantua ... se obligavit et promissit per pactum et merchatum conclusum Reverendo in Christo Patri et domino don Lodovico de nuvolonibus Dei gratia abbati Monasterii Sancti Andree de Mantua ... dare traddere et asignare eidem domino Abbatis colonas prete vive sex cum capitellis et bassis suis longitudinis et grossitudinis ac rositudinis quibus sunt ille collone marmori in opere posite ad porticum et sub voltis portici ecclesie Sancti Andree de Mantua in monasterio Sancti Andree per totum mensem februarii proxime futuri et illas sucessive laborare et reducere ad formam et laborerium prout sunt predicte dicte porticus ecclesie sancti Andree, et illas colonas sic laboratas tempore debito ponere in opera ad locum suum prout stare debebunt operando se et exercendo cum eius persona dando sibi feram et plombum necessarium pro illis in opera ponendis, pro quibus colonis sex sic laboratis et in opera positis teneatur et obligatus sit dictus dominus Abbas eidem Magistro Antonio dare et exbursare pro pretis earum et eius mercede et labore ducatos centum auri bon Justi ponderis....

Succesive idem Magister Antonius tayapetra promissit et se obligavit dicto domino Abbati recipienti nomine dicti monasterii per pactum et merchatum conclusum cum dicto magistrato Antonio dare traddere et asignare ipsi domino Abbati in dicto monasterio collonas prete Vive trigintaduas et plus si erit necessarium pro faciendo Unam porticum in Voltis ante faciem Apothecarum monasterii eundo per Viam Ciconie, longitudinis et grositudinis sicuti sunt alie colonie posite sub Voltis Inclaustri novi facti in monasterio sancti Andree per Reverendum in Christo Patrem dominum dominum Guidum de Gonzaga tunc Yconomum dicti monasterii, cum bassis et capitellis suis, in opera positas et laboratas per ipsum ad Ystar et similitudinem sicuti sunt predicti dando sibi plombum et

ferrum pro illis in opera ponendis quas colonas laborare debet in dicto monasterio, et ibi conducere prout facere debet de alijs primis sex colonis, pro quibus colonis sic laboratis et in opera positis teneatur et obligatus sit dictus dominus Abbas et sic promissit dicto Magistro Antonio presenti et recipienti, dare et solvere pro qualibet colona ducatos septem auri boni et Justi ponderis eidem magistro

Antonio computata eius labore et mercede quia sic actum et pactum extitit inter ipsas partes. Et promissit predictas colonas dare et traddere conductas per totum mensem madij proxime futuri sive Junii tunc proxime futuri. . . .

ASA, scaff. C, busta XXII, fasc. I

# Appendix II

1) Ill. d.ne . . . dire a don Baptista deli Alberti che se voglia venire a gonzaga o domani o laltro quando pui. . . .

    Luzara xxiii sept. 1470
ASM, AG, 2891, 66, 23v
Published here for the first time.

2) Illustriss. dom. mi post rec. Luca taglia pietre me mostra una lettera della S. V. sopra el titulo ad turrim etc. Per hora me venne in mente de far questo che sara con queste lr. Iterum cogitabimus. Ceterum io intesi a questi dì che la S. V. et questi vostri cittadini ragionavano de edificare qui a Sancto Andrea. Et che la intentione principale era per havere gram spatio dove molto populo capesse a vedere el sangue de Cristo. Vidi quel modello del Manetti. Piaquemi. Ma non mi par apto a la intentione vostra. Pensai et congettai questo qual io vi mando. Questo sara piu capace piu eterno piu degno piu lieto. Costera molto meno. Questa forma de tempio se nomina apud veteres Etruscum sacrum. Sel ve piasera daro modo de notarlo in proportione.

    Raccom. alla V. S.
    Servitor V.
    BAPTISTA DE ALBERTIS
Ill.mo d.no meo Domino
    Marchioni
ASM, AG, Raccolta Autografica
Braghirolli, p. 14. In the last sentence he read *rectarlo* in place of *notarlo*.

3) D.no Baptiste de Albertis
    Ven.lis. Havemo recevuta la vostra cum quello tondo et lettere notate per vui che se hano a mettere in quella pictura de la torre, che ne piaceno, et cussi se fara secundo el parer vostro. Havemo etiam visto el designo de quello tempio ne haveti mandato, el quale prima fatie ne piace ma perche non lo possiamo ben intendere a nostro modo

aspectaremo che siamo a Mantova poi parlato che habiamo cum vui et dictovi la fantasia nostra et intesa anche la vostra faremo quanto ne parera sia il meglio.

    Gonzage, XXIII octobris 1470.
ASM, AG, 2891, 66, 66r
Braghirolli, p. 14

4) Luca Lapicide
Dilecte. nos. havendo visto quanto per la tua ne scrivi del mercato hai concluso cum prontezza de quella cento carra de calcina per S. Andrea, ad che mandemo che nui passato domani saremo a mantua, et alhora porai ricordarcelo che vedaremo farli avere danari.

    16 januarij 1471
ASM, AG, 2891, 66, 79r
Published here for the first time.

5) Massario
Perche se possa dar principio a la fabrica de la giesia de S. Andrea nui a questa Ascensione vorressemo se comenciasse a fare qualche bella offerta et cussi nui habiamo terminato darli 300 ducati, et il Cardinale nostro ne dara duecento; haremo a caro che tu parli cum queste arte, e persuadere a tutte de fare qualche bella offerta a la Ascensione, non dicemo de comparere ne pompa, ma del offerte acio se possa dare principio ad essa giesia.

    Burgifortis, 27 aprilis 1471.
ASM, AG, 2891, 66, 93v
Braghirolli, p. 17

6) Carolo de Rodiano
Car. nos. havemo visto quanto per la tua ne scrivi de quelli docento ducati per la offerta de S. Andrea ad che rispondemo che questo ne paiono de le offerte de S. Sillo da pavia che quelli la gli apizano la candela e ge la mostrano poi subito la morzano et la rimeteno nel carnero chi

facesse a questo modo el non se comenzaria al lavorare tu sai bene che vui da roma haveti cum nui pocho credito. come se sia se ti Carlo ne voi prometere de restituire essi denari liberamente et che ne advisi del tempo che li vorai rimettere essendo termine honesti ne seremo contenti altramente nui non exbursaremo li nostri si che avisane del termine che voresti et se sei contento farce la promessa che per dire deli primi denari intrarono poriano star tanto ad intrare che non se lavorara ala chiesa dio sa quando et nui benche se trovamo haver deli bisogni et grandi non dimancho se restringemo per dar fora li nostri ducento ducati li quali non volemo gia nui ritor indreto e non lassar che se spendano in la fabrica quando quelli altri se dagano fora.

18 maij 1471
ASM, AG, 2891, 67, 25v
Published here for the first time.

7) Reverendissime in Xto pater et Domine fili noster honorandissime.

Noi voressimo dar principio alla Chiesa di S. Andrea alla qual fabrica abbiamo volto il core si per esser de necesitade, che la viene a terra, si etiam per onor vostro e nostro e di questa cittade e speriamo che in dui anni o tre se gli fara tal principio che sera casone di ingegliardire molto la brigata a spendergli perche sara posto in opera due milioni di prede al creder nostro, advisandone, che secondo uno modello ch'e facto non gli andara la spesa ne il tempo che se credeva, e non tanto a Vui che siete zovene ma ancora Nui compando, qualsia in piacere de Dio [sic]. Sicche vorresimo vedestine de essere cum la Santita de N.ro Signore che se degni dare licentia a buttar zoso, e voressimo comenzare a far mettere a terra al pozo qual sta bon tempo fa come sapete cascare, e cosi la chiesa dal pozo verso la Porta e la Piazza tutta quella parte, e tirarla suso inanti se buti zoso l'altra parte l'e vero chel andera piu longa, in alcuni loghi piu larga it in alcuni piu stretta, che bisogna in la licentia chiarire, che la possiamo fare come pare a nui, e cosi bisogna se faci menzione in essa licentia che si possa metter a terra detto pozo, e questa parte avemo detto della chiesa verso la piaza, a rincrescene essere stato tanto a pensargli sopra. perche al butar zoso gli va pur tempo che li homini veniranno in le facende de fare in le vigne e li lavoreri de fora: che se adesso avessimo la licentia, so se attenderia ad altro et se averia homini quanti se volesse et cum bona condictione. pero vogliati vedere de parlarne subito cum N. S. et mandarme detta licentia cum ogni prestezza se ben dovesti far tuore un Messo a posto che lo faremo satisfare. Mantuae 2 gennaro 1472.

Il Marchese di Mantua
R.mo D.no Cardinale Mantuae

Giovanni Gaye, *Carteggio inedito d'artisti dei Secoli XIV. XV. XVI.* (Florence, 1839), vol. 1, doc. C. Carlo D'Arco, *Delle Arti e Degli Artefici di Mantova* (Mantua, 1859), vol. 2, p. 13.

8) Adij 6 de febraro 1472 fo chomenzato a butar zoxo la gexia de san Andria in Mantova per volerla refare piu bela et questo prinzipio foe fatto de dinarij chera restato de li offertij che se fano a la sansione. E foe extimato e dito che perfina a anij 22 se lavoreria la dita gexia che vigniria finida de lano 1494.

Andrea Schivenoglia, *Cronaca di Mantova di Andrea Schivenoglia dal MCCCCXLV al MCCCCLXXXIV*, Carlo d'Arco, ed., *cronisti e documenti storici lombardi inediti* (Milan, 1857), pp. 16–26.

9) Petrophilippo
Car.me n.re. ulterius vedi mandar a turo le calcine per S.to Andrea: Zohannes da Padua ne scrive che per tuto heri ne sera cocto una cocta e che la se potera condure tuta in questa septimana e credemo che conducta sia questa cocta ne avanzara le 300 libri, le quale vederai de haver e se attendera a far haver e condure il resto e gli faremo credito 100 ducati ala offerta dela assensa.

xiii aprilis 1472
ASM, AG, 2892, 70, 7v
Published here for the first time.

10) Illustrisime princeps et ex. d.ne d.ne mi singularissime Io ho intiso quanto quela scrive de lavolta se ha a fare e certo aveva già preso partito de fare quanto quela scrive risalvato che non ritrovandose dal muro Al pozo lavolta essere fata faceva pensero dandare come lavolta et oltra per infino Al muro dila chamara de li Adrapamenti chi tene zanpolo niente di mancho sio atrovaro lavolta laqual raimondo dise non essere stata fata vi postezaro suso e si la non sera stata fata la faro fare al mio appropisito e oltra questa ne faro una altra che pontara da questa al muro dela chamara suprascritta e di poi radopiaro lavolta grande per alteza e faro la postezare al muro de la dita chamara per el designo quela potera intendere.

perche ele fato una parte de la chaviga del pozo dala ruota e maxime precipiando in sula contrata dela rovere la qual via e molta basa per forma che non e achaduta a fare tanto fondamento chel sia chavato tanto tenero che si posa coprire ditta chaviga e li citadinij ne richiedono careti per interire la chaviga e dichono che siando frescha e stare discoperta si guastara ne ho voluto dar alla vostra excelentia per tre respecti primo perche non mi trovo tereno in la cita davanzo secondo che in lanchona dala chadena quela terza za dito che non gi lasa chavare tera terzia che dovendo mandare tre in sulti sera gravezza assai ali chareti ai quali non mi par dar alchuna ordine senza licentia di quella. El designo chi o receudo da quella mi satisfa prima per intendere l'opera secondarie come achade espeso venire ambasadori e signori che per honorarli si cercha dimostrare loro opere e stupendi io haro adonche questo disigno mirabile da potire mostrare, che non credo che si ritrova alchuno altro de mirabile, di qual ringrazio la vostra S.

ex Mantua, xxvii aprilis 1472
V. F. S. Lucha de Florentia
Al march. Lodovico
ASM, AG, 2413

*Note*: The last part of this letter—"El designo . . . vostra S."—was published by Braghirolli (doc. V) in relation to S. Andrea, although there is no specific reference to the church either in the part he published or in the rest of the letter, published here in its entirety. Clinio Cottafavi (*Ricerche e documenti sulla costruzione del Palazzo Ducale di Mantova dal secolo XIII al secolo XIX* [Mantua, 1939], p. 34) brought the entire letter to light for the first time. He seems to have been innocent of any knowledge that the last lines of the letter had been published by Braghirolli in relation to S. Andrea. Indeed, Cottafavi felt that the part about the "disigno mirabile" referred to a design by Mantegna for the Logge di Castello of Palazzo Ducale, since the first part of the letter clearly deals with those *logge*.

Between these two parts of the letter, however, there intervenes a discourse on filling in a large excavation in a low-lying part of Mantua, the *contrada della rovere*, which is far from both S. Andrea and Palazzo Ducale. Clearly, the letter had three sections, two of which can be related to specific works in specific places.

The "disigno mirabile," however, cannot be related with certainty to any particular project. It is highly unlikely that it has anything to do with S. Andrea. A *modello* for the church was completed at least by January 1472, when Lodovico mentioned it in a letter to his son Francesco (cf. this App., no. 7). But the design Luca received in April 1472 specifically allowed him to "intendere l'opera," whatever that "opera" may have been. When he wrote this letter, however, he must already have known the *modello* for S. Andrea for some time. This letter, then, should be removed from the list of those documents surely related to S. Andrea.

11) Ill. princeps et ex. D.ne d.ne mi sing.
Li monazi de S. Andrea mi domandano sel si de fare la festa sacondo la consuetudine ali quali ho risposto chel mio parere e di si niente di mancho, ma parso darne aviso a quela io ho facto inpire di quadreli chosi al suto sote al pozo per forma chel pozo resta fortissimo siche aparando il dito pozo si potera stare alongamente suso a mostrare il sangue di Cristo.
Datum Mantue die ultimo aprilis 1472
V. LUCHA DE FLORENTIA
Al marchese di Mantova
ASM, AG, 2413
Braghirolli, doc. VI

12) Massario mantue
Caris.me n.r Visto quanto ne scrivi per la tua lettera credemo che la mantione nostra e che se faria lofferta a S.to Andrea nel di dela sensa secondo se usato far et che se monstri il sangue de Cristo al mancho la mattina dela festa che se poria ancora monstrare la vigilia al vespro. ma stemo per ussarsi per il caldo per essere levato via il coverto de la gesia non dimancho se trovaremo a mantua tanto a tempo che poria essere deliberaremo el se monstri ancora al vespro. perche luca nostro inzignero ne scrive havendo proveduto e fortificato il pozo per modo chel se potera apararsi monstrare il sangue de Cristo li, secondo usato, a che se veda di tirare li pani dove e levato al scoperto si che manda per esso a intendere che lui a delli chel po ancora far spianare al meglio che si po quelli prede a rotami in la gesia che mettendoli sopra asse, o store, o altra cosa le persone ge possano stare suxo et ognuno poter veder como prima e forsi meglio perche quelli se trovasseno fin in quelli botteghe et quello di grassi vedriano como havendo dicto saremo presto a mantua che potremo meglio dar ordine a questa cosa. la offerta che ha a far ad ogni modo dal canto nostro sa quello che se ne richiede per lo suo affare.
30 Aprilis 1472
ASM, AG, 2892, 70, 23v
Published here for the first time.

13) Illustriss. princips et ex. D.ne d.ne mi sing. etc. Perche el me scripto che la eccellentia Vostra è stata a S. Andrea et ha ordinato se faza una pontata dal pavimento del coro in su, e, considerato che non e diccenuto i muri sicondo arano andare dal pavimento in su, e dubito che loro non gli saperano diccenere senza me, ma me parerave che non andasse più alto cum li murij per fina a tanto che non sia la. Come ancora gie ordenaj in anze che me partisse, e anche per rispecto che ho ordinato alquni lavoreri e di fornaxe per principiare uno basamento de preta chota i quali anchora non se possono avere etc.
Ex Gonzaga VI, julj 1472
V. F. S. LUCHAS T. FIORENT.
Al marchese di Mantova
ASM, AG, 2414
Braghirolli, doc. VII

14) Illustri, princeps et Ex.o d.ne d.ne mi singularisime perche eri sera io have uno messo da mantua che per cosa alcuna io non restasse che subito fusse achaxa perche mia mogliere sta molto male . . . e se ala Cel. V.ra pare che pur fuse de bisogno che io me ritrovase li avendone avixo vignero subito ho de die ho de note che sia . . . mi ricomando de continue ala Vostra S.
ex mantue xxi julli 1472
V. F. S. Luchas T. Flore.tus Scult.
ASM, AG, 2413, 584
Published here for the first time.

15) Luca lapicide.
Havemo visto quanto per la tua ne scrivi del caso accaduto a tua mogliere per lo quale te sei mosso ad andare a Mantova, che ne rincresce assai. Ma perche il factore ne dice che la principale rasone si e stata per Sancto Andrea che non se trovano boni fondamenti da laltro lado vogliamo che per dio tu vedi usar ogni diligentia e sollecitudine acio che se trovano boni fondamenti perche queste sonno cose a che se vole metter mente e haverli gran riguardo e cussi mesurarle tre e quattro volte prima che

se faciano, si che per dio usali ogni diligentia.

Gonzage, XXII julii 1472

ASM, AG, 2892, 47r

Braghirolli, p. 18

16) Ill. princ. et ex. D.ne d.ne mi singul.

Questo e solun per che quella intenda se fa alla fabricha de Sancto Andrea, de verso il monastero e facto la mitade, prencipiando dal campanile e seguitando verso la segrestia, et e alzato al livelo de la parte aposita de verso li botegi: Laltra parte se va fagendo cum piu solicitudine si puo. non se ha potuto tirarla suxo si tosto per difecto che glie una parte chel sie bisognato andar piu zoxo a trovare el buon tereno e proprio in quella parte se retrovato tanti fondamenti chel non se ha potuto lavorar cum homeni assaij e asi bisognato apontelare li murij et il tereno perche continuo riunnava niente de mancho se facto bon lavoro. Excepto se facto uno puocho di malle a dui lavorenti cum lor medesimi si lanno cerchata luno di loro si lago stare in mezo di una muracha et il tereno se roto uno osso di dui del brazo stancho et subito fu conzo. stimo non havera mal nesuno. laltro glie dete una stanga in uno fiancho in mane essendo di sopra voltando fora dela segrestia uno pezo de una muracha la quale se divixij indue parte e non stando lui atento si presumij che una de queli parte dela dicta muracha ribatese la dicta stanga. Et si chava il fondamento dela fazada e principiato di fondare questa septimana chi vene e stimo sera fornito tuti li fondamenti a livelo de quelo la Ex. V.ra havite facto.

Mantua VI augusti 1472

S. F. Lucha T. Florentinas

Al March. di Mantova

ASM, AG, 2413, 586

Braghirolli (doc. VIII) published the first part of the letter—"Questo e . . . bon lavoro."

The remainder is published here for the first time.

17) Luca talia petre.

Commendamo te de quanto ne scrive del corso levato a S. Andrea e del rasonamento facto cum Carlo de Rodiano, scrivemo opportunamente ad Albertino cerca cio siche cum lui te porai intendere. Nui non havemo calcina ne prede che possiamo prestare che sapiamo li cento ducati meglio se poriano retrare, pur sel non se potesse andare ala tre braza se poria fare uno brazo o quello più se potese a cio che se vedesse molto bene come dovesse andare. Lunedi saremo a Borgoforte poterai venire li, et referire quello sara facto e se gli havemo modo alcuno de prestare prede ne calcina, crediamo pur de non el faremo volentieri.

Gonzage, 17 sept. 1472

ASM, AG, 2892, 79r

Braghirolli, doc. IX

18) Albertino pavexio

Carissime nostre: Cum questa nostra haverai inclusa una de Luca tagliapetra e vedrai quanto scrive: di che

vogliamo te trovi cum carlo da rodiano et gli dighi che il partite propone ne pare quoadunc impossibile che se trovi tanta prede, et calcina in prestito. Li centi ducati se trovariano meglio per questo poco tempo stara el Cardinale a mantua et vedi che per ogni modo il faza provisione acio se possa continuare el lavorero et levarlo alo tre braza secondo era deliberato e de quello ne haverai debbi advisar ad esso Luca il quale ha a venire da nui lunedi per che acio ne lo possi referire.

Gonzage, 17 sept. 1472

ASM, AG, 2892, 70, 79r

Published here for the first time.

19) Illustri. Princeps et ex. d.ne d.ne mi singularisimme

Item Avisso la S. V.ra come al nostro lavorerio de S.cto Andrea che glie alzato fino a questa hora uno brazo e mezo deli muri datorno e similiter la parte zotto deli capeli e tuta via si va lavorando cum grande solicitudine. non altro de continuo me ricomando ala S. V.ra.

ex mantue 26 sept.bris 1472

V.r S. F. Luchas T. Florentinus

ASM, AG, 2413, 587

Published here for the first time.

20) Illustrissimo signor mio padre

Pere lo debito de nicolo tosabese cum sancto andrea de trecento ducati o puocho pui qual ho tuolto in me ne la compra de la casa suoa: ho ordinato ad carlo da rhodiano: che paghi a la Ex. v. cento ducati in denari. et che per lo resto: che sono duecento ducati o circa dia tante pietre per lo edificio de la chiesa per tuto marzo proximo: computando lo percio lor a quello che si vendeno a denari contanti. E per questa via la opera ne sera assai subvenuta a tempo: et io ne ricevo qualche commoditate de che me parso dar aviso a v. s. acio che la intenda lordine dato: et che cum suoa satisfactione e contenteza se digni acceptare questa determination per me commessa: come ho dicto: che a me sera de piacer assai: Me raccomando a la: s. v.

Mantue XXVI septembris MCCCCLXXII

Filius observantissimus

F. de gonzaga Car.lis mantuan.

ASM, AG, 2413, 780

Published here for the first time.

21) R. d. Cardinali

Rme. Havemo visto quanto per la vostra ne scriveti del ordine priso per quelli trecento ducati che se trova debitore Nicolo Tosabezzo cum S. Andrea, come Carlo da Rodiano ne debbe adesso exbursare ducati cento, el resto in tante petre al pretio se vendeno a denari per tuto marzo proximo ad che respondemo che nui come sapeti non habiamo a tochar quelli danari se perho poreti ordinare cum esso Carlo sel intenda cum quelli hanno cura de la fabrica e a lor li exbursi che nui ne rimaneremo contenti e cum loro el se pora intendere de le petre; bene valete.

Saviole, 26 sept. 1472
ASM, AG, 2892, 91r
Braghirolli, doc. X

22) Ill.e p. d.ne d.ne mi singularissime
Richordandomi dalqune chose per le quali enportava chio
venisi a mantova et masime per la fabricha di S.to
Andrea. Veduto che a revere per ogi non achadeva di far
se non el chavamento avendo jo enformato el maestro
quanto fa bisognjo circa cio mi parse per miglior partito
de venir questa sera qui et domani far quello machade
qua et ritornar a revere ala piu lunga gioba da matina per
star pare chi di bisogniando et questa et solo perche la
S.ria V.ra non pigliase animazione et anche quela sapia
dove io sono.
   ex mantue 15 otobre 1472
   V.o S. F. Lucha Fiorent.
ASM, AG, 2413, 589
Published here for the first time.

23) Illustri.e domine mi singularissime.
Circa el levare tria braza li muri de la giesia de s.cto
Andrea questo supra li fundamenti. V.ra Signoria hara
multo ben suo intento resta che quella preveda de li
cento ducati me promisse acio possa osare el debito a li
poveri manuali hanno servito et a cui ce ha subvenuto de
suo predecto lavorerio. el qual deo dante per sua grazia
feniremo ali tempi nostri.
   Mantue die 22 octobris 1472
   Ser.tor cum recomendatione
   Albertinae de pavexijs
ASM, AG, 2413, 569
Published here for the first time.

24) In questo tempo [1473] se lavorava fortemente a
santo Andria. . . . Andrea Schivenoglia, *loc. cit.*

25) Ill.me princeps ac ex.e D.ne Domine noster sing.me.
Avisamo la V. Ill.ma S. che heri metina Maistro Lucha
inzignero mando chi a sancto Andrea adar combiato ali
maistri che concianane le nostre camare segondo che
V. Ex.e S. comisse al spectabile Albertino pavese dovesse
far fare per modo potessime habitarle: et sentendo nuj
questo havessime ricorso al prenotato Albertino mar-
andoge questo era fatto. qual comisse a francesco supras-
tante che dovesse far finire dicte nostre Camare: e cossi
fece dicto francesco, et condusse li maistri ala opera
principiatta, paremo che iterum di nuovo il prenotato
Maestro Lucha luj impersona questa matina sia venuto
sulo lavorerio, il habia datto combiato al suprascripta
francesco soprastante: et ali maistri cum grandissime
minacie per modo che e rimasto lo lavorerio in com-
pitto e perche se ritrova alchuni cum nostri canonici che
hanno scoperte le Camere, et dissertate pregamo V.
Ill.ma S. se degni far fare tal provisione che gli possiamo
habitar per far el debitto nostro ala giessa e pregar idio
per la V. Ill.ma S. ala qual continuo se ricomandiamo.

Mantue, 17 februarj 1473
Collegium Sancti Andree
cum iteralta ricomandatione
Al Marchese Lodovico
ASM, AG, 2416, 19
Published here for the first time.

26) Illustrissimo Signor nostro.
non per detrare a le virtude et Inzegnero de Maestro
Luca el qual e sufficientissimo suo pare, ma per obviare
ali damni occorse lanno passato ala fabrica de sancto
Andrea la quale V. S. cum grande solicitudine a sua
spese desidera e solicita se faccia. et acio per lo advenire
non accada tal inconveniente "Vostra Excelentia" e che
li possa provedere denotaremo alcuni mancamenti non de
Inzegno. ma alcuni per affectione alcuni per merite et
alcuni per parcielita di la quali anui pare siano accadute
per sua casone.
   Prima in principio del dicto lavorerio Luca li ellesse
uno Andrea del zarda muratore el qual e ydioto[1] e val-
lenthomo quanto dar se possa lanno passatto comisse
cento errori le quali se mostraranno al bisogno et maxime
circa le lumage. fece piu scandali e questione cum altri
maistri e bracenti. zetto via mille opere havendo ligname
et asse de poterse reparare apiare li fundamenti maxime
de verso el monasterio dove li ruyno piu fiate el terreno
adosso.
   Luca Continuamente a tenuto suso dicto lavorerio dui
lavoranti che la matina se partiano a meza terza luno ator
la spesa a laltro a cunzar li cavalli e non tornavano de li
a quatro hore cossi la sera como la matina et tamen [?][2]
fusiavano pagate per opera compita, similiter quando
veniva el sabato pigliava le tre a quatro opere e mandava
a tore el fino per soi cavalli e quel die non tornavano piu
a lopera e pur la fabrica pagava.
   Questo Andrea del zarda haveva auctoritade de ellezere
Magistri Muratori chi li piaziva ma non li poteva intrare
niuno che no fesse prima due o tre opere a casa de luca.
e cossi el sabado a la officiala tuti levavano dal lavorerio et
andavano a lavorare a la dicta casa, se la septimana se-
quente vollivano tornare a quello, ben che questo non era
damno de la fabrica per che non se pagavano se non per
meza opera quel die.
   La vigilia de la assumtione de agosto tuti li magistri
e bracenti disseno vollir dezunare[3] e non lavorare per il
caldo grande. Tuti li ghiamo a casa sua. E chi non li
volsi andare el primo die de lavoro che vene dredo tuti
li casso. non havendo respecto piu a un como a un altro.
E questo dicemo perche furono cussi alcuni che erano stati
al caldo e pioza e mille volte al pericolo de la vita che fu
una gran vergogna.
   Non vogliamo tediare Vostra Signoria per che el ce seria
asia cosa che dire. Nui havemo havuto da francesco da
glusiano el qual governava dicta fabrica che per bisogna
de dicta sua casa la levato multe cose de la dicta fabbrica
e che non e venuto in diferentia cum dicto Luca senon
per vollir metter mente al fatto suo. Se dicto Luca ha com-

messo dicti inconvenienti essendoli posto cura. Che faral hora chel havera quest altro asuo comando. Chi non ghe mette niente le cose andarano de sparpagno.[4] Luca ha una natura chel vol supeditare cadauno. Costui convenere far a suo modo altramente fano a le piu brute del Sacro. El ce po lodovico da fiorenza suprastante suo conpatriota et electo da lui che certo lo reputamo homo da bene e dolesse che luca facia queste cose. finalmente se strinze ne le spalle. El ce Zohannesfrancesco cogrosso el qual cognosse V.S. el qual altra fiade fu retrovado in defecto. questo non fa piu inanci ne indredo como vol luca e quello che in ogni cosa li fa scorta. un altro suprastante ce che ha nome Zohanne da viadana. lo credemo bono ma e bayulo[5] de luca. Tuta questa fabrica ha in mane e damo inanti non ce haremo a far coelle. e questi dui suprastanti li ha ellecti dicto luca senza nostra saputa cum spesa non bisognosa ala fabrica.

De una altra cosa vogliamo avisare Vostra Signoria chel ha una careta e un cavallo che continuamente lavora e ha lavorato a la dicta fabrica e son vostri et ogni dicto lavoratore per la careta e cavallo ne ha dece soldi. et el fameglio[6] 6.7. o. 8. secondo i tempi—non dicemo alcuna cosa de le prede ha menate cum dicta careta dal porto a da la piaza a casa del dicto luca.

A nuy pareva che fusse nostro carrico de ellezere Suprastanti Maistri e bracenti: e chel luca li havesse bene a comandare quanto se apartene a la fabrica et anche se volesse piu un maistro che un altro dircel a noy e cossi de le cose volesse per dicta fabrica ma mettere cavare e comandare a suo appetito non ce par honesto. lanno passato aposta de quel zarda el ge ha lavorado la piu extranea sorte de magistri del mundo. nuy non conosivene niuno. nientemeno nuy ne remetiamo a Vostra Signoria e de tuto quello vui terminariti ne remaneremo ben contenti e satisfatti. Ma supra ogni cosa facia la prefata Signoria Vostra che Suprastanti habiano intelligencia cum nuy. e che ce obediscano e non siano cagneti de luca per che de qui pende el fato de la fabrica.

Non e homo de noy che se aspecti ne voglia merito alcuno da dicta fabrica anci meterli de le proprie facultade secondo la conditione nostra. Excepto che qualche retributione da dio. e gratia de la S.V. e tanto piu quanto sentemo caldo el peto de Vostra Excelentia circa cio. E per cio crediate che passione non ce move ma la propria Veritate.

per eiusdem Servitores deputatos ad fabricam ecclesie
nove Sancti Andree de mantua
Albertinum de pavexiis
Jacobus de copinis
Valentis de Valentibus
Illustrissimo Principi et domino nostro
singularissimo domino Lodovico Marchione
Mantue etc. ducali Locumtenenti generali etc.
ASM, AG, 2416, 294
Published here for the first time.

*Note*: This letter is not dated, but it is clear from Luca Fancelli's letter which follows immediately below that he saw this letter the day he wrote his reply to it, 21 February 1473. The two letters are contemporary, then, although this one may have been in preparation a day or two before Luca saw it.

*Notes*
1. "semplice uomo."
2. A very difficult word to transcribe, thus the question mark.
3. "stare a casa."
4. "andarono male."
5. Lit. "portatore."
6. "servo."

27) Illustrissime princeps et Ex. d.ne d.ne mi singularissime

... io essendo[1] andato in su la piaza della massaria[2] io vedendo Jacomo de coppino e Albertino ... soma [?] ... costaj per voler preponer aloro alcuna cosa che achadeva da fare circha alla fabrica. E sopra giunti de dreto alloro credendome che loro me videssimo e stando attento visti una scrita de mano de Albertino la quala luj aveva in mano e legievella al dicto Jacomo. la quale io legiendola visti che loro fata in mi inputacione ben percio de panzanige.[3] me io fo chaxo dela voluta a vegna che glie deli anni .16. che Albertino ma sempre hodiato. e ma menaciato e dito che io non sono ancora a chaxa cum il livo[4] e so che queste parole io notifichai a vostra Celsitudine e quela me disse lassa pure fare ame da puoi e son giunto molti cossi liquali mi io ho taciuti. ma pure vedendo alla giornata per chongiture che li maveva en hodio. Jo ogi fa otto giornij notifichai a quella che mi bisognava aver rispecto per che lui e li altri modiavano. Ora quella lovedra mani[5] perfettamente per loro scripto quale contene quanto che dicono chio ho meso. e piu tristi maestri che siano a mantua a Sancto Andre e che per rispecto di zio nisumo bono maestro non va voluto lavorare e questo in fino da hora rispondo che io posso a provare de havire tolto gli migliorij e per che quella me cognosse in parte gli daro in notta. di puoi dicheno queste soprastante non pare a loro suficienti delle chosse non provate non ne so regionare di poi dicheno chel gliene uno soprastante fiorentino e che io fo de lui a mio modo e puoi se giungione che gliene dui altrij e quali essendo questa stade[6] gran bisogno de soprastante cum loro licentia si tolseno. li quali non stano li a mia istancia se a loro piace chasseli che io non ho a fare niente: e in suma a vano tenzonando[7] de trovare chagione che io non me inpazi dela fabricha: e glie el vero che io ho fato perfino qui quello che io ho saputo e come aflizione e come amore et non sanza mia Vergogna. si puo dar questa in proxima a uno altro niente de mancho. quando a quella pare che io non me ne impazi sia cum il nome de dio Jo haro pacientia acio che loro abiano chagione de fare bene. e piu tosto volglio uno pocho de vergogna e che la giexia se facia che stare in questa conventione e che fazando io bene io sia imputato: ma sollo una gratia dimando alla Vostra Excelentia a che quella me conceda che quando e me imputano de alcuna cossa che io sia al parangone che cum ragione so che non me posseno inputare e vadino envestigando a lor modo: Jo mando questa

per che sia risposta ala loro se la manderano et anche se bene e non la mandeno che quella posa entendere lodio che mi porteno e la praticha che meneno. et solo per francesscho[8] e dichono che io non voglio parangon e che io volglio che chi vole lavorare a Sancto Andrea chio volglio che lavorij ala mia chaxa e molte panzanige e dicheno chio tenevo dui familgli[9] a Sancto Andrea questo quanto e fusse il vero saria stato ben fato. perho che non seria stato robato la fabricha ma io no ho familglio alcuno e questo staro a ogni tumento [?][10] di poi dicheno chel cavalo dela chareta il quale tengo a charegiato a Sancto Andrea alcune prete tagliate il quale e chari rompevano e tute e volgheno imputarme per che io ho prexe gli dinarij il quali asendeno ala somma de libre .9. vel circha il tuto. io tengo per che avendo fruste a rote glie rode per lo charegiare de giaronij[11] deli saligate. Jo ordenai a maestro mioranzo da goito che mene fosse uno paro e cosi fece e mandolij e io vedendo erano bassi gli ristutuij e ordenai qua uno altro paro e per che de puntino la S.ra V.ra sia informata posi far entender da dito maestro mioranzo il quale glie li io son contento che la Vostra Excelentia mi cementi so che quella ara piacire asai che io sia de 24 charati ed io spero mene segue utilita aprexo vostra signoria alla quale continuo mi ricommando.

die 21 febraij 1473
V.o F. S. Lucha T. Fiorent.
ASM, AG, 2416, 470
Published here for the first time.

*Notes*

1. This letter is unfortunately so severely damaged on the upper right hand side that it was impossible to transcribe the first two lines. The transcription thus begins approximately one sentence into the letter, with one major blank spot still to follow.
2. Piazza del Broletto.
3. "bugie."
4. The sense of the phrase "a chaxa cum il livo" is not clear.
5. "domani."
6. "estate."
7. "litigando."
8. Probably the "francesco da glusiano" of the previous letter.
9. "servi."
10. This word can¯ be read either "tumento" or "trimento." In neither case is the significance clear.
11. "sassi."

28) Illustris. princeps et Ex d.ne d.ne mi singullarissime etc. perche il temppo ha disturbato che non se ha posuto lavorare alla fabricha de Sancto Andrea et non ho possuto diccenere certi cossi che ho a diccenere....

ex mantue 8 maij 1473
V. S. F. Luchas T. Florentinus
ASM, AG, 2416, 474
Published here for the first time.

29) Ill.mo et ex d.ne d.ne mi sing.
Alla parte de Sancto Andrea e glie reconzo quanto io hordinai e seguitase diligentemente per forma che domane de sera sera compito di levare tute le capelle a livello deli pontate secondo lordine prexo per quelo se aspeta a fare de za dala Senssa e lavorassi cum vintisepte chazoli: sollo restera da levare la porta grande de lintrata dela giesia. si che la septimana che viene non se lavorrara si non cum dodice chazoli e stimo che zobia sera desseratato ogni cossa per che questi chanonizi ne fano intendere che quel die principia la perdonanza sel paresse alla Cel. V.ra che se fazoxa piu una cossa che unaltra ultra il puozo. hordinato ho de coprire de tende ho frassche ho daltro ornamento quella puo dare aviso e cussi se seguira.

Ex mantue xiiii maij 1473
V. S. Luchas T. Fiorent.
Al Marchese di Mantova
ASM, AG, 2416, 475
Braghirolli (doc. XI) published the first half of the letter— "Alla parte ... dela giesia." The remainder is published here for the first time.

30) Illust. Princeps et ex. d.ne d.ne mi singularissime etc. Bartholomeo bonato me a facto intendere che quella non ha havuta la littera la qualle sabato de sera mandai in la quale se contigneva questa medexima sustancia prima cum qui a Sancto Andrea il lavoro andava benissimo e mandato chadauno manchaniento e prixo forma del puozo e dele tende quanto bissogna....

ex mantue 17 maij 1473
V. F. S. Lucha Taglaprete
ASM, AG, 2416, 477
Published here for the first time.

31) Ill.me principe etc. d.ne d.ne mi singularissime. Qui a Sancto Andrea questa setimana se fato asa buono lavorjo ma non ne alto anchora in nessuno luogo ale .20. braza questa setimana che vjene si lavora chon .20. chazuole e spero andar chon una parte alle .20. brazo.

mantua 7 agosto 1473
Vostro fidel servidor Lucha Fiorentinus
ASM, AG, 2416, 488
Published here for the first time.

31a) Luce lapicide
Vogliamo che tu faci subito fare una chiasara grande cum una chiave catenazo forte per mettere a quella porta de S. Andrea la quale pagaremo nui....

Burgifortis
j julij 1474
ASM, AG, 2893, 76, 70r
Published here for the first time.

31b) Ill. p. et ex. dne dne mi singularissime
Jeri di sera circha 21 ora esendo a S.to Andrea entrando innuna chapella oltre a una serata da ge nel chalare mi feci male uno testicholo....

ex Mantua 2 agosto 1475
V.S.F. Lucha Fioren.
ASM, AG, 2416, 993

Clifford M. Brown, "Luca Fancelli in Mantua," *Mitteilungen des kunsthistorischen Instituts in Florenz* 16 (1972), p. 156. Lodovico Gonzaga replied sympathetically to Luca in a letter of the same day from Cavriana (ASM, AG, 2893, 79, 14r)

32) Ill. d.ne mi singul.
Le decedoto mesi che io fui assolto del carico del conto de la fabricha de Sancto Andrea de la quale alora patrene del vida era creditore de lire 667. 13.2 per calcine date per essa fabricha: a questo Natale proximo sera uno anno de questo suo credito io ne exbursai per lui a mess. Baldassare da Castiglione L. 600 et L. 67. 13. 2 li ha exbursato Petro Antonio de Guarneri novo depositario questo anno per compimento de dicto credito.
 Mantue, 7 decembre 1475.
 Fidelis servus
 ALBERTINUS DE PAVEXIIS.
 Al Marchese Lodovico
ASM, AG, 2416, 854
Braghirolli, doc. XV

33) Albertino pavesio
Carissime noster. Havemo visto quanto ne scrivi del credito che ne supplico a questo di aver presso si patrone per calcine date a Sancto Andrea. delche te comendiamo et hai facto bene ad avisarcene, nel vero nui te mandassemo a dire quelle parole maravigliandone che se supportasse zohanne francesco de sachetta per credito patrone per calcina per che li denari de Sancto Andrea non hanno a far alcuna cosa cum li denari del datio del vino a minuto. se dicto patrone venira ad nui saperemo che rendere [intendere ?].
 Burgifortis 9 decembris 1475
ASM, AG, 2894, 80, 46r
Published here for the first time.

34) Ill. p. et ex. d.ne d.ne misingularissime etc.
Io nonposo dar quello avixo ala V.r Signoria che io credeti per che credeti en questi di aver volto una chapella a Sancto Andrea et chosi disparato quelli i aveva a fare per questo ano alla cha del mercha. En vero questi maestri di questa terra ano posuto pocho lavorare perche ano auto male una gran quantita di loro et chi nonauto auto amalati de suoi di chaxa pur ala cha del merchato io ho fate chontinui qualchosa e adezo la verra per forza ma a santo andrea no vedo aviamento. Io licenziai quei maestri chome mordino la signoria Vostra a disi alioperari che mene achatassino 4 allor modo et mai non nano atrovati questa matina sono stato chon gianj di bardellone perche ieri lo solecitai che mi trovase maestri el no mi par chel sia per trovarne li altri operari. non sono in questa terra sel parese alla Signoria Vostra chio ne trovassi mi netrovero se io sono avisato da quela perche esia pur bon chonpir questa terza chapella questo anno ne altro per queste se non che chontinuo mi rachomando alla gratia di Vostra signoria.

mantue, 15. setemb. 1477
V. minimus S.vitor Lucha Fiorent.
 Taiapreta
Al March. Lodovico
ASM, AG, 2418
Published here for the first time.

35) Illust. d.ne nostre.
Illustriss. . . . Altro circa cio ce accade senon perche Luca nostro inzegnero ne scrive che a Sancto Andrea non sel lavorato ne se lavora perche lui licentio quelli muratori glie fue ordinato ne mai per li operarij dela fabrica glie stato proveduto de altri et che havendolo ricordato novamente a Johanino de Bardelone non pare che se ne curi ne li altri operaij se trovano a Mantua, et aquestomodo la fabrica de Sancto Andrea e interlassata che ne rincresce certo et scrive esso Luca che se anui pare el trovara altri maistri suficienti essendo absente come siamo male poteressemo havere il cervello aquesta facenda. Johanino nel vero e homo da bene ma in questa fabrica lui anche ha certa sua opinione differente da quella de Luca haressemo acaro vedestive di parlare cum quelli operarij et chel se gli pigliasse qualche partito che questa opera digna non se interlasasse che ce ne fareti piacere assai Questa opera non se po far senza Luca perche non glie altro che la intenda che lui perho seria pur necessario se intendessero cum lui. . . .
 Se nui fussemo acasa vederessemo pur pigliare qualche partito aquesta facenda de Sancto Andrea. Johanino a persona de bene como havemo dicto ma el non intende questi lavorerij sutili perche e usato far sue case e fenilli in villa et va dreto alla derata et queste belle cose non se possono far senza gran spesa per Dio vedeti se se gli po pigliare qualche buon modo chel non se interlasassi lopera.
 Ex Balneis, 20 sept. 1477
ASM, AS, 2894, 84, 61r
Braghirolli, doc. XVI

36) Luce Lapicide
Delecte noster: Tu hai facto bene ad avisarne di quanto se e facto a S. Andrea et ala casa de mercato dilche asai te comendiamo et rispondendo ala bisogno ne rincresce che ala fabricha de S. Andrea no se lavori altramenti et perho ne scrivemo ala Illustrissima nostra consorte che veda de parlarne cum quelli operarij et che se piglij qualche buon partito vedi anche tu dal canto tuo non mancarli de quello potrai avisandone di quanto se fara et li et altro [v] e circa quelli maestri Lavorerij perche havemo piacere intender il tuto come anche questi Zorni te scrivessemo et per dio vedi anche tu cum quelli operarij che usare buone parole et adaptarse a quello cognoscerai esser lo vale ed bene dela gesia che non ne poresti fare maior apiacer.
 de balneis 20 sept. 1477
ASM, AG, 2894, 84, 62r
Published here for the first time.

37) Luce Lapicide.
Dil. n.r Havemo visto quanto per la tua ne hai scritto cussi

circa il lavorero della casa del Mercato como anche de S. to Andrea dil che assai te commendiamo et respondendo al bisogno saressemo contenti che de questo lavoro de S. to Andrea tu ce ne havesse piu presto dato aviso et non aspectare il tempo fusse tanto inanti perche non vedemo horamai se gli potesse far cosa che andasse bene et maxime dove va opera de intaglio et perho ne pareria fusse meglio lassar star questo anno de farli altro salvo sel non te paresse ricunzare qualche cosa de quello che se guastasse per il zelo per lo inverno passato et anche sel te paresse che questo che se ricunzasse adesso non fusse per durar et chel zelo che ha avenire lo devesse guastare per non potersi sugare a tempo perche hora mai saremo in octobre come tu vedi saria anche meglio lassare star questo per non butare via la spexa, ma el ne pareria bene chel se vedesse ad ogni modo da far tal aparechio et monitione in questo mezo che lanno che vene el se potesse poi fare un bon lavorero et migliore che non se facto questo anno.

Ex Balneis, 20 septembris 1477
ASM, AG, 2894, 84, 63v
Braghirolli, doc. XVIII

38) In litt.il Ill. dne. dne. nostre.
Post scripta. Benche nui havessemo scritto quelo che vedereti circa il lavorero de Sancto Andrea non dimanco havendo poi pensato che oramai saremo de octobre ne piu se poteria far cosa che andasse bene maxime in questi lavoreri sutili ad nui ne pare sia meglio non far altro per questo anno se non tanto quanto scrivemo a Luca nostro inzegnero ma el ne pare bene che se facia tal aperechio et tal provisione che lanno che vene se possi far altro et miglior lavorero che non se a facto questo anno et de questo vedeti parlarne cum li operarij in opportuna forma advisandone che nui ne facemo mazor consientia chel se getti via spesa alcuna circa questa fabrica de S. to Andrea che sel lavorero fusse nostro proprio quando poi saremo ritornati acasa vederemo anche nui de parlar cum tutta quella brigata et pigliarli qualche bon partito.

Ex Balneis, 20 sett. 1477.
ASM, AG, 2894, 84, 64r
Braghirolli (doc. XVII) omitted the phrase "de Sancto... poi pensato."

39) Ill. p. et ex. d.ne d.ne misingullarissime
ieri ad .23. duj litera da quela entrezo [?] apieno e questa perche avendo mj lunedi precipitato de lavorar a Sancto Andrea per vogiere quella terza chapella emi sonj io et maestri dichono me sion di zannzior dachordo choluj dapoi chello non ratrovato njsuno chelli basti lavjsta dinta in su lopera mi fede per iachomo ordine che chosi faccesi et poi lui medesimo In suma mi paria manchamento da bandonar lopera esendo meso su i centoli et fato da ogni lato Braza .4. de volta et necesario seguire perche i centoli si buteriano i romagni [?] et chossi et alevargli se guasteria quello a fato ma io duplicero i maestri et spaccero presto avegna che non sia dubio njsuno delli ornamenti perche sono choti avanta giatamente Anchora o scrito a firenze per .4. maistri taia preti

per far lavorar quella preta de sancto andrea perche qui non ne che posino lavorare sono tuti stati amallati et io o mandato a verona per 2 volte atorne chome ghano lavorato oto di sono infermati fu ora che io dubitai de non poter seguir la cha del mercha ne altro alla gratia di quela chontinuo me richomando

ex mantua 24 setendris 1477
V. S. M. Lucha taglia prieta.
Al March. Lodovico
ASM, AG, 2418
Braghirolli (doc. XIX) published two excerpts from this letter: "e questa perche ... terza chapella" and "Anchora o scritto ... sono infermati." The remainder is published here for the first time.

40) Luce Ingeniario.
Dil. noster. Respondendo alla lettera tua ne piace chel se fornisca de voltare quella terza capella in S. Andrea poiche sono posti li centuli et chel glie dato principio acio che li centoli non se guastano et anche perche non se zeti via quello pocho e facto a levarli anche siamo contenti la se fornisca, non essendo dubbio de zelo come ne scrivi....

Ex Balneis, 28 sept. 1477
ASM, AG, 2894, 84, 76v
Braghirolli (doc. XX) gave an incorrect date of 27 September to this letter.

40a) Ill. p. et ex. d.ne d.ne mi sing.
A santo andrea si lavora forte e volto una chapela e preso un altra....

Mantua 22 sept. 1479
V.S.F. Lucha T. Fiorent.
ASM, AG, 2422
Published here for the first time.

41) Illu. Prin. et ex. domine d.ne mei singularissime.
Io como li superiorj dela fabricha de Sancto Andrea siamo stati ala presentia del R.mo Monsignore Chardinale, a gran tentione e intra li altri cossi dicti operari hanno dicto non havendo facto spessa ne niento niuno. diche per li libri del conto se trova hanno spesso senza mia saputa piu di tre millia libri intea. liquali hanno compro carra centoeundece e mezo de calzina in cinque volte, la quale chalzina trovo essere descharigata adescriptione senza prjso ne missura. Lasso pensare a quella la chasone per che ma dicerto intendero piu ultra e diltuto ne daro adviso a Vostra ex. Ultra aquesto ne laseptimana pasata trovo Zohannefrancesco de pisterla havere mandato doa charra tra chalzina e polverajo ala dicta fabricha in locho de doa chara de bona chalzina et li havea prestato dicti operarj etuto el di ne prestano inza e inla che contra li ordinj che senza mandato de V.ra Ill. si. non dovea prestare niente, et anche trovo el massaro havere havuto asse dodece per harenare soi revolti che lui fa el soprastante de la fabricha non mi vole monstrare ilibrj de li inventarj disse ha comission cossi dali operarj non so sel fusse per che lui se ha facto uno revolto e una casa li in lo monesterio in uno certo terrena atolto alivello, del che mi dubito non

habia menate li mane, ma dicerto ne intendiro per bona via. . . .

Mantua 9 septembris 1480
V. S. F. Luchas T. Fiorent.
ASM, AG, 2424
Published here for the first time.

## 42) D.no Cardinali Mantuano

Hebbi anchora la lettera de quella de VII circa la fabrica de S.to Andrea, e mi pare che Vostra Signoria habbia posto bono ordine e fatto tal provisione che judico non se li pora usare occulti trabalci in detrimento de essa fabrica et de li advisi quella me ha datto ringratio la S. V. Laudando molto quanto circa cio ha operato quella: che come ho ditto le provisione fatte sono optime. e dapoiche la S. V. ad utile dessa fabrica se dignata pigliare questa cura. essendomi nuovamente scritta questa lettera inclusa da M.ro Luca benche li sia una parte del mio edificio me parso mandaria a quella acio che la intenda per loriginale proprio tuto quelo ne vene scritto: et apresso laltri boni provedimenti la posa adjungerli quellaltri che li parera meritare qualche parte de questa lettera.

Ex. S.to Benedetto X Settembre 1480.
ASM, AG, 2897, 100, 73v
Braghirolli, doc. XXII

## 43) Illustris. domine

Havuta la risposta heri sera al tardo de V. S. circa la maestria de questa fabrica de sancto andrea, e vedendo per la inclusa de maestro Luca alcune piu particularitate: cha quello fu ragionato a principio: mandammo hoggi de novo per lo massaro, e presidenti de la fabrica, per corregere ugni errore, che in summa se li trovasse, e dare tuta volta miglior ordine al governo de essa per lavenire.

Havemoli tuti insieme, e maestro luca cum lor. E qui tochassemo tute le partite allegate da maestro luca in [. . .] de la fabrica secundo la suoa lettera: qual legessemo: per venirne piu presto a conclusione. Et intender che rispuosta dariano a le imputatione fatte. A la parte de li centoundece carra de calcina scaricata a discretion senza peso o misura: dissero questo non essere mai fatto, se non in una condutta de .XV. carra dati una fiata per dominico maleschco, che allagano essendo condutta, se bagnoe in via per certa piogia. E lo soprastante andoe a Zohannino dicendoli, come faremo nui de questa calzina, che sendo bagnata, sera mal de pesarla. Zohannino li rispuoste, che dicendo dominico, che la fusse .XV. carra, lui li crederia, perche lhaveva sempre trovato in simel condutte veridico che pare se ne sia fatto sagio, non solamente per questo fabrica, ma anche per sandominico, e per lospitale. E trovano che le suoe misure riestono in fare buona opera. E per questo se curoe de dire, che la se acceptasse a questo modo, ne mai fu fatto in altra quantitate, ne ad questa limitation luca perho hebbe altro da contradirli, se non che uno li haveva ditto non erano piu che xii [. . .] il che non provava per altro reperimento ne fusse fatto. Et e vero, che nui dicessemo a luca, che [. . .] voressemo venisse cum piu certeza, che de dire, io lho intieso. Et

maxime, che per dire [. . .] sta condutta fu .xii. carra, puoria perho qualche volta al peso esserne .xv. De li doa carra [. . .] ristituiti da zo. francesco pusterla, rendeno esser vero, che lui li mando. E lor ordinarono, [. . .] la fusse posta da canto, e bagnata seperatamente, per veder, se bagnata vendeva tanti soglij: quanti lui ne haveva havuti in prestito. e questo acio supplisse, mancandogene. E fin qui non e fatta la prova. e perho non sanno iudicarli suso. Del prestare contra li ordeni, dicono non havere mai intieso tal prohibitione, se non con nui ge la facessemo mo quarto o quinto di. E questo da qui inanti lo servaranno Et iquesto proposito cadeno le asse per stare al massaro, qual lui confessa havere per [. . .] itio come se era consueto fin qui renderalle hoggi o domane esenza danni dela fabrica.

E de cetero niente tuora in prestito pe se, ne consentira el darne ad altri: De libri de inventarij, quali dice luca no haverli voluto mostrare el soprastante, allegando cussi esserli sta commandato da lor: rendeno non havere mai dato ta commissione. ma che ben li hanno prohibito non dia fuora li libri senza la licentia. E questo acio che non se smariscano. Circal seno dato in pagamento per Zohannino arigono, che dica luca haverne produtto testimonij: nui dicemo essere vero, che ce condusse luno solo, el qual senza altro iuramento essendo nui in sala, che andavamo a messa, ce disse che uno haveva intieso de senno dato al venditore de la calzina. ma non disse se fusse per pagamento de essa calcina. anti riexaminandose mo hoggi la cosa, parse fusse seno dato ad un altro. da chi dependeva puo costui de la chalcina: El qual essendo debitore de Zohannino per lo seno, e devendo puo anche lui havere da questo de la calcina rimasero dacordo, che Zohannino pigliasse certa quantitati de denari, che se rimborsava per la calzina, in pagamento del seno a lo principal dato: unde non appare quando cussi sia, chel seno fusse dato in pagamento de la calzina. E non fu omnino de primo trabalzo: sotto giongetino lor, che dicontinuo a tempo de maestro luca la se compra a sette libri el carro, e lor hanno havuta per libre cinque e soldi quindeci. Cominciarono qui de novo ad alterarsi. E Zohannino a protestar per lo impropetio a lui fatto, de haverlo calumniato presso al principe, de iniuria de ducate domilia. E Luca rendendo, che quando lhabia provato protesta anchor lui la iniuria suoa de haverlo voluto fare menzognere e calumniato [. . .] Vedendo questo, ne parse de lavarne le man di queste imputatione e desordeni [. . .] pretendeno de caricarse lun laltro, perche qui bisognava venire su le prove. E ques [. . .] ad riexaminare testimonij, non e per nui. parene officio piu presto da .d. Donino [. . .] E cussi la S. V. volendo de questo fare riexamine, puora ordinarli suso, come li [. . .] che le cose da qui inanti vadino bene, E che se rimovano de queste occasion [. . .] o saltem dare suspecto de fraude a la fabrica, li attenderemo de buono voglia. E cuj [. . .]cammo el medesimo de laltro di. e lor hanno accepta-to de farlo. restara no, come an[. . .] vessemo, che V. S. chiarisca, se la vole, che ultra lo trovarsi maestro luca a li mercati, li concorra in li pagamenti necessari la sua

sottoscriptione a le cedule o siano man.ti. Havemoli che de novo faciano liventarij dugni cosa: acio che quelli siano puoi maestri ad [...] ad essere: E se niente li mancara. o sera usurpato, che a quello modo se ne tenira buon conto. Per che rivedano, cio che e prestato via, e faciase rendere universalmente. Dela calcina, puo che adesso per essere bagnata, non se puo vederne el iusto peso e misura, saltem per qualche incontro, fariano tenere conto, quanto opera fara: che pur si connoscera saltem apresso, quanta era inveritate, dislinguendo li lavorieri, secundo li va piu grassa e piu magra. Speramo cum tal ordeni andaranno le cose tanto chiare, che meglio se ne puora dicernere il vero. Rimandiamo la lettera de luca cum questo aviso de lopera nostra de hoggi a la Ex. v. que bene valeat.

Mantua ii [11] septembris MCCCCLXXX.

Fr. F. de gonzaga cardinalis mantuan. Bononie e Legatus.

ASM, AG, 2424

Published here for the first time. The lacunae in the text result from the bad state of preservation of the letter.

### 44) Rev.mo D.no Card.li Mantuano

R.me A me pare che questi deputati ala fabrica de S. Andrea farano per lo meglio a portarse per altra forma per lo advenire ad utile de essa fabbrica che non demostreno haver fatto fin qui e non tediar piu cum queste altarcatione la R.a S. V. la qual puo statuire e ordinare quelli modi gli pare se debbano servare como per laltra mia estiam gli scrisse rendendome certo che poi non potevano cossi de facile ridur suspitione dun de laltro de agravar la fabrica e disponga la R.ma S. V. come gli pare e piace de le sottoscretione inventarij e altri conti over provisione se habiano a fare che tutto quello la fara serra ben facto ringratio la S. V. de li admisione ha datti circa cio benche non fosse bisogno me ne facesse altra notitia per che mi remetto il tuto a quella che di presente e sul fatto: Racommandome al la R.ma S. V.

Ex S. to Benedicto, XII sett. 1480

ASM, AG, 2897, 100, 77v

Braghirolli (doc. XXIII) published all of this letter, save for the last part, beginning "ringratio la S. V.," which is published here for the first time.

### 45) Declaratio Capellarum Sancti Andreae de Mantua

In Christi nomine Amen Anno Domini ... millesimo quadregentesimo octuagesimo primo ... die dominica vigesimo mesis Maij. ... Ibique cum sit quod ecclesia collegiata Sancti Andreae de mantua. una cum multis capellis et sepulchris in ea constructis et fabricatis fuerit demolita et destructa pro reficiendo et refabricando eam in melium et laudabilium et ad laudem et honorem omnipotentis deij eiusque gloriose matris marie semper Virginis Cumque post modum dicta ecclesia fuerit et sit refabricata pro una buona parte et similiter multe capelle fuerint constructe et in ea fabricate quecundum consecrate fuerunt nec declarate nominande et consecrande sub titulo et vocabulo alicuius sancti quod Reverendissimus in

Christo pater et Dominus Dominus Francischus de gonzaga ... dedit et declaravit quod prima capella que est constructa a latere dextro in introytu dicte ecclesiae collegiatae sit denominanda et consecranda sub titulo et vocabulo Sancti Michaelis archangeli et sanctae agatae virginis et martiris, et quod secunda capella ... sanctae Annae. Et quod tersia capella ... sancti Matthej apostoli et sancti Benedicti abbatis, et quod quarta capella ... Virginis gloriosae, et quod quinta capella ... sancti Bartholomei apostoli. Et quod de sexta et ultima capella constructa a dicto latere dextro in presentiarum non declarat sed reliquit eam declarandam esse sub quo titulo et vocabulo denominari et declarari debunt et hoc demandato et ommissione prefati Reverendissimi domini Cardinalis rectoris predicti. Preterea et similiter dixit et declaravit quod prima capella que ist constructa a latere sinistro in introitu dictae ecclesiae collegiatae debeat denominari et consecrari sub titulo et vocabulo sancti Johannis baptistae et quod secunda capella illam seguens ... sancti Nicolaij et Crucifixi, et quod tercia capella ... annuntiationis virginis, et quod quarta capella ... sanctae Ursulae Virginis et Martiris et Sancti Johannis evangelistae, et quod quinta capella ... sancti Antonii abbatis. De sexta autem et ultima capella constructa a dicto latere sinistro in introjtu dictae ecclesiae in presentarium non declarat sed reliquit eam declarandam esse sub quo titulo et vocabulo denominari et declarari debeat ... et etiam de voluntate et consense Illustrissimi principis et excellentissimi domini nostri Marchionis mantuae pro presenti dicit et declarat quod in qualibet capella parva predictarum capellarum fieri debeat una sepultura tantum. Et quod in qualibet capella magna fieri debeant et possint duae sepulturae designanda et designandae per prefatum Reverendissimum dominum Cardinalem et sue per ipsum dominum archipresbiterum dicto nomine et eius successores illis qui haberent jus sepulturae in dictis locis et capellis. ...

ASM, Instrumenti del Notaio Ferimo, 2, 1480–1482. Published here for the first time.

### 46) D.no Card.li Mantuano

La santitate de N.ro Sig.e ha mandato a dimandare li denari che si sono riscossi qui per la cruciata, et seranno circa doa millia e trecento ducati. La S. V. scia che la continentia de la bolla prima era che queste tal denari devevasse spendere contra el turcho overo ad pias causas. Lo edificio di S. Andrea qui haveria grande bisogno de subsidio, essendo necessitate de farli in quasi ad un tempo una bona spesa per coprirlo e seria opera pijssima adiutar questa fabrica. A nui non e parso de lassare levare de qui questi denari fin tanto non habia risposta de V. S. de questo nostro scrivere: per lo quale prego quella voglia supplicare alla S. te prefacta sia contenta de condonare a questo edificio quella parte de dicti denari, che li parera e piacera, e subito el resto sera mandato secondo comandare suoa beatitudine, ben prego la S. V. che voglia vedere possa di cio havere presta risposta.

Mant., 22 iunii 1481.
ASM, AG, 2897, 102, 224
Braghirolli, doc. XXIV

47) Anno domini ... millesimo quadragentesimo octuagesimo primo... die Mercurij vigesimo secundo mensis augusti.... unam capellam denominatam et consecratam sub titulo et vocabulo Sanguinis Christi positam et fundatam in dicta ecclesia sancti Andreae de Mantua....
ASM, Instrumenti del Notaio Ferimo, 2, 1480–1482
Published here for the first time.

48) Anno domini millesimo quadringentessimo octuagiessimo secondo ... die dominica quartodecimo mensis Julij ... et secretarium profati Reverendissimi domini Cardinalis per se suosque succesores ac vice at nomine dicte Reverendissimi domini Cardinalis rectoris predicti Toto clero dictae ecclesiae Cathedralis ac prefatae Coligiatae ecclesiae sancti Andreae in processionali ... et una magna parte populi solemniter congregato in dicta ecclesia Sancti Andreae et ante infrascriptam Capellam apparatam quod dicta Capella que est sexto et ultimo constructa et fabricata a latere sinistro al introitus Ecclesiae ... sit denominanda et consecranda sub titulo et vocabulo dicti sancti bonaventurae episcopis confessoris....
ASM, Instrumenti del Notaio Ferimo, 2, 1480–1482
Published here for the first time.

49) Ill.me Princeps et Excel.me D.ne D.ne Noster singularissime.
Fin dal anno 1485 et del mese di Zugno fu prestato alla Vra. Illma. Signoria Ducati cento dieci de quelli della fabrica di S. Andrea, cioe ducati cento exbursati al spettabile Antonio Scazano, suo Tesorero, e Ducati dieci a Maestro *Luca*, tagliapreda, per commissione di quella, delli quali mai no se ne avuto noma ducati quindici. Et a questa festa della Ascensione proxima passata la prefata Illma. Signoria Vra. fece far la offerta de Ducati ducento, li quali poi furono restituiti cum provisione de farli risponere fra termine de uno mese, delli quali ancora se

ne resta aver libre seicento nel circa. e richiedendoli al spettabile Messer lo Massaro recusa darli, dicendo aver commissione de non dar denari a persona alcuna senza expressa licentia de Vra. Signoria. unde non avendo noi il modo di far lavorar, ne parso farne notizie a quella, per non esser imputati de negligenti. Avvisandola che avuti questi denari, seria voltata la terza parte; e sapendo noi la prelibata Illma. Sig. Vra. desiderosa che se lavora in detta fabrica, ne par pregar quella se degna provveder se abbia detti denari, accio se possa lavorar alla gagliarda, come credemo esser intenzione di quella, alla quale de continuo se reccomandiamo. Mantuae 15 Septb. 1490.
Servitore fidelissimi Presidentes Fabricae S. Andree.
Ill.mo Principi et Ex.mo D.no D.no Francisco Marchioni Mantue D.no Nostro Singularissimo
ASM, AG, 2438
Gaye, vol. 2, doc. CXXXIII
D'Arco, vol. 2, p. 30

50) Ill.me Princeps et Excel.me D.ne D.ne noster singularissime.
Ritrovandose la Fabrica di S. Andrea creditrice di V. E. de Ducati 400 nel circa, et avendo noi deliberato voltare quest'anno questa terza parte resta voltare, dandone V. Ill. Signoria aiuto; quella pregamo se degni commettere al Massaro suo che dicta Summa de denari ne volia exbursare ducati cento; cioe ducati dieci ogni septimana. et cosi mediante lo aiuto de V. E. questo anno se voltara essa parte resta a voltare, quella per altro modo non se poteria voltare. et facendone questo, lo riceveremo de singular grazia da prefata V. E. alla quale de continuo se racomandiamo.
Mantue, 30 Maii 1494
E.D.V.
Servitores fidelissimi Presidentes
Fabricae S. Andree
Ill.mo Principi et Ex.mo D.no D.no Francisco de Gonzaga Marchioni Mantue D.no Nostro Singularissimo.
ASM, AG, 2446
Gaye, vol. 1, doc. CLVII
D'Arco, vol. 2, p. 39

# Appendix III

1) Joannis de' cremaschis 1526 10 october
De una petia terrae casamentinae cum domo et Apotheca supra cupata murata et solerata cum tribus solarijs posita in civitate Mantuae in porticu S.ti Andreae in contrata Leopardi, penes Jura eccl.iae S.ti Andreae de Mantua que nunc tenent heredes g. Joannis francisci de grossis ab uno latere Lodovicu. panitia. pro juribus dictae eccl.iae a secondo Plateam Broletto a tertio et cimiterium dictae eccl.iae a quarto. . . .
ASA, scaff. C, *Catastrum Fozia Primiceriatus*, vol. 1, fol. 21r

2) Dominicus panitia 1526 11 october
DE Una Petia terrae casamentinae cum domo supra cupata murata et solerata cum Una Apotheca sita Mantuae in contrata Leopardi, penes Viam co.is a primo latere Jura eccl.iae S.ti Andreae que tenebant heredes Bonaventurae de cremaschis a secundo eccli.am S.ti Andreae a tertio Jura Mri. Anselmi de Veraria a quarto ITEM de quaddan parva parte petiae terrae cum curticella et revolto que supertavit de illa petia terrae casamentae cum curticella que accepta fuit per fabricam dictae eccl.iae Sancti Andreae: . . .
ITEM q dictus Mr. D.nicus non posit facere aliqua melioramenta sine expressa licentia praefati R.di D.ni Primicerij et si fecerit illa non possit patere à p.to R.do C.no Primicerio vel successoribus suis. ITEM q dictus M.r Dominicus vel eius heredes non teneantur ad pensionem dictae Apothecae et curticellae et rer. locatar. vel ad affictum aliquem pro tempore pestis si factu. fuerit proclama parte Principisq. cives possint pro ipsa peste recedere vel recesserint alij cives et M.r Dominicus de civitate Mantuae cum suis familijs ad habitandu. foras, et evacuaverint civitatem pro maiori parte et consuerint fieri pro peste. ITEM q si petia terrae in qua est curticella vel eius pars demoliretur, vel occuparetur pro fabrica dictae eccl.iae S.ti Andreae totu. damnu. sit dicti M.ri Dominici vel heredum suor, quia sic actum extitit inter predictas partes et in dicta precedenti Investitura: et tenutam dictae petiae terrae et curticellae quam dictus Investitus habere dixit et confessus fuit Vigore praecendentis Investiturae rogatae p. d.num Michaelem camporam civem et not.m pub. mant. sub die mercurij quinto decimo mensis septembris Anni Millesimi quingen.mi Vigesimi quarti ibi exhibitae et p.ntatae ipse R.dus D.n.s. Primicerius sibi noviter et plenissime confirmavit. . . .
ASA, scaff. C, *Catastrum Fozia Primiceriatus*, vol. 1, fol. 25v

3) M.r Sancti de grassis 13 october 1526
DE UNA Petia terrae casamentinae cum statione seu domo supra cupata murata et solerata posita in civitate Mantuae in contrata Leopardi, penes Iura dictae eccl.iae

que tenent M.r. Dominicus panicia ab uno latere, Jura dictae eccl.iae que tenet and pr.is Jacobus de Luca a secondo viam co.is a tertio et cimiteriu. dictae eccl.iae a quarto. ITEM de una curticella longitudinis brachior. decem et septem et latitudinis brachior. octo penes Magistrum Dominicum panitiam ab uno latere pro Iuribus dicti Primiceriatus, cimiteriu. dictae ecclesiae S.ti Andreae ab alijs, salvis alijs confinibus verioribus si qui forent dictae petiae terrae: quar. petiar. terrar. utile dominu. et melioramenta ipse Mag.r Sanctus emit à d.no Ant.o de veraria ut constat instr.to publico rogato per d.num Io. Anselmu. de Carmmatis civem et notariu. publicu. Mantuae sub die [?] anni instantis, qui d.ns Antonius alias in simili forma fuit Investitus, ut constat Instru.to publico rogato per d.num Federicu. de folengis civem et not.m publicu. Mantuae sub die martis primo mensis decembris anni mill.mi quingentesimi sexti ibi exhibito et p.ntato. . . .
HOC enim pacto alias facto et nunc confirmato inter ipsas partes q adveniente casu q pro fabrica dictae eccl.iae S.ti Andreae opus esset demoliri facere edificia et muros facta et factors super dicta curticella et e.t capi in totu. seu partem ipsius, q tunc et eo casu dicta edificia et muri demoliantur et Lapides et tegulessint et esse intelligantur applicati et donati ad dictam fabricam, omni exceptione remota: et casu quo non demolirentur praedicta pro dicta fabrica et dicta curticella posset liberari, q tunc et eo casu dictus Investitus teneatur et obligatus sit et sic promisit et promittit dictus Investitus per se et ut sup. in casu liberationis dictam curticellam liberare in duplu. habita ratione ad affictum soldor. Viginti parvor ment. quia sic inter ipsas partes actum extitur pariter et conventum. . . .
ASA, scaff. C, *Catastrum Fozia Primiceriatus*, vol. 1, fol. 27r

4) Investitura m.ri Bernardini de gilbertis
Anno d.ni . . . Mill.mo quingentesimo trig.io tertio. die sabbati q.nto Mensis Aprilis.
Bernardinum fq. Joannis de gilbertis muratorem civem et habitatorem Mantu.e . . . DE UNA Apotheca seu statione una cum volta, que est ante dictam Apothecam versus plateam campan.e [the present Piazza Mantegna], ac et cum una scala que est inter eccl.iam sancti Andre.e et dictam Apothecam, egrediendo de dicta ecclesia à manu sinistra usq. et in tantum quantum indiget ipse investitus pro eundo et redeundo ad cameras et loca, quas et que. intendit ipse m.r B.nardinus construere super dictam voltam: et cum hoc e.t q. Presidentes et agentes Fabric.e dict.e eccl.ie. possint ad eorum libitum et voluntatem ire et redire per dictam scalam pro necessitatib. et occurentiis dict.e fabric.e sine aliqua molestia et impedimento dicti m.ri B.nardini nec eius heredum: et que Apotheca est posita in civitate Mantu.e in contrata Leopardi apud

eccliam sancti Andre.e, egrediendo de dicta eccl.ia in capite scale à manu sinistra, longitudinis usq. ad columnas inclusive brachior. sexdecim et latitudinis in faciata brachior. undecim, penes illos del cervetta à primo et s.do viam seu plateam à tertio et eccl.iam p.dictam sancti Andre.e à quarto, salvis aliis confinibus verioribus si qui forent dict.e peti.e terr.e. ... m.r B.nardinus nec sui heredes possint nec valeant amovere nec amoveri facere pilastrum existens intus dictam apothecam sine expressa licentia Presidentium dict.e fabric.e. ...

ASA, *Catastrum Fozia Primiceriatus*, vol. 1, fol. 9r

5) Investitura m.ri B.nardini de gilbertis
Anno d.ni Mill.mo quingen.mo trigesimo sexto. Die sabbati mensis decembris
... B.nardinum fq. Joannis de gilbertis Muratorem civem et habitatorem Mantu.e in contrata pusterl.e ... DE UNA Apotheca seu statione posita in civitate mantu.e in contrata Leopardi apud eccl.iam sancti Andre.e egrediendo de dicta eccl.ia in capite scal.e à manu sinistra, logitudinis usq. ad columnas inclusive brachior. sexdecim, et latitudinis in faciata brachior. undecim, penes illos del cervetta à primo et secundo, viam seu plateam à tertio, eccl.iam p.d.c.am sancti Andre.e à quarto, salvis aliis confinibus verioribus si qui forent dict.e peti.e terr.e. ... m.r. Bernardinus non possit nec valeat amovere nec amoveri facere pilastrum existens intus dictam Apothecam sine expressa licentia Presidentium dict.e fabric.e. ...

ASA, *Catastrum Fozia Primiceriatus*, vol. 1, fol. 181v

In this document mention is made of a consultation "cum Mag.co D.no Carolo de Bononia Mazzario g.n.ali civitatis Mantu.e, Mag.co d.mo Hieronymo de frambertis, et Mag.co d.no Julio Romano superioribus Fabrice sancti Andre.e de Mantua" before it was decided to rent the property to Bernardino Giberto.

6) In 1546 the contract of 1536 was renewed with the same language repeated.
ASA, *Catastrum Fozia Primiceriatus*, vol. 2, fol. 21r

7) Federigo Gonzaga to his Treasurer General
M.ae etc. havendo noi inteso chel tocca alli presidenti della fabrica di S. Andrea ed elleger et provedere d'uno superior di essa in cambio del Brianza che vi era, e che voi come massaro di Mantua sete il primo Presidente, volemo che voi ellegiate M. Francisco de Donino nostro soprastante in quel loco, non vi essendo alcuno delli altri presidenti il come intendemo. Bene valete.
    Marmirolo, xx julii 1528
ASM, AG, 2931, 295

A. Bertolotti, *Architetti*, p. 29

8) Alli presidenti della fabbrica de S.to Andrea.
Dil.ti nostri. La S.ta di N.S. mi ha compiaciuta de una plenaria indulgentia per chi visitasse quella nostra chiesa de S.cto Andrea nel tempo delle station di Roma come appare per un Breve di S. Beatitudine qual havemo man-

dato in le mani di Ven.i Canc.i et Cap.lo della dicta chiesa. Et perche lo intento della pred.cta S.ta et nostro e che tutte le elemosine che se percepiranno siano dispensate per soccorso e beneficio di quella fabrica, volemo che sii v.ra impresa de intromettervi cussi nel scoderla, come de farne tener fedel conto; si che li denari non habiano ne possino dispensarsi se non a questo sol effetto per il qual ci siamo mosse ad impetrar da N.S. la indulgenza predicta.
    Bononie x Maii 1530.
ASM, AG, 2933, 300
Willelmo Braghirolli, "Leon Battista Alberti a Mantova," *Archivio Storico Italiano*, 3, no. 9 (1869), p. 26

9) Federicus Mantuae dux ecc. Avendone fatto intendere li presidenti de la fabrica di S. Andrea che piu volte hanno advisato li Potestati, Commissarii et Vicarii del dominio nostro che vogliano pagare il loro debito consueto a detta fabrica secondo le impositioni fatte per li Illus. nostri precessori, ma che pare che poco curino ne lettere ne nuntii di essi Presidenti dicendo anche che tale obbligo non e de nostro consenso, et percio pregandone a volerli fare opportuna provisione: Per vigore de le presenti nostre strettamente comandiamo a tutti li Massari et deputati de qualunque castello de lo dominio nostro, che subito vista la presente debbiano esborsare et numerare al presente ostensore tutta quella quantita de dinari che li dimandara secondo pero la lista che li mostrara del debito del suo offitiale per Noi deputato in quel loco, la qual lista sera sottoscritta de mano di essi Presidenti, et essi dinari volemo che siano posti a bon conto di essi offitiali ancora quanto per la presente nostra se ordene e comanda non sera per detti massari it huomini deputati de qualunque Potestaria. Commissariato et Vicariato nostro data piena executione senza verun rispetto li sara mandato il nostro bargello in casa el qual li havera ad stare sino tanto si mostrara sia satisfatto integramente el debito predetto del quale non intendemo che alcuno vadi exempto.
    Mantuae 29 augusti 1532
    Vincentius de Pretis secretarius — Calandra

D'Arco, *Delle arti*, vol. 2, p. 153

10) Visita Apostolica Fatta l'Anno 1575
Qui primo visitavit venerabile sacramentum, quod super altar maius conservatur in tabernaculo satis magno deaurato, et satis congruo, et honesto, sed sacramentum ipsum in inferiori parte ipsius tabernaculis loco admodum depresso, reconditur, quo loco de commissione dicti R.mi D. Vis.ris. aperto visum fuit vasculum quoddam parvu., in quo reperte fuerunt plures particulae conservatae sup. posta corporalis deposita et locus ipse de intus totus quidem coopertus de serico rubei coloris apparuit; sed eo viso, et habito super hoc longo sermone cum dicto R.do D. Primicerio, et Canonicis. Ordinavit provideri ut Sacram.m ipsum omnino ex inde ammoveatur, et collocatur in tabernaculo ipso, et videlicet infra corpus ipsius taber-naculi cum provisione, quod commodè inde, et levari, et reponi possit, quod facile factu erit si tabernaculum ipsum, quod nunc super quatuor columnis reperitur, ipsis

columnis remotis, deponeretur, et locaretur super altare alisq. columnis. Ordinavit insuper provideri de alio vasculo, sive coppa argentea deaurata, et intus, et extra in forma congrua abitrio R.mi D. Ep.i pro conservatione ipsius S.mi Sacramenti Et quia due lampades vitreae satis parvae ardent hinc, et inde ad cornua altaris maioris. Ordinavit, et mandavit fieri lampadarum decens, et pulchru. quod collocari mandavit coram, et in prospectu ipsius tabernaculi, et lampadulas illas in lateribus altaris p.te existentes removeri.

Et quia eidem R.mo D. Visitatori, et ab ipso R.do D. Primicerio, canonicis et ca.lo, et quampluribus alijs, et cl.icis, et laicis sepius dictum fuit, quod in Ecclesia ipsa habetur de Sanguine Christi et de Spongia, cum qua potatus fuit Salvator ipse Idem. R.mus D. Visitator se contulit ad locum, in quo conservari dicuntur reliquiae p.tae, et est locus subterraneus praeseferrens pietatem, et devotionem maximam, et dum genuflexus existeret in prospectu loci, in quo actualiter reliquae ipsae sunt reconditae, vidit locum ipsum quampluribus cratibus ferreis circumquaq. clausum, Itaq. locus ipse valde fortis, et tutus admodum redditur et demum apertis omnibus clausuris, que tribus clavibus diversis, et clauduntur, et reserantur, eidem R.mo D. Vis.ri p.ntata fuere duo vasa, sive tabernacula totalo de auro confecta, maxima cu. arte laborata et aperto altero ex tabernaculis vidit in Vasculo de christallo montaneae entare (ut dicitur) de Sanguine Christi, et in alio tabernaculo vidit particulam quandam spongiae, quam dicebant omnes haberi, et semper habitam fuisse pro spongia, qua potatus fuit Dominus noster, dum in Cruce penderet, et quia vidit quamplures lampades ardentes coram dictis reliquijs demonstratis. Interogavit Idem R.mus D. Visitator quamplures ex circumstantibus clericis, et laicis, an lampades ipsae continue arderent, et dictum fuit uniformiter ab omnibus ex ipsis lampadibus quatuor die noctaq. semper ardere, et ad ipsas oleum subministratur ab hominibus et confraternitate in dicta Ecclesia existente sub nomine, et titulo Sanguinis Xpi. . . . Et demum ostensa sibi fuit lamina quaedam plumbea cum l.ris antiquissimis haec verba describentibus JESU CHRISTI SANGUIS, quae (ut dictum fuit) aderat super capsula marmorea, quae inventa fuit in dicta ecclesia cum dicto Sanguine, quem, ut dixerunt, cives et populus Mantuanus semper habuerunt pro Sanguine de Christi latere fuso, et a centum annis, et ultra in eadem ecclesiam celebratur festivitas illius diei, quo capsula ipsa cum dicta super scriptione inventa fuit.

## DIE SECUNDA DECEMBRIS

Suprascriptus R.mus D. Visitator Apostolicus proseguendo visitationem, iam. ceptam in dicta collegiata eccl.ia S.ti Andreae devenit ad visitationem altarium et p.o se contulit ad altare maius, quod videns, reperiit ipsum esse totum ligneum, et sub tobbaleis reperijt altare quoddam portatile consecratum, sed adeo angustum, et brevel ita ut vix possit super eo Calix commode collocari.

Et prop.ea. in p.is altare ipsum maius totum fieri ord.it lapideum, et consecrari vel saltem super eo inseri altare unum portatile marmoreum consecratum unciarum octo in longitudine, et untiarum sex in latitudine, illudq. adeo accomodari, it ut commode super eo sacerdos valeat consecrare.

Et [?] eidem R.mo D. Vis.ri et ab ipso D. Primicerio, et alijs Canonicis dictum fuerit, quod nullum ex altaribus in dicta ecclesia existentibus est dotatum, Voluit nihil.s altaria omnia singulatim visitare, et per eorundem visitationem vidit altaria omnia esse lapidea quidem, sed non consecrata cum altare portatile satis angusto, et brevi Prop.ea.

Ordinavit in primis altaria ipsa consecrari, aut saltem in unoquoq. eorum altare unum portatile inseri, vel includi longitudinis et latitudinis, de quibus supra, quod accomodare mandavit ita versus pectus sacerdotis celebrantis, ut possit super eo commodè consecrari. Ordinavit insuper provideri, ut unumquodq. altare, aut unius uniusq. altaris Icona temporibus debitis cortina linea possit cooperiri. Ordinavit insuper provederi, quod unum quodq. altare semper sit munitum tribus tobaleis, candelabris congruentibus, et palio saltem de coramine deaurato, et quod semper super unoquoq. ex altaribus p.tis habeatur una Crux saltem lignea depicta auri frigiata, et quod ex altaribus ipsis removeatur charta pro gloria in excelsis, quia que habentur super altaribus ipsis sunt de antiquioribus, et loco earu. Mandavit apponi charta. unam, de noviter impressis iuxta formam, et ordinem missalis novi. Mandavitq. insuper ita provideri, ut sacerdos super altaris bireta, et alia utensilia non deponant, sed in aliquo loco super altaris bireta, et alia utensilia non deponant, sed in aliquo loco ab ipso altare poenitus separato.

Et cum vidisset capellam unam sub titulo S.ti Sebastiani admodum obscuram, perquirendo invenit hoc factum fuisse quia vicini in prospectu dictae cappellae altus parietes suos extulerunt, et su luminibus capellae officium, et propterea Mandavit et ordinavit impedimenta quaecumq. luminibus capellae dictae officientia inde removeri. Et prorsum ecclesiam ipsam perlustrando vidi finestras capellar. esse de tella confectas, antiquatas, et in pluribus partibus laceratas, et non reddentes capellis ipsis nec splendorem, neq. decorem, at propterea Ordinavit fenestras ipsas vitreas fieri, et aliae fenestrae, quae sunt vitratae cum visae fuissent totae pulvere, et in pluribus partibus confractae Mandavit et ordinavit fenestras ipsas sic immundas, et deccastatas, et lavari, et restaurari, itaquod in eis, vel earum aliqua vitreum aliquid occulum non deese cognoscatur, sed sint in omni parte de vitro conclusae. Videns insuper idem R.mus D. Vis.or in Ecclesia ipsa tam ampla sedes aliquas non haberi pro confessionibus poenitentium audiendis, cum maxime quandoq. ad Ecclesiam ipsam concursus poenitentium habeat. saltem eorum qui sub cura, et Parochia S.ti Laurentij consistunt propter incapacitatem, et indecentiam ipsius Ecc. E. S.ti Laurentij. Ordinavit, et mandavit duas sedes ad minus aptas, et condecentes, ac iuxta mensuram, et forma. in Ecc.a Cathed.li prescriptam fabricari, easq. aptari, et collocari in aliqua parte ipsius Ecclesiae, et arbitrio R.di D. Primicerij, cum decreto quod confessarij in Ecclesia ipsa alicuius

secularis confessiones non audiant, nisi in sede ipsa ad cratem in illa locandam, et cum cotta, et stolla, et quod ante ortum solis, nec post occasum mulieres aliquas non audiant in confessione.

Et quia interogando Canonicos, et Clericos ipsius Ecclesiae Idem R.mus D. Vis.tor habuit, quod in Paschale in Ecclesia ipsa S.ti Andreae fuint generales communiones in calice consecrato exhibitur Prop.ea

Et cum tandem totam ipsam ecclesiam perlustrasset, vidissetq. ea. in suis structuris, et edificijs, et volta, quae est mirabilis pariter et in pavimentis benè se habere, audivissetq. fieri pulchram admodum fabricam, quae iam diù cepta fuit, et adhuc remanet imperfecta, Idem R.mus D. Vis.or se contulit ad fabricam ipsam, quam vidit in suo principio esse regiam, et sublimem; sed in eo statu reperiri, quod spes aliqua non habetur ipsius complementi, et per longi temporis intervallum, et ut relatum fuit iam sunt decem anni, et ultra quod in ea aliquid, quod relevet, actum non fuit. Nam fabrica ipsa nihil habet de reddita praeteo eleemosinas et oblationes, quae in dicta ecclesia fieri consueverunt in die ascensionis Domini, quae, ut dictum fuit, ad summa. ducatorum centum, et quinquaginta saequis ascendu[nt], quaru. quide eleemosinarum computa Ser.mus Dux Mantuae rettineri facit, et pecuniae aliquae non expenduntur, nisi cum subscriptione deputatoru. praesidentium Eleemosinarum pta.r computa ipse R.mus D. Vis.or aliter non vidit, quia fabrica ipsa sub immediata protectione ipsius Ser.mi Ducis existit, et eleemosinae quae offeruntur proveniunt à subditis, eius status, et dominij [?], et diligentia, ac maxima pietate celsitudinis suae Eleemosinae aliunde provenientes, et quae in ipsa Ecclesia habentur inter Canonicos, et Capellanos distribuuntur. ... Quibus peractis se contulit ad Sacristiam dictae Ecclesiae quam visitavit, et vidit eam satis ornatam, et fulsitam quibuscumq. paramentis, et ornamentis pro divino cultu necessarijs, viditq. omnes libros, calices plurea, paramenta, planetas, pluvinalia, corporalia, missalia, et breviaria reformata, quae omnia cum benè se haberent, et essent munda, nitida, et ornata, ac in bono et laudabilit statu, laudavit summopere sacristam, qui inibi rettinetur ad curam Sacritiae cum Salario scutor. trium quolibet mense de redditibus Sachristae, et ipse deputatur, et pro libito ammovetur per R.du. D. Primicerium, et Canonicos. ...

## DIE TERTIA DECEMBRIS

Suprascriptus R.mus D. Vis.or eius visitationem proseguendo se contulit ad visitationem coemeterij, quod cum vidisset, et muris circumcinctum et porta lignea claudi consuetem ipsumq. esse mundum et nitidum, et nihil occurrere ordinandum in eo, nisi, quod in medio coemeterij apponatur Crux super pilastrello de lapidibus construendo, seù columna marmorea ibidem apponenda altitudinis congruentis, ita ut ab omnibus videri possit inde recessit. Et se contulit ad visitationem domor. canonicalium, in quibus omnes Canonici, Capellani, et Clerici cohabitant, mansiones tamen ab invicem separatas, et distinctas habentes. ...

Qui R.mus D. Visitator habitu colloquio cum Ser.mo Duce, sub cuius protectione est fabrica ipsa declaravit, et ordinavit impensam p.tam huiusq. supportatam per ipsos R.R. DD. Canonicos, Cap.lu., Capellanos, et alios beneficiatos p.tos de coetero fieri, et supportari per fabricam dictae Ecclesiae respectu tertiae partis, respectu tertiae supporta. per R. D. Primicerium, et pro alia tertia per ipsos Rever. DD. Canonicos, Cap.lu., Capellanos, et alios beneficiatos.

Et cum deinde Indem R.mus D. Visitator vidisset ante portam ipsius ecclesiae S.ti Andreae maximum numerum appothecarum etiam de assidibus, et tabulis ligneis magna ex parte confectarum, et maximum inconveniens esse, quod in atria ipsius Ecclesiae traficus, et mercimoniae debere et alterius similia non apponi, sed plateoleam ipsam seù potius atrium dictae Ecclesiae debere perpetua liberam, et expedita. remanere, super quor. executionem, at R.mi D. Ep.i, et R.di D. Primicerij, de dictae Ecclesiae Canonicor. conscientias pergravavit. Et cum eidem R.mo D. Visitatori dictum fuerit, quod in [?] in quem appothechae removerentur per vicinos et alios pios Christi fideles plateola ipsa coate ferrea ad instar plateae la piazza del formento nuncupatae circumdabitur, et prout erat anteg. appothecae huoi apponerentur.

Mandavit, et ordanivit, quod R.mus Ep.us, R.D. Primicerius, et Canonici etiam cum concilio, et auxilio Ser.mi Ducis, qui se paratum obtulit, et non est defuturus omnino provideant, quod ne dum appothecae ipsae inde ammoveantur, sed quod plateola ipsa circumdetur, aptitur, et in pristinum reponatur.

ASA, scaff. A

11) Ill.tre sig.or m.

Io otolto uno marangon co me e siamo andato asaminar la paredana della testada d.la chiesa de s.to Andrea per veder se si potese remediar di conciarla repesarla come mea comisa V. S. ma trovamo andaria spesa varii tanto me si fese di novo per chi livole ponti e fatura asa che saria una spesa trata via per li asa marci se vedere e vadesi delli ase vechi da meterli da baso etorne se no cento di novi el telaro nō sapemo come stia a marzo o borij si che nō se levea vie li vechie & dir bisognave dire che spesa m.dma a farla nō se puo dirlo nō se vede tuto el mal porio dir asa e poria andar mancho e forsi piu le stada reconoia una detta volta delli ase vechi adoperarli da baso quo listi per gli comisuri in cambio d cantineli di dentro per li straventi di laqua e del fredo si che v. s. termina quello che melio qui soto metero la spesa ala melio che si puo ali 14 novembre 1580

p.o. sitora ase cento largi piu che 5ı puo acio sin manco co misuri per laqua qui

| | |
|---|---|
| in mantova vole soldi quaranta | 200 — 0 |
| chiodaria metero il parer mo nō so farlo giusto | 34 — 0 |
| uno paro di scale legieri di . . . farli novi | 9 — 0 |
| . . . i ponti di piella boni | 34 — 8 |

fata vede ali marangoni che cosa vole della fatura tuti toca di scuti quindecima quando se vora farla alora se fermara poi el mancho le vera che ellanori in comodo

alto piu di braza sesanta li ponti va fati in aiero alti e andar su queli scali a lumacha loro dice asa fatica      90 — 0

        367/8/0

Cesar pedemonti
ASM, AG, 2611

12) 1580.3.Xbre
Si e veduta la paradana di S.to Andrea la qual' ha molto

bisogno di esser repparata, accio il essa col Poggio no 'marciscano et sarebbe grandiss.a spesa, Il disegno della detta Paredana V. S. l'havra co'la parte insieme co'la notta della spesa che Illma cosi puo far, cosi considerata dal Pedemonte soprastante che [scudi] 367, [soldi] 8, puotra V. S. farlo saper a, S. A. accio la coma' di quanto la piaceva che si facia, che mons.r Primicerio ne'fa instancia. . . .
ASM, AG, 2611

# Appendix IV

1) . . . ho dato principio alli disegni di Sant' Andrea et farò anco quelli della cappella di santo Francesco et anco starò in ordine quando però la resti servita V. A. S.ma servirsi di me a fiorenza o dove la mi commanderà, et con questo restero di continuo pregando Nostro Signor Iddio gli dia lunga vita et felicità. di Roma el dì 4 di febraro 1589
Carlo Lombardi

A. Bertolotti, *Artisti in relazione coi Gonzaga Signori di Mantova* (Modena, 1885), p. 67

2) 1597
partendosi di Mantova a' ventiotto di Luglio, doppo haver fatte le solite christiane preparationi: ordinando frà l'altre cose, che si ripigliasse, & proseguisse la fabrica del Coro di Sant' Andrea, conforme all'antico disegno del Marchese Lodovico secondo: al che fù dato principio a ventisette d'Agosto dal Primicerio Petrozanni, che n'hebbe il carico principale.
Ippolito Donesmondi, *dell'Istoria Ecclesiastica di Mantova*, vol. 2 (Mantua, 1616), p. 344

3) 1600
nel qual tempo essendosi già per tre anni continuamente lavorato intorno alla fabrica di Sant' Andrea, fu ridotta a quel termine di perfettione, che al presente hà, per la diligenza usatavi dal Primicerio Petrozanni, che v'impiego anche del suo parecchie migliaia di scudi. Et occorse, che cavandosi sotterra per aggrandire il luogo, ove si conserva il santissimo Sangue, trovarono non molto lungi da quello un sasso di bianchissimo marmo, . . . in cui era impresse le piante d'un huomo di commune statura. . . .

Donesmondi, vol. 2, p. 359

4) Nel seguente poi, hebbe compimento il corpo d'essa Chiesa, restandovi il Coro, che fù possia fatto, come si dirà. Et perche da auttori gravissimi, e specialmente dal Vasari sopra modo intendente dall'architettura, ella viene annoverata trà le fabriche notabili, che sono in Italia, perciò non voglio restar di farne qualche distinta descrittione, come meglio saprò, in gratia di quelli, che mai l'hanno veduta. E adunque il sopradetto tempio tutto di terra cotta, in forma di Croce, con un volto solo, che forma la parte inferiore di quella, sovraposto al corpo maggiore della Chiesa: lungo braccia cento quattro, è largo braccia quaranta, senza catena alcuno di ferro, ò legno, che lo sostenti; & è tutto d'opera composita, havendo nell'ordine d'esso corpo, che lo regge, tre capelle grandi per ogni parte, & altrettante picciole, fatte ne' pilastroni, con le colonne, il Zocco delle quali è alto un braccio in circa, & i suoi pedestalli per la terza parte d'esse colonne; l'architrave poi, fregio, gocciolatoio con debita proportione sono la quinta parte dell'altezza della predete colonne, compresevi le basi, & i capitelli. Il corniciamento ricinge nella parte superiore tutta la Chiesa, Cupola, e Coro; & il pavimento delle Capelle è più alto del corpo maggiore quasi tre piedi, e nelle braccia della Croce vi sono due Capelle per ciascuno, opposte l'una all'altra. Il mezo poi del quadrato, dove si deve fabricar la cupola, è largo braccia presso à quaranta, e nelli cantoni de' quadri circostanti al predetto quadrato vi sono quattro pilastroni della medesima larghezza, con i suoi spacij dentro proportionati. Oltre il quadrato della cupola, vi è il Coro di forma ovale, lungo braccia cinquanta due, e largo quanto è il corpo della Chiesa, il quale con il predetto quadro fù l'anno del Salvatore mille seicento, fornito sino alli ultimi corniciamenti, conforme al modello

antico. La fabrica tutta, per la fortezza sua, accenna alla perpetuità, essendo i pilastroni, i quali reggono tutta la machina, della larghezza, già dette; con i lumi incavati per la Chiesa in essi sopra alle capelle picciole, oltre i vaghi, & artificiosi loro ornamenti, con tutto il rimanente, e specialmente nella faciata di fuori, ove è una bellissima loggia di tre volte, con le colonne, e frontispicio proportionati, e con tre porte, la maggior delle quali, che è nel mezo, è ornata di marmi bigi, lavorati anch'essi. Frà le portelle, & la porta maggiore vi sono due pietre grandi di marmo bianco nel muro, una per parte, con lettere intagliate di carattere Romano. ... è d'avvertire, che ambedue furono fatto al tempo di Francisco primo Signor di Mantova, quando l'Abbate Antonio Nerli fece fabricare di nuovo la facciata della Chiesa (come all'hora si disse) le quali poi nel rifarsi quest'ultima volta la stessa facciata, furono riposto nel medesimo luogo di prima.
Donesmondi, vol. 2, p. 43f.

5) 1595
adi 13 d.o. [maggio] spesa in fare accomodare il [?] dell'altare del sangue di N. Sre.
adi 20 d.o. spesa in 3 cenaprio p. fare il paglio di Assi p. l'altare da basso
adi 21 d.o. per havere fatto rosso il pali di assi p. l'altare da basso. ...
ASA, scaff. C, busta XX

6) 1595
adi 31 d.o. [ottobre] spesa in fare discoprire l'ochio della Capella di Sto. Longino. ...
adi 4 9bre 1595 spesa in fare reffare l'ochio della vedreada sopra la Cap.a di S.to Longino. ...
ASA, scaff. C, busta XX

7) 1596
adi 10 d.o. [luglio] spese in fare fare un ponte all'ochi grande delle Chiesa p. accomodari li finistrelli della vedrado. ...
ASA, scaff. C, busta XX

8) 8 Aprile 1603
... Quod in Ecca.pred.a: sancti And.a in Sacello seu subterraneo sanctuario, ubi sacratis: et E.que pretiosissimus ... sanguis D. N.ri Iesu Xpi, Dei et Redemptoris n.ri. colebrentur et colebrati debeant omni et singulo die in perpetuum duedecim misse. omnes a Mortuis, si, et quando tempus patiet, pro anima ipsius D. Ducis, et alior. Fidelu. defuntor, di domo sua de Gonzaga.
ASM, AG, P. 3302

9) 26 December 1609
Donatio facta per ill.mum R.mum D. Primicerium Tullium Petrozanum Ser.mi D. Cons. ... S.ti Andree Mantue. Anno D. millimo sex.mo nono ... die ... Mercurij vig.ma sestia mis. Decemb. Ibi Ill.mus et R.mus D. Tullius filius ... Zynobij Petrozanni Ser.mi D. Cons. Primiceriusque Eccl. Coll. S.ti Andree Mantue ... dedit ... et consegnavit cum ea expressa conditione ... paramentum, et libros ut

in dicta lista donatos in Eccl.a p.ta ... pro usu altaris Capelle per d. Primicerio in d.a Eccl.a constituta, et non alibi. ...
ASA, scaff. C

10) Extracts from the Testament of Vincenzo Gonzaga
Corpus verum suum, sive cadaver sepelliri voluit et mandavit in capella inferiori subterranea, ubi in collegiata ecclesia S.ti Andreae Mantue reconditur sacratissimus Sanguis D. N. Jesus Cristi, cuius ecclesiae ... est de iure patronatus suae Cels.is. ...

Quod quidem Cadaver sepelleatur, et sepellire voluit, et mandavit, non quidem ut moris est iacendo, sed sedendo, cum suo ense apposito super catedra marmorea ad hoc parata, nullo autem modo in arca lignea includatur, et reponatur in Camerino, in quo iacet corpus S.ma D. D. Eleanora Ducessa Mantue eius uxoris dilectissimae, et prope arcam ligneam. ...

Quam quidem dictae ecclesiae capellam inferiorem iam ampliatam tantum quantum caput circumferentia interior capella maioris, qua in bona parte est completa, et esset finienda, ornari mandavit cum incrostaturis marmoris, et cum sepulcris marmoreis Principum familiae Gonzagiae, Incipiendo ab Aloisio Gonzag. antiquiore, a quo Mantua et sui status dominatio capit in lombardie partibus, et postea in hunc usque diem feleciter conservatur, et aucta et inclusive et seguendo usque ad ipsum Ser.m D.num testatorem, Jugendo cuique sepulcro immaginem, et memoriam uxoris singulorum ipsorum principum, illius scilicet, a qua linea Principum, seu primogenitura processit. In quibus sepulcris ponatur sigillatim Cadavera et Cineres respective praefati d. testatoris, eo modo quosupra dictum fuit, e aliorum imaginorum Principum cum uxoribus statuis et Immaginibus marmoreis supra cum armis et insignibus familiae, qua viventis detulerunt, et pro temporis antiquitate inveniri poterunt.
1612, 3. Febrij
ASM, AG, 330, D. VI, 1

11) Lunedi 8 febb. 1677
L.Ill.mo et Ecc.mo S. Marce Rizzardo Hippoliti delli Co. di Gazoldo Cav.ro Mag.e di S.A.S., e del suo Cons.o riservato stando nel suo solito Palagio, com.e a me infra Not.o di far nota come Comanda il Ser.mo Prone., che il S. A. Pres.te del Maest.e faccia subite chamare a se li D.i Heredi Porri, fran.o Malpizzi, e gli altri interessati, e prelendenti d'havere rationi nel sito controverso [?] la fabrica di S. And.a di q.ta Citta, p. il che non si può tirare avanti la med.a fabrica, et assignargli un termine p. emptorio di quindeci giorni pross.mi a dedurre in iure, et in facto le loro rag.ni, spirati li quali il med.o S. Co. Pres.te su le ragioni addotte dovera farne all'A.S. una distinta relatione colli fondam.ti p possia med.a Alt.za risolvere quando gli la dettara il sovrano suo intendim.to appoggiato sempre alla giustitia, tal essendo la sua precisa mente.
ASM, AG, P. 3303 bis

12) Venerdi 16 luglio 1677
L'Ill.mo sig. Co: Girolamo Magno Seg.lio di Stato, di S.A.S. stando nella Corte della med.ma Altezza Com. a me infrato Notaro di raf. nota, come Havendo il Ser.mo Sig. Duca Prone fatta leggere, id maturamente considerare in pieno Consiglio la relatione fatta dal sig. Co: Presid. del Maestrato sopra le rag.ni risultanti dalle Investiture concesse a Sig.li Porri, it altri Mercanti di quest Citta, a loro rag.ni addotte p. esimersi dall'obligat.ne, alla quale per parte del Patriomoniale della Ducal Camera e stata fatta instanta, che siano tenuti di cedere alcuni siti di Muraglie, Corticelle, et altri luoghi posti nelle loro Case, e Botteghe contigue alla Chiesa Collegiata di S: Andrea, affinche si possa proseguire, et perfettione la fabrica d'essa Chiesa. Col parere dell' accennato Cons.o, S. A. S. vuole, et espressamente commanda che dal pred: to Sig. Co. Presid.e del Maestrato venga ordinato subito a Med:mi Sig.ri Mercanti interessati di cedere senza contraditione li siti, come sopra l'effetto sodetto, sotto quelle pene, che a lui parerano piu propie, senza ammettere alcuna oppositione, che vaglia a ritardare questa ben precisa, et assoluta volonta dell A. S. Altro in contrario non ostante.
ASM, AG, P. 3303 bis

# Appendix V

1) Relazione Distinta De I Disegni Della Chiesa Di S. Andrea Di Mantova
Pianta di tutta la Chiesa è quella che hà la Scala di piedi 100, misura di Bologna.
Spaccato della pianta sudetta è quello che hà la Scala di piedi 80 di Bologna. Alzata per di fuori della Testa della Chiesa dalla parte verso il Coro, con i fianchi laterali delle facciate delli bracci della pianta sudetta, che fanno croce, è quella che hà la Scala di piedi 60 di Bologna. Il disegno delle tre facciate per di fuori è quello che hà la Scala di piedi 40 di Bologna.
Armadura del Coperto è quell, che hà la Scala di piedi 50 di Bologna.

Auvertimenti Alli Disegni
Primo si deve auvertire, che le pilastrate disegnate nella pianta di tutta la Navata grande del Corpo della Chiesa tutte vanno mosse in parte dal luogo, cioè parte vanno ristrette, e parte vanno allargate, mà tutte vanno tagliate dalle parte dell'imboccatura delle Capelle per allargare le medeme, e sono quelle segnate alla lettera A., e quelle delli pilastroni della Cupola vanno tagliate dove sono le lasene segnate alla lettera B. per far le medeme più grande. Secondo le pilastrate dell'imboccatura del Coro di presente non fanno risalto nel Coro, e nel disegno pretenderia che ve ne fosse, e per far detto risalto, e non voler restringere la sudetta imboccatura, che purtroppo è stretta, và tagliato il muro del Coro ingiro tanto, che nascono i risalti, che mostrano i disegni.
Terzo il Confessio, che di presente si [tr]ova, à mio parere hà dell'impossibile il poter conservarlo, è di necessità il riempirlo per due capi, la ragione del primo è che quel vano trà li piloni, dove và eretta la Cupola, overo Catino, non bisogna, che sia voto, nemeno i piloni devono essere disuniti con quelle Scale, e porte, che di presente si trovano, mà bisogna, che siano tutti pieni, e di buon muro. La seconda è non esser luogo a proposito, perche volendo illuminare il detto, è di necessità le finestre per il suolo della Chiesa, & è cosa, che non stà bene in luogo sacro vi si chi camina sotto, e sopra con commodo di veder un sotto l'altro senza esser veduto. Quarto dovendosi ergere il Catino, overo la Cupola sopra i quattro piloni, e non volendo perdere quel commodo di quelle quattro Scale lumache, che sono fatte nelli detti; sopra di questo ne hò fatto gran reflessione, & hò trovato esser meglio il far la Cupola appresso di me di nuova invenzione alla forma, che mostra il disegno, essendo cosa assai più galante di quello possa essere qualsivoglia Catino, il qual disegno mostra, che quando son fatti gl'Arconi nel modo, e misura, che mostra lo Spacato, e che sopra à quelli sul labro delli quattro arconi il farli una balaustrata con sue Statue, e poi ritirarsi tanto in dentro con il muro della Cupola tanto vi resta un sito commodo da passegiare intorno alla detta la quale fà due effetti, uno si allarga la Cupola, che resta più grande, e la balaustrata vieni più ad ornare, & è fuori di modo che sino ad hora si sono fatte tal sorte di fabriche. Circa poi alla sustanza della fabrica non và dubbio alcuno che essendo quella eretta quasi nel mezzo degli Arconi li detti fanno la sua forza eguale a conseguentemente non sforzano, ne calcano i piloni più da una parte, che dall'altra, e nelli

quattro angoli delli Arconi resta più vicino al [?] vivo delli pilastroni sudetti la sudetta Cupola.

Quinto le porte segnate la lettera C. sono le porte delle Sagrestie, dove sopra si vanno collocati li Organi. Sesto la pianta segnata la lettera D. è il Campanile vecchio da distruggere. Settimo la pianta segnata la lettera E. è il Campanile da farsi.

2) Il Profilo del Corpo della Chiesa, con le Capelline, piante, e facciate delle Lunette per il di fuori, è quello, che hà la Scala di piede 60. misura di Bologna. Dovendosi fare li Lunetoni alla Chiesa di S. Andrea, alla forma, che mostrano li Disegni, da me fatti; cioè che trà un Lunetone, e l'altro, nel dritto delle pilastrate, che ornano detta Chiesa, se li deve fare il suo sott'Arco, ò fascione, sotto il detto volto, alla forma del dissegno già fatto, e come ancora del presente, dove mostra alla Lettera A., sì nella Pianta, come nell'alzata; li quali sott'Archi, ò fascioni si devono immorsare nel volto; ed anco mettervi in distanza di 5. ò in 6 brazza al più, Chiavaselle di ferro, che tengano unito li detti con volto vecchio; quali Chiavaselle devono passare sopra il volto, cioè nel sito, segnato alla Lettera B. e B. comi si vede la detta Chiavasella segnata con la Lettera C., andando poi verso la Lettera D., dette Chiavaselle devono esser fatte, e immorsate nel volto, come mostra la Lettera E., mà poi saldato in gesso ben fresco. Ciò fatto diligentemente si devono poi ingrossare li muri, che tramezzano le Capelle piccole dalle grandi, e si devono ingrossare, e ridurre alla grosezza, che mostra il colore giallo, e le quattro Lettere F.G.H.I. sopra de i quali si devono creare li Speroni alla forma, e altezza, che mostrano le alzate alla Lettera K., non ostante questo si deve ingrossare, e ridurlo alla grosezza il muro della Chiesa dalla parte dell'ingresso delle Capelle piccole, che viene ad'esser contro alli fascioni, detti di sopra, come mostra il dissegno dalla Lettera L. alla Lettera M., che è per la grosezza del muro, e deve esser detta grosezza di longhezza, per quanto tiene la larghezza della Capella piccola, è la grosezza delli due Speroni, cioè dalla Lettera N. alla Lettera O.; e vanno alzati così grossi, sino al pari delli Speroni; e per far questo, pare, che il dissegno mostrì esser necessario il formare le Cupolette alle Capelle piccole; Se si farà, sarà meglio, ma non volendolo fare, basta il voltare un Arcone, dove mostra il Dissegno alla Lettera P. segnato di ponti, fatto sul mezzo tondo e ponervi una Chiave di ferro, dove mostra il dissegno alla Lettera Q., qual chiave deve essere di spiagione di peso di lib. 15. per ogni brazzo Mantovano; e li polzoni fatti di quadrone di ferro, longhi un brazzo, e mezzo, e di peso li. 32. pr. ogni brazzo; mà sia ferro ben schietto, e poi le chiavi ben bollite dal Fabro, che in tal maniera parmi, che il volto sia assicurato da potervi fare li finestroni, e similmente li Lunetoni. Fatto dunque tutti li soprascritti lavorieri, si deve venire alla fabrica delli Lunetoni, a Fenestroni, e per far detti, prima è necessario il fare il Ponte per li Muratori nella Chiesa sopra il Corniciotto della medema, che vadi da un muro all'altro, con suoi

dritti, distanti uno dall'altro, alla forma, che si fecero li ponti per fare le Volte nuove, si nel Coro, come nelli braccij di detta Chiesa, e devono esser radoppiati, e devono essere ben stuccati sotto al Volto vecchio di detta Chiesa, che fatto questo, si deve poi rompere, e voltare li Arconi delli Fenestroni à pezzo, apezzo, mà ben murati, e li Arconi ben striccati, che havendo poi terminato questo, si verrà similmente all'opera di tagliare li Lunetoni nel Volto vecchio, e suoi rinfianchi, il qual taglio si principierà dalla parte del Fenestrone, e se ne taglierà di larghezza trè brazza per volta, fatto che sarà il taglio, si dovrà subito fare la sua Volta nuova à detto Lunetone, lasciando sempre la morsa dalla parte, dove và seguitato il taglio, per poter compire detto Lunettone; quali Lunettoni, e Fenestroni vanno fatti due alla volta, uno di rincontro all'altro; terminato questo; si principierà poi à lentare à poco, à poco, li dritti del ponte detti di sopra, che tengono armato detta Volta. Esseguito tutto questo, io crederei, che fosse assicurato il Volto, e assieme illuminata, e ornata la Chiesa, che è l'oggetto, per il quale si fà detta Fabrica etc.

ASA

3) PRIMO ANNO
Conto dimostrativo dell'impiego fatto delle Lire cento trenta sei mille, duecent'ottanta nove, e Soldi tre, che dalla Pietà Christiana sono state offerte in Contanti e Matteriali come sotto, al detto Pretiosissimo Sangue per la fabrica di S. Andrea di Mantova per l'Anno 1697; che si è ripigliata la fabrica stessa, e sino a' 31 Marzo 1698—inclusive nelle seguenti fatture, come nel Libro Maestro della fabrica, a' carte 31—
La Fabrica fatta come sopra nella Chiesa di S. Andrea, consiste che doppo piantato il Ponte nel Coro tutto di Legname di Monte di Trani da 45. radopiati sino alla sommità del Volto, et incatenato di Legni do 40; e da 36; si sono alzati, e terminati li quattro Speroni, che fiancheggiano il Volto, con Brazza venti di Longhezza di Muraglia per ciascheduno Sperone, B.a 5. di grossezza, e B.a 22 di Altezza, e fatto il Volto del Coro, che è di longhezza B.a 24½ e di giro B.a 63.2; con la Cappa del Coro, Arcone, Arconcello, e fassone, qual Volto è di Grosezza due Brazza, cioè di sei teste. Terminata la qual' opera, col suo coperto di Coppi, senza Travatura fù dato principio li 17 Agosto 1697 a risarcire le Muraglie verso la Piazza, che notabilmente erano danificate, essendo convenab. riffare gran parte de fondamenti, con l'alzamento della muraglia, sino al principio della Cornice, che ascende la sua altezza a' B.a 30; delli quali n'erano in essere circa B.a 8. però in gran parte distrutta, qual muraglia è grossa sette teste, con haver poi accresciuti li due Pilloni Latterali a detta Muraglia, e riffondato altro Pillone del Pozzone, e fatt' un altro Pillone, contiguo alla Bottega del S.r Gio. Tran. Moro da fondamenti, sino alla sommità della Capella, che a caggione d'una scala, è convenuto con gran spesa asicurarlo nel modo che al presente si trova.

SECONDO ANNO

Conto dimostrativo dell' impiego delle L. 64497.18, che dalla pietà Christiana sono state offerte in contanti, e matteriali, come sotto al Pret.mo Sangue di Giesù Christo Nostro Redentore per la fabrica di S. Andrea, e per l'anno 1698; che è il secondo della detta fabrica, recominciata li 12 Maggio, e per tutto il mese di Dec.re, come nel libro Maestro della fabrica.—

Si diede principio alla fabrica dalla parte verso Li Portici, e prima si piantò il Ponte reale simile a quello dell' anno pasato; sino alla somità del Volto, doppo di questo si principiò alzare li due Pilastroni laterali verso la Piazza longhi per cadauno B.a 22.6; e larghi B.a 12; con due Pozzoni nelli cantoni di q.lli alti B.a 22. per uno, compreso la cornice, che li gira d' attorno, si alzò la Muraglia di faciata, col gran finestrone nel mezo, si alzavano li altri due Piloni verso la Chiesa, dove vi sono le due scale a lumaga, si sone fatte le due muraglie sopra le due Capella Laterali, con le due Arcate, sopra le quali gira la cornice d' intorno, si è disfatto la Cornice Vecchia ch'era posto sul falso, et si è principiato l'architrave nuovo sopra quello, il friso, e poi il suo cornicione, secondo la Sagoma nuova del disegno del S.r Torri Architetto. Di poi si cominciò il gran Volto Longo B.a 27.4; e di giro B.a 63.2; con le sue fasse, e controfasse come si vede dal disegno; è grosso detto Volto sei teste, tutto fiancheggiato con Muraglie fatte pienne, con sua pendenza coperta di Coppi, senz' alcuna travatura, si alzò il frontespicio a' ramenato con la sua Cornice per coprire la pendenza de' Coppi, con havervi alzato nel mezo il suo piedestale di Marmo per porvi La Croce, e terminato questo si è piantato il Ponte Maestro nell' altr' ala verso la Canonica, sino alla somità del Cornicione vecchio.—

TERZO ANNO

Conto dimostrativo dell' impiego delle L. 46224.4. state offerte in Contanti, e Materiali per la fabrica di S. Andrea dell' anno 1699; ricominciata li 3. Aprile per tutto Decembre, come nel libro Maestro della fabrica.

Si principiò la fabrica dalla parte verso la Canonica col alzamento intiero del Ponte Reale, cioè dal Cornicione vecchio, sino alla sommità del Volto, fatto questo si comminciò a disfare il pezzo di Muraglia sopr' il detto Cornicione vecchio col disfacimento ancora del medemo Cornicione, tanto da una parte, come dall' altra, qual' era posto sul falso, come quello dell' anno scorso, dippoi si cominciò l'architrave nuovo, simile al già fatto l'anno scorso, sopr' il quale si è proseguito col suo freggio, e poi il Cornicione nuovo alla forma del dissegno del S.r Architetto Torri, terminato il quale, si principiò attorno li due Latti alzare le due muraglie laterali grosse ciascuna B.a 5. con la facciata, la longhezza del qual sito, e Larghezza è simile a quella fatta l'anno scorso, poi si è disfatto li due pilastroni con la Cornice vecchia che traversava la facciata, sino al piano della Chiesa, si continuò poi alzare li quattro Pilastroni laterali, ove sono quattro scale a Lumaca, che si sono alzate simili a quelle verso la Piazza, si alzavano le due Muraglie di fuori con sue arcate per dar lume alle meze Lunete,

sopr'esse muraglie vi è il Cornicione che gira d'attorno. Si alzò il frontespicio della facciata, conforme il dissegno con due Cartelloni grandi, e due Cartelle piccole per accompagnare le muraglie laterali, poi si principiò il gran Volto longo B.a 27.74; di giro B.a 63.72. con fasse, e contrafasse grosso sei teste, tutto fiancheggiato con muraglie, con pendenza, e coperto di Coppi, e si sono coperte tutte le Muraglie d'attorno di Coppi con Corvici, di poi si disfece il Coperto Vecchio levata la travatura, e dalata abbasso, disfatto il Coperto sopra l'atrio abbasati li Pilloni avanti la facciata, e di nuovo rifatto detto Coperto più basso, perche prima occupava gran parte del finestrone, e coperto di nuovo le due Capelle latterali di S. Stefano e S. Carlo, con haver riagiustati tutti li coperti vecchi attorno detto braccio di Chiesa per la stessa fabrica.

QUARTO ANNO

Conto dimostrativo delle L. 14905.1, state offerte da diversi Divoti in contanti, e materiali per la fabrica di S. Andrea dell'anno 1700—

ricominciata li 25 Genaro per tutto li 15 Dicembre, come al libro della fabrica—Cominciossi bagnando Calcina, riffondendo, e nettando il Pozzo della Canonica per il bagnamento di essa Calcina, rasicando, e squadrando diversi Legni d'Arice per far li Telari delli finestroni, stabilito il Volto grande verso la Canonica, et imbianchito, con diverse altre piccole fatture di rapezzamenti ...

QUINTO ANNO

Conto dimostrativo dell'impiego delle L. 35219.2. che si sono havute d'elemosina da diversi Divoti in Contanti, e Materiali per la fabrica di S. Andrea, ricominciata li 6. Maggio 1701; per tutto il primo Marzo 1702—

Si principiò la fabrica, col disfacimento delli Corniccioni sott'il piede del primo Arcone verso il Coro, riffacendo li Cornicioni medemi secondo la nova sagoma, ò modello havendo prima fatto il Ponte tutto di nuovo, facendo di poi l'arcone sudetto alla parte del Coro di grosezza teste quatordeci, terminato, et appianato di sopra il qual arcone si fece il gran parte dimezo per disfare il coperto vec.hio, e si alzavono li sedici Pilastroni, otto sopr'il detto arcone, et altrui otto sopr'il Volto Vecchio, et havendo disfatto tutto il coperto Vecchio, si fece il coperto grande nuove, coprendo ancora le quattro scale latterale a limacca. Murando frà un Pilastrone, e l'altro, et alzando le due muraglie di frontispicio, e quelle coperte, disfatte le due muraglie laterali che sostenevano il coperto vechio stabilito il detto Arcone, disfatto il sudetto gran ponte, et unito il Legname in Chiesa, e nel latterale verso la Piazza, risarciti li salicati, dove si ruppe per piantare li Legni del ponte, e nel fare l'arcone sudetto si è alzato il principio delli altrui due Arconi, che devono corispondere, e quest'alzamento in altezza di circa Brazza dieci per esser meglio concatenati, quando a Dio piacerà dar il modo, che si faccino gli altrui arconi.—

SESTO ANNO

Conto dimostrativo delle L. 15353.17. havute da diversi

Divoti per la continovazione della fabrica di S. Andrea, ricominciata le 20. Giugno 1702.—

Si principiò a piantare il Ponte nella facciata maggiore del di dentro della Chiesa per ridurla simile a quelle delli due Bracci, e Secondo dimostra il Dissegno, con haver atterato il Corniccioto che si trovava nella medema, con li due Colonati tra la porta grande, e le due piccole, e rifatti nelli due Angoli li Cornicciotti nuovi, come il Dissegno. fatto l'arcone sotto l'Arconcello, e rifatto il finestrone di tondo in quadro longo B.a 8; et alto B.a 18; tirato la facciata a piombo dalla cima, sino sopra la finestra della Porta maggiore già turato, come anche due Nicchi, che erano sopra le portelle in molt'altezza, e furono fatti li sei spivelli, con le sue Vetriate di Cristallo. Alli 15. Luglio 1702. si levò la Campana, e fu portata indisparte, a causa di detto Ponte, e con tal occasione si tocò, e fu trovato rotta, ma non ostante haveva un suonoro tuono, in presenza del S.r Marchese Claudio Gonzaga, e di Monsignor Primicerio Bonaventura Guerrieri Deputati di S.A.S. sopra la fabrica. Li 30 Genaro 1703. si disfece il Ponte, et alli [?] Febraro si posevo li due lavelli tra la Porta maggiore, e le due picole per tenere la Chiesa più libera, et in fine si fecerò le sei Ramate di filo di ferro sopra li sei spivelli del sudetto finestrone.—

SETTIMO ANNO
Nel settimo Anno 1704; no si è fatto altro, che far ponere sopr'il Tetto, dove va eretta la Cupola, la Croce, con l'Effigie di San Longino.—

Doppo il settimo anno, da Genaro 1705; ad Aprile 1710— si è comprato il sitto dal S.r Marchese Allessandro Mainoldi, e ridotta in forma di Arsenale da riponere le robbe attinenti alla fabrica per il valore di Scuti duecento cinquanta, e con l'anno livello di L. 44.4.3. che si paga al Primiceriato di S. Andrea, e inoltre si sono riportati verso l'Altare Maggiore li Scalini, ch'erano vicini alla Capella di S. Longino, abassando, e conducendo via il Ter.eno, allargate le finestre delle ferrate del sotterraneo,

et aggiontatone delle altre, prezzo, e fattura delli marmi per la nuova Scalinata dell'Altare Maggiore, etc.— ASA

4) 1692 23 febraio
Ser:mo Altezza
Li Agenti del Ven. Collg.o di S:to Andrea Ser:ri Umilis:mi di V. A. Ser. riverentemente li rapresentano, come la Fabrica di d:ta Chiesa minacia nelli Tetti grande ruina, piovendo in più luoghi, onde p. loro scarico, ne pongono questo ricordo all'A.V.S. acciò il degni ordinare alli superiori d'essa Fabrica che proveddano oportunamente . . . .
ASM, AG, P. 3303 bis

5) 1696. 15. Xbre
Eravi in questo tempo sù l'argine di questa Città un magazeno della polvere, i cui materiali per l'ammontare di cinquecento migliara di pietre furono donati dal Ser.mo Duca di Mantova alla fabbrica da intraprenderà nella Chiesa di Sant' Andrea. . . .
ASM, AG, P. 3303 bis

6) 1696. 17. Xbre
Commissione del Sig. Marchese Claudio Gonzaga, autorizato dalla Convocazione sopra la Fabbrica di S. Andrea, al Sig. Gio. Battista Ardenna Regolatore per spedire il mandato al Mastro Muratore Francesco Bianchi sud.o di L. 900. accordategli di anticipazione per il disfacimento; e condotta alla Chiesa di Sant' Andrea delle Pietre del *Torrione dell'argine*, delle quali ha fatto dono il d.o Duca alla d.a Fabbrica. . . .
ASM, AG, P. 3303 bis

7) 1708 in giugno
Fu eretto il nuovo altare maggiore in S. Andrea. . . .
ASM, AG, P. 3303 bis

# Appendix VI

1) Carlo Sesto
Ill.mo, Diletto Cugino, e P.pe Vostra Dilezione vedrà dall'anno Recapito quel tanto, che abbiamo clementiss.te risolto intorno alla supplica avanzataci da Lei sotto li 22: Gen.o Anno corrente concernente la Chiesa di S. Andrea, a gli ordini stati da Noi spediti sovra tal particolare al Nostro Consiglio Arcano dell'Austria superiore.

Vostra Dilezione farà dunque di ciò consapevole il Primicerio, con avvertirli, che egli da canto suo osservi il tutto essatamente per impedire qualsiasi frode, che con tal occasione potesse venir fatte, e che mandi a Insprug nel modo prescrittogli le specificazioni alle mani del Nostro Consiglio Arcano dell' Austria Superiore, con saper contener a norma de' nostri ordini, E restiamo

Laremburg li 3: Maggio 1732

CARLO
Cioè
Piane 200—grosse di Pezzo
Travi 400: da 45: di Pezzo
Travi 400: da 40: di Pezzo
Boroni 400: di Pezzo
Piane 100: di Larice
Baroni 140: di Larice
ASM, AG, P. 3303 bis

2) Filippo Langravio di Hassia Darmestati Prencipe d'Hirschfelt & Governatore del Ducato di Mantova Supplicati da Monsig. Primicerio di questa Collegiata Arciducale di St. Andrea, a volergli condure la Rocca ruinata e suoi Muri di Canetto affatto inutile alla Camera per valersene in aiuto della Fabbrica della Gran Cupola della Chiesa Medesima, per cui la Maestà dell'Agustissimo Padrone si è degnato di prestare il Clementissimo suo assenso, con effetti di pijssima munificenza, siamo ben volontieri conducessi ad accordargli li materali tutti, che se potranno ricavare dalla Rocca, e Muri sudetti per impiegarli à benefizio d'essa Fabbrica; e però commettiamo al Sig. Consigliere Arcano dell'Austria Superiore Presidente, e Maestrato Arciducale di dare gl'Ordine opportuni, perche sia permesso all'accennato Monsig. Primicerio di servirsi del Materiale della stessa Rocca, e suoi Muri di Canetto, in aiuto come sopra della Fabbrica predetta.... Di Mantova Li 16. Luglio 1732
Filippo Langravio di Hassia
ASA, scaff. C, busta XXII

3) Ier l'altro poi inesivamente all'Idea di comiciar la gran Mole essendo primitivamente state avvisato dallo stesso Monsignor Primicerio, il Sig.r Andrea Galluzzi, Architetto di questa Altezza Ser.ma ed Accademica Clementino perchè s'esaminasse da questi Ingegneri e da altri Periti dell' Arte il modo da tenersi nella Fabbrica, piacque all' Altezza Sua, che in Galleria di Corte fosse tenuta una Assemblea alla presenza di Lei medesima, del Serenissimo Sig. Principe Giuseppe e del Serenissimo Sig. Principe Leopoldo, arrivato qua il dopo pranzo del giorno antecedente dalla Transilvania e coll'intervento di amendue gli Ill.mi ed Ecc.mi Signori presidente del Senato e Maestrato, essendovi anche molta Nobiltà, Matematici ed Ingegneri, ed ivi il predetto Sig. Galluzzi fece un' erudita Dissertazione nella quale colle Piante e Disegni da lui esposti, scansando le difficoltà dell'Architetto Torri, provo ad evidenza potersi stare al primo Disegno lasciato dal famoso Architetto Leon Battista degli Alberti Nobile Fiorentino; e questo suo parere riporto l'approvazione di tutti i Periti ivi presenti e di tutto rèstante dell'Assemblea.
*Gazzetta di Mantova*, 6 June 1732
Guglielmo Pacchioni, "La Cupola di S. Andrea a Mantova e le Pitture di Giorgio Anselmi," *Bolletino d'Arte* 13 (1919), p. 1

4a) Il Card. Albani al Marchese d'Ormea Roma, 1 Marzo 1733
Il Sig.r Abate Basca [sic] Primicerio della Collegiata Arciducale di S. Andrea in Mantova mio parziale, trovandosi impegnato nella Fabrica della nova gran Cupola per quella Chiesa mi ricerca d'interpormi in codesta Corte acciò si dasse licenza al Sig.r Cav. Juvarra di dare colà una scorsa *per riconoscere quell'opera, e specialmente per considerare se i Piloni, che già sono fatti siano capaci di sostenere la Machina che ci va sopra.* Mi dice di più che trattandosi di un'opera, che si fa con elemosine, e contribuzione di Divoti, bramerebbe il Risparmio possibile della spesa per l'Architetto. Quanto al primo punto gli rispondo che passerò l'uffizio, come in fatto ne prego l'E.V., quando però il Sig.r Cav. predetto non si trovi impegnato in qualche opera di S.M.; quanto al secondo mi riporto alla pietà e divozione del med.mo, stimando però che non sia per esservi alcuna difficoltà in ciò che concerne la spesa del suo accesso, recesso e permanenza....

4b) Il Ministro D'Ormea al Cardinale Alessandro Albani li 11 Marzo 1733
Il Sig.r Cav. Juvarra ritrovandosi attualmente ammalato, aspetto che sia ristabilito in sanità per parlargli del desiderio, che s'avrebbe che fosse a visitare la nuova Chiesa arciducale di Mantova, onde mi riserbo di render poi V.E. intesa delle sue risoluzioni, sperando intanto che per parte di S. M. non sia frapporsi impedemento....

4c) Il Ministro d'Ormea al Cardinale Alessandro Albani, li 15 Aprile 1733.
Il Sig.r Abate Juvarra essendosi ristabilito in sanità gli ho spiegato il desiderio, che si ha della sua andata a Mantova per dare il suo giudicio in riguardo alla Gran Cupola, che deve costruersi alla Chiesa Arciducale di S. Andrea, esso si è mostrato disposto di secondare in questa parte le premure di V. E. senza badare all'interesse, ben peruaso per altro che non sia per succedergli come nell' ultimo suo viaggio di Roma, onde sia almeno rinfrancato della spesa....

4d) Il Ministro D'Ormea al Cardinale Alessandro Albani, li 3 Giugno 1733.
Al ritorno del Sig. Abate Juvarra, che presentemente si ritrova fuori di città, gli comunicarò quel tanto che V.E. mi significa in ordine alla sua andata a Mantova ad effetto che possa pigliarne le sue finali risoluzioni....

4e) Il Ministro D'Ormea al Cardinale Allesandro Albani li 19 Agosto 1733.
Il Sig. Abate Juvarra è stato ieri di ritorno da Mantova, dove si è portato per dare il suo sentimento circa la fabrica della Consaputa Chiesa, e mi dice che non solamente è stato rimborsato della spesa, ma anche regallato....

Leonarda Masini, "La Vita e l'Arte di Filippo Juvarra,"

*Atti della Società Piemontese di Archeologia e Belle Arti* 9, no. 2 (1920), pp. 197–299.

5) E partito da questa città ove si trasferì giorni sono il sig. cavaliere Abate D. Filippo Juvarra, famosissimo architetto della Maestà del re di Sardegna che alle fervorose istanze di questo Ill.mo e Rev.mo Primicerio di S. Andrea appoggiate dall'Eminentis.mo Alessandro Albani, ed Ecc.mo Sig. March. d'Ormea, dalla Maestà Sua è stato conceduto per visitare e dare una sicura Idea della Gran Cupola di detta Basilica; come infatti avuta matura considerazione a quanto fin'ora è stato operati, ne ha approvato il tutto, d'indi ha lasciato un vaghissimo Disegno con varie istruzioni perchè colla più suntuosa magnificenza sia innalzata un Opera cotanto ragguardevole che, terminata, sarà una delle più magnifiche del mondo.
*Gazzetta di Mantova* (N. 34, 21 Agosto 1733)

6) 21 Aprile 1758—Verona.
Contratto di Giovanni e Gerolamo Bellavite per la construzione e la collacazio ne a posto di una balla di rame dorata con croce di ferro, stemma di rame nel mezzo co' suoi Ragi dorati ad Asta, osia Perno pur di ferro che posta nel Piedestallo di pietra sopra d'esso vicenio, e parti la d.a Balla e Croce, quale deve essere riposta sopra il Cupolino della gran Cupola di S. Andrea di Mantova.
Pacchioni, 1

7) Spese occorenti in Muratori, e provvista di Materiali per terminare la gran Cupola di St. Andrea Mantova

| | |
|---|---:|
| Per l'Attica esterna per la finizione delli quattro fenestroni rotondi a L 240 cadauno compresivigli occorenti materali | 960 |
| Braccia 160 Cornice a L 10 il B.a. | 1600 |
| Pertiche 24 stabilitura a L 20 la P.a | 480 |
| Otto Candelabri di vivo sopra le Colonne | 8000 |
| Quattro Vasi sopra le finestre rotonde a L 320 caduano | 1280 |
| Braccia 240 Cornicione, ed Architrave a L 80 il B.a | 19200 |
| Riquadratura delle finestre, porre in opera li telaj. e ramate | 2400 |
| A stabilire le otto Colonne a L 90 caduano | 720 |
| Per otto pilastri, e sedice mezzi Pilastri | 1200 |
| Dodici specchiature a L 40 l'una | 480 |
| Braccia 224 di bassamento a L 10 il B.a | 2240 |
| Braccia 224 Cimaza de' Piedestalli a L 5 il B.a | 1120 |
| Per compire le vecchie Scale a lumaca per le quali si possa salire alla Cupola | 8000 |
| Per le quattro Scalette nuove da farsi nelli Piloni del Tamburo della Cupola | 14000 |
| Per ferri occorrenti da fissarsi in giro nel Zoccolo sopra il secondo Cornicione, a cui attaccarsi in caso di ristauri Pesi 80 circa ferro a L 30 il P.o | 2400 |
| Per Braccia 430 Lastra di Marmo per coprire il Cornicione immediatamente sopra li coppi, che a L 20 il B.a, sono | 8600 |
| Pei Ponti, ed attrezzi occorrenti per la formazione de' medesimi | 4320 |
| Sommano in tutto | 85000 |

Mantova a. 30 Agosto 1780
Sottoscrit. Alessandro Vassalli Capo Mast.ro Cam.le
ASA, scaff. C, busta XXV

8) Ill.mi ed Ecc.mi Sig.ri
Dopo l'occorrenza di Ristauro al Seliciato dell'Atrio d'ingresso nel tempio di S. Andrea, rassegnata dal sottoscritto alle SS.rie LL. Ill.me ed Ecc.me fino dalli 28 aprile pp. ed approvata con Loro ossequiata lettera 30 medesimo; accade ora allo stesso sottoscritto di sottoporre con ogni rispetto al R. D. Dicastero d'aver trovati nel disfacimento di quel seiciato i mattoni in coltello per la maggior parte eccessivamente logori ed anche spezzati; vi ha egli devuto perciò nel rinnovarlo farvi aggiungere non poca quantità di pietre nuove per vederlo finito. . . .

Vi sarebbe oltracciò da rimettere anche in parte le quattro basi di terracotta sotto ai pilastri di fronte tre delle quali sono state restaurate da mano inesperta e l'altra del tutto vi manca.

Non vorrebbe perciò in niuna maniera il sottoscritto incontrare degli ostacoli presso il R. D. Dicastero se egli asserir volesse che dette basi vi sia necessità di rinnovarle, lascia al sagace discernimento Loro di comprovarne l'assunto; gli basta però che le SS.rie LL. Ill.me et Ecc.me si degnino di considerare che esso tempio di S. Andrea è uno dei rinomatissimi monumenti che ci abbia lasciato il celeberrimo Architetto Leon Battista degli Alberti Fiorentino che per essere tale e sì fattamente ben disposto ha servito di unico modello agli altri tempi cattolici posteriormente inalzati. Quindi si fa coraggio lo stesso rispettoso sottoscritto di suggerire che un simile edificio meriterebbe che conservato fosse con ogni possibile cautela e non giammai affidarlo, come altra volta è succeduto alla corutella di pseudo architetti i quali come chè, vaghi di licenziosa novità, lo hanno a quest' ora in molti luoghi difformato e sfornito dei suoi scielti ornamenti.

Se la valevole mano delle SS. LL. Ill.me ed Ecc.me non si frappone a riparare una sì vergognosa commutazione il maestoso e ben ornato Tempio dell'Alberti s'assicurino è perduto.

Accettino di buon grado le giuste querelle dell'ossequioso sottoscritto, il quale in ogni tempo lo troverano pieno del dovutole rispetto e venerazione; mentre sa di essere

Delle SS.rie LL. Ill.me ed Ecc.me
Mantova 26 Giugno 1778
Umil.mo Dev.mo ed Obblig.mo Servitore.
Paolo Pozzo
Pacchioni, 2

9) Al Sig. Pozzo, 27 Giugno 1778

Approviamo che Ella vi faccia eseguire quanto troverà esservi di necessità nel miglior modo a Lei beneviso sì per la solidità che per l'eleganza e dignità corrispondente alla magnificenza del tempio e conservaz.^ne del med.^o conciliando però con questi giusti riguardi la compatibile economia conforme alla di Lei capacità e zelo. etc.

F.to LAURRI.

Pacchioni, 3

10) Ill.^mi ed Ecc.^mi SS.^ri

Con relazione 26 Giugno 1778, hà il sottoscritto sottoposto alle SS.^rie LL. Ill.^me ed Ecc.^me d'essere il tempio di S. Andrea stato in molti luoghi diformato, e sfornito de' suoi scielti Ornamenti.

Fu dal R. D. Dicastero coll'ossequiata lettera 27 medesimo approvato il contenuto nella detta rappresentanza, incaricando l'Esponente di far eseguire quanto troverà esservi di necessità nel miglior modo da esso beneviso sì per la solidità, che per l'eleganza, e dignità corrispondente alla magnificenza del tempio.

Parte delle accennate occorrenze sono di già state compite, e parte rimangono tuttavia da effettuarsi.

Fra queste trovarsi quella del vecchio Cornicione interno quasi per la metà smantellato, e fatto rinnovare dalla Pia unione della Fabbrica della gran Cupola, in modo però non confacente alle simmetrie, ed alla venustà del Tempio.

Convenendo adunque al decoro ed alla eleganza del medesimo di rimettere al pristino il Cornicione, che esisteva, col far levare la troppo pesante, e licenziosa forma del costrutto di nuovo; deve prima però il Sottoscritto stesso prevenire le SS.^rie LL. Ill.^me ed Ecc.^me col farle presente, che essendo stato eseguito un tale nuovo lavoro sotto l'anzidetta Pia Unione, dovrebbe pure alla medesima spettare la grave spesa che sarà per occorrere nel rimettere al primiero stato il Cornicione del tempio dell'Alberti.

Forse essa unione si sarà previamente proveduta dell'opportuno permesso da chi spetta, la qual cosa potranno le SS.^rie LL. Ill.^me ed Ecc.^me rilevare per poter dare li corrispondenti ordini per la necessaria esecuzione.

In tanto ha il piacere il sottoscritto di dichiararsi con ogni ossequio, e rispetto, Della SS.^rie LL. Ill.^me ed Ecc.^me

Mantova, 31 Luglio 1780

Dev.^mo   Obblig.^mo   Umilis.^mo   Servit.^re—PAOLO POZZO.

Pacchioni, 4

11) A.—Dettaglio delle spese da muratori e falegname che occorrono per risarcire la vecchia Fabrica di S. Andrea rimettendo ogni cosa su l'antico disegno di Leon Battista degli Alberti.

Primo sei pilastri da farsi nelle intestate del Tempio tra materiali e fatture compresaci li suoi piedistalli ............ 1.   4.500. —

Aprire il finestrone rotondo di facciata per ricevere maggior lume la spesa sarà di ............ 2.000. —

Un telarone con vetri e ramata ............ 1.500. —

Altri due simili nella crociera con l'apertura dei medesimi finestroni ............ 7.000. —

Per le riquadrature delle volte delle due capelle di una crociera la spesa sarà di. ............ 1.400. —

3 Porte di legno alla parte della Canonica con le sue ferramenti le spesa scenderà a ............ 1.800. —

Per rimettere le 3 finestre quadrangolari, nel coro ed altrettante rotonde la spesa sarà di ............ 3.600. —

Per la formazione di otto nichie nove con colone d'ordine corinto la spesa sarà di ............ 7.200. —

Specchi quadrati sopra le medesime ............ 1.600. —

Pel ristauro dei piedistalli vecchi e contorno delle porte ............ 4.000. —

Per aprir le 4 nichie nelle intestate ............ 800. —

400 Braccia di cornicione da rimettersi sul modello Antico ............ 40.000. —

Per levare il rialzo sopra il frontispizio di facciata e per ottenere un lume diretto nel Tempio riducendo lo spazio sopra il Proneo ad uso di terrazza o pure ricoprirlo con tetto la spesa ascenderà alla somma di ............ 10.000. —

Per riordinare li coppi circa pertiche 800 ............ 6.400. —

Accomodatura dei latoni e canali per le acque ............ 3.000. —

Rinnovare il selicato di questo Tempio pertiche 380 ............ 57.000. —

Per ponti, atrezzi ed altri ristauri la spesa di ............ 8.200. —

Sommano in tutto f.   160.000. —

Mantova, li 30 agosto 1780

ALESSANDRO VASSALLI, Capo Mastro.

Pacchioni, 14

12) B.—Dettaglio di stuccatore—Le fatture di stucco e terra cotta da farsi nel compimento della V.^a fabbrica di S. Andrea.

B.^a 400—Cornicione, con N. 7 ornamenti sutegliati, che compresovi lo stucco o terra a f. 60 ............ f. 24.000. —

100—Imposta simile f. 30. ............ 3.000. —

48—Basi 180 ............ 2.840. —

48—Capitelli 200 ............ 9.600. —

2—Capelle ornate e Cassettoni ............ 9.000. —

— —Ornato alla Tribuna corrispondente al Tempio ............ 1.000. —

40—Ornato intorno alle finestre rotonde nel Coro ............ 1.200. —

Diversi altri ristauri dietro a vecchi ornamenti parte di terra cotta, a parte di stucco ..... 3.960. —

Totale f. 60.000. —

Mantova, li 30 agosto 1780
In fede STANISLAO SOMAZZI, Stuc.re
Pacchioni, 15

13) Mantova, 31 agosto 1780.
C.—Distinta ed importo degli ornati da rimettersi nel Tempio di S. Andrea.

Per dipingere il contorno con cornice, e frontespizio delle tre finestre grandi del Coro, ed altro contorno d'ornato alle tre finestre rottonde, che sono sopra di quelle ..... f. 450. —

Per rinnovare braccia 400 di fregio ..... 4.000. —

Per ornare la Corona ed i dentelli nella lunghezza di B.ª 400 di Corni- cione ..... 800. —

Per dipingere N. 6 Pilastri nuovi con candelabri corrispondenti ai vecchi ..... 5.400. —

Per ritoccare gli altri pilastri già dipinti ..... 800. —

Per dipingere a scomparti simili a quelli della volta del Tempio le volte della crociera e quelle del Coro col suo cadino ..... 12.800. —

Per rimettere N. 11 cassettoni nella suddetta volta del Tempio ..... 1.100. —

Per ritoccare il rimanente d'essa volta ..... 1.000. —

Per dipingere gli Arconi che nelle intestate dei volti corrispondono agli sporti de'Pilastri ..... 5.800. —

Per ritoccare e rimettere in varie parti del Tempio delle Cappelle alcune pitture ..... 4.000. —

Somma di f. 36.150. —

GAETANO CREVOLA, Pittore d'ornati.
Pacchioni, 16

14) All'intiero compimento della gran Cupola di S. Andrea, secondo i Disegni lasciati dal Cav. Don Filippo Juvarra l'anno 1733 li 12 Agosto, non mancano, che gli Ornamenti, e le intonacature esterne, e parte degli orna- menti interni di già avvanzati, con assieme la formazione delle scale a lumaca nelle quattro Pile di essa Cuba. Colla maggiore possibile accuratezza adunque furono dal sotto- scritto rilevate le accennate occorenze, le quali, per vieppiù assicurarsi delle spese, le ha calcolate unitamente ai diversi Artefici, col far pure estendere dai medesimi le minute, compiegate nell'inserto Dettaglio I.

Sotto detto stesso Dettaglio vi ha aggiunti i diversi creditori per le operazioni già fatte, ed i residui di quelle preventivamente furono contrattate, e che presso sono al loro termine. Avrebbe desiderato il Sottoscritto stesso, che

almeno gli Ornamenti nella suddetta Cupola fossero più corrispondenti a quelli del vecchio Tempio, i quali in tal modo avrebbero fatto maggior armonia ed unità di Lavoro. Quanto è mai diverso il gusto del Juvarra da quello dell'Alberti!

Oltre le suddette occorenze a compimento della ripe- tuta Cupola, altre facilmente più bisognose, e di maggior entità ve ne accaderanno a ripulire la vecchia Fabrica Architettata da Leon Battista Alberti l'anno 1472, come riferisce Mario Equicola nella cronica di Mantova. Le incompatibili commutazioni, che furono fatte nell'orna- tissimo Tempio dell'Alberti, specialmente quella di molta parte del Cornicióne, hanno obbligato il sottoscritto medesimo di renderne inteso il R. D. Magistrato Cam. le con Relazioni 26 giugno 1778, e 31 luglio p. p. to, che quia in copia unisce per maggiore chiarezza, assieme a Decreto Magistrale in riscontro della prima.

Tale è lo stato odierno di questo maestoso Tempio, a ripulire il quale, ed a rimettere tutte le mancanze, e com- mutazioni vi occorreranno le spese portate dall'altro in- serto Dettaglio II, dedotto dalle liste firmate dai rispet- tivi Artefici. Aggiungendosi inoltre che le vecchie pitture nel Tempio, sì d'ornati, che di figure sono state eseguite da Andrea Mantegna, e suoi Scolari, ed in particolare quelle nel Pronao le quali furono travagliate dal solo Antonio Allegri da Correggio, il di cui pezzo migliore situato sulla maggior Porta fu barbaramente smantellato nel mezzo per introdurvi un'inservibile finestrone. Che è quanto accadeva di fare al sottoscritto, vivendo egli con speranza, che verranno aggraditi da chi spetta i suoi giusti rilievi a sugerimento.

Mantova, 7 Settembre 1780
PAOLO POZZO.
Pacchioni, 6

15) Dettaglio delle spese, che accaderanno nella vecchia Fabrica di questo tempio di S. Andrea, particolarmente in rimettere il Cornicione sulla forma dell'antico, modinato dal celeberimo Architetto Leon Battista degli Alberti, ed in eseguire tutto ciò che stà espresso nelle unite minute.

DISTINTI:

| | | |
|---|---|---|
| N.º A. In spese da muratore | f. | 160.000. — |
| B. In quelle da stuccatore | | 60.000. — |
| C. Simile in pitture d'ornato | | 35.150. — |
| | In tutto f. | 255.150. — |

Che forse potrebbero anche ascendere alla somma di Fiorini ventiseimila.

Mantova, 7 settembre 1780.
PAOLO POZZO
Pacchioni, 13

16) La Deputazione per la fabrica della Cupola di questa Chiesa di S. Andrea di Regio Patronato ebbe l'eccitamento del R. D. Magistrato Camerale in data 30 Agosto 1780 d'informare del tempo in cui fosse rinnovato l'interno cornicione di essa Chiesa, con quale abilitazione ed a spesa

di chi ciò venisse eseguito. Diverse circostanze ed accidentali combinazioni hanno fatto differire la risposta fino al presente oltre a ciò che ha portato di ritardo la difficoltà di ritrovare sicuri documenti con cui soddisfare ai proposti quesiti.

Essendo però riuscita vana ogni altra diligenza praticata dalla Deputazione ho preso lo spediente di umiliare al R. D. Magistrato Camerale un attestato sottoscritto da più vecchi di Città dal quale apparisce l'epoca di questa introduzione del novo Cornicione essere sicuramente e per lo meno anteriore al 1732, in cui eccitati i Mantovani dalla beneficenza della Maestà di Carlo Sesto diedero incominciamento alla Fabrica Magnifica della Cupola sul disegno del ben noto Architetto Abbate Filippo Juvara dove è da notarsi che in questo tempo solamente, ed a questo fine d'assistere alla Fabrica di detta Cupola fu stabilita la Deputazione; probabilmente però l'introduzione del nuovo cornicione fu fatta circa il 1697. Allorchè l'Imperatore di gloriosissima memoria Leopoldo primo con la Cesarea sua magnificenza eccitò questo Pubblico a proseguire l'opera interrotta da molto tempo e compire sul disegno dell'Architetto Bolognese Giuseppe Torri il Coro ed i due Laterali della Croce della Cappella Maggiore. Ciò sembra vero anche da ciò che leggesi in un pubblico foglio stampato in Mantova (N. 23) in data 6 Giugno 1732 che l'Architetto Andrea Galluzzi fece una erudita Disertazione nella quale volle piante e disegni da lui esposti, scansando le difficoltà dell'Architetto Torri provò ad evidenza potersi stare al primo disegno lasciato dal famoso architetto Leon B.ª Alberti Nobile Fiorentino.

Dal che sembra doversi argomentare avere il sopradetto Architetto bolognese Torri introdotta nel proseguimento della fabrica qualche variazione e novità discostandosi dal disegno detta Alberti. Quindi apparisce chiaramente non avere avuto la Deputazione parte nessuna nella introduzione del nuovo Cornicione, giacchè questa fù stabilita solamente per la fabrica della Cupola. E quanto alla abitazione e alla spesa è manifesto che ebbero sempre il loro fondamento nelle zello e pietà generosa dei Sovrani i quali di mano in mano hanno protetta e con benefici soccorsi promossa quest'opera grandiosa da Lodovico Gonzaga secondo Marchese di Mantova sino al Regnante gloriosissimo Imperatore Giuseppe secondo.

L'indispensabile necessità di rimettere nella primiera originaria sua regolarità la parte del Cornicione interno, il quale essendo troppo pesante e di licenziosa maniera viene a difformare la maestà e simmetria del Tempio come egregiamente riflette e riconosce il R. D. Magistrato Camerale fa coraggio alla Deputazione di presentare insieme con queste notizie quali ha potuto raccogliere in risposta ai quesiti proposti una supplica umilissima per ottenere un egregio soccorso ed una generosa determinazione di dar mano a si necessario lavoro in una fabrica tanto mal compiuta che sarà sempre di pregio alla Città ed un monumento immortale della generosa e munifica pietà Austriaca.

In espettazione delle sperate disposizioni La Deputazione medesima con tutto il rispetto si rassegna.

Tommaso Marchese Arrigoni—Ferdinando March. Cavriani—Francesco Renedelli—Claudio March. Genesio (?)—Conte d'Arco—Ferrante M.se Agnelli—Carolus trenti Canonicus—Antonius Scavanzoni Canonicus—Domenico Luvanti—Ardizio Corradi Legnana Cap.to—Giuseppe Botturi—Bernardino Marinelli.

La Deputazione.

(Segue l'attesto in data 23 Ottobre 1781 a firma di otto ottuagenarie della città. La cupola è detta "di presente terminata").

Pacchioni, 5

17) Lettera scritta all'agosto del 1783 da persona non nominata A.C.

A tenore di quanto vi promisi nella mia scrittavi l'anno scorso sul proposito del suntuoso appartamento degli arazzi in questa Corte torno a ragionarvi di un altra opera voglio dire della maestosa cupola di S. Andrea. Questa fù incominciata l'anno 1732 e la prima pietra fù posta al 23 novembre assieme ad un medaglione d'oro coniato apposta con dall'un canto efigiato il vaso del SS. Sangue e all'intorno le parole *opus erectum an. 1732*, e dell'altro il ritratto dell'Imperatore con attorno Carolus VI Romanor. Imp. dux Mantuae. Erano già trascorsi quasi 40 anni da che fù comminciata si vasta mole e presso la fine, quando fù domandata il parere dell'architetto Pozzo, il quale propose la riforma totale degli ornati interni, giacchè per l'esterno no vi era riparo; ma un ostinata opposizione non lo permise—Al 21 maggio dell'anno scorso fù scoperto all'occhio di tutti il dipinto e l'ornato interiore della grandiosa cupola. Già saprete che l'ultimo dei Bibiena progettò la maniera con cui si dovesse ornare l'interno di quella, e ne fece un modello che esposto alla vista di tutti, e lo viddi anch'io e parvemi allora che potesse servire al desiderato effetto; ma fattane la prova per una quarta parte si accorse che l'effetto non corrispondeva alla aspettazione. Il caso allora presentò il pittore Giorgio Anselmi . . . ; ed a lui fù commesso di dipingere *alio modo* tutta la gran cupola. Il progetto dell'Anselmi fù spedito all'illustre nostra Accademia che con ragionata memoria provò che lo studiato fantastico pensiero era di gran lungo distante dell'ordine degli ornati della chiesa, a che volendosi far cosa che degna fosse di reggere al paragone conveniva riquadrare la cuba, introducendovi nè riparti delle medaglie, ove vi sarebbe state luogo ai dipinti. Codesto sentimento fù appoggiato al sempre costante uso degli antichi, i quali nelle loro volte v'introdussero il riparto, o se pur liscie le facevano, i pittori che le dovevano dipingere procuravano d'uniformarsi coll'idea degli architetti facendo in modo che il loro dipinto si naturalizzasse con l'architettura. Così si avesse seguito il disegno dell'Alberti, il quale immaginave un bacile semplice, chè non sarebbe deformato il tempio con sostituirvi la presente mole, distruggendo l'antico ordine già stabilito dall'Alberti. Voi avrete lette le lodi date all'Anselmi dalla Gazzetta di Mantova del 24 maggio 1782, ma chi esamina con occhio imparziale il dipinto dell'Anselmi non potrà a meno di

tacciare di poco intelligente l'editore del foglio. E siccome la succennata data dà una ben giusta lode anche a que' pittori che sonosi impiegati negli ornati del tempio vi dirò che il Sig. Pozzo ha molto contribuito alla vaghezza di quelli, procurando coi suoi consigli e sull'esempio de' già rimasti ornati, che i nuovi si accostassero a quelli; ed infatti ora miriamo con piacere tutta la gran croce ridipinta sul gusto del restante. Così le regolatrici teste a cui sono ingiunte le spese del ristauro totale del tempio si fossero attenute a savii consigli del Pozzo che non si vedrebbe ora con somma obbrobio distrutto il vecchio dipinto per sostituirvi un altro che per quanta diligenza si possa usare nell'imitarlo, non potrà mai gareggiare con quello. Da questo comprenderete il molto che taccio per non parer maldicente e sono.

Mantova, all' agosto del 1785.

D'Arco, *Delle arti*, vol. 2, p. 239.

# Appendix VII

Descrizione delle opere e capitoli da osservarsi da chi assumerà l'appalto delle riparazioni occorrenti all'atrio, ed alla facciata *dell'Insigne Basilica di Sant' Andrea in Mantova*

*Ristauri da eseguisi ai muri ed alle cornici di cotto ed altre parti dell'atrio—*

1. Si dovranno far rilevare da abile artista i lucidi (così detti spolveri) di tutti gli ornati dipinti a fresco che fregiano le pareti, e le volte a cassettoni dell'atrio del Tempio. Tali disegni verranno consegnati alla Fabbriceria.

2. I dipinti a fresco esistenti nei due dischi superiori agli archivolti che mettono rispettivamente al campanile ed al portico di Sant' Andrea saranno accuratamente conservati, al quale scopo vi si dovranno fare preventivamente gli opportuni ripari d'assi di pioppo, affinchè non vi succede alcun guasto pendenti i lavori da descriversi in appresso.

3. Riguardo poi alle dipinture degradate esistenti al di sopra della porta principale d'ingresso al Tempio, l'appaltatore farà obbligato a formare gli occorrenti ponti di servizio, e fornire gli attrezzi necessari all'oggetto di tentare se è possibile di levare dalla parete le parti conservate delle dipinture anzidette, le quali saranno pure consegnate alla Fabbriceria. Quest'opera sarà abbonata all'assuntore sulle liste da presentarsi dopo eseguita l'operazione, se potrà essa effetuarsi, giacchè non potrebbe assegnarsi con precisione, per l'oggetto di cui si tratta, la spesa preventiva.

Le liste suddette saranno liquidate dall'Ingeg.e Dirett.e.

4. L'appalt.e dovrà pure far ricoprire con assi di pioppo assicurate coi necessari parpaglioni immurati gli stipiti e cornici di marmo ad intagli della porta principale d'ingresso alla Basilica, come anche al monumento sepolcrale posto davanti alla porta che mette al campanile, e ciò con quel metodo e solidità che si richiede, sicchè siano le dette parti affate difese e garantite da qualunque danno pendente i lavori di cui si tratta.

5. Sarà interamente scrostata la stabilitura di tutte le superficie delle volte e pareti dell'atrio, levando la calce vecchia sino alla superficie delle pietre, e raschiando esattamente le commesure fra le pietre stesse sino alla profondità almeno di due centimetri.

6. La crepatura esistente all'unione della volta principale dell'atrio ed muro frontale dell'ingresso nel Tempio sarà atturata con muro in calce di materiale nuovo, e ciò a tutta grossezza della volta attuale, levando, ove occorre, le pietre smosse, e dilatando opportunamente la fessura, onde possa succedere al più solido collegamento fra la vecchia e la nuova muratura.

7. Per impedire poi in seguito ogni movimento della fabbrica nel succennato punto si porranno in opera quattro chiavi di ferro grosse m. 0,03. larghe 0,06, lunghe ciascuna cm. 8.50. con due occhiettoni bolliti a dovere. ad ogni chiave vi faranno due stanghe di ferro grosse m. 0,04. in quadro, lunghe ciascuna m. 2.00. Le anzidette quattro chiavi saranno poste in opera sotto all'architrave della facciata, e nei punti che verranno indicati all'atto del lavoro onde abbiano ad abbracciare ed assicurare la suddetta volta, per il che dovranno farsi gli occorrenti feri tanto nel muro di facciata, che in quello che divide l'atrio suddetto dal corpo della chiesa, onde farvi passare le chiavi ripetute; avvertendo che le stanghe di contraste dovranno porsi in opera di maniera che restino a filo della parete in rustico [?]. All'effetto poi che le chiavi stesse siano ben tese si dovranno porre i così detti biettoni di ferro alle stanghe, interrandoli a mezza fra la stanga e l'occhiettone, e quindi fare agli squarci nelle pareti tutti gli occorenti muri di atturamento.

8. Altre due chiavi di ferro grosse e lunghe come sopra, e riunite ciascuna di due stanghe dalle suddette dimensioni cogli analoghi biettoni si metteranno in opera al livello del fregio del cornicione sostenente il grande archivolto della facciata, avvertendo che saranno incassate a dovere nella muratura, e ritenute nel resto tutte le altre norme stabilite nell'art. precedente.

9. Le pareti da scrostarsi nell'interno della chiesa per fare i fori, e per mettere in opera le stanghe delle chiavi sud-descritte saranno rimesse nel primitivo loro stato, . . . cioè nel più lodevole modo, rinnovando la stabilitura, ed i dipinti a fresco, che si faranno intaccati, lo che avrà

effetto col mezzo di diligente ed abile Pittore da presciegliersi dalla Fabbriceria.

10. Saranno a previsione otturate le crepature esistenti nel cornicione d'imposta della volta principale dell'atrio, e ciò tanto alla parte destra, che alla sinistra, riducendo in seguito a livello, ed a linea retta le varie sagome costituenti la cornice e l'architrave. Saranno pure otturate collo stesso metodo tutte le altre fenditure, che esistono tanto nelle volte, che nelle pareti dell'atrio ripetuto, squarciando preventivamente, ove occorra, il muro nelle parti laterali, onde la riparazione riesca solida e durevole.

10½. Saranno levati i rosettoni ed i chiodi romani di legno che adornano i cassettoni della volta principale dell'atrio, i quali si trovano in giornata rotti per la maggior parte, e nel resto consunti.

11. Sarà in seguito rinnovata la stabilitura di tutte le superficie prescritte da scrostarsi all'art. 5. della presente descrizione, avvertendo che in quanto ai cassettoni tanto della volta principale dell'atrio che delle laterali saranno fatte le sagome intagliate a stucco come anche le sagome liscie nelle loro intelerature nel modo con cui vengono in oggi indicate dai dipinti da levarsi.

La formazione delle sagome in rilievo sarà pure estesa ai sotto in sù degli archivolti, ed a tutte le parti in cui le sagome stesse trovansi in oggi dipinte.

Saranno inoltre eseguite in istucco forte e con un rilievo conveniente tutti gli ornati attualmente dipinti a fresco nelle parti piane delle fascie dell'inteleratura di tutti i cassettoni delle volte dell'atrio, e ciò giusta il preciso modello degli ornati attuali, di cui si è prescritto al paragrafo n. 1. di rilevare i lucidi.

Per tute le membrature da farsi tanto ai cassettoni, che alle loro intelerature saranno fatti preventivamente gli analoghi modelli e sagome in legno ferrate giusta i profili che verranno dati all'appalt.e dall'Ingeg.re Direttore.

12. Saranno a dovere rimesse tutte le sagome di cotto intagliate al cornicione delle imposte della volta principale agli archivolti sottoposti alle imposte medesime ai capelli delle sei portine nell'interno dell'atrio, e finalmente alle imposte degli archivolti anzidetti, e delle volte minori corrispondenti.

Tutti i pezzi in cotto da rimettersi per le sagome relative saranno preventivamente modellati sulla precisa forma dei pezzi vecchi esistenti in buono estato, e quindi si avrà cura che alle fornaci siano i pezzi nuovi ben cotti senza alterare possibilmente la loro forma.

Tutti i pezzi da rimettersi avranno una rientranza eguale a quella dei vecchi, ed anche maggiore nei luoghi in cui fosse necessario per meglio collegarli colla vecchia muratura e saranno posti in opera con tutta la diligenza in modo che si otenga nel lavoro la massima esatezza e solidità.

Il cemento da adoperarsi per questo lavoro, e per tutti gli altri simili da descriversi in appresso, sarà composto a parti eguali di calce e polvere di mattoni. Tutte le altre sagome vecchie si intagliate, che liscie saranno a dovere ripulite, e lavate onde possano ricevere la tinta, come si dirà in appresso.

13. Saranno formati in istucco forte tutti i chiodi romani agli angoli delle intelerature dei cassettoni tanto della volta maggiore dell'atrio, quanto a quelle delle volte laterali. Alle tre mezzelune ed ai sotto in sù degli archivolti dell'atrio stesso; i chiodi stessi esistono parte in legno, e parte in dipinto; verranno quindi rimessi tutti in istucco come si è detto, e saranno solidamente assicurati al corpo delle volte con una forte zanca di ferro, il di cui modello si darà all'atto dell'esecuzione. I predetti chiodi romani avranno rispettivamente le dimensione, a profilo degli esistenti tanto dipinti, che in rilievo. I chiodi, di cui si parla, saranno nel seguente numero, cioè n. 72. nella volta principale dell'atrio; n. 21. simili nella mezzaluna superiore alla porta grande del tempio; n. 216. nelle due volte minore dell'atrio; n. 40. nelle due mezzelune superiori agli archivolti che mettono rispettivamente al portico ed al campanile.

14. Saranno pure costruitti in istucco forte n. 50. rosettoni pei cassettoni della volta maggiore, e n. 176. per quelli delle volte laterali; si gli uni che gli altri avranno quel diametro proporzionale al campo in cui verranno riposti, che si determinerà all'atto dell'esecuzione. Oltre ai rosettoni summentovati, se ne formeranno n. 5. come sopra nel sotto in sù del grande archivolto della facciata, altretanti nell'archivolto corrispondente alle mezzelesene laterali alla porta principale, ed altri n. 6. in sotto in sù dei due archivolti sottoposti alle imposte della volta principale dell'atrio. Ciascuno dei rosettoni medesimi sarà assicurato con una grappa di ferro ingessata nella volta nel modo prescritto di sopra pei chiodi romani. I rosettoni saranno intagliati a foglia d'ulivo, d'acanto, ed in altre foggie da adottarsi all'atto di esecuzione, e tanto i primi che i secondi saranno rispettivamente di quattro diverse forme, onde avvicendare opportunamente gli scomparti. All'atto di esecuzione si farà un modello al naturale di ciascuna forma di cassettone.

15. Sopra alle imposte delle volte laterali, e nei due lunettoni superiori agli archivolti che mettono rispettivamente al portico di Sant'Andrea ed al campanile si faranno in rilievo i riquadri lateralmente ai dischi dipinti a fresco colle sagome a linee attualmente dipinte.

16. All'ingiro dell'atrio sarà messo in opera al piede delle pareti uno zoccolo da formarsi con lastre di marmo di Verona del corso rabbiosa grossa non meno di m. 0.10, alto constantemente m. 0.70, compresa la parte da farsi entrare sotto al pavimento dell'atrio medesimo; queste lastre saranno ridotte ad esatto squadro in tutta la grossezza del loro contorno, onde possano riunirsi a precisione colle parti vicine, e spianate a martellina finissima nelle superficie viste. Dette lastre conservata la prescritta altezza e grossezza saranno in vari pezzi delle seguenti dimensioni, cioè due pezzi da porsi lateralmente agli stipiti della porta principale larghi ciascun m. 1.45. Due altri lateralmente alle spalle delle due porte minori d'ingresso al tempio larghi ciascun m. 3.40.

Quattro altri lateralmente agli archivolti che mettono rispettivamente al portico di Sant'Andrea ed al campanile larghi ciascuni m. 1.05.—

Quattro altri a contatto degli stipiti delle portine aperte e finte nel lato guardante la piazzetta in ragguaglio larghi m. 0.45. ciascuno.

Due altri larghi ciascuno m. 1.90. da porsi alle spec-

chiature delle due finte portine.

Otto altri nelle grossezze delle spalle dei due archivolti conducenti al portico, ed al campanile, e delle due portine della facciata lunghi m. 0.90.

Ciascuno dei suddetti pezzi sarà incassato nel muro in modo che combacci esattamente colla parete, al quale scopo gli sarà fatta scorrere per di dietro la corrispondente calce ben liquida, e sarà inoltre assicurato colla parete medesima con quattro forti chiavelle di ferro, grosse m. 0,02. per 0,015. lunghe m. 0.40, compresi i risvolti da ingessarsi e da impiombarsi fortemente nei marmi.

17. Nelle fronti guardanti l'interno dell'atrio saranno poste in opera n. 4. spalle di marmo large m. 0.45, grosse 0.30, lunghe m. 16.60. Tali spalle dovranno essere assicurate con due chiavelle forti di ferro per ciascuno impiombate nel modo sopradetto. Le spalle stesse saranno profilate come quelle già esistenti alla fronte dell'archivolto guardante il portico, e saranno travagliate finamente colla martellina.

18. Gli stipiti di marmo, che contornano le sei portine dell'atrio, saranno in ogni parte riparati valendosi dei pezzi buoni da levarsi dalle due portine della facciata. La posizione dei pezzi stessi si farà colle stesse norme prescritte pegli stipiti dei due archivolti dell'atrio. All'atto della esecuzione s'indicherà il modo preciso, con cui si vogliono eseguite le suddette riparazioni.

19. La cornice di marmo ad intagli della porta principale del Tempio, essendo ammalorata, saranno levati due pezzi smossi alla parte sinistra della cornice medesima; e quindi dopo rimesso a luogo il pezzo di voltatesta si sostituirà al pezzo medio un nuovo della stessa forma, dimensioni, e lavoro, dandovi quella lunghezza che è necessaria, onde compire la cornice nel modo il più esatto. I pezzi suddetti saranno assicurati alla muratura con due forti chiavelle di ferro impiombate per ciascuno.

20. Le due mezze lesene coi corrispondenti capitelli rustici in cotto, che formano coritmia coi due pilastri di marmo scannelati sostenenti il grande archivolto della facciata della Chiesa, saranno ambidue scarpellati, onde sostituirvi due mezze lesene di marmo delle seguenti forme e dimensioni.

Si porranno in opera due mezze basi attiche di marmo alte m. 0.58, lunghe m. 1.02. compresa la rientranza di m. 0.15. nel muro, e larghe m. 0.72, notandosi che alla base stessa vi dovrà essere attacato anche il pezzo formante lo spigolo del piedritto dell'attiguo archivolto. la base stessa sarà profilata colle identiche forme e dimensioni di quelle dei due pilastri sostenenti l'archivolto della facciata. Ciascuna delle due mezze lesene avrà il fusto formato di tre pezzi di marmo, i primi due, incominciando dall'imoscapo, avranno la lunghezza ciascuno di m. 3.16.5, la grossezza di m. 0.50, e la larg.a di m. 1.02. compresa la rientranza di m. 0.15, nel muro. Si avverte che ai suddetti pezzi è attacato lo spigolo del piedritto dell'attiguo archivolto, come viene indicato dalle linee rosse del disegno. Il terzo pezzo che serve di compimento al fusto di ciascuna lesena sarà lungo m. 2.20, grosso 0.20, largo 0.80. I due pezzi del sommoscapo saranno assicurati alla muratura con quattro grosse chiavelle impiombate.—

Le due mezze lesene suddescritte avranno al piede il

corrispondente listello collo sguscio, ed in sommità il tondino e listello profilato in conformità di quelle dei due pilastri sostenenti il grande archivolto della facciata in parità dei quali saranno pure scannellate.

In sommità di ciascuna delle lesene ripetute si metterà in opera un mezzo capitello composto di marmo alto m. 0.95, largo all'imoscapo m. 0.80, grosso almeno m. 0.30 non compresi gli sporti dei fogliami e sagome. I capitelli stessi saranno in tutto conformi a quelli esistenti in opera in sommità dei due pilastri sunnominati e veranno assicurati alla muratura ciascuno con quattro grosse chiavelle impiombate.

*Ristauri da eseguirsi alle cornici ed alle altre parti della facciata*

21. Saranno levati i lastroni di marmo colle corrispondenti basi e capitelli composti pure di marmo dei pilastri che attualmente sostengono il grande archivolto della facciata. I capitelli saranno levati colla massima diligenza, affinchè non vi succeda alcun guasto, dovendo i medesimi essere riposti in opera come si dirà più abbasso.

Per eseguire tale operazione si dovranno preventivamente disporre tutti quei partellamenti che occorreranno a dettame dell'Ingeg.e Direttore, affinchè non abbia a succedere alcuno scomerto nei muri della facciata e negli attigui.

I due pilastri che servono di sostegno al grande archivolto della facciata saranno rivestiti di nuovo con n.o 12, pezzi di marmo ponendone 3. pezzi per ciascuna fronte del fusto.

Le due basi saranno di marmo nembro, e verranno profilate e modellate in piena conformità delle attuatli e saranno alte ciascuna m. 0.58, lunghe m. 1.55, e larghe altretanto.

I primi quattro pezzi del fusto di ciascuno pilastro dipartendosi dall'imoscapo saranno lunghi m. 3.17. ciascuna, della larghezza eguale a quelli degli ora esistenti, e della grossezza di m. 0.30. Nei pezzi che si aggirano sulla base vi dovrà essere il listello e sguscio collo sporto marcato pei pilastri attuali. Il terzo pezzo di ciascuna facciata di pilastro sarà alto m. 2.20, grosso 0.25. e largo come gli attuali; alla sommità dei pezzi stessi vi sarà un tondino e collarino con sguscio col profilo, e sporto attuale, di modo che siano conservate le attuali dimensioni, sagome, ed ornamenti dell'impelliciatura.

Ciascuno dei pezzi nominati sarà solidamente assicurato, e congiunto coi suoi vicini lateralmente, sotto, e sopra, e cogli adjacenti muri con materiale nuovo, calce, e con due chiavelle impiombate, delle quali ve ne saranno otto per ciascun pezzo grosse 0.03. in quadro, lunghe m. 0.70.

Tali pezzi dovranno pure essere scannellati in piena conformità a quelli già esistenti nei pilastri stessi.—

Saranno posti in opera i due capitelli composti sopra i due pilastri, assicurandoli a dovere ai muri adjacenti con materiale nuovo e calce, e due chiavelle di ferro impiombate con rispettiva zanca grosse 0.03. in quadro, lunghe 0.70.—

Ai capitelli stessi saranno fatte tutte le necessarie riparazioni ponendovi dei tasselli alle parte mancanti, le

quali saranno rimese colle stesse forme a fogliami delle parti corrispondenti in buono stato. Tali tasselli dovranno porsi colla necessaria diligenza congiungendoli alle parti antiche con stucco forte e con bironi di ferro impiombati.

Saranno poi rimesse di nuovo tutte le parti del cornicione d'imposta del grande archivolto della facciata come anche tutte le parti da squarciarsi colla posizione in opera dei suddetti pilastri colle rispetive basi e capitelli.

22. I quattro piedestalli sostenenti le lesene della facciata, consistenti ciascuno in uno zoccolo, dado, a cimasa di marmo, saranno levati, essendo totalmente deperiti. In sostituzione poi dei medesimi si metteranno in opera i seguenti pezzi. Tre zoccoli di marmo profilati come i zoccoli attuali, lungo ciascuno m. 2.10, alti 0.65, grossi 0.60. Uno Zoccolo in due pezzi sul'angolo del fruttajuolo lungo ciascuno m. 2.10, alti 0.65, e grossi 0,60. profilati come sopra. Cinque dadi grossi almeno m. 0.20, larghi 1.70, alti 1.70, con una specchiatura rettangola in fronte, larga m. 1.05, alta 1.05, il di cui sfondo sarà confromato da una gola sagomata come quella esistente ai piedestalli dell'interno della Chiesa. Cinque cimase profilate come le cimase esistenti lunghe m. 2.00, alte 0.30, grosse 0,65.

Tutti i suddetti pezzi di marmo saranno solidamente immurati con materiale nuovo, a calce prevj gli opportuni scalpellamenti: le cimase e gli zoccoli avranno per ciascun pezzo due chiavelle di ferro impiombate, grosse me. 0,02. in quadro, lunghe 0.50, comprese le zanche. I dadi avranno pure per ciascun pezzo quattro chiavelle come sopra. Si avrà riguardo di non apportare alcun guasto alle basi di cotto dei lesenoni delle facciate che in ogni case dovranno essere risarciti a spese dell'appaltatore.

23. Gli stipiti delle due portine della facciata essendo molto ammalorati ne potendosi in mancanza di un marmo di qualità e tinta eguale all'esistente avere dei pezzi nuovi atti a ristaurarli saranno interamente levati colla massima diligenza, affinchè non succeda alcun deperimento o guasto ai pezzi godibili. I pezzi godibili saranno impiegati a rimettere i pezzi rotti, ed a riparare gli stipiti delle sei portine simili esistenti nell'interno dell'atrio, e ciò nel modo che sarà indicato dall'Ingeg.e Direttore all'atto del lavoro.

In sostituzione degli stipiti levati come sopra si porranno in opera a ciascuna delle portine ripetute due spalle di marmo larghe m. 0.44, alte m. 4.25, grosse 0.30, oltre gli sporti delle sagome, le quali nelle fronti delle spalle stesse saranno indentiche con quelle degli stipiti vecchi. A ciascuna portina si metterà pure in opera un cappello o architrave largo, grosso, e profilato come le spalle anzidescritte e lungo m. 2.80. Ciascun pezzo sarà assicurato alla muratura adjacente con due chiavelle delle già prescritte dimensioni, impiombate da una parte nella grossezza del marmo, e verrà pure a dovere unito alla vecchia muratura con muro in calce di materiale nuovo in tutta quella estensione che si richiederà al più lodevole collegamento dei pezzi medesimi.

24. I due finestroni terminati a semicerchio, che trovansi fra le lesene della facciata lateralmente al grande archivolto, saranno nel più lodevole modo riparati nella fronte guardando la piazzetta di S.t' Andrea, levando le parti in legno che attualmente trovansi frammiste alla muratura,

la quale sarà in ogni punto a dovere rimessa, facendovi poscia la stabilitura previo il regolarizzamento delle aperture che danno lume ai locali superiori all'atrio.

25. Tutte le parti del cornicione, e del frontone della facciata, e del fianco verso i portici, della grande imposta dell'archivolto, delle zambrane dei quattro nicchioni, delle cornici delle due portine, e della fascia all'ingiro del grande archivolto suddetto non che delle basi dei quattro lesenoni, che presentano dei guasti qualunque, saranno riparate, levando preventivamente tutti i mattoni ad intaglio, che si trovano smossi, e rimettendo di nuovo i mattoni intagliati rispettivamente come gli esistenti in modo che ogni parte sia ridonato allo stato di primitiva costruzione. In quest'opera si comprendono anche i cherubini del fregio della facciata. A tale effetto si dovranno fare rilevare preventivamente tutti i modelli delle singole qualità di pietre, le quali per rapporto alle rientranze dovranno avere quelle dimensioni che ne garantiscano in seguito la loro stabilità e consistenza. La terra da impiegarsi per la formazione dei mattoni intagliati, da porsi in opera come sopra, sarà della più perfetta, e si manipolerà colla più grande diligenza, affinchè non risultino delle sfogliature o altri difetti che deformino il travaglio.

26. Sarà interamente e diligentemente scrostata tutta l'attuale stabilitura della facciata del tempio e del piccolo tratto di fianco riguardante il portico di S.t Andrea, e ciò colle stesse norme di già stabilite di sopra per le parti dell'atrio della Chiesa. In seguito tutte le stabiliture scrostate come sopra saranno rinnovate rimettendo le pareti e le parti delle cornici diverse nel primitivo loro stato.

27. Alle pareti dell'atrio, ed a quella della facciata e fianco suddetto sarà data a tre mani la tinta colore di stucco in modo che riesca dappertutto eguabile, unita, e durevole, al quale scopo le tinte saranno stemprate nel latte, aggiungendovi anche l'occorente quantità di colla. Prima di dare la tinta ogni parte, e massime le cornici, saranno a dovere lavate, e ripulite, onde le tinte possano fare buona presa.

28. Sarà disfatto l'attuale pavimento di cotto nell'atrio, trasportando altrove i vecchi mattoni, ed il sottofondo soprabbondante: i mattoni si cedono all'appaltatore.

Il pavimento stesso sarà in seguito ricostruitto con lastre di marmo di Verona del corso secchiaro grosse m. 0.15. in numero di quarantacinque pezzi che rappresenteranno lo scomparto marcato nel disegno. A. Ai pezzi stessi pertanto si dovranno dare per ciascuno le dimensioni di lunghezza e larghezza determinate dal disegno predetto, avvertendo che tali dimensioni dovranno aumentarsi di otto centimetri in tutti quei lati in cui i lastroni combacciano coi muri dell'atrio.

Si osserva che i nove pezzi constituenti il ripiano in sommità della gradinata marcati coi n. 9.9.9.9.9.9.9 = 10.10 avranno la costante grossezza di m. 0.18. dovendo formare in fronte l'alzata dell'ultimo gradino. La superficie totale dei suddetti lastroni compresi i nove anzidetti e di m. q. ti 176.47.—

Le lastre dovranno essere appianate esattamente in superficie, rappresenteranno un piano perfettamente oriz-

zontale, e saranno lavorate per tutta la grossezza del loro contorno, onde abbiano a combacciare perfettamente fra loro. Le lastre saranno adagiate sopra uno strato di calce alto almeno m. 0.10, e si sottomureranno con materiale nuovo posto in calce agli angoli, onde a lavoro finito il nuovo lastricato rapresenti un piano esatto, continuato ed inalterabile.

Il nuovo lastricato nel senso del portico sarà orizzontale, e nel senso del prolungamento della mezzaria della Chiesa avrà una pendenza totale di nove centimetri verso la piazzetta. In aderanza al muro frontale dell'atrio il lastricato si terrà a livello del pavimento attuale.

29. L'attuale gradinata estesa a tutto il prospetto della Basilica trovandosi in uno stato disdicevole alla sontuosità dell'edificio, a cui appartiene, sarà interamente disfatta estensivamente anche ai muri che la sostengono: tanto i marmi vecchi che i mattoni risultanti della demolizione si cedono all'appalt.e, essendosene avuto riguardo nella perizia.

La nuova gradinata da sostituirsi all'attuale è rappresentata dal disegno A, ed abbraccia tutta l'estensione della fronte della Chiesa; i gradini saranno sei, alti costantemente m. 0.1633. I primi cinque partendo dal piano della piazzetta avranno la pedata di quattro decimetri: il sesto che forma la continuazione del lastricato dell'atrio di sopra descritto ha la larghezza di m. 1.55, misurandola dalla fronte esterna dello zoccolo dei piedestalli della facciata. La lung.a del ripiano o sesto gradino ristulta in totale di. m. 20.—quella del primo gradino è di m. 24.—

I gradini risvolteranno ai lati nel modo indicato dal disegno, e ad angolo retto sino a raggiungere la fronte del basamento della chiesa, nel quale i gradini stessi dovranno rientrare per m. 0.15. I gradini intermedi hanno la lung.a che risulta, mettendo gli angoli delle risvolte sulla stessa linea retta.

Alla sinistra ascendendo la scala sarà in modo combinata da conservare l'ingresso alla esistente Bottega: alla destra poi il primo gradino avrà tutto quell'aumento di grossezza, che occorre, affinchè, attesa l'inclinazione del piano della piazzetta ed adjacente strada, abbia esso a rientrare per m. 0.05 sotto il piano infimo della strada e piazzetta per tutta la lunghezza in cui l'inclinazione suddetta lo esigerà.

I primi cinque gradini rappresenteranno un piano orizzontale nella pedata, ed avranno la costante larghezza di cinquanta centimetri, per cui ciascuno di essi rientrerà un decimetro sotto il gradino superiore.

La lunghezza e larghezza del ripiano o gradino in sommità fu già determinata al paragrafo in cui si è parlato del pavimento dell'atrio. Gli altri cinque gradini inferiori saranno in diversi pezzi non meno lunghi di tre metri, avvertendo di alternare regolarmente le loro unioni in modo che quella del superiore risulti sul piano dell'inferiore. Nei gradini di risvolto la lunghezza dei pezzi sarà eguale al risvolto medesimo con di più m. 0.15. di rientranza nel muro come si è detto di sopra.

Tutti i pezzi della gradinata saranno di marmo bianco di Verona cosidetto *nembro* di tinta biancastra ed uniforme, esente da ogni difetto che tenda a diminuire tanto

la solidità che la bellezza dell'opera. Ogni pezzo sarà compito nelle dimensioni, cioè rappresenterà un parallelepippedo retto, e sarà lavorato nelle parti viste e di combacciamento in modo che gli angoli risultino retti, e le superficie perfettamente piane e della massima politura ottenibile collo scalpello e colla martellina. Un pezzo sarà a perfetto contatto coll'altro in tutta l'altezza e larghezza.

Ciascun pezzo della gradinata è basato sopra solida muratura fondata convenientemente sopra i fondamenti del Tempio: ove questi non vi esistessero la muratura di sostruzione sarà spinta almeno settanta centimetri sotto al piano della piazzetta di S.t Andrea.

Alla base della gradinata e sul piano della piazzetta vi sarà un marciapiede di lastre di marmo del corso secchiaro, il quale sarà largo costantemente m. 1.50, e lungo m. 24.00, in diversi pezzi non meno lunghi di m. 3.00, questi saranno lavorati e connessi come si è prescritto di sopra pei gradini. Al lembo esterno il marciapiede avrà un filetto di marmo grosso m. 0.10, alto m. 0.30, in diversi pezzi lunghi m. 2.00, almeno bene lavorati e riuniti.

L'Appaltatore dovrà sottoporre al marciapiede uno strato di calce alto m. 0.10, serrando i diversi pezzi con delle scheggie di mattoni: le lastre agli angoli saranno sottomurate.

Si dovrà poi ricostruire il selciato della piazzetta, e dalla strada in tutte le parti da scomporsi coll'esecuzione delle suddette opere. Si rimetteranno inoltre in situazione da determinarsi all'atto dell'esecuzione le tre boccare che illuminano il sotterraneo inferiore alla piazzetta.

Mantova 12 Maggio 1830

Ing.e P. Pianzola

Alla Fabbriceria dell'insigne Basilica di S. Andrea

Mantova 16, Luglio 1831

Sono esse indispensabili a riparare diverse parti dell'edifizio che all'atto d'esecuzione del travaglio sonosi trovati nel più assoluto deperimento, e per supplire ad alcune altre, le quali lasciate nello stato attuale farebbero uno sgradevolissimo contrasto col confronto delle grandiose membrature in marmo che ad esse sono vicine—

Per norma delle risoluzioni che la Fabbriceria crederà di prendere nell'argomento espono alcune osservazioni per giustificare la convenienza delle opere addizionali di cui si tratta.

*Opere addizionali proposte*

1. Compimento dello zoccolo di marmo all'ingiro delle pareti dell'atrio, ch'è prescritto in progetto dell'altz.a di m. 0.70, lo si è scortato invece all'altezza di m. 1.65.

Lo scopo di quest'opera si fa in origine di presidiare quelle pareti in modo che non venissero macchiate o lese dalle persone che intervengono al tempio massime nei giorni di grande [?]: se si fosse data allo zoccolo di marmo l'altezza di metri 0.70 soltanto, si mancarà assolutamente al su espresso fine, poichè con bastoni ed altro si sarebbe ben presto guastata la stabilitura delle pareti stesse. Si è quindi data allo zoccolo ripetuto l'altezza di m. 1.65—proposta nell'originario progetto, e che viene ridotta nella sua riforma per sole viste di risparmio.

2. Tre archivolti di marmo alle aperture che mettono rispettivamente al portico ed al campanile.

nel contratto è contemplata la posizione degli stipiti di marmo sagomati soltanto alle spalle verticali di esse aperture: È quindi assolutamente necessario di compire lo stipite medessimo colla posizione degli archivolti che vennero soppressi nell'appaltato progetto per convertirne il valore nella spesa della gradinata e del lastricato dell'atrio—.

3. Due spalle sagomate da farsi in marmo per l'archivolto verso il portico.

Attualmente esistono a quest'apertura due spalle di marmo nericcio, le quali sono rotte in diversi luoghi: Dovendo ponersi l'archivolto nuovo di marmo bianco alla loro sommità, l'ornato esige che questo e per qualità e per tinta si uniformi alle spalle. Le spalle vecchie poi potranno essere adoperate per l'atrio verso la Canonica.

4. Rinnovazione degli stipiti di marmo delle sei portine sotto l'atrio.

Gli stipiti attuali delle portine di cui contro sono di marmo nericcio, e trovansi rotte in molte parti, nel progetto è prescritto di rappezzarle coi pezzi da levarsi dalle due portine della facciata, i quali però dopo levati si riconobbero in tale stato di diperimento da non essere suscettibili all'scopo.

Per uniformare quindi gli stipiti di dette portine alla tinta delle nuove lesene, allo zoccolo, ed alla nuova stabilitura da farsi alle pareti dell'atrio si crede conveniente il costruirle di nuovo in marmo bianco— Quest'opera è per altro diffesibile, e può essere eseguita senza inconvenienti anche dopo il perfezionamento d'ogni lavoro.

5. Rinnovazione in marmo delle basi intagliate dei cinque lesenoni della facciata—

Le vecchie basi erano in cotto ed intagliate: essendo esse state esposte per gran numero d'anni allo stillicidio, ed al gelo si sono per la maggior parte sguagliati negli ornamenti.

Dovendosi quindi rinnovarle è evidente la convenienza di sostituirle di marmo, poiche oltre al miglior effetto, e decoro che si procura alla facciata, riusciranno queste molto più durevoli.

6. Due capitelli compositi di marmo pei pilastri di sostegno del grande archivolto della facciata—.

Nel progetto è stabilito di rappezzare e di lavare gli esistenti capitelli che si credevano di marmo. Visitati dopo la construzione dei ponti di servizio si è rilevato che i medesimi sono di tuffo ed affatto rotti. Gli è quindi che avuto riguardo alle loro esposizione, alla impossibilità di ridurli eguali nella tinta a quelli delle lesene laterali alla porta principale, ed alla difficoltà di ristaurarli in modo lodevole, e durevole, si crede conveniente ed utile alla buona riuscita dell'opera di riformare in marmo bianco i capitelli anzidetti.

7. Cinque capitelli in marmo d'ordine corintio da porsi ai lesenoni della facciata.

I capitelli attuali sono di semplice stucco formato con calce e polvere di mattoni, e si riconoscono quasi consunti: Il volere metterli di una eguale materia si farebbe un'opera poco solida, e durevole, perche continuamente esposta alle intemperie. Pegli stessi motivi indicati per le basi di esse grandi lesene si propone quindi di ricostruire i capitelli medesimi in marmo bianco—.

8. Ante nuove da farsi alle due porte minori d'ingresso al Tempio.

Quest'opera non calcolata nella perizia è indispensabile poichè i serramenti attuali sono ridotti per vetustà consunti ed indecenti, ed inoltre sono malsicuri essendosi non ha molto fatta rottura da malandrini, che si introdusero di notte in Chiesa per rubare: si propone la ricostruzione loro alla foggia delle due ante della porta principale.

9. Tinta ad olio della porta principale.

Opera necessaria per accompagnare la tinta delle due porte laterali proposte da farsi in nuovo—

10. 11. Ricostruzione del muro di otturamento dell'archivolto attiguo alla scala del Campanile, e formazione di una coperta o finta porta contro di esso con portina mobile onde accedere al campanile ed attiguo cortiletto—

Il muro di cui si tratta è cadente, ed inoltre ha una finestra difesa da crociara di legno che si deve sopprimere. Si potrebbe demolire il muro stesso munendo l'apertura di rastrello di ferro, e così lasciar scorrere la risuale dell'atrio nel vicino cortile, se questo fosse un luogo spazioso, ornato e pulito.

Ma essendo quel sito angusto, in isbicco colla direzione della mezzaria dell'atrio, e potendo dal medesimo propagarsi nell'atrio medesimo le fetenti esalazioni della esistentevi fogna, è necessario di ricostruire il muro sud. lasciandovi una portina di communicazione, e coprendone tutta la fronte con una finta porta da colorirsi come quelle della Chiesa: Questo partito fra i diversi studiati si è reconosciuto il più opportuno ed anche il meno dispendioso—

Quest'opera potrà differirsi a piacere della fabbriceria.

12. Pezzi di marmo per compire lo zoccolo del piedistallo d'angolo verso i portici in vicinanza della porta da fruttajolo—

Quest'opera non è compresa ad contratto e la semplice ispezione locale persuade della necessità della sua esecuzione—

13. Telari e spirelli con lastroni e ramate da porsi ai due finestroni della facciata

Questi serramenti contemplati nel primitivo progetto furono stralciati dalla perizia riformata per convertirne l'importo sulla gradinata, e nel selicato di marmo dell'atrio.

In giornata è evidente che essi riescono assolutamente necessari—

Le precitate opere come risulta in dettaglio dalla perizia importano la spesa totale di L.11567:28—la quale fu calcolata dietro le stesse norme ed elementi che servirono di base alla stima delle opere già appaltate—

Sarà ora della compiacenza della fabbriceria il prendere la cosa ad esame, ed a fare poi conoscere a suo tempo le deliberazioni che troverà di dover prendere sulla proposta in discorso.

Ing.e P. Pianzola

# Notes

## *Abbreviations*

| | |
|---|---|
| Alberti, *De re aed.* | L. B. Alberti, *L'Architettura* [*De re aedificatoria*], trans. G. Orlandi, intro. and notes by P. Portoghesi (Milan, 1966) |
| ASA | Archivio di S. Andrea, Mantua |
| ASM, AG | Archivio di Stato, Mantua, Archivio Gonzaga |
| Bertolotti, *Architetti* | A. Bertolotti, *Architetti, ingenieri e matematici in relazione coi Gonzaga signori di Mantova nei secoli XV, XVI e XVII* (Genoa, 1899) |
| Braghirolli, "Alberti a Mantova" | W. Braghirolli, "Leon Battista Alterti a Mantova," *Archivio Storico Italiano* 3, no. 9 (1869), p. 3f. |
| D'Arco, *Delle arti* | C. D'Arco, *Delle arti e degli artefici di Mantova*, vol. 2 (Mantua, 1859) |
| Donesmondi, *Dell'Istoria* | I. Donesmondi, *Dell'Istoria ecclesiastica di Mantova*, 2 vols. (Mantua, 1613–1616) |
| Gaye, *Carteggio* | G. Gaye, *Carteggio inedito d'artisti dei secoli XIV, XV, XVI*, 2 vols. (Florence, 1839) |
| Hartt, *Giulio Romano* | F. Hartt, *Giulio Romano* (New Haven, 1956) |
| Hubala, "Langhaus" | E. Hubala, "L. B. Albertis Langhaus von Sant Andrea in Mantua," *Festschrift für Kurt Badt* (Berlin, 1961), p. 83f. |
| Janson, *Donatello* | H. W. Janson, *The Sculpture of Donatello* (Princeton, 1957) |
| Krautheimer, "Templum" | R. Krautheimer, "Alberti's Templum Etruscum," *Münchner Jahrbuch der Bildenden Kunst* 4 (1961), p. 65f. |
| Marani/Perina, *MLA* | E. Marani and C. Perina, *Mantova: Le Arti*, vols. 2 and 3 (Mantua, 1961–1965) |
| Mazzoldi, *MLS* | L. Mazzoldi, *Mantova: La Storia*, 3 vols. (Mantua, 1959–1963) |
| Nerlius, *Breve Chronicon* | A. Nerlius, *Breve Chronicon Monasterii Mantuani Sancti Andreae Ord. Benedict. ab Anno MXVII usque ad MCCCCXVIII*, in L. A. Muratori, *Rerum Italicarum Scriptores*, vol. 24 (Milan, 1738), p. 1071f. |
| Paccagnini, *Mantegna* | G. Paccagnini, *Andrea Mantegna, Catologo della Mostra di Mantova* (Venice, 1961) |
| Paccagnini, *MLA* | G. Paccagnini, *Mantova: Le Arti*, vol. 1 (Mantua, 1960) |
| Ritscher, "Die Kirche" | E. Ritscher, "Die Kirche S. Andrea in Mantua," *Zeitschrift für Bauwesen* 49 (1899), pp. 1f., 181f. |
| Thieme-Becker | U. Thieme and F. Becker, *Allgemeines Lexikon der bildenden Kunstler*, 1907–1950 |
| Wittkower, *Architectural Principles* | R. Wittkower, *Architectural Principles in the Age of Humanism*, 3d ed. (London, 1962) |

*Chapter I*

1. See Mazzoldi, *MLS*, the most recent study of the history of Mantua.

2. For the Gonzaga collections, see A. Luzio, *La Galleria dei Gonzaga venduta all' Inghilterra* (Milan, 1913).

3. See below, chapter II, *passim*.

4. Reported in *Kunstchronik* (December 1960). The controversy over Alberti's original design goes back at least as far as the differing opinions found in Carl von Stegmann and Heinrich von Geymüller, *Die Architektur der Renaissance in Toscana* (Munich, 1885–1907), vol. 3, sections 1a and 1b. Stegmann (section 1a, p. 8) suggested that the transept might have been taken over by Alberti from Manetti's earlier model (cf. Appendix III, no. 2). Stegmann's obvious uneasiness about the transept was countered by Geymüller (section 1b, p. 5), who felt the interior to be so unified a composition that it was either all Alberti, or not Alberti at all.

5. Ritscher, "Die Kirche," pp. 1–20, 181–200.

6. His observations were published in amplified form in Erich Hubala, "Langhaus," p. 86f.

7. Ibid., p. 88: "Damit verliert die Vierungslösung von Sant Andrea ... zwar ihre sensationelle entwicklungsgeschictliche Bedeutung, die ihr vermeintlich zukam: sie geht dem römischen Gesù und vergleichbaren Bauten des 16. Jahrhunderts zeitlich nicht um fast hundert Jahre voraus, sondern ahmt diese nach."

8. Krautheimer, "Templum," p. 65f.

9. See chapter II for a discussion of this letter.

10. Alberti, *De re aed.*, Bk. 7, ch. 4.

11. Krautheimer, "Templum," fig. 1a.

12. Ibid., *passim*, esp. p. 66.

13. Ibid., p. 68. Krautheimer feels that the distinction Alberti made between *basilica* and *templum* was "pointed very specifically against the entire tradition of church building as Alberti knew it by 1450," including even such advanced contemporary buildings as S. Lorenzo and S. Spirito in Florence. Such churches, with naves flanked by aisles, transepts, and ample lighting fall into Alberti's category of *basilica*, rather than the category of *templum*.

14. Ibid., p. 71. See also his postscript to the republication of this essay in Richard Krautheimer, *Studies in Early Christian, Medieval, and Renaissance Art* (New York, 1969), p. 344, for a more recent opinion.

15. For a description of the decorations of the church, see Chiara Perina, *La Basilica di S. Andrea in Mantova* (Mantua, 1965).

16. See chapter VI for a discussion of these decorations.

17. The structural systems of the other parts of the church—transepts, choir, and dome—differ in several essentials from that of the nave. Since these parts were built later than the nave (and at differing times themselves), their structural characteristics will be considered later at appropriate points in the text.

18. The primary source for a history of the relic is Antonius Nerlius, *Breve Chronicon* pp. 24, 1071–1084.

19. Ibid., p. 1073, "nova et parva Basilica" (see Appendix I, no. 1).

20. Nerli (p. 1074) would have it that the church "quae nunc cernitur" (see Appendix I, no. 2) was completed in the very short span of seven years. Such a case seems highly unlikely. It is not entirely clear from Nerli's text whether the second church of S. Andrea occupied the same site as the first. S. Andrea II grew up around the place where the Blood was found in 1049. Thus the Blood would have to have been interred inside or very near S. Andrea I, if the second church occupied the site of the "parva basilica." Nerli himself, naturally enough, was less well informed about the Carolingian church than about its successor. The records he worked from are now lost to us.

21. See letter of 2 January 1472 (Appendix II, no. 7) from Lodovico Gonzaga to his son, Cardinal Francesco. In the letter Lodovico clearly states the fact that the old church must be torn down to make way for the new.

22. Ibid. According to Lodovico, the new church "andera piu longa, in alcuni loghi piu larga it in alcuni piu stretta." The present church is more than 37 meters wide across the nave and chapels. If the eleventh-century church was more than 37 meters wide, it was indeed large. Perhaps it might even have had five aisles, like the later Duomo of Mantua.

23. The monastery persisted until 1472, when it was suppressed by Pope Sixtus IV. This part of the history of the church is discussed in chapter VII. A monastic complex grew up to the north of the present church during the eleventh century. The cloister occupied part of present-day Piazza Alberti, as can be seen in the Ranieri map of Mantua, 1831 (pl. 66), which was drawn before most of the monastic buildings were razed. The east and south sides of the cloister were built between 1227 and 1239 (Nerli, p. 1077 [Appendix I, no. 3]); the north and west sides between 1277 and 1313 (ibid., p. 1078 [Appendix I, no. 4]). The still-standing south (compass direction) arcade was subsequently incorporated into a row of houses (pl. 38).

24. Ibid., p. 1079 (Appendix I, no. 6). In this account we are told by Nerli that the relics were buried to the right of the high altar. We should trust this observation, for it was during Nerli's abbacy that the disposition of the relics was radically altered (see n. 25).

25. This information can be gleaned from a long document (Appendix I, no. 9), dated 13 May 1401, cited, but not published, by Leonardo Mazzoldi, *MLS*, vol. 2, p. 18. Unfortunately, for our purposes here, the document is not very helpful. It tells us almost nothing specific about the church itself in that year, nor does it talk in precise terms about either the old or new location of the relics.

The story the document relates can be briefly summarized: The relics were taken out of their old hiding place and placed in elaborate tabernacles designed for optimum viewing conditions. When Ascension Day (actually 12 May 1401) arrived, the relics were shown "above the podium of the church itself" to the assembled

throngs. To accommodate the crowds, three separate showings, one reserved strictly for women, were held. After the third showing, there was a slight delay in final preparations before the relics could be installed in their new, accessible, permanent quarters. This installation involved putting the relics in a box placed on top of an altar. The place of the altar was then locked in some fashion that required eight keys held by eight different men. (The system of numerous keys still exists today.)

The new location of the relics (where in relation to the old location?) may also have been below ground level. In the preserved correspondence relating to the fifteenth-century building campaign, a "well" (*pozzo*) is mentioned in connection with the relics in five separate letters (Appendix II, nos. 7, 11, 12, 29, 30; the letters date between 2 January 1471 and 17 May 1473). Indeed, it seems to have been the custom before 1472 to show the relics above this "well" (Appendix II, no. 12: "havendo proveduto e fortificato il pozo per modo chel se potera apararsi monstrare il sangue de Cristo li, secondo usato"). This "well" was venerable enough for Lodovico Gonzaga to want special mention of it in the papal permit for razing the old church (Appendix II, no. 7). Also, this hole seems to have been located between the nave and choir of old S. Andrea, for in 1472 the church was to be torn down in two sections (Appendix II, no. 7: "e cosi la chiesa dal pozo verso la Porta e la Piazza . . . , e tirarla suso inanti se buti zoso l'altra parte").

The 1401 document makes tantalizing mention, as we noted, of the podium: "Igitur adveniento die dicta [Ascension] , et in Ecclesia Sancti Andree super podium ipsius ecclesie. . . ." There are at least two possible interpretations of the word "podium." One would refer to a raised choir over a crypt, such as one finds in the nearby church of S. Zeno in Verona and in the Duomo of Modena. At S. Andrea, the land slopes down from the façade toward the east, so that a crypt at ground level would have been possible under a choir raised up about 3 meters over the pavement of the nave. Such a solution would probably have been essential, given the extremely high water table in Mantua. But such an arrangement, although possible, does not square with the fact that in 1354 the relics were located below the pavement to the right of the high altar. Surely the vases would not have been lodged in the masonry between the choir floor and the vault of the crypt.

Whitney Stoddard has kindly suggested to me a far more plausible explanation to this puzzling question. To begin with, the language of the document is deliberately redundant—"in the church of S. Andrea above the podium of the church itself." This redundancy could have resulted from a departure from normal procedures, a departure that the author of the letter in question (Nerli himself—he writes "Ego abbas") wished to stress by making it clear that the podium was inside the church, and not somewhere else. In this light, it is useful to recall that temporary structures erected in the open for special ceremonies were common in the medieval and Renaissance

periods. Perhaps it had formerly been the custom, whenever the Blood had been shown, to exhibit it from a temporary stage in one of the major squares of the city. In 1401, then, that custom would have been changed, and the podium erected inside S. Andrea itself.

26. Appendix I, no. 9: "Qua hora multo maior multitudo utriusque sexus convenit, ita ut communi extimatione, excederent numerum decem milia personarum."

27. Fratris Petri de Nivolaria Ordines Carmelitarum, *Opusculum de sanguine Jesu Christi, qui est Mantuae* (1489) MS in Biblioteca Comunale, Mantua, A.1.6, fol. 31r. Cited by Mazzoldi, *MLS*, p. 18: "Testimonio sono molti che ancora vivono in carne, che se ricordano solergli venire il di della Ascensa, quando si monstra, tanti populi forastieri, che apena capire nella citta: et pareasi essere a Roma al tempo del iubileo."

28. Nerli, p. 1081 (see Appendix I, no. 7). Nerli's history was completed posthumously by another author, who carried the chronicle through the abbacy of Johannes, Nerli's successor (see Appendix I, no. 8).

29. Ibid., p. 1082 (Appendix I, no. 8).

30. According to a document of 27 October 1450, which I found in the Archivio di S. Andrea (Appendix I, no. 10).

31. Ritscher, "Die Kirche," p. 2; Donesmondi, *Dell' Istoria*, vol. 1, p. 333.

32. Ludwig von Pastor, *The History of the Popes*, vol. 3 (London, 1894), p. 45f. The question of the importance of the relic for the new S. Andrea is discussed at greater length in chapter VII of the present volume.

33. According to S. Lang ("The Programme of the SS. Annunziata in Florence," *Journal of the Warburg and Courtauld Institutes* 17 [1954], p. 299), Alberti was in Mantua in 1455. Lang cites K. Badt as the source for this information.

34. F. Amadei, *Cronaca universale della città di Mantova*, ed. G. Amadei et al. (Mantua, 1954–1957), pp. 2, 107f.

35. Appendix II, no. 7: "Noi voressimo dar principio alla Chiesa di S. Andrea . . . per esser de necesitade, che la viene a terra."

36. Ibid.: "per onor . . . nostro e di questa cittade."

## Chapter II

1. Braghirolli, "Alberti a Mantova," p. 14; see Appendix II, no. 2. This letter is not dated, but can be roughly assigned a date on the basis of Lodovico Gonzaga's reply to Alberti's letter on 23 October 1470. All of the letters relating to S. Andrea published by Braghirolli have been well covered by Ritscher, who, however, dealt with them entirely in German translation.

2. Alberti's words must be taken rather literally here. From a newly discovered letter of 23 September 1470, we know that Alberti was invited to join Lodovico at Gonzaga within one or two days (see Appendix II, no. 1). If the project for a new S. Andrea had been dis-

cussed at that time, there would have been no need for Alberti's remark "Ceterum io intesi a questi di...."

3. Alberti's famous phrase "piu capace piu eterno piu degno piu lieto" represents a departure from his statement in *De re aed.*, Bk. 6, ch. I: "Ex tribus partibus, quae ad universam aedificationem pertinebant ... ad usum apta, ad perpetuitatem firmissima, ad gratiam et amoenitatem paratissima...."

4. Paccagnini, *MLA*, vol. I, p. 6.

5. Krautheimer, during the discussion of his paper at the Munich Congress, pointed out that whatever Alberti sent Lodovico Gonzaga must only have been "eine kleine und sehr generelle Skizze" (*Kunstchronik* [December 1960], p. 367). If the sketch were enclosed in the letter, which measures 21.1 × 14.5 cm. fully opened, it could not have been very large either.

6. Such a procedure would be in line with the working methods Alberti described in *De re aed.*, Bk. 9, ch. x: "De me hoc profiteor: multas incidisse persaepius in mentem coniectationes operum, quae tum quidem maiorem in modum probarim; eas cum ad lineas redegissem, errores inveni in ea parte ipsa, quae potissimum delectasset, et valde castigandos; rursus cum perscripta pensitavi et numero metiri adorsus sum, indiligentiam cognovi meam atque redargui; postremo, eadem cum modulis exemplaribusque mandassem, nonnunquam singula repetenti evenit, ut me etiam numerum fefelisse deprehenderim."

7. Appendix II, no. 3: "el quale prima fatie ne piace; ma ... non lo possiamo ben intendere...."

8. On one occasion Lodovico wrote to his wife that a piece of work "molto fantastico" was being carried out at Cavriana, and that this work required his presence directly on the spot (Mazzoldi, *MLS*, vol. 2, chapter 1, n. 102). In correspondence he frequently referred to himself as a student of Luca Fancelli in architecture (Marani, *MLA*, vol. 2, p. 66). One cannot be sure how seriously we should allow ourselves to take these remarks of Lodovico's, but in any event his interest in architecture is clear.

9. A recently discovered letter in the Archivio di Stato, Mantua (Appendix II, no. 4) allows us to connect Luca with the project for S. Andrea much earlier than had previously been possible. In the documents published by Braghirolli, the name of Luca Fancelli does not appear until the end of April 1472. The supplies that Luca purchased were "cento carra de calcina per S. Andrea."

10. The basic documents relating to Luca's work in Mantua were also published by Braghirolli: "Luca Fancelli scultore architetto e idraulico del secolo XV," *Archivio Storico Lombardo* 3 (1876), pp. 610–638. For further bibliography on Fancelli, and for a survey of his career, cf. Marani, *MLA*, vol. 2, pp. 63–115. Recently, Clifford M. Brown ("Luca Fancelli in Mantua," *Mitteilungen des Kunsthistorischen Instituts in Florenz* 16 [1972], p. 153f.) has published an enormously useful checklist of all the autograph letters of Fancelli preserved in the Archivio di Stato, Mantua.

11. Appendix II, no. 5.

12. Appendix II, no. 6: "non se lavorara ala chiesa dio sa quando."

13. Andrea Schivenoglia, *Cronaca di Mantova di Andrea Schivenoglia dal MCCCCXLV al MCCCCLXXXIV*, in *Cronisti e documenti storici lombardi inediti*, ed. Carlo d'Arco (Milan, 1857), pp. 16–26 (see Appendix II, no. 8). Schivenoglia's chronicle reads as if it were based on a personal diary.

14. Gaye, *Carteggio* vol. I, doc. C; see Appendix II, no. 7.

15. Ibid.: "alla qual fabrica abbiamo volto il core." "noi voressimo dar principio alla Chiesa di S. Andrea alla qual fabrica abbiamo volto il core si per esser de necesitade, che la viene a terra, si etiam per onor vostro e nostro e di questa cittade."

16. Ibid.: "secondo uno modello ch'e facto non gli andara la spesa ne il tempo che se credeva."

17. Ibid.: "al pozo qual stà bon tempo fà come sapete cascare."

18. See chapter I, n. 25.

19. Appendix II, no. 7: "la chiesa dal pozo verso la Porta e la Piazza tutta quella parte, e tirarla suso inanti se buti zoso l'altra parte."

20. H. Grotefend, *Taschenbuch der Zeitrechnung...*, 10th ed. (Hanover, 1960), p. 158.

21. Braghirolli, "Alberti a Mantova," doc. VI; see Appendix II, no. 11.

22. Appendix II, no. 12.

23. See Appendix II, no. 11: "io ho facto inpire di quadreli chosi al suto sote alpozo per forma chel pozo resta fortissimo siche aparando il dito pozo si potera stare alongamente suso a mostrare il sangue di Cristo."

24. See Appendix II, no. 12: "stemo per ussarsi per il caldo per essere levato via il coverto de la gesia."

25. See n. 16.

26. Gaye, *Carteggio*, vol. I, doc. XCIV.

27. Girolamo Mancini, *Vita di Leon Battista Alberti* (Florence, 1911), p. 495.

28. Donesmondi, *Dell'Istoria*, vol. 2, p. 42.

29. Braghirolli, "Alberti a Mantova," doc. VII; see Appendix II, no. 13: "la eccelentia Vostra e stata a S. Andrea et ha ordinato se faza una pontata dal pavimento del coro in su, e, considerato che non e diccenuto i muri sicondo arano andare dal pavimento in su e dubito che loro non gli saperano diccenere senza me, ma me parerave che non andasse piu alto cum li murij per fina a tanto che nonsia la."

30. Ritscher, "Die Kirche," p. 9.

31. Ibid., p. 14. The drawing is preserved in the ASM, along with two documents relating to it (cf. Appendix III, nos. 10 and 11).

32. The drawing was made in the course of estimating repairs to the temporary wooden screen that closed off the east end of the nave. The sketch shows the east end of the nave as it appeared in 1580. We know that it could only represent the nave, for the part of the building shown is vaulted, and it is possible to demonstrate that

the rest of the church was not vaulted until the end of the seventeenth century, whereas the nave itself was vaulted by around 1500. The brick side walls of the nave are shown to left and right, together with the vault, covered by a low gabled roof, spanning the distance between them. The thickness of the vault is given by an inscription that reads, "la volta d. tezi 6 grossa," and the vault is shown connected directly to the roof by a rather thin section of masonry.

Under the vault appears the wooden wall, called the "paredana" in the documents, composed of wooden planks arranged in three horizontal bands. The planks were attached by nails to six horizontal members on the reverse (interior) side of the wall. The individual planks must have been 10 *braccia* long, in that two rows fill the 20-*braccia* distance from the springing of the vault to the apex of the vault.

Below the wooden wall two narrow brick walls, about 30 *braccia* high, extend out from the nave walls a distance of roughly 6 *braccia*. Between and directly above these walls runs what appears to be a trabeated system capped by a triangular gable. If the walls to either side take up approximately 12 *braccia* of the 40-*braccia* width of the nave, then the object in between must be about 28 *braccia* wide, or about 14 meters. This fairly wide entablature appears at first glance to have no visible means of support, for it is very clearly shown to be between the narrow flanking walls, rather than resting on them.

The blank space between the two walls (which are clearly shown as brick) bears two inscriptions. Indeed it is the only large part of the paper left blank so that it could carry an inscription. The lower and longer inscription reads: "la paredana d.la testada d.la chiesa di s.to Andrea ch. sono da refarlla elarga braza 41 li ase sivede che livole n.ro 100 che faremo da baso co. queli vechie eco.li listi p. li comisuri." This is essentially a technical description dealing with the work that was to be done to repair the wooden wall. It does, however, locate the wall at the "testada" of the church of S. Andrea.

The upper inscription is probably more important. It states: "la capella antica difora della chiesa in la fabrica." Like the inscription in the vault, it is to be read as a label describing the object on which it is found. That is, the inscription identifies the form between the projecting walls as "the old chapel outside the church in the area under construction." The architrave and gable, then, rest on independent walls, the structure of which is not described in the drawing in order to make room for the long inscription dealing with the repairs to the "paredana."

Ritscher read this inscription as a reference to the medieval chapel, as we have noted. Pedemonte's phrase, "capella antica," need not be interpreted, however, as meaning a building several centuries old. He could have meant a building precisely 108 years old, and if that building was a hastily erected, temporary structure, it could easily have seemed "antica" by 1580. It would be fortuitous indeed had the medieval choir been both

exactly the height of the nave walls and located precisely on axis with the new nave. Moreover, the shape of the "capella," as shown in the drawing, has a decidedly fifteenth-century, Albertian-Fancellian quality to it, especially with its classical trabeation and low-pitched roof.

I would like, therefore, to reconstruct the following sequence of events. We know from Lodovico's letter of 2 January 1472 that the church was to be razed in two campaigns, the first working from the high altar to the façade, leaving the eastern part to be leveled at an unspecified time in the future (n. 19). There is no reason to assume, however, that a long time elapsed before the second part was torn down also. I prefer to think that by July the old choir had disappeared, or was about to disappear, and that there was an urgent need to erect some temporary structure for the holding of services. Thus Lodovico's haste in having the scaffolding erected while Luca was away, even though the actual form the temporary structure was to take had not been planned. The Pedemonte drawing records for us the appearance, in the most general terms, of this temporary structure and the manner in which it was connected to the nave walls, as well as to the vault, by means of the "paredana." Pedemonte set down for us what he saw when he stood to the east of the end of the nave to make his drawing. In all probability, what he saw was entirely fifteenth-century construction.

I am very grateful to Ronald Malmstrom for suggesting this line of reasoning about the Pedemonte drawing to me.

33. Braghirolli, "Alberti a Mantova," p. 18; see Appendix II, no. 15.

34. Appendix II, no. 12.

35. Braghirolli, "Alberti a Mantova," doc. VIII; see Appendix II, no. 16.

36. Ibid.: "de verso il monastero e facto la mitade, prencipiando dal campanile et seguitando verso la segrestia, et e alzato al livello de la parte aposita de verso li botegi."

37. Ibid.: "l'altro parto se va facendo cum piu solicitudine si puo."

38. Ibid.: "non se ha potuto tirarla suxo si tosto per defecto che glie unaparte chel sie bisognato andar piu zoxo a trovare el buon tereno e proprio in quella parte se retrovato tanti fondamenti chel non se ha potuto lavorar cum homeni assaij et asi bisognato apontelare li murij et il tereno perche continuo ruinnava niente de mancho se facto bon lavoro."

39. Appendix II, no. 16. "Et si chava il fondamento dela fazada e principiato di fondare questa septimana chi vene e stimo sera fornito tuti li fondamenti a livello de quelo la Ex. V.ra havite facto."

40. *Kunstchronik* (December 1960).

41. Appendix II, no. 16: "luno di loro si lago stare in mezzo di una muracha et il tereno se roto uno osso di dui del brazo stancho et subito fu conzo."

42. Ibid.: "laltro glie dete una stanga in uno fiancho in mane essendo di sopra voltando fora dela segrestia uno pezo de una muracha la quale se divixij in due parte e non

stando lui atento se presumij che una de queli parte dela dicta muracha ribatese la dicta stanga."

43. Braghirolli, "Alberti a Mantova," doc. IX; see Appendix II, no. 17. "Nui non havemo calcina ne prede che possiamo prestare che sapiamo li cento ducati meglio se poriano retrare."

44. Appendix II, no. 18: "Li centi ducati se trovariano meglio per questo poco tempo stara el Cardinale a mantua et vedi che per ogni modo il faza provisione acio se possa continuare el lavorero."

45. Ibid.: "et levarlo ale tre braza secondo era deliberato."

46. See n. 47.

47. Appendix II, no. 17: "sel non se potesse andare ala tre braza se poria fare uno brazo o quello piu se potesse a cio che se vedesse molto bene come dovesse andare."

48. Appendix II, no. 19: "Avisso la S. V.ra come al nostro lavorerio de S.cto Andrea che glie alzato fino a questa hora uno brazo e mezo deli muri datorno e similiter la parte zotto deli capeli e tuta via si va lavorando cum grande solicitudine."

49. Appendix II, no. 20: "Pere lo debito de nicolo tosabese cum sancto andrea de trecento ducati o puocho piu qual ho tuolto in me ne la compra de la casa suoa: ho ordinato ad carlo da rhodiano: che paghi a la Ex. V. cento ducati in denari. et che per lo resto: che sono duecento ducati o circa dia tante pietre per lo edificio de la chiesa per tuto marzo proximo."

50. Braghirolli, "Alberti a Mantova," doc. X; see Appendix II, no. 21: "nui como sapeti non habiamo a tochar quelli danari se perho poreti ordinare cum esso Carlo sel intendo cum quelli hanno cura della fabrica et a lor li exbursi che nui ne rimaneremo contenti."

51. Appendix II, no. 22: "et questa et solo perche la S.ria V.ra non pigliase animazione et anche quela sapia dove io sono."

52. Appendix II, no. 23: "Circa el levare tria braza li muri de la giesia de s.cto Andrea questo supra li fundamenti. V.ra Signoria hara multo ben suo intento resta che quella preveda de li cento ducati me promisse."

53. Ibid.: "el qual deo dante per sua grazia feniremo ali tempi nostri."

54. Appendix II, no. 7: "Sara posto in opera due milioni de prede al creder nostro." Such careful calculations are urged by Alberti (*De re aed.*, Bk. 2, ch. 1), when he talks of the benefits of making models.

55. Appendix II, no. 26. It seems pointless here to make extracts from the document, which really should be read as a whole. The one point of real importance in the letter for the architectural history of the church we will deal with below.

56. Appendix II, no. 27: "volgheno imputarme per che io ho prexe gli dinarij i quali asendeno ala somma de libre .9. vel circha il tuto."

57. Appendix II, no. 25: "Maestro Lucha luj impersona questa matina sia venuto sulo lavorerio, il habia datto combiato al suprascripta francesco soprastante: et ali maistri cum grandissime minacie per modo che e rimasto

lo lavorerio in compitto." The work of which the canons wrote seems to have been on their own rooms, not on the church proper.

58. Braghirolli, "Alberti a Mantova," doc. XI; see Appendix II, no. 29: "domane de sera sera compito di levare tute le capelle a livello deli pontate secondo lordine prexo per quelo se aspeta a fare de za dala Sensa e lavorassi cum vintisepte chazoli: sollo restera da levare la porta grande de lintrada dela giesia."

59. Appendix II, no. 31: "Qui a Sancto Andrea questa setimana se fato asa buono lavorjo ma non ne alto anchora in nessuno luogo ale .20. braza questa setimana che vjene si lavora chon .20. chazuole e spero andar chon una parte alle .20. brazo." This important letter was overlooked by Braghirolli.

60. Appendix II, no. 24: "In questo tempo [1473] se lavorava fortemente a santo Andria."

61. From this three-year period only two documents seem to have survived: Appendix II, no. 32 (Braghirolli, "Alberti a Mantova," doc. XV), and Appendix II, no. 33. From the letter dated 9 December 1475, which speaks of "calcine date a Sancto Andrea," we can surmise that work was continuing on the site during that year.

62. Appendix II, nos. 34–40.

63. Braghirolli, "Alberti a Mantova," doc. XIX (Appendix II, no. 39): "avendo . . . lunedi prencipiato de lavorar a Sancto Andrea per vogiere quella terza chapella." Braghirolli omitted a later part of the letter, in which Luca informed Lodovico that by 24 September, the date of the document, he had "meso su i centoli et fato da ogni lato Braza .4. de volta."

64. Ibid., "Anchora o scrito a firenze per .4. maistri taia preti per far lavorar quella preta de sancto andrea." We do not know when these stone-carvers from Florence may have arrived in Mantua, or if they came at all.

65. Ibid., but omitted from the document as published by Braghirolli.

66. Appendix II, no. 34: "En vero questi maestri di questa terra ano posuto pocho lavorare perche ano auto male una gran quantita di loro et chi nonauto auto amalati de suoi di chaxa." Also Braghirolli, "Alberti a Mantova," doc. XIX (Appendix II, no. 39): "qui non ne che posino lavorare sono tuti stati amallati."

67. Appendix II, nos. 41–44. Numbers 42 and 44 were published by Braghirolli ("Alberti a Mantova," doc. XXII and XXIII, respectively).

68. See p. 19 f. for a further discussion of the ornament produced during this first building campaign.

69. Braghirolli, "Alberti a Mantova," doc. XVI (Appendix II, no. 35): "Questa opera non se po far senza Luca perche no glie altro che la intenda che lui perho seria pur necessario se intendessero cum lui [Johannino]." This letter, dated 20 September 1477, and the postscript that Lodovico sent after it later the same day (see Appendix II, no. 38), are both addressed to his wife ("Illust. d.ne nostre"), Barbara of Brandenburg. These are the only letters relating to S. Andrea in which she figures, although Lodovico frequently called on her to take care of matters

while he was out of Mantua overseeing his possessions, or in Tuscany at the baths. One gathers from this information that she took an active part in the governing of the Gonzaga realm, even to the point of trying to settle petty squabbles among the workmen at S. Andrea.

70. Ibid. (Appendix II, no. 35). As Lodovico succinctly put it: "queste belle cose non se possono far senza gran spesa."

71. Lodovico, however, was opposed to the idea of vaulting the third chapel before the next year of building (see Appendix II, no. 38).

72. The problems surrounding the works at S. Andrea that confronted Lodovico on 20 September 1477 seem to have left him more than slightly unsettled. Uncharacteristically, he seems to have sent to his wife and Luca one set of instructions in the morning, and then another set later in the day. By publishing only three of these letters, and leaving an important phrase out of the last of these (Appendix II, no. 38), Braghirolli somewhat obscured the sequence of events. Moreover, he also failed to publish the letter Luca wrote to Lodovico on 15 September (see Appendix II, no. 34), the letter that precipitated Lodovico's difficulties of the 20th.

73. For instance, on 12 September 1480, Federigo wrote to his brother, the Cardinal, in relation to the problems at S. Andrea: "mi remetto il tuto a quella che di presente e sul fatto." (Braghirolli, "Alberti a Mantova," doc. XXIII, published all of this letter except the last lines, which include the above-quoted phrase [see Appendix II, no. 44].)

74. As we learn from the documents found in Appendix II, nos. 41–44. The documents contain no information that furthers our knowledge of the state of construction at this point. Another chapel, however, was vaulted in 1479 (see Appendix II, no. 40a).

75. Appendix II, no. 45.

76. Ibid.; "Et quod de sexta et ultima capella constructa adicto latere dextro in presentiarum non declarat sed reliquit eam declarandam esse sub quo titulo et vocabulo denominari et declarari debunt. . . . De sexta autem et ultima capella constructa a dicto latere sinistro in introjtu dictae ecclesiae in presentarium non declarat sed reliquit eam declarandam esse sub quo titulo et vocabulo denominari et declarari debeat."

77. Braghirolli, "Alberti a Mantova," doc. XXIV (Appendix II, no. 46). "La santitate de N.ro Sig.e ha mandato a dimandare li denari che si sono riscossi qui per la cruciata, et seranno circa doa millia e trecento ducati. La S. V. scia che la continentia de la bolla prima era che questi tal denari devevasse spendere contra el turcho overo ad pias causas. Lo edificio di S. Andrea qui haveria grande bisogno de subsidio, essendo necessitate de farli in quasi ad un tempo una bona spesa per coprirlo e seria opera pijssima adiutar questa fabrica. A nui non e parso de lassare levare de qui questi denari fin tanto non habia risposta de V.S. de questo nostro scrivere: per lo quale prego quella voglia supplicare alla S.te prefacta sia contenta de condonare a questo edificio quella parte de dicti

denari, che li parera e piacera, e subito el resto sera mandato secondo comandare suoa beatitudine."

78. Appendix II, no. 48: ". . . in dicta ecclesia Sancti Andreae et ante infrascriptam Capellam apparatam quod dicta Capella que est sexto et ultimo constructa et fabricata a latere sinistro al introitus Ecclesiae . . . sit denominanda et consecranda sub titulo et vocabulo dicti sancti bonaventurae."

79. This chapel contains the bones of St. Longinus, relics that have always been important in the church. The veneration of Longinus in the church, therefore, would have required a special location for these relics. As we now know the original dedications of all the other chapels, it seems safe to assume that this one unknown chapel must have been originally intended for Longinus. The decorations of the chapel, carried out around 1534 under the direction of Giulio Romano, all have to do with Longinus and the Most Precious Blood. Giulio's altarpiece for the chapel, now in the Louvre, depicted the Nativity flanked by SS. Longinus and John the Evangelist, while frescoes designed by Giulio depicting the Crucifixion, with Longinus in a prominent position, and the finding of the Blood in the eleventh century cover the side walls. (Cf. Hartt, *Giulio Romano*, p. 208f.; Perina, *MLA*, vol. 2, p. 461.)

80. Appendix II, no. 47. "unam capellam denominatam et consecratam sub titulo et vocabulo Sanguinis Christi positam et fundatam in dicta ecclesia sancti Andreae de Mantua."

81. See chapter I, p. 5 f. for a discussion of this question.

82. Appendix II, no. 26: "uno Andrea del zarda muratore . . . lanno passatto comisse cento errori . . . et maxime circa le lumage."

83. The stairs that flank the west porch were also built during the fifteenth-century campaign, but they are rectangular, not circular, and therefore not *scale a lumaca*.

84. See chapter IV, p. 29.

85. This much of the archaeological situation was clear to Ritscher (see "Die Kirche," p. 191).

86. These changes are also discussed in chapter IV.

87. The diameters of the walled up oculi are roughly 2.5 meters, as are the diameters of the oculi still visible along the nave.

88. The existence of these niches in the original building was first noted by G. B. Intra in his pioneering study, "La Basilica di S. Andrea in Mantova," *Archivio Storico Lombardo*, 9 (1882), p. 300. His observation, and indeed his study of the church, have largely gone unnoticed. Windows, instead of niches, in these intermediate zones of the nave piers seem unlikely, in that the little domes over the small chapels would probably have cut off most of the available light. It has not been possible to verify the existence of these niches through an archaeological investigation of the piers. Such an investigation would involve removing at least part of one of the eighteenth-century frescoes. The filling in of the niches was, in all likelihood, coeval with the execution of these frescoes.

89. For a fuller discussion of the building of this transept, see chapter III, p. 24f.

90. Paccagnini, *Mantegna*, p. 52.

91. Gaye, *Carteggio*, vol. 2, doc. CXXXIII (Appendix II, no. 49): "Avvisandola che avuti questi denari, seria voltata la terza parte." Also later published by Carlo D'Arco, *Delle arti*, p. 30.

92. Appendix II, no. 49: "Fin dal anno 1485 et del mese di Zugno fu prestato alla Vra. Illma. Signoria Ducati cento dieci de quelli della fabrica di S. Andrea.... Et a questa festa della Ascensione proxima passata la prefata Illma. Signoria Vra. fece far la offerta de Ducati ducento, li quali poi furono restituiti cum provisione de farli risponere fra termine de uno mese, delli quali ancora se ne resta aver libre seicento nel circa."

93. Gaye, vol. 1, doc. CLVII; D'Arco, p. 39 (Appendix II, no. 50): "Ritrovandose la Fabrica di S. Andrea creditrice di V.E. de Ducati 400 nel circa, et avendo noi deliberato voltare quest'anno questa terza parte resta voltare.... quella pregamo se degni commettere al Massaro suo che dicta Summa de denari ne volia exbursare ducati cento; cioe ducati dieci ogni septimana...."

94. ASA, scaff. C, busta XXV, fasc. I (Appendix VII). In the following remarks I have attempted to synthesize the important information contained in these rather lengthy documents of the nineteenth century. Anyone who is interested in pursuing the matter further will find the documents themselves quite sufficiently self-explanatory. This reconstruction of the porch is discussed briefly in P. Bottoni, *Mantova numerizzata* (Mantua, 1839), p. 166; and G. C. Zupellari, *Mutamenti e fatti avvenuti in Mantova nella prima metà del secolo XIX* (Mantua, 1865), p. 21.

95. Ibid.: "due pilastri di marmo scannelati sostenenti il grande archivolto della facciata della Chiesa."

96. Ibid.: "si e rilevato che i [capitelli] sono di tuffo... si crede conveniente ed utile alla buona riuscita dell'opera riformare in marmo bianco."

97. Leandro Ozzola, *Il Museo d'Arte Medievale e Moderna del Palazzo Ducale di Mantova* (Mantua, n.d. [after 1949]), pp. 589–592.

98. The four fragments measure, left to right: .69 × .89 m., .675 × .88 m., .70 × .545 m., and .69 × .73 m.

99. Appendix VII: "le due mezze lesene coi corrispondenti capitelli rustici in cotto, che formano coritmia coi due pilastri di marmo scannellati sostenenti il grande archivolto della facciata della Chiesa, saranno ambidue scarpellati, onde sostituirvi due mezze lesene di marmo."

100. Illustrated in Paccagnini, *Mantegna*, pls. 11–14.

101. Illustrated in Carl von Stegmann and Heinrich von Geymüller, *The Architecture of the Renaissance in Tuscany* (New York, n.d.), pl. 20. The capitals at the Badia must date to about 1460, or shortly before, since work on the monastic buildings of the Badia seems to have been nearly completed before work commenced on the church in 1461. (See chapter VIII, n. 38, for bibliography.)

102. Janson, *Donatello*, fig. 151a.

103. Appendix VII: "i capitelli attuali sono di semplice stucco formato con calce e polvere di mattoni, e si riconoscono quasi consunti."

104. Wittkower, *Architectural Principles*, p. 54.

105. L. H. Heydenreich, "Die Cappella Rucellai von San Pancrazio in Florenz," in *De Artibus Opuscula XL; Essays in Honor of Erwin Panofsky*, ed. Millard Meiss (New York, 1961), p. 219f. Also two articles by M. Dezzi Bardeschi, "Il complesso monumentale di S. Pancrazio a Firenze ed il suo restauro," *Quaderni dell'Istituto di Storia dell'Architettura* 13 (1966), pp. 1–64; and "Nuove ricerche sul San Sepolcro nella Cappella Rucellai a Firenze," *Marmo* 2 (1963), pp. 135–161.

106. We do not know the actual date of the design of the tomb. Presumably it is 1444, the date of Bruni's death, or later.

107. For Brunelleschi's capitals, see Howard Saalman, "Filippo Brunelleschi: Capital Studies," *Art Bulletin* 40 (1958), p. 113f.; and Martin Gosebruch, "Florentinische Kapitelle von Brunelleschi bis zum Tempio Malatestiano und der Eigenstil der Frührenaissance," *Römisches Jahrbuch* 8 (1958), p. 65f.

108. Richard Milesi, "Mantegna und die Reliefs der Braut-Truhe Paola Gonzagas," *Festschrift Rudolf Egger* vol. 3 (Klagenfurt, 1958), p. 382f. I am very grateful to Dr. Milesi for his generous assistance in Klagenfurt.

109. *Kunstchronik* (December 1960), p. 356.

110. Ibid., pp. 356, 358.

111. This information was first published by Paccagnini (*Mantegna*, p. 52) in 1961.

112. *Kunstchronik* (December 1960), pp. 356, 358.

113. See n. 64 above.

114. Appendix VII: "in cotto ed intagliate ... per la maggior parte sguagliate negli ornamenti."

115. Ibid.: "Sara disfatto l'attuale pavimento di cotto nell'atrio, trasportando altrove i vecchi mattoni."

116. As Perina notes (*MLA*, vol. 2, p. 546), the Mola brothers are never referred to in contemporary documents as stone-carvers, but only as workers in intaglio.

117. Ibid., p. 550. She connects the sculptural work in the porch with the pictorial decorations carried out there by Mantegna and the young Correggio between 1490 and 1510. Such need not be the case, and Perina does not insist on the contemporaneity of the sculptural and pictorial decorations.

118. Ibid., p. 319f.

119. Marani, *MLA*, vol 2, p. 179.

120. A corner pilaster of a house at 17 Corso Vittorio Emmanuele, Mantua (Perina, *MLA*, vol. 2, p. 550), offers interesting analogies both to the door of S. Andrea and to the ceiling of Isabella's *Grotta*. The tendrils on this pilaster curve in parallel rows, as they do at S. Andrea, but the thinness and delicacy of the form recalls the decoration of the *Grotta*. The carving on the pilaster would seem, then, to be a reflection of the design of the S. Andrea portal in the more elegant style of the period of Isabella d'Este.

121. John Pope-Hennessy, *Italian Renaissance Sculpture* (New York, 1958), p. 338.

122. Idem, *Catalogue of Italian Sculpture in the Victoria and Albert Museum* (London, 1964), p. 308.

123. See n. 64 above. An interesting parallel can also be drawn between the portal of S. Andrea and a drawing of ornament in the *Libro* of Giuliano da Sangallo (fol.llr), which has been dated to 1485. Both designs may well have a common source in Florentine circles, since it is possible that a stone-carver from Florence executed the portal of S. Andrea (cf. *Il Libro di Giuliano da Sangallo*, ed. Christian Huelsen [Leipzig, 1910].) The pulpit on the interior of S. Andrea has been attributed to the designer of the portal (Perina, *MLA*, vol. 2, p. 549). Although there are similarities, one should hold the question open. The pulpit is clearly close to several carved bases in the museum of Palazzo Ducale (ibid., p. 550, pls. 422, 423).

124. Appendix VII: "rosette e chiodi romani di legno ... ornati attualmente dipinti a fresco nelle parti piane della fascie dell'intelerature di tutti i cassettoni delle volte."

125. To my knowledge, this information has not previously been published.

126. See chapter VI, p. 42.

127. This fragment of decoration came to light during the general cleaning the church was given in the summer and fall of 1971 in preparation for the celebration of the five-hundredth anniversary of the laying of the cornerstone of the church and of the five-hundredth anniversary of the death of Alberti. As far as I know, the information has not as yet been published, although some note may have been made of it in local Mantuan journals.

128. Paccagnini, *Mantegna*, pp. 51–57; Perina, *MLA*, vol. 2, pp. 281–284.

129. Wolfgang Lotz, "Zu Hermann Vischers D. J. Aufnahmen italienischer Bauten," *Miscellanea Bibliotecae Herzianae* (Munich, 1961), p. 73, fig. 124.

130. Alberti, *De re aed.*, Bk. 7, ch. 12: "Apertiones fenestrarum in templis esse opertet modicas et sublimes, unde nihil praeter caelum spectes, unde et qui sacrum faciunt quive supplicant, nequicquam a re divina mentibus distrahantur. Horror, qui ex umbra excitatur, natura sui auget in animis venerationem; et coniuncta quidem multa ex parte maiestati est austeritas."

131. At S. Francesco, Rimini, and S. Sebastiano, Mantua. For a further discussion of the point, see chapter VIII.

132. Cf. Wittkower, *Architectural Principles*, p. 55, for instance.

133. I am very grateful to Federick Hartt for generously sharing with me a set of photographs which he took of the "ombrellone."

134. If one applies the critical principles set forth by Robert Venturi (*Complexity and Contradiction in Architecture* [New York, 1966]) to the problem of the façade of S. Andrea, and to the "ombrellone" in particular, the composition can then be said to "work." In general, it is illuminating to look at Alberti with Venturi's thesis in mind.

## Chapter III

1. See, for instance, the capsule histories of the church presented both by Hubala, "Langhaus," p. 83, n. 3, and Christian Norberg-Schulz, "Le ultime intenzioni di Alberti," in *Acta ad archaeologiam et artium historiam pertinentia*, ed. H. P. L'Orange and H. Torp (Oslo, 1962), p. 131f., n. 2. Both of these scholars extracted their chronologies from Ritscher, but in part erroneously (cf. n. 2 below).

2. Ritscher, p. 20. He spoke at this point of "dem noch auszuführenden Querschiff."

3. Hubala, "Langhaus," p. 84, n. 2.

4. Eugene Johnson, "Notizie storiche sulla Basilica Concattedrale," *La Citadella* (Mantua, 6 December 1964). The signature was first published in this article.

5. ASA, scaff. C, *Catastrum Fozia Primiceriatus*, vol. 1, fols. 27r., 181v. (see Appendix III, nos. 4, 5, and 6). This information was also first published in "Notizie storiche" (see note 4 above).

6. Ritscher, as we have noted, postulated a minor campaign around this date, a campaign restricted solely to the north porch. Marani (*MLA*, vol. 2, chapter 4, n. 64) collected all the available documents, but felt (p. 128) that probably only "lavori di rifinitura e di decorazione" were carried out.

7. ASA, *Catastrum Fozia Primiceriatus*, vol. 1. (See Appendix III, nos. 2 and 3.)

8. Ibid. (Appendix III, no. 3): "et cimiteriu. dictae eccl.iae a quarto [latere]."

9. Ibid. (Appendix III, no. 1): The land rented is described as having "Plateam Broletto a tertio et cimiterium dictae eccl.iae a quarto."

10. ASA, *Catastrum Fozia Primiceriatus*, vol. 1.

11. A. Bertolotti, *Architetti*, p. 29 (see Appendix III, no. 7).

12. Braghirolli, "Alberti a Mantova," doc. XXVI, (Appendix III, no. 8).

13. D'Arco, *Delle arti*, p. 153 (Appendix III, no. 9): "... non intendemo che alcuno vadi exempto."

14. The record of the visit is still preserved in the ASA in a nineteenth-century transcription of the original document, the location of which is unknown. Excerpts from the document, which is largely concerned with learned debates on various theological questions, are to be found in Appendix III, no. 10. I have reproduced only those parts that bear directly on the building itself. Unfortunately, these notices offer only a very poor and fragmentary description of the building in 1575.

15. Ibid.: "ut relatum fuit iam sunt decem anni, et ultra quod inea aliquid, quod relevet, actum non fuit."

16. Work may have stopped in 1563, for in that year construction seems to have begun in earnest on S. Barbara, a church within the complex of the Ducal Palace itself. This remarkable building was designed by Giovanni Battista Bertani, *superiore delle fabbriche ducale* since 1550. Bertani could well have taken the work crews from S. Andrea and sent them to his own building, which rose

rather quickly. S. Barbara was, after all, not just any church, but the Palatine chapel of the Gonzaga family. Marani (*MLA*, vol. 3, pp. 3–70) was the first to attempt a serious account of Bertani's career, which has fallen into undeserved obscurity. S. Barbara, although little known, has one of the most interesting interiors of the mid-sixteenth century.

17. See chapter II.

18. As will be demonstrated in chapter V.

19. A fire seems to have occurred around the southeast corner of this pier.

20. See chapter V for a discussion of this campaign.

21. For a discussion of the campaign of 1597–1600, see the following chapter.

22. Ritscher's acount of the building history after 1600 is correct in all essentials.

23. That is, the depth of the north transept had been determined by the laying out of its west wall during the fifteenth-century campaign.

24. In the 1536 document (see Appendix III, no. 5) that records the renting of the house next to the west façade of S. Andrea to Bernardino Giberto, "Mag.co D.no Julio Romano" is mentioned as one of the three "superioribus Fabrice sancti Andre.e de Mantua."

25. Hartt, *Giulio Romano*, p. 67.

26. Chiara Perina, *La Basilica di S. Andrea in Mantova* (Mantua, 1965).

27. Certain details of the brick moldings on the north porch, however, are almost identical to details found on the interior of the church of S. Benedetto Po, which was being remodeled under Giulio's direction at this time (cf. Hartt, p. 241). The architectural ornaments of both buildings, then, seem to have come out of the same workshop.

28. For a further discussion of this question, see chapter VII.

29. Appendix III, no. 10: "Et cum vidisset capellam unam sub titulo S.ti Sebastiani admodum obscuram perquirendo invenit hoc factum fuisse quia vicini in prospectu dictae cappellae altus parietes suos extulerunt, et su luminibus capellae officium, at propterea Mandavit et ordinavit impedimente quaecumq. luminibus capellae dictae officientia inde removeri."

30. Ibid.: "Et prorsum ecclesiam ipsam perlustrando vidi finestras capellar. esse de tella confectas, antiquatas, et in pluribus partibus laceratas, et non reddentes capellis ipsis nec splendorem, neq. decorem, et propterea Ordinavit fenestras ipsas vitreas fieri."

31. Ibid.: "et alia fenestrae, quae sunt vitratae cum visae fuissent totae pulvere, et in pluribus partibus confractae Mandavit et ordinavit fenestras ipsas sic immundas, et deccastatas, et levari, et restaurari...."

32. Ibid.: "vel earum aliqua vitreum aliquid occulum non deesse cognoscatur, sed sint in omni parte de vitro conclusae."

33. ASA, scaff. C, busta XX (see Appendix IV, no. 6). At some later date, possibly in the late eighteenth century, the windows of the large chapels were remodeled into

"bath" windows, as they appear in Ritscher's section of the church. Later, even after World War II in some cases, the windows were returned to the original (?) circular shape. Hubala ("Langhaus," p. 110, n. 25) has judiciously left open the question of Alberti's original design for these windows. At this state of our knowledge the question should remain an open one.

34. Appendix III, no. 110: "R.mus D. Vis.or se contulit ad fabricam ipsam, quam vidit in suo principio esse regiam, et sublimem; sed in eo statu reperiri, quod spes aliqua non habetur ipsius complementi.... Nam fabrica ipsa nihil habit de reddita praeteo eleemosinas et oblationes, quae in dicta ecclesia fieri consueverunt in die ascensionis Domini.... eleemosinarum computa S.mus Dux Mantuae rettineri facit, et pecuniae."

35. Pedemonte was appointed "soprastante alla fabricadi S. Andrea" in 1542, and in 1554 he became "revisor delle fabbriche ducali" (Bertolotti, *Architetti*, p. 74).

## Chapter IV

1. A. Bertolotti, *Artisti in relazione coi Gonzaga Signori di Mantova* (Modena, 1885), p. 67. (See Appendix IV, no. 1.)

2. Donesmondi, *Dell'Istoria*, vol. 2, p. 344. (See Appendix IV, no. 2.) Another local chronicler, the less reliable Gasparo Asiani (*Istoria del Sangue tratto dal costato di Giesù Cristo per Longino* [Mantua, 1609], p. 31), tells us that building began "nel principio del mese di Settembre dell'anno 1597."

3. Donesmondi, vol. 2, p. 359. (See Appendix IV, no. 3.)

4. Ibid., p. 43f. (See Appendix IV, no. 4.)

5. See the following chapter for an account of this campaign.

6. Still another example is S. Salvatore in Lauro, Rome, the nave of which was rebuilt after 1591, probably on a design of Ottavio Mascarino. The church has a single vaulted nave flanked on either side by three chapels. Pairs of freestanding columns, which rise in front of the crossing piers, narrow the space at the crossing. Cf. Jack Wasserman, *Ottavio Mascarino and His Drawings in the Accademia Nazionale di San Luca* (Rome, 1966), p. 191f., figs. 188, 189.

7. See Appendix IV, no. 4: "si deve fabricar la cupola."

8. See Appendix IV, no. 2.

9. Donesmondi, vol. 2, p. 359. (See Appendix IV, no. 3.) In his biography of Vincenzo (ibid., p. 472) Donesmondi notes that "in honore del preziosissimo Sangue di Cristo fece la nuova fabrica del Santuario, Coro e Capella grande nella Chiesa di Sant' Andrea." By "Santuario" we know that Donesmondi meant the crypt, both by process of elimination ("Coro" must mean the choir, while "Capella grande" indicates the terminating apse) and by his further notice (ibid., p. 474) that

Vincenzo was buried in the "santuario a basso in quel camerino stesso ove era il corpo della defonta moglie."

10. Ritscher, "Die Kirche," p. 181. (See Appendix IV, no. 10.)

11. The altarpiece is now in a fragmentary state, having been dismembered by Austrian troops. The major portion still preserved is now in Palazzo Ducale, Mantua. For a recent attempt to reconstruct its original form, see Frances Huemer, "Some Observations on Rubens' Mantua Altarpiece," *Art Bulletin* 48, no. 1 (1966), p. 84; followed by an exchange of letters in the *Art Bulletin* 48, nos. 3–4 (1966), p. 468f., between Huemer and Julius Held.

12. Donesmondi, vol. 2, p. 477f.

13. See Appendix III, no. 10: "R.mus D. Visitator se contulit ad locum, in quo conservari dicuntur reliquae p.tae, et est locus subterraneus praeseferrens pietatem, et devotionem maximam.... vidit locum ipsum quampluribus cratibus ferreis circumquaq. clausum, Itaq. locus ipse valde fortis, et tutus admodum redditur et demum apertis omnibus clausuris, que tribus clavibus diversis, et clauduntur, et reserantur.... Interogavit Idem R.mus D. Visitator quamplures ex circumstantibus clericis, et laicis...."

14. Marani, *MLA*, vol. 3, p. 173.

15. The attribution to Viani seems to go back to G. Cadioli, *Descrizione delle pitture, sculture, ed architetture, che si osservano nella città di Mantova, e ne' suoi contorni* (Mantua, 1763,) p. 52. Ritscher (p. 182) was not eager to accept this old attribution without question, and he was probably right. Cadioli is not always a reliable historian. Marani (*MLA*, vol. 3, p. 172), on the other hand, accepts the attribution and dates the design 1595. His reasons for dating the design to that year are not clear to me. Some documents I found in the Archivio di S. Andrea (see Appendix IV, nos. 5 and 6) indicate that work was being carried out in the crypt in 1595, especially in relation to the altar. As far as I know, Marani had no knowledge of these documents, which in any case do not mention the name of Viani.

16. Marani, *MLA*, vol. 3, p. 173. With good reason, he dates the altar around 1610.

17. See n. 9 above.

18. For a discussion of the fourth campaign, see chapter V.

19. At this time this chapel was furnished and decorated by the *Primicerio*, Tullio Petrozzani, at his own expense. He was buried beneath its pavement. The chapel deserves some attention, for it is quite different in many details from all others in the church. The rosettes of the coffers of the vault, for instance, are larger than any of the rosettes of the other chapel vaults. The capitals of the rear pilasters are not the usual painted channeled ones, but rather are decorated with busts of the four Evangelists, two to each capital. The style of these capitals recalls that of Viani in the Sala degli Arcieri in Palazzo Ducale, for instance (Marani, *MLA*, vol. 3, p. 116), and it is highly likely that he was their designer.

The fresco decorations were carried out contemporaneously, probably by Ippolito Andreasi. Pamela Askew ("The Question of Fetti as Fresco Painter: A Reattribution to Andreasi of Frescoes in the Cathedral and Sant' Andrea at Mantua," *Art Bulletin* 50 [1968], pp. 1–10) has rightly removed the frescoes from the *oeuvre* of both Viani and Domenico Fetti. In 1609, Petrozzani donated a complete set of furnishings for the chapel, including vestments, cloths for the altar, and appropriate religious texts (see Appendix IV, no. 9).

Above the vault of this chapel a pair of contiguous, shallow ramping barrel vaults rise from the exterior wall to the transept vault to support the roof. This particular kind of vault, with bricks laid in a herringbone pattern, occurs only in this one place in S. Andrea. The roofs over the other three chapels of the transepts are supported by wooden beams, probably placed there during the fourth campaign. The roofs over the nave chapels, as we noted in chapter I, are supported by a markedly different vaulting system.

20. Marani (*MLA*, vol. 3, p. 162) points out that Viani was in Mantua by early January 1591.

21. Viani's career in Munich is discussed by Karl Feuchtmayr in *Thieme-Becker*, vol. 34 (1940) p. 321; and by F. Hermanin and E. Lavagnino in *L'opera del genio italiano all'estero: Gli artisti in Germania*, vol. 3 (Rome, 1943), p. 41f.

22. For the history of St. Michael's, see Max Hauttmann, *Geschichte der kirchlichen Baukunst in Bayern/Schwaben und Franken/1550–1780* (Munich, 1921), p. 110f.

## Chapter V

1. ASM, AG, P. 3303 bis (see Appendix IV, no. 11).

2. Ibid. (see Appendix IV, no. 12): "alcuni siti di Muraglie, Corticelle, et altri luoghi siti nelle loro Case, e botteghe contigue alla Chiesa Collegiata di S. Andrea."

3. Ibid. (see Appendix V, no. 4).

4. Appendix V, nos. 5 and 6.

5. The brief notice in *Thieme-Becker*, vol. 33 (1939), p. 303, cites only his work at S. Andrea. Perhaps some day a full-scale investigation of the late-seventeenth-century architecture of Bologna will uncover the story of his career. Clearly related to his work at S. Andrea is a polygonal structure attached to the choir of the former church of the Jesuits in Mantua. This small building carries a heavy *cavetto* molding very similar to that which Torre used on the exterior of S. Andrea.

6. ASA (see Appendix V, no. 1). In 1964, this unpublished document was framed and hanging on the wall of the room directly above the first chapel on the right as one enters the church. Pigeons had been roosting in this room for some time and appear to have found comfortable perches on the frame. The occasional *lacunae* in the transcription of the document are a direct result of these sleeping arrangements. The document describes the drawings as follows:

Pianta di tutta la Chiesa è quella che hà la Scala di piedi 100, misura di Bologna.

Spaccato della pianta è quello che hà la Scala di piedi 80 di Bologna.

Alzata per di fuori della Testa della Chiesa dalla parte verso il Coro, con i fianchi laterali delle facciate delli bracci della pianta sudetta, che fanno croce, è quella che hà la Scala di piedi 60 di Bologna.

Il disegno delle tre facciate per di fuori è quello che hà la Scala di piedi 40 di Bologna.

Armadura del Coperto è quell, che hà la Scala di piedi 50 di Bologna.

7. Published by R. Bellodi, "La Basilica di S. Andrea in Mantova," *Emporium* 14 (1901), p. 355; and by Hubala, "Langhaus," after Bellodi, fig. 6. The original seems to have disappeared. I could find no trace of it in the archives.

8. Appendix V, no. 1. "tutte vanno mosse in parte dal luogo, cioè parte vanno ristrette, e parte vanno allargate, ma tutte vanno tagliate dalle parte dell'imboccatura delle Capelle per allargare le medeme...."

9. See n. 7.

10. Appendix V, no. 1: "e quelle [pilastrate] delli pilastroni della Cupola vanno tagliate dove sono le lasene segnate alla lettera B. per far le medeme più grande."

11. Ibid: "le pilastrate dell'imboccatura del Coro di presente non fanno risalto nel Coro, e nel disegno pretenderia che ve ne fosse, e per far detto risalto, e non voler restringere la sudetta imboccatura, che purtroppo è stretta, và tagliato il muro del Coro ingiro tanto che nascono i risalti, che mostrano i disegni."

12. Ibid.: "il Confessio ... è di necessità il riempirlo."

13. Ibid.: "per due capi, la ragione del primo è che quel vano tra li piloni, dove và eretta la Cupola, overo Catino, non bisogna, che sia voto, nemeno li piloni devono essere disuniti con quelle Scale, e porte, che di presente si trovano, ma bisogna che siano tutti pieni, e di buon muro."

14. Ibid.: "La seconda è non essere luogo a proposito, perche volendo illuminare il detto, è di necessità le finestre per il suolo della Chiesa, & è cosa, che non stà bene in luogo sacro vi si chi camina sotto, à sopra con commodo di veder un sotto l'altro senza esser veduto."

15. Ibid.: "hò trovato esser meglio il far la Cupola appresso di me di nuova invenzione alla forma, che mostra il disegno."

16. It is not altogether clear what was meant by the term "Catino." It might mean a pendentive dome, or it could mean a dome on pendentives. My preference is for the latter meaning, in that the two churches that arose in Mantua in the late 1470s that directly demonstrate the influence of S. Andrea—the Cappella dell'Incoronata next to the cathedral and the new choir of S. Francesco—both have domes on pendentives over their crossings. These buildings seem to have been designed by Luca Fancelli, who knew, if anyone knew, what the original scheme for a dome was. Moreover, the little chapels of S. Andrea are also capped by domes on pendentives rather

than pendentive domes, and it would seem strange to change dome forms in mid-church, as it were. This question is discussed in chapter VII.

17. Ibid.: "più galante di quello possa essere qualsivoglia Catino."

18. Ibid.: "si allarga la Cupola, che resta più grande, e la balaustrata viene più ad ornare, & è fuori di modo che sino ad hora si sono fatte tal sorte di fabriche. Circa poi alla sustanza della fabrica non và dubbio alcuno che essendo quella eretta quasi nel mezzo degli Arconi li detti fanno la sua forza eguale e conseguentemente non sforzano, ne calcano i piloni più da una parte, che dall'altre...."

19. Ibid.: "un sito commodo da passegiare intorno alla detta [cupola]."

20. Ibid.: "le parte segnate la lettera C. sono le porte delle Sagrestie, dove sopra vanno collocati li Organi."

21. Ibid.: "la pianta segnata la lettera D. e il Campanile vecchio da distruggere."

22. Ibid.: "la pianta segnata la lettera E. e il Campanile da farsi."

23. Appendix V, no. 2.

24. See n. 6 above, especially the "Alzata per di fuori della Testa della Chiesa dalla parte verso il coro [an elevation of the east end], con i fianchi laterali delle facciate delli bracci ... che fanno croce...." There is no indication in the document as to the relationship between the transept façades of his plan and elevation and other designs that preceded his. We do now know that he found the porch of the north transept completed (see below).

25. For example, A. Venturi, *Storia dell'arte italiana*, vol. 8, pt. 1 (Milan, 1923), p. 220.

26. ASA, scaff. C, busta XXII (see Appendix V, no. 3). The cover page of the document bears the legend "Sia in eterno benedetto, et adorato il/Preziosissimo Sangue di Gesù/Christo Nostro Redentore." The document was signed by Antonio Ardenna and bears the date 20 May 1731. This document was known to Ritscher, who published it in German transcription ("Die Kirche," pp. 183–188).

27. Appendix V, no. 3, "Primo anno."

28. Ibid.

29. Ibid.

30. I part company here with Ritscher (pp. 183–184), who takes the "Pilloni Latterali" to be the southernmost piers, and the other two piers, described in more detail, to be the crossing piers.

31. Appendix V, no. 3: "Secondo anno."

32. Ibid.

33. I was unable to uncover any documents relating to these intriguing doors. A sacristan of the church informed me that the side doors had been open during his father's lifetime to allow access to the church from the houses along its south flank. Wooden "storm doors" of late-eighteenth-century design still cover these portals, and were presumably placed over them because the doors were used.

34. The Bellodi section shows only one large door in

the end wall of the south transept. The tomb that now occupies the space of the central door was placed there in the late eighteenth century (see chapter VI).

35. Appendix V, no. 3: "Terzo anno."

36. Ibid.

37. The frescoes in the western chapel of this arm of the transept have recently been attributed to the Mantuan painter Ippolito Andreasi by Pamela Askew ("The Question of Fetti as Fresco Painter: A Reattribution to Andreasi of Frescoes in the Cathedral and Sant' Andrea at Mantua," *Art Bulletin* 50 [1968], p. 1f.). Askew (ibid., p. 9) dates the frescoes 1600–1608. Clearly the transept must have been covered in some manner before the walls of the chapel could have been decorated.

38. Appendix V, no. 3: "Quarto anno."

39. Ibid.; "Quinto anno."

40. See chapter IV.

41. Appendix V, no. 3: "Sesto anno."

42. The niches measure .945 meter in width by 1.97 meters in height. Their centers are located at a point 5.52 meters from the central axis of the wall, or directly above the centers of the small doors of the west wall. The bases of the niches are approximately 1.4 meters below the bottom of the present great oculus. The niches must have sat almost directly on the cornice. In connection with these niches, obviously part of the original structure, it is interesting to note that Alberti (*De re aed.*, Bk. 7, ch. 12) stressed the need for windows in *templa* to be high up, and modest in size; cf. chapter II, no. 127 above.

43. Appendix V, no. 3: "Sesto anno."

44. See chapter VI.

## Chapter VI

1. The *Gazzetta di Mantova*, 21 August 1733, noted that a new design was produced "alle fervorose istanze" of Tasca. (See Appendix VI, no. 5.)

2. Appendix VI, no. 4, *passim*. The documents relating to Juvarra's role at S. Andrea were published by Leonardo Masini, in "La Vita e l'Arte di Filippo Juvarra," *Atti della Società Piemontese di Archeologia e Belle Arti* 9, no. 2 (1920), pp. 197–299. For the most recent discussion of Juvarra, see Richard Pommer, *Eighteenth Century Architecture in Piedmont* (New York, 1967). See also C. Brandi, "La cupola dello Juvarra a S. Andrea a Mantova e un precedente," *Arte in Europa, Scritti di storia dell'arte in onore di Edoardo Arslan* (Milan, 1966), p. 813f.

3. Appendix VI, no. 4a.

4. Guglielmo Pacchioni, "La cupola di S. Andrea a Mantova e le Pitture di Giorgio Anselmi," *Bolletino d'Arte* 13 (1919), p. 61 and n. 2.

5. Appendix VII, nos. 1 and 2.

6. Appendix VI, no. 46.

7. Ibid., nos. 4c and 4d.

8. Ibid., no. 4d.

9. Ibid., no. 4e.

10. Ibid., no. 5. Paolo Pozzo in a letter of 1780 spoke of the "Disegni lasciati dal Cav. Don Filippo Juvarra l'anno *1733* li 12 Agosto" (Appendix VI, no. 14). Presumably he saw two or more dated drawings, but unfortunately these drawings are no longer known.

11. A. E. Brinckmann et al., *Filippo Juvarra*, vol. 1 (Milan, 1937), p. 26, pl. 76. The drawing for Como (Museo Civico, Turin) is one of two on the same sheet for the same building. The actual dome in Como is much simpler than the one in the project, particularly in that the four large buttresses were eliminated. F. Frigerio (*La cupola della Cattedrale di Como e la sua Vicende* [Como, 1935], p. 15) mistakenly placed the Como project after, rather than before, that of S. Andrea.

12. Appendix VI, no. 6.

13. Ibid., no. 14.

14. Ibid., no. 9. One wonders if Paolo Pozzo vetoed these particularly playful parts of the decoration, which he would have termed "licenziose."

15. Ibid., no. 16.

16. Brayda, Carlo, Laura Coli, and Dario Sesia, "Ingegneri e architetti del sei e settecento in Piemonte," *Atti e Rassegna Tecnica della Società degli Ingegneri e Architetti in Torino*, vol. 17 (Turin, 1963), p. 43f.

17. The domes are sometimes given to Vanbrugh by modern scholars. Cf. Viktor Fürst, *The Architecture of Sir Christopher Wren* (London, 1956), n. 412, in which he concurs with an opinion presented earlier by the editors of the *Publications of the Wren Society*, vol. 6 (London, 1928), p. 11f.

18. The statues and the stucco work are the responsibility of one Paolo Bolla. Pacchioni, doc. 12.

19. Appendix VI, no. 14: Paolo Pozzo explained, "Quanto è mai diverso il gusto del Juvarra da quello dell'Alberti." Ibid., no. 17: In 1783 an anonymous writer informed his readers that Alberti "immaginava un bacile semplice, che non sarebbe deformato il tempio con sostituirvi la presente mole, distruggendo l'antico ordine già stabilito dal Alberti."

20. For his lighting of a church with vaulted nave flanked directly by side chapels, cf. his Church of the Carmine, Turin, where there are large openings in the ends of very shallow chapels to give the nave a maximum amount of light (Pommer, figs. 127–130).

21. Appendix VI, no. 8.

22. Moreover, his attack on the baroque style parallels the anti-baroque stance of the critic Antoine-Chrysostome Quatremère de Quincy, whose *Dictionnaire d'architecture* began to appear in 1788. For a discussion of this period in painting, cf. Robert Rosenblum, *Transformations in Late Eighteenth Century Art* (New York, 1966).

23. Appendix VI, no. 8: "di unico modello agli altri tempi cattolici posteriormente inalzati."

24. Ibid. In this letter, dated 24 June, he referred to a letter written as far back as April.

25. Ibid.: "si per la solidità che per l'eleganza e dignità corrispondente alla magnificenza del tempio."

26. Ibid., no. 10: "per quasi la metà."

27. Ibid.: "troppo pensante, e licenziosa forma."

28. Appendix VI, no. 11: "sei pilastri da farsi nelle intestate del Tempio.... Aprire il fenestrone rotondo di facciata per ricevere maggior lume.... Un telarone con vetrine ramata.... Altri due simili nella crociera con l'apertura dei medesimi finestroni...."

29. Ibid.: "rimettere le 3 finestre quadrangolari, nel coro ed altrettanti rotonde."

30. Ibid.: "la formazione de otto nichie nove con colone d'ordine corinto."

31. Ibid.: "aprire le 4 nichie nelle intestate."

32. Ibid.: "Per levare il rialzo sopra il frontispizio di facciata e per ottenere un lume diretto nel Tempio reducendo lo spazio sopra il Proneo ad uso di terrazza o pure ricoprirlo con tetto."

33. Paolo Orioli, *Foglie e Spighe ... I dipinti candelabri nella Basilica di S. Andrea di L.B. Alberti in Mantova* (Mantua, 1900). Perina (*MLA*, vol. 3, p. 627) dates the beginning of work on these decorations in 1785, but they were probably begun earlier (cf. n. 37 below).

34. Appendix VI, no. 13: "Per dipingere N. 6 Pilastri nuovi con candelabri corrispondenti ai vecchi."

35. Ibid.: "Per ritoccare gli altri pilastri gia dipinti."

36. Ibid.: "Per dipingere a scomparti simili a quelli della volta del Tempio le volte della crociera e quelle del Coro col suo cadino.... Per rimettere N. 11 cassettoni nella suddetta volta del Tempio.... Per ritoccare il rimanente d'essa volta...."

37. Ibid. no. 17: "E siccome la succennata data da una ben giusta lode anche a que' pittori che sonosi impiegati negli ornati del tempio vi dirò che il Sig. Pozzo ha molto contribuito alla vaghezza di quelli, procurando coi suoi consigli e sull'esempio de' già rimasti ornati, che i nuovi si accostassero a quelli; ed infatti ora miriamo con piacere tutta la gran croce ridipinta sul gusto del restante." This letter was first published by Carlo D'Arco, *Delle arti*, vol. 2, p. 239.

38. Appendix VI, no. 14: "le vecchie pitture nel Tempio, si d'ornati, che di figure sono state eseguite da Andrea Mantegna, e suoi Scolari...."

39. The shells originally painted in the niches of the west façade are shown clearly in the Visscher drawing of 1515 (see chapter II, n. 129). Traces of these shell frescoes still exist (pl. 21) in the niche next to the campanile.

40. Appendix VII, no. 11.

41. Egon Verheyen, "Jacopo Strada's Mantuan Drawings," *Art Bulletin* 49 (1967), pp. 62–70. See also K. W. Forster and R. J. Tuttle, "The Palazzo del Te," *Journal of the Society of Architectural Historians* 30 (1971), p. 267f.

## Chapter VII

1. See Ritscher, "Die Kirche," pp. 1–20, 181–200.

2. Hubala's whole article ("Langhaus"), in a sense, is devoted to differentiating the style of the nave from that of the east end.

3. Krautheimer, "Templum," *passim*.

4. Hubala, "Langhaus," p. 88.

5. The basic account of the historical development of the Mantuan cityscape is found in Stefano Davari, *Notizie storiche topografiche della città di Mantova nei secoli XIII–XIV e XV* (Mantua, 1903). Arturo Carlo Quintavalle (*Prospettiva e ideologia, Alberti e la cultura del sec. XV* [Parma, 1967], p. 154) presents some interesting ideas about the relationship of S. Andrea to the Mantuan scene. He erroneously states, however, that Alberti created on the north side of S. Andrea a piazza (Piazza Alberti) symmetrical with the one on the south (Piazza dell'Erbe). Piazza Alberti, as we now know it, did not exist until the nineteenth century (cf. the Ranieri map of Mantua, 1831 [pl. 66], which still shows at least part of the old monastery still standing).

6. Hubala, in conversation, particularly stressed Alberti's long preoccupation with the Pantheon. The structure, even, of S. Andrea, with its honeycomb-like character of mass and void, is reminiscent of the essentially hollow structure of the Pantheon (cf. William MacDonald, *Roman Architecture* [New Haven, 1965], p. 104f). Alberti (*De re aed.*, Bk. 7, ch. 10) clearly appreciated this structure: "Ad templum Pantheon Praestantissimus architectus, pariete cum esset opus crasso solis ossibus usus est, caetera complementa respuit, apatiaque istic, quae imperiti complevissent, scafis et apertionibus occupavit, eoque pacto impensam minuit, molestiam ponderum sustulit operique elegantiam adiecit."

7. Davari, p. 51.

8. Ibid., p. 53.

9. Ibid., p. 50.

10. Ibid.

11. Ibid., p. 63.

12. Ibid.

13. Braghirolli, "Alberti a Mantova," p. 6, notes that the first letter we have from Lodovico Gonzaga to Alberti, written in December 1459, indicates both a familiarity between Lodovico and Alberti as well as Alberti's having been in Mantua for some time.

14. Elizabeth B. MacDougall, "Nicholas V's Plan for Rebuilding St. Peter's, the Vatican Palace and the Borgo" A.M. thesis, New York University, 1955). Also Torgil Magnuson, *Studies in Roman Quattrocento Architecture* (Rome, 1958). Magnuson's work was reviewed by MacDougall in *Art Bulletin* 44 (1962), p. 67f.

15. See Enzo Carli, *Pienza, la città di Pio II* (Rome, 1966), esp. p. 83, n. 66, for bibliography.

16. Davari (p. 63) points out that the houses with porticoes parallel to the south flank of the church were of very old origin. What stand today are fifteenth- and sixteenth-century (and still later) reconstructions of much earlier buildings. The houses now crowd up against the south side of the church, so that the Vicolo del Muradello no longer exists.

17. Alberti, *De re aed.*, Bk. 7, ch. 3: "Demum, ubi

templum colloces, esse oportet celebre illustre et, uti loquuntur, superbum, et ab omni profanorum contagio expeditum. Ea re pro fronte habebit amplam et se dignam plateam, circuetur stratis laxioribus vel potius plateis dignissimis, quoad undevis praeclare conspicuum sit."

18. On this point I agree with Quintavalle (p. 154), although his reasons for proposing a south porch are not wholly adequate.

19. See chapter I, n. 26.

20. See chapter I, n. 36.

21. L. von Pastor, *The History of the Popes*, vol. 3 (London, 1894), p. 286. For a more recent discussion and bibliography of the controversy, cf. Marita Horster, "Mantuae Sanguis Preciosus," *Wallraf-Richartz Jahrbuch* 25 (1963), esp. p. 163f.

22. von Pastor, p. 287f.

23. Ibid.

24. Cardinal Francesco Gonzaga reported the proceedings of the Christmas 1462 disputation to his father in a letter of 7 January 1463 from Rome. Ibid., p. 288, n. 1. The letter reads as follows: "Illustrissimo Si. mio padre. Secundo la determinazione che scrissi a V. S. essere fatta circa la disputatione de la materia del Sangue de Christo. Lunedi e martedi proxime passati se congregarono Li frati de s. francesco e de s. dominico nanti la santita de nostro si. e qui in presentia de cardinali et laltri prelati arguirono ciascuno de lor sutilmente che haveveno chiamati a questa disputatione. Li principali valenti homini de lordine lor. e benche circa questa materia fossero publicati piu capituli: pur insistorono solamente circa uno che fu questo. an a sanguine effuso de corpore christi per tridivum ante illius reassumptionem seperata fuerit divinitas. Li frati minori tenevano che si. Li predicatori che non. La cosa e riducto a questo termine: che debbano notare inscriptis tuti questi suoi argumenti e produrli. poi la Santita de nostro Signore dice volere havere li voti de tuti li prelati. e qui tractata dapuoi la cosa in consistorio secreto farne la dechiaratione. de quello se concludera ne sera advisata V. S. ala quale non me occorre alpresente scrivere altro: se non che ad essa dicontinuo me raccomando. Roma vij Januarij MCCCCLXIIJ" (ASM, AG, 842, 2).

25. John M. Hunisak has generously allowed me to peruse an unpublished paper of his in which he considers this very question. Hunisak points out that a logical conclusion to have reached in the hypostatic debate, had the Franciscan (negative) side prevailed, would have been the following: "The consecrated wine of the Eucharist . . . would be superior to any relic of the blood He physically shed at the time of His Passion."

26. *In Historiam Mantuanam Gonzagiamque Familiam* (1482), MS in Biblioteca Comunale, Mantua; P. de Nivolaria (Novellara), *Opusculum de sanguine Jesu Christi, qui est Mantuae* (1489), MS in Biblioteca Comunale, Mantua; B. Spagnoli, *Tractatus de Sanguine Christi* (1492), MS in Biblioteca Comunale, Mantua (published Mantua, 1892).

27. Illustrated in Horster, fig. 129. Also Paccagnini, "Mantegna," p. 100, fig. 144, and Perina, *MLA*, vol. 2, pl. 405. Horster (p. 170f.) also discusses a medal cast in 1475 by

Bartolomeo Melioli. On the obverse, the medal carries a bust portrait of Lodovico Gonzaga surrounded by an inscription: LUDOVICUS II MARCHIO MANTUAE QUAM PRECIOSUS XPI SANGUIS ILLUSTRAT. In his unpublished paper, Hunisak argues convincingly that the well-known bronze relief of the Crucifixion (the Medici Crucifixion) in the Bargello in Florence (Janson, *Donatello*, p. 243) exhibits iconographic peculiarities that can best be explained in relation to the relic of the Blood of Christ conserved in S. Andrea. He further suggests that the relief could have been commissioned by the Gonzaga from the Donatello workshop. It could have been intended for Mantua, or else for the rotunda of the SS. Annunziata in Florence, of which the Gonzaga were the patrons.

28. Horster, p. 167.

29. Horster (p. 180) attributes the relief to Luca Fancelli and suggests that it might be connected with one of the early works of religious architecture that Fancelli carried out in Mantua. While I do not wish to become involved in the troublesome question of the attribution of the work, I would like to suggest the possibility that the work might have been intended for S. Andrea itself.

30. It has been suggested to me that Pius II's acquisition of the head of St. Andrew, which he carried triumphantly into Rome in 1462 (Pastor, vol. 3, p. 258), may also have played some role in the decision to rebuild S. Andrea. I do not deny the great importance of the event, nor should one doubt the Gonzaga interest in it—Francesco Gonzaga marched in the Roman procession, and the ceremonies were reported to Lodovico Gonzaga by his Roman agent (ibid., n. 1). On the whole, however, I find it difficult to believe that the arrival of the head in Rome engendered the rebuilding, eight years later, of a church in Mantua. Had the Gonzaga acquired the head, instead of the pope, the connection, of course, would be obvious.

31. A recent account of Lodovico's career may be found in Mazzoldi, *MLS*, vol. 2.

32. F. Amadei, *Cronaca universale della città di Mantova*, ed. G. Amadei et al. (Mantua, 1954–1957), vol. 2, p. 173.

33. Ibid., p. 182f. Amadei gives a date of 22 June 1472, ten days after the laying of the cornerstone, for the suppression of the monastery. Amadei (p. 188f.) also noted that on 24 July 1472 Sixtus conferred the *ius patronato* of the church onto the Gonzaga family, which had put up a "preventitivo deposito di mille fiorini di Camera da applicarsi all'incomminciata nuova fabbrica della chiesa, il quale deposito ed effettivo sborso fatto dal Marchese apparisce ne' documenti del notaio Matteo Trezona, che se ne rogo li 17 settembre 1475."

34. Pastor, vol. 4, p. 203.

35. Donesmondi, *Dell'Istoria*, vol. 2, p. 41.

36. For the genealogy of the Gonzaga family, see *Mostra Iconografica Gonzaghesca, Catologo delle Opere* (Mantua, 1937). I am very grateful to Ronald Malmstrom for bringing this book to my attention.

37. Marani, *MLA*, vol. 2, p. 87f.

38. Ibid., p. 95f. The unfortunately destroyed choir of S. Francesco (replaced after World War II by a fake late-Gothic design) seems little known. It may well deserve more careful study than it has received. Surely it would seem to be one of the most immediate and important prototypes for the choir that was added, toward the end of the century, to S. Maria delle Grazie in Milan. It also forms a very interesting parallel with the eastern parts of the presumably later S. Bernardino in Urbino.

39. The most recent student of this cassone, Richard Milesi ("Mantegna und die Reliefs der Braut-Truhe Paola Gonzagas," *Festschrift Rudolf Egger*, vol. 3 [Klagenfurt, 1954], p. 386) noted that the building in question could be "ein primitives Abbild von Albertis San Andrea in Mantua." Paola Gonzaga was married to Count Leonhard von Görz in 1477. The cassone is mentioned in an inventory of her possessions made the following year. The attribution of the decorations is very much an open question, although clearly the artist was not ignorant of the work of Mantegna and his circle. Milesi (p. 392) places the work near that of Bartolomeo Melioli, a Mantuan goldsmith and medalist, since the treatment of certain heads brings to mind techniques of the medal carver.

40. Such portraits are not unknown, however, in triumphal scenes of the later quattrocento—for example, the panel depicting the Triumph of Chastity, now in the Galleria Sabaudia, Turin, attributed to Cosimo Roselli or Bartolomeo di Giovanni, and datable to the last quarter of the century. In the background of the scene there is a view of Florence in which both the tower of Palazzo Vecchio and the great bulk of Palazzo Pitti are clearly identifiable (cf. Marziano Bernardi, *La Galleria Sabaudia di Torino* [Turin, 1968], p. 106). The Klagenfurt cassone does in fact include an unmistakable "portrait" of an ancient building, the Basilica of Maxentius (probably derived from a similar view of the same monument in Mantegna's frescoes in the Camera degli Sposi); cf. Robert Eisler, "Die Hochzeitstruhen der letzten Gräfin von Gorz," *Jahrbuch der K. K. Zentral-Kommission fur Kunst-und Historischen Denkmale* 3, no. 2 (1905), p. 69.

41. Krautheimer, "Templum," p. 71.

42. Appendix II, nos. 2 and 3.

43. Ibid., no. 5.

44. Howard Saalman, "Early Renaissance Architectural Theory and Practice in Antonio Filarete's Trattato di Architettura," *Art Bulletin* 41 (1959), p. 103.

45. Ibid.

46. Ibid.

47. John Spencer (*Filarete's Treatise on Architecture* [New Haven, 1965]) has published in facsimile the only illustrated copy of the treatise. For another discussion of the dating and content of the treatise cf. Peter Tigler, *Die Architekturtheorie des Filarete* (Berlin, 1963). Tigler notes (p. 170) a "merkwürdige Unterdruckung der Perspektive in der Mehrzahl der Traktatillustrationen Filaretes." His statement is misleading. Most of the illustra-

tions, except for ground plans, are rendered in perspective, although Filarete may use two or more vanishing points in the same drawing in an attempt to give a visual description to more than one side of a building at the same time, or to render plan and elevation simultaneously. Filarete himself realized the inadequacy of his own system (cf. Wolfgang Lotz, "Das Raumbild in der Italienischen Architekturzeichnung der Renaissance," *Mitteilungen des Kunsthistorischen Instituts in Florenz* 7 [1956], p. 193f).

48. Pointed out by Saalman ("Early Renaissance Architectural Theory," p. 105), and accepted by Tigler (p. 170).

49. This key passage is found in *De re aed.*, Bk. 2, ch. 1: "Inter pictoris atque architecti prescriptionem hoc interest, quod ille promenentias ex tabula mostrare umbris et lineis et angulis comminutis elaborat, architectus spretis umbris prominentias istic ex fundamenti descriptione ponit, spatia vero et figuras frontis cuiusque et laterum alibi constantibus lineis atque veris angulis docet, uti qui sua velit non apparentibus putari visis, sed certis, ratisque demensionibus annotari." I translate this passage as: "Between the rules of the painter and those of the architect there is this difference—the first strives to show relief on a flat surface by means of shadows and diminished lines and angles [foreshortening in perspective], the architect, disdaining shadows, lays out his relief by means of a plan of the foundation [ground-plan], but he indeed in other places [in other drawings] demonstrates the spaces [sections] and the design of each façade and side [elevations of exterior and interior] with constant lines and true angles [no perspective; but an absolute relationship of parts], so that he wants to be judged not by appearances to the eye, but to be evaluated on the basis of sure and determined measurements."

50. Ibid.: the architect's models should be "nudos et simplices."

51. From his description in *De re aed.* (Bk. 9, ch. 10; see chapter II, n. 6 above) of his own designing methods, it is clear that he went through at least two stages in designing a building. First he made a rough sketch, and then he corrected that sketch according to mathematical ratios, a process that, he noted, often surprised him when he realized how far his own intuitively designed forms were from the sets of proportions he had ideally in mind. From the evidence of his own letter of October 1470 to Lodovico Gonzaga, it is clear that he continued this practice into his old age. The letter (Appendix II, no. 2) was accompanied by a sketch, which Alberti offered to "rectarlo in proportione," should Lodovico like his ideas.

The letter also brings up the question of what Alberti meant when he used the word "modello." He says that he has seen a "modello di Manetti" for S. Andrea. This modello, which must in some way or other have been on view, was probably a fairly finished presentation model. Yet Alberti opposed his own sketch—"questo qual io vi mando" to "quel" of Manetti. Furthermore, the modello Alberti referred to in a letter to Matteo de' Pasti in 1454 concerning the construction of the Tempio

Malatestiano must have been a finished modello, for the Tempio was being built on the basis of this model, while Alberti himself resided in Rome (cf. Cecil Grayson, *Alberti and the Tempio Malatestiano* [New York, 1957 ] ).

The evidence in *De re aedificatoria* for Alberti's meaning of "modello" is also somewhat contradictory: "Iccirco vetus optime aedificantium mos mihi quidem semper probabitur, ut non perscriptione modo et pictura, verum etiam modulis exemplariisque factis asserula seu quavis re universum opus et singulae cunctarum partium dimensiones de consilio instructissimorum iterum atque iterum pensitemus atque examinentur, priusque quid aliud aggrediare, quod impensam aut curam exigat." Alberti here could have referred to models made of wood ("modulis ... factis asserula"), if one understands "asserula" as a generic reference to wood. On the other hand, "asserula" could refer to a single piece of wood, used in the manner of a straightedge. The former interpretation would indicate a three-dimensional model, the latter a drawing.

From this evidence it is probably safest to conclude that "modello" did not, for Alberti, refer to a specific kind of visual approximation of the future building, but could be anything ranging from a rapid sketch to a set of working drawings to a wooden model of large scale. It is not impossible, even, that his "modello" for S. Andrea consisted of both working drawings and a wooden model. His specifications must have been quite precise— witness the great subtleties in the handling of details on the façade (see below, chapter VIII). I side with Wittkower's original position (p. 54, n. 2) on this question.

52. As Grayson (*Alberti and the Tempio Malatestiano*, p. 6) points out, Alberti's turning over the construction to a professional builder is consistent with the view he expressed in *De re aed.*, Bk. 9, ch. 11: "Adstitoribus ista quidem solertibus circumspectis rigidis demandanda sunt, qui quae facto opus sint, diligentia studio assicuitate procurent." On the other hand, we should not assume that Alberti never took an interest in the technical problems of construction. *De re aed.* is filled with observations of a technical nature. Moreover, I have recently found a document which shows Alberti in the role of giving advice on how to lay bricks directly on the site. In a letter to one of his foremen, Giovanni da Padova, who was working on the Gonzaga fortress at Cavriana, Lodovico Gonzaga on 20 May 1460 gave the following order: "Il resto del terreno veder de butarlo dallo canto de fuori o chel se porti via come meglio te parera, preterea voressemo el vede de far lavorare de quelle prede al modello, che disse messer Baptista perche non poriano esser megliore da la scarfa ove gli andara tante prede cotte..." (ASM, AG, 2885, 31, 61v). The work at Cavriana on which Alberti gave advice has in all probability disappeared, for the building is in a ruinous, if picturesque state.

53. For example, the following lines from the prologue to *De re*: "Praeclare igitur apud Tuchididem prudentia veterum comprobatur, qui ita urbem omni aedificiorum genere parassent, ut longe, quam erant, potentiores

videruntur. Et quis fuit summorum ac sapientis simorum principum, quin inter primas propagandi nominis et posteritatis curas rem habuerit aedificatoriam?"

54. It is very likely that the designs for his earlier buildings were made the same way. The fact that S. Francesco in Rimini and S. Sebastiano in Mantua were not finished according to their original plans has more to do with the mundane fact that they were never finished at all than with Alberti's renderings of his plans for them.

55. Hartt, *Giulio Romano*, p. 67.

56. Appendix III, no. 5.

57. These sentiments are expressed in the famous letter of 1519 to Pope Leo X, for whom Raphael was engaged on a vast project of recording the ancient buildings of Rome. Even if the letter was not written by Raphael himself, it clearly must express his feelings about the great monuments of the ancient past. The text of the letter is published in Vincenzo Golzio, *Raffaelo nei Documenti* (Vatican City, 1936), p. 82f.

58. Wolfgang Lotz, "Zu Hermann Vischers D. J. Aufnahmen italienischer Bauten," *Miscellanea Bibliotecae Herzianae* (Munich, 1961), p. 73, fig. 124.

59. Published by Mancini, *Vita di Leon Battista Alberti* (Florence, 1911), p. 396. James S. Ackerman ("Architectural Practices in the Italian Renaissance," *Journal of the Society of Architectural Historians* 13 [1954], p. 3f, n. 10) notes the existence of two other drawings after the same plan. One is found in a sketchbook of about 1535–1540 attributed to Aristotile and Giovanni Battista Sangallo (Palais des Beaux-Arts, Lille). The other is a copy of the Lille drawing, from a sketchbook of Oreste Vannocci, c. 1510 (Biblioteca Communale, Siena).

60. Ackerman, p. 4.

61. Gustavo Giovanonni, *Antonio da Sangallo il Giovane* (Rome, n.d.), p. 254f., fig. 210. Giovanonni (p. 257) noted that Antonio had taken up an Albertian idea.

62. Ibid., p. 191f., fig. 138 (Uffizi A. 921), fig. 139 (Uffizi A. 925).

63. Ibid., p. 139, fig. 76 (Uffizi A. 67).

64. This fascinating building is still not well studied, although it holds a rather significant position in the history of Renaissance architecture. It is a very important source for Palladio's far nobler Redentore in Venice, and thus the key link between Alberti's and Palladio's masterpieces. The relationship to S. Andrea has been pointed out by Luigi Serra (*L'Arte nelle Marche, il periodo del Rinascimento* [Rome, 1934]). Cf. also B. Patzak, *Die Villa Imperiale bei Pesaro* (Leipzig, 1908), p. 149f. Girolamo Genga knew Mantua well, having visited it on more than one occasion (cf. Patzak's *voce* on Genga in *Thieme-Becker*, vol. 13 [Leipzig, 1920], p. 386f; also A. Pinelli and O. Rossi, *Genga Architetto* [Rome, 1971]. Pinelli and Rossi do not acknowledge any connection between S. Giovanni Battista and S. Andrea).

65. Hartt (p. 243) relates the flank rather to Bramante, but Giulio could hardly have failed to take notice of S. Andrea, the first example of the "rhythmische-travée," the example closest at hand, and ultimately, of course, the source for Bramante.

## Chapter VIII

1. Wittkower, *Architectural Principles*, p. 54. Many of the ideas in this chapter are either based on or grow out of Wittkower's fundamental analysis of Alberti's architecture.

2. Ibid.

3. Ibid.: "Alberti's fusion of two systems incompatible in antiquity is thoroughly unclassical and paves the way for the Mannerist conception of architecture during the 16th century." There were, of course, Roman triumphal arches to which pediments were applied. The Arch of Augustus at Rimini, which Alberti clearly knew, is only one such example. It is interesting to note that at least one other quattrocento architect saw his way clear to superimpose a pediment on a triumphal arch. In reconstructing the arch of Septimius Severus at Rome, Giuliano da Sangallo gave it a pediment which it surely never had in antiquity, but which, in Giuliano's mind, was appropriate. Could Giuliano have discussed this very problem with Alberti sometime around 1470? Cf. C. Huelsen, ed., *Il Libro di Giuliano da Sangallo* (Leipzig, 1910), fol 21v. There is also a building which Giuliano thought to be part of the Forum of Trajan (fol 2r.), which may have exerted a certain influence on Alberti at S. Andrea. One finds in Giuliano's drawing several striking parallels. The round central arch rises from capitals which have masks on their corners. Inside the arch, set into a slightly recessed wall, is a round window, or at least a roundel. To either side of the central portal are two rectangular doorways. Finally, the whole is capped by a triangular pediment. The heavy rustication of the masonry would seem to have nothing to do with S. Andrea, and yet there are those traces of painted rustication still preserved on the south side of the west porch (pl. 64).

4. For Wittkower, Alberti's medievalisms seem to stop with the façades of S. Francesco and S. Maria Novella (dated c. 1450 and 1458, respectively)—Wittkower (p. 45) was the first to date the façade of S. Maria Novella securely.

5. The façade of Crema Cathedral dates from about 1314 (cf. Angiola Maria Romanini, *L'Architettura Gotica in Lombardia*, vol. 1 [Milan, 1964], p. 219, who remarks of the façade, "si tratta di uno vero e proprio finto-nartece." Also, Amos Edalo et al., *Il Duomo di Crema* [Milan, 1961]).

6. Alberti began this practice in Rimini, where many of the major elements of the design of the exterior are derived from the local Arch of Augustus and also from the nearby Mausoleum of Theodoric in Ravenna. The Florentine buildings— S. Maria Novella, Palazzo Rucellai, and the chapel in S. Pancrazio—also all rely heavily on local tradition.

7. Leon Battista Alberti, *On Painting and On Sculpture*, C. Grayson, ed. and trans. (London, 1972).

8. Piero Sanpaolesi ("Il tracciamento modulare e armonico del S. Andrea di Mantova," *Arte Pensiero e Cultura a Mantova nel Primo Rinascimento in Rapporto con la Toscana e con il Veneto* [Florence, 1965], p.97) seems to have been the first to have noted this important source for Alberti. I had independently come to the same conclusion before reading Sanpaolesi's article.

9. Corrado Ricci (*Il Tempio Malatestiano* [Milan and Rome, 1924] ) is still the primary source for a study of the Tempio (cf. also Wittkower, pp. 37–41, and Cecil Grayson, *Alberti and the Tempio Malatestiano* [New York, 1957]). Carlo L. Ragghianti ("Tempio Malatestiano," *Critica d'Arte* 71 [1965], p. 23f., and 74 [1965], p. 27f.) has attempted a reconstruction of Alberti's original design for the church. See also Città di Rimini, *Sigismondo Pandolfo Malatesta e il suo tempo* (Vicenza, 1970).

10. Bibliography in W. Paatz, *Die Kirchen von Florenz*, vol. 3 (Frankfurt, 1952), p. 663f; Also Wittkower, pp. 41–47.

11. Bibliography in Marani, *MLA*, vol. 2, p. 133f.

12. Wittkower, pp. 47–53 and fig. 7. Marani (*MLA*, vol. 2, p. 125–126) has rightly challenged Wittkower's proposed single staircase in front of the façade. As Marani pointed out, such a staircase leaves no possibility for an entrance into the crypt. In his remarks at the Alberti Congress held in Mantua in April 1972, Marani shrewdly observed that the Wittkower staircase made Alberti a Palladian before Palladio.

13. Wittkower (p. 51) attributed the cornice to Pellegrino Ardizoni, the man who completed the church (as far as it was ever completed) at the end of the quattrocento. Marani (*MLA*, vol. 2, p. 135, n. 24) seems to feel that the cornice was erected in 1479, under the direction of Luca Fancelli. I tend to side with Wittkower.

14. Appendix I, no. 10.

15. Wittkower (p. 54) notes: "The mouldings and denticulation of the entablature on which the pediment of the 'temple' rests are repeated in the entablature which by rights belongs to the triumphal arch and the form of the capitals of the outer pilasters—which is not identical with that of the inner ones—is echoed in the capitals of the small order."

16. Max Theuer, *Albertis Zehn Bücher über die Baukunst* (Vienna, 1912), p. 356.

17. Krautheimer ("Templum," p. 68f.) in part reaffirms Theuer's position, but adds that certain Roman mausolea and related building types also stand behind Alberti's concept of the *templum etruscum* (p. 69f.).

18. For a discussion of the close relationship between Alberti and Federigo da Montefeltro, Lord of Gubbio, see L. H. Heydenreich, "Federico da Montefeltro as a Building Patron," *Studies in Renaissance and Baroque Art presented to Anthony Blunt on his 60th Birthday* (London and New York, 1967), p. 5f. The chances of an Alberti visit to Gubbio are very high. For the Palazzo de'Consoli, see John White, *Art and Architecture in Italy, 1250–1400* (Baltimore, 1966), p. 176f.

19. Romanini (p. 188) dates it around the middle of the twelfth century. Cf. also Paccagnini, *MLA*, vol. 1, p. 145.

20. Alberti's precise role on the interior of S. Francesco

has yet to be defined. Ricci (p. 255) believed that Alberti was not involved in remodeling the interior. Wittkower (p. 43) felt that the interior at least in part was Alberti's responsibility, although he does not spell out his opinions in detail. Wittkower essentially supports the position taken by Geymüller (Stegmann-Geymüller, *Die Architektur der Renaissance in Toscana*, vol. 3 (Munich, 1885–1907), Appendix to Alberti, p. 4) that Alberti was the mastermind behind the whole scheme. Although I hesitate to accuse Alberti of the architectural decorations one finds on the interior, I am convinced that the disposition of the spaces was his responsibility.

21. These two domed spaces are specifically noted by A. Schiavi (*Il restauro della chiesa di S. Sebastiano* [Mantua, 1932], esp. pp. 14, 23, 27). Otherwise, these chambers seem to have escaped scholarly notice. Schiavi called the domes blind, but the southern dome does have a lantern. The dome of the northern chamber had been torn out before Schiavi's time to make room for a staircase ascending the tower in which the north room is actually located.

22. Alberti, *De re aed.*, Bk. 8, ch. 1. "Nostros tamen non ausim vituperare, qui intra urbem sacratissimis locis condant, modo cadaver non intra templum inferant, ubi patres et magistratus ad aram vocatis superis conveniant, ex quo illud fiat interdum, ut sacrificii puritas contaminetur corrupti vaporis foeditate."

23. Appendix II, no. 45.

24. Alberti, *De re aed.*, Bk. 8, ch. 3.

25. See chapter VII, n. 6.

26. Adriano Peroni, "La struttura del S. Giovanni in Borgo di Pavia e il problema delle coperture nell'architettura romanica lombarda," *Arte Lombarda* 14, no. 1 (1969), p. 21f.; and 14, no. 2 (1969), p. 63f. The churches in question are S. Giovanni in Borgo, Pavia (destroyed); S. Michele, Pavia; and S. Savino, Piacenza.

27. Ibid., 14, no. 2 (1969), p. 69. At S. Michele, Pavia, moreover, the little vaults that support the side roofs are connected to a series of flange buttresses below roof line, just as the side vaults are connected to the flange buttresses along the flanks of S. Andrea (ibid., fig. 18a).

28. As we know from the Labacco drawing. See chapter VII, n. 59.

29. For a contemporary precedent for aspects of the structure of S. Andrea, cf. the discussion of the Badia Fiesolana below.

30. Janson, *Donatello*, pl. 296. For this aspect of S. Andrea, the Basilica of Maxentius offers a far more logical solution to the problem of vaulting such a wide space. The central vessel was covered by a series of three groin vaults, which directly related to the three transversely barrel-vaulted auxiliary spaces along each side. Alberti clearly avoided this "easy way out," preferring a visually more complicated system. One suspects that the great hall of the Palazzo de' Consoli in Gubbio, with its single barrel rising from three arches on either side, must indeed have been in his mind.

31. Earlier in his career, Alberti spoke strongly against the use of round windows, both because they tended to weaken the structure and because they tended to diminish the amount of light a window could admit into an interior (cf. Grayson, p. 11). At S. Andrea he seems clearly to have changed his mind, perhaps for the visual unity of his nave. Round arched windows, such as those that occur in the side bays of the west façade, would have made the structural situation clearer than the present round windows do.

32. Krautheimer, "Templum," p. 68.

33. Heinrich Klotz, "L. B. Albertis 'De re aedificatoria' in Theorie und Praxis," *Zeitschrift für Kunstgeschichte* 32, no. 2 (1969), pp. 93–103.

34. It is, of course, always tempting to speculate on the possible meanings that the various architectural forms Alberti used at S. Andrea had for him. Why the specific combination of triumphal arch and temple front? Did he mean to join them together to indicate that the building had both secular and religious connotations? Does the triumphal arch stand for the church triumphant, in an analogous manner to the way the Blood of Christ conserved in the building reminds us of Christ's triumph over sin and death, and thus the devout believer's like triumph? At present, we do not have the hard evidence at our disposal to answer these questions. There is also the possibility that Alberti thought of the triumphal arch as a backdrop against which the relic would be displayed to crowds in the surrounding squares. Such a situation does obtain in the relief on the tomb of Pius II, now in S. Andrea della Valle, Rome. There, in the scene of the Consecration of the Head of St. Andrew, the pope himself holds up the reliquary containing Andrew's head in front of a triumphal arch which is not dissimilar to the façade of S. Andrea. The tomb was probably designed shortly after the death of Pius in 1464 and executed in the years immediately following. Thus there could easily be some connection between this relief and Alberti's design of the façade of S. Andrea. Cf. W. R. Valentiner, "The Florentine Master of the Tomb of Pope Pius II," *Art Quarterly* 21 (1958) p. 117f., fig. 9. I am grateful to Richard E. Lamoureux for suggesting this possibility to me.

35. Richard Krautheimer, *Early Christian and Byzantine Architecture* (Baltimore, 1965), fig. 21.

36. A capsule history, with bibliography, of this church is given by Suzanne Lewis, "Function and Symbolic Form in the Basilica Apostolorum at Milan," *Journal of the Society of Architectural Historians* 28, no. 2 (1969), p. 83f.

37. Romanini, pl. 95b.

38. See the remarks of H. Saalman in his introduction to Antonio di Tuccio Manetti, *The Life of Brunelleschi*, ed. H. Saalman, trans. C. Enggass (University Park, Pa., 1970), pp. 29–32.

39. L. H. Heydenreich, "Brunelleschis Spätwerke," *Jahrbuch der preussischen Kunstsammlungen* 52 (1931), p. 1f.

40. Wittkower, *Architectural Principles*, p. 55f.

41. Ibid., p. 38.

42. Manetti, ed. Saalman, p. 23.

43. S. Spirito remains a disputed building. P. Sanpaolesi's contention (*Brunelleschi* [Milan, 1962], p. 77f.) that the nave was originally intended to be vaulted has been reaffirmed by E. Luporini (*Brunelleschi: Forma e Ragione* [Milan, 1964]). That both writers are wide of the mark is demonstrated by Howard Saalman in his review of Luporini in *Art Bulletin* 48, nos. 3–4 (1966), p. 442f. Sanpaolesi's supposed vault for S. Spirito raises, unnecessarily, the question of the influence of that imaginary vault on the design of S. Andrea.

44. Wittkower, fig. 15a.

45. The modern bibliography for the SS. Annunziata includes: L. H. Heydenreich, "Die Tribuna der SS. Annunziata in Florenz," *Mitteilungen des Kunsthistorischen Instituts in Florenz* 3 (1930), p. 268f.; *idem*, "Gedanken über Michelozzo di Bartolomeo," *Festschrift für Wilhelm Pinder* (Leipzig, 1938), p. 264f.; W. Lotz, "Michelozzos Umbau der SS. Annunziata in Florenz," *Mitteilungen des Kunsthistorischen Instituts in Florenz* 5 (1940), p. 402f.; A. Sabatini, "La Chiesa della SS. Annunziata di Firenze prima della ricostruzione michelozziana," *Rivista d'Arte* 22 (1940), p. 229f.; W. Paatz, *Die Kirchen von Florenz*, vol. 1 (Frankfurt, 1941), p. 62f.; R. Taucci, *La Chiesa e il Convento della SS. Annunziata di Firenze e il loro ampliamento fino alla metà del secolo XV* (Florence, 1942); and S. Lang, "The Programme of the SS. Annunziata in Florence," *Journal of the Warburg and Courtauld Institutes* 17 (1954), p. 288f. It seems quite clear that there was a plan from the beginning (1445) to terminate the building with a centralized structure. Alberti, of course, later participated in some capacity in the building of the rotunda, which was financed by Lodovico Gonzaga.

46. The most recent digest of the building history of the S. Casa is found in Floriano da Morrovalle, *Loreto bell'Arte* (Genoa, 1964), p. 19f. The church seems to have been begun in 1468, and the foundations were apparently in place by 1471. Cf. a review of this book by Kathleen Weil-Garris Posner, *Art Bulletin* 50, no. 1 (1968), p. 108f.

47. Longitudinally planned churches with strongly centralized east ends, in contrast to purely centralized churches of the Renaissance, have not been studied *in extenso* as a particular building type. It is clear, however, that longitudinal churches with centrally planned east ends form a very important group in the history of fifteenth-century architecture in Italy. In recent years, following Wittkower's pioneering study (part 1, pp. 1–32), Wolfgang Lotz ("Notizien zum Kirchlichen Zentralbau der Renaissance," *Studien zur Toskanischen Kunst, Festschrift für Ludwig Heinrich Heydenreich* [Munich, 1964], pp. 157–165) and Staale Sinding-Larsen ("Some Functional and Iconographical Aspects of the Centralized Church in the Italian Renaissance," in *Acta ad archaeologiam et artium historiam pertinentia*, vol. 2, ed. H. P. L'Orange and H. Torp [Rome, 1965], pp. 203–252) have demonstrated that centrally planned churches of the Renaissance tend to share certain physical, functional, and iconographic aspects. The S. Casa in Loreto and S. Andrea in Mantua each fall into two of the iconographic categories that Sinding-Larsen has established. Both churches relate to his category 1 (p. 219), that is, martyria and sepulchral and memorial buildings, as does Nicholas V's St. Peter's. S. Andrea also falls into his second type (p. 219), that is, it is related to Christ's Death and Passion. The S. Casa, on the other hand, has to do with his fourth category (p. 220), churches related to the Virgin. What seems to distinguish the churches in Rome, Loreto, and Mantua from purely centralized structures, with similar dedications, of the same period is that they had to serve not only as memorial structures, but also as major pilgrimage centers capable of containing vast throngs of the faithful. Not until Bramante presented his design for St. Peter's did an architect actually propose a centrally planned structure that would also accommodate an enormous congregation.

Lotz ("Notizien," p. 157) stressed the fact that centrally planned churches tended to act as monuments ("Der Zentralbau als Denkmal"), with as much attention paid to their exterior articulation as to that of the interior. The monumental aspect of the S. Casa, when viewed from the primary approach along the Via Adriatica, is striking for any visitor. Had S. Andrea been given a porch on the south transept arm, with a dome visible above that arm, then its character as a monument within the Mantuan cityscape would doubtless have been far more forceful. As Lotz has noted, however, (ibid., p. 159) an urban situation made the problem of the visibility of the church as monument far more difficult than in those freestanding examples on the edges of cities (Prato, Todi, Montepulciano, etc.). The whole question of the longitudinally planned church with a strongly centralized east end in fifteenth-century Italy deserves further study (see Heydenreich, "Gedanken über Michelozzo," *passim*).

48. Heinrich von Geymüller, *Les Projets primitifs pour la basilique de Saint-Pierre de Rome* (Paris and Vienna, 1875), pls. 9–11.

49. T. Magnuson (*Studies in Roman Quattrocento Architecture* [Rome, 1958], p. 163f.) discusses Manetti's rather confusing description of St. Peter's as Nicholas V intended to rebuild it. Magnuson also (p. 351f.) republishes those parts of the Manetti *Vita* that discuss Nicholas's activities as a builder. See also G. Urban, "Zum Neubauprojekt von St Peter unter Papst Nikolaus V," *Festschrift für Harald Keller* (Darmstadt, 1963), p. 131f.

50. Ibid., p. 194f. Magnuson, however, does not follow Manetti's text to the apparently logical conclusion that the dome, 20 *braccia* high over a 40-*braccia*-square crossing, would have had to be hemispherical. Manetti's description of the lantern, taller than the dome, pierced with windows and encrusted with a variety of architectural ornament, curiously calls to mind more the work of Guarino Guarini than that of the quattrocento.

51. In addition, the fortified exterior of the western end of St. Peter's found a clear echo in the fortified

exterior of the church at Loreto (ibid., p. 200).

52. Ibid., p. 168. He points out that Palmieri's date of 1452 for Alberti's action is contradicted by the actual building accounts, which record payments for the work on the *tribuna* as late as 1454. But the mistaken date does not necessarily invalidate the rest of the statement, which I prefer to take as reliable. Magnuson's alternative hypothesis—that Palmieri was actually referring to Nicholas's order to stop construction on his great tower of the palace walls—is hardly convincing. On the other hand, I agree with Magnuson's position that Alberti had nothing to do with the designing of the project for the *tribuna*, as we know it from the Manetti description and Uffizi A 20.

53. *De re aed.*, Bk. 10, ch. 17.

54. Ibid., Bk. 1, ch. 10.

55. The typological similarities between S. Andrea and Palladio's Redentore of almost exactly 100 years later should also be noted. As Staale Sinding-Larsen ("Palladio's Redentore, a Compromise in Composition," *Art Bulletin* 47 [1965], p. 419f.) has pointed out, a design for a centrally planned church seems to have preceded the present longitudinal plan, with its triconch east end. To suit the functional requirements of the program, however, the centralized plan seems to have been abandoned in favor of a plan that strongly recalls, both in general typology and in some architectual details, S. Andrea in Mantua as we have reconstructed it. Sinding-Larsen has also demonstrated (p. 431f.) that the iconographic program of the Redentore stressed the theme of the Risen Christ. For this aspect of Palladio's Church, S. Andrea also forms a key precedent. Toward the end of the first building campaign at S. Andrea, Andrea Mantegna, or one of his followers, decorated the tondo above the main portal of the nave with a fresco depicting the Ascension (Paccagnini, *Mantegna*, pp. 35, 36; figs. 49, 50, 51), or, perhaps more accurately described, the Risen Christ surrounded by a nimbus of cherubs. According to Donesmondi (*Dell'Istoria*, vol. 2, p. 46f.) the fresco in the roundel above the portal was accompanied by figures of SS. Andrew and Longinus flanking the doorway ("sotto la loggia avantilla chiesa sono due figure, una di S. Andrea e l'altra di S. Longino con l'Ascensione di Cristo sopra la porta...."). The three figures appear together in Mantegna's engraving of the Risen Christ between SS. Andrew and Longinus (Paccagnini, *Mantegna*, p. 148, fig. 164). The depiction of these three figures directly around the main portal stressed the redemptive qualities of the relic conserved within, as well as the particular

importance of SS. Andrew and Longinus, who also appeared in the tondo of the pediment, in the history of the church and of its relic. Even if Alberti himself had no part in planning such an iconographic program for the façade, it is clear that in the last decades of the fifteenth century it seemed desirable to stress to the visitor to the church the theme of Resurrection and Redemption, and this was exactly the same theme that was stressed 100 years later at the Redentore, especially by the statue of the Risen Christ placed atop the dome. For the Redentore, see Wladimir Timofiewitsch, *La Chiesa del Redentore* (Vicenza, 1969; English ed., University Park, Pa., 1971).

56. The Badia has been attributed variously to Brunelleschi, Michelozzo, and Cosimo de' Medici. The Brunelleschi attribution goes back to Vasari (*Le vite*, vol. 2, p. 367): "fece il modello della badia de'Canonici regolari di Fiesole a Cosimo de' Medici...." In recent times both Sanpaolesi and Luporini have attempted to keep the Badia in the Brunelleschi *oeuvre*. Saalman (see n. 35) has rightly attacked their position, as well as the attribution advanced by Lorenzo Gori-Montanelli (*Brunelleschi e Michelozzo* [Florence, 1957] of the Badia to Michelozzo. Recently Ugo Procacci ("Cosimo de' Medici e la Costruzione della Badia Fiesolana," *Commentari* 19 [1968], pp. 80–97) has proposed Cosimo himself as architect. Were Cosimo to have been the architect, he would surely have needed a little help from his friends. For a general history and bibliography on the monastery, see P. Vincenzo Viti, *La Badia Fiesolana* (Florence, 1956). Also see L. H. Heydenreich, "Die Cappella Rucellai und die Badia Fiesolana, Untersuchung über Architektonische Stilformen Albertis," *Kunstchronik* (December 1960), pp. 352–354.

57. We know from an inscription on the east wall of the choir that it was dedicated in 1466: "Sacrum Pro Salute D. Bartholomeo Apostolo Petrus Medices. Cosmi F. Libero Munere Anno Gratiae MCCCCLXVI."

58. Saalman, in his review of Luporini (p. 443), relates the structural system of the Badia to vaulting practices found in such Romanesque churches as St. Sernin in Toulouse. I find this relation rather far-fetched. He is right, however, in pointing out the uniqueness of this structural system in the Italy of its day, as well as both the uniqueness of the conception of the church as a whole and its generally Albertian characteristics. Cf. his remarks in the introduction to his edition of Antonio di Tuccio Manetti, *The Life of Brunelleschi*, ed. H. Saalman, trans. C. Enggass (University Park, Pa., 1970), p. 31.

# Bibliography

Ackerman, J. S., "Architectural Practices in the Italian Renaissance," *Journal of the Society of Architectural Historians* 13 (1954), p. 3f.

Alberti, L. B., *On Painting and On Sculpture*, ed. and trans. C. Grayson (London, 1972).

————, *Della pittura*, ed. J. Spencer (New Haven, 1956).

————, *L'Architettura* [*De re aedificatoria*], trans. G. Orlandi, intro. and notes by P. Portoghesi (Milan, 1966).

————, *Alberti's Ten Books on Architecture*, trans. J. Leoni, ed. J. Rykwert (London, 1955).

Amadei, F., *Cronaca universale della città di Mantova*, ed. G. Amadei et al. (Mantua, 1954–1957).

Argan, G. C., *Brunelleschi* (Milan, 1955).

Asiani, G., *Istoria del Sangue tratto dal costato di Giesù Cristo per Longino* (Mantua, 1609).

Askew, P., "The Question of Fetti as Fresco Painter: A Reattribution to Andreasi of Frescoes in the Cathedral and Sant' Andrea at Mantua," *Art Bulletin* 50 (1968), p. 1f.

Bellodi, R., "La Basilica di S. Andrea in Mantova," *Emporium* 14 (1901), p. 16f.

Bertolotti, A., *Artisti in relazione coi Gonzaga Signori di Mantova* (Modena, 1885).

————, *Architetti, ingegneri e matematici in relazione coi Gongaza signori di Mantova nei secoli XV, XVI, e XVII* (Genoa, 1889).

————, *Le arti minori alla corte di Mantova nei secoli XV, XVI e XVII* (Milan, 1889).

Bottoni, P., *Mantova numerizzata* (Mantua, 1839).

Braghirolli, W., "Leon Battista Alberti a Mantova," *Archivio Storico Italiano* 3, no. 9 (1869), p. 3f.

————, "Luca Fancelli scultore architetto e idraulico del secolo XV," *Archivio Storico Lombardo* 3 (1876), p. 610f.
C. Brandi, "La cupola dello Juvarra a S. Andrea a Mantova e un precedente," *Arte in Europa, Scritti di storia dell'arte in onore di Edoardo Arslan* (Milan, 1966), p. 813f.

Brayda, C., L. Coli, and D. Sesia, "Ingegneri e architetti del sei e settecento in Piemonte," *Atti e Rassegna Tecnica della Società degli Ingegneri e Architetti in Torino*, vol. 17 (Turin, 1963).

Brinckmann, A. E., et al., *Filippo Juvarra*, vol. 1 (Milan, 1937).

Brown, C. M., "Luca Fancelli in Mantua," *Mitteilungen des Kunsthistorischen Instituts in Florenz* 16 (1972), p. 153f.

Cadioli, G., *Descrizione delle pitture, sculture ed architetture, che si osservano nella città di Mantova, e ne' suoi contorni* (Mantua, 1763).

Carli, E., *Pienza, la città di Pio II* (Rome, 1966).

Carra, G., "I 'Pastelli' per Leon Battista Alberti," *Cultura Mantovana, Supplemento n. 8, Gazzetta di Mantova* (July 15, 1961), p. 3.

Cottafavi, C., *Ricerche e documenti sulla costruzione del palazzo Ducale di Mantova dal secolo XIII al secolo XIX* (Mantua, 1939).

D'Arco, C., *Delle arti e degli artefici di Mantova*, vol. 2 (Mantua, 1859).

Davari, S., *Notizie storiche topographiche della città di Mantova nei secoli XIII–XIV e XV* (Mantua, 1903).

De Angelis d'Ossat, G., "Enunciati Euclidei e 'Divina Proporzione' nell' architettura del Primo Rinascimento," *Il Mondo Antico nel Rinascimento, Atti del V Convegno Internazionale di Studi sul Rinascimento, 1956* (Florence, 1958), p. 253f.

Dezzi Bardeschi, M., "Nuove ricerche sul San Sepolcro nella Cappella Rucellai a Firenze," *Marmo* 2 (1963), p. 135f.

————, "Il complesso monumentale di S. Pancrazio a Firenze ed il suo restauro," *Quaderni dell'Istituto di Storia dell'Architettura* 13 (1966), p. 1f.

Donesmondi, I., *Dell'Istoria ecclesiastica di Mantova*, 2 vols. (Mantua, 1613–1616).

Edalo, A., et al., *Il Duomo di Crema* (Milan, 1961).

Eisler, R., "Die Hochzeitstruhen der letzten gräfin von Görz," *Jahrbuch der K. K. Zentral-Kommission für Kunst- und Historische Denkmale* 3, no. 2 (1905), p. 69f.

Fabriczy, C., *Filippo Brunelleschi* (Stuttgart, 1892).

Fasolo, V., "Osservazioni sul S. Andrea di Mantova,"

*Arte Pensiero e Cultura a Mantova nel Primo Rinascimento in Rapporto con la Toscana e con il Veneto, Atti del VI Convegno Internazionale di Studi sul Rinascimento, 1961* (Florence, 1965), p. 207f.

Feuchtmayr, K., on A. M. Viani, *Thieme-Becker*, vol. 34 (1940), p. 321.

Forster, K. W., and R. J. Tuttle, "The Palazzo del Te," *Journal of the Society of Architectural Historians* 30 (1971), p. 267f.

Fraser Jenkins, A. D., "Cosimo de' Medici's Patronage of Architecture and the Theory of Magnificence," *Journal of the Warburg and Courtauld Institutes* 33 (1970), p. 162f.

Frigerio, F., *La cupola della Cattedrale di Como e le sue Vicende* (Como, 1935).

Fürst, V., *The Architecture of Sir Christopher Wren* (London, 1956).

Gadol, J., *Leon Battista Alberti, Universal Man of the Early Renaissance* (Chicago, 1969).

Gaye, G., *Carteggio inedito d'artisti dei secoli XIV, XV, XVI*, 3 vols. (Florence, 1839).

Gionta, S., *Il Fioretto delle Cronache di Mantova* (Mantua, 1587).

Giovanonni, G., *Antonio da Sangallo il Giovane* (Rome, n.d.).

————, *Saggi sulla architettura del Rinascimento*, 2d ed. (Milan, 1935).

Golzio, V., *Raffaelo nei Documenti* (Vatican City, 1936).

Gombrich, E., "Zum Werke Giulio Romanos," *Jahrbuch der Kunsthistorischen Sammlungen in Wien* 8 (1934), p. 79f.; and 9 (1935), p. 121f.

Gori-Montanelli, L., *Brunelleschi e Michelozzo* (Florence, 1957).

Gosebruch, M. "Florentinische Kapitelle von Brunelleschi bis zum Tempio Malatestiano und der Eigenstil der Frührenaissance," *Römisches Jahrbuch* 8 (1958), p. 65f.

Grayson, C., *Alberti and the Tempio Malatestiano* (New York, 1957).

————, "The Composition of L. B. Alberti's *decem libri de re aedificatoria*," *Münchner Jahrbuch der Bildenden Kunst* 3, no. 9 (1960), p. 152f.

Grayson, C., and G. C. Argan, on Alberti in *Dizionario Biografico degli Italiani*, vol. 1 (Rome, 1960).

Grotefend, H., *Taschenbuch der Zeitrechnung . . .*, 10th ed. (Hanover, 1960).

Hartt, F., *Giulio Romano* (New Haven, 1956).

Hauttmann, M., *Geschichte der Kirchlichen Baukunst in Bayern/Schwäben und Franken/1550–1780* (Munich, 1921).

Hermanin, F., and E. Lavagnino, *L'opera del genio italiano all'estero: Gli artisti in Germania*, vol. 3 (Rome, 1943).

Heydenreich, L. H., "Die Tribuna der SS. Annunziata in Florenz," *Mitteilungen des Kunsthistorischen Instituts in Florenz* 3 (1930), p. 268f.

————, "Brunelleschis Spätwerke," *Jahrbuch der preussischen Kunstsammlungen* 52 (1931), p. 1f.

————, "Gedanken über Michelozzo di Bartolomeo," *Festschrift für Wilhelm Pinder* (Leipzig, 1938), p. 264f.

————, "Die Cappella Rucellai und die Badia Fiesolana, Untersuchung über Architektonische Stilformen Albertis," *Kunstchronik* (December 1960), p. 352f.

————, "Die Cappella Rucellai von San Pancrazio in Florenz," in *De Artibus Opuscula XL: Essays in Honor of Erwin Panofsky*, ed. M. Meiss (New York, 1961), p. 219f.

————, "Federico da Montefeltro as a Building Patron," *Studies in Renaissance and Baroque Art Presented to Anthony Blunt on his 60th Birthday* (London and New York, 1967), p. 5f.

Horster, M., "Mantuae Sanguis Preciosus," *Wallraf-Richartz Jahrbuch* 25 (1963), p. 151f.

Hubala, E., "L. B. Albertis Langhaus von Sant Andrea in Mantua," *Festschrift für Kurt Badt* (Berlin, 1961), p. 83f.

Huelsen, C., ed., *Il Libro di Giuliano da Sangallo* (Leipzig, 1910).

Intra, G. B., "La Basilica di S. Andrea in Mantova," *Archivio Storico Lombardo* 9 (1882), p. 289f.

Janson, H. W., *The Sculpture of Donatello* (Princeton, 1957).

Johnson, E., "Notizie storiche sulla Basilica Concattedrale," *La Cittadella* (Mantua, 6 December 1964).

Klotz, H., "L. B. Albertis 'De re aedificatoria' in Theorie und Praxis," *Zeitschrift für Kunstgeschichte* 32, no. 2 (1969), p. 93f.

Krautheimer, R., "Alberti's Templum Etruscum," *Münchner Jahrbuch der Bildenden Kunst* 4 (1961), p. 65f. Reprinted in R. Krautheimer, *Studies in Early Christian, Medieval, and Renaissance Art* (New York, 1969), p. 333f.

————, "Alberti and Vitruvius," *Acts of the Twentieth International Congress of the History of Art*, vol. 2 (Princeton, 1963), p. 42f. Reprinted in R. Krautheimer, *Studies in Early Christian, Medieval, and Renaissance Art* (New York, 1969), p. 323f.

————, *Early Christian and Byzantine Architecture* (Baltimore, 1965).

Krautheimer, R., and T. Krautheimer-Hesse, *Lorenzo Ghiberti* (Princeton, 1956).

Lang, S., "The Programme of the SS. Annunziata in Florence," *Journal of the Warburg and Courtauld Institutes* 17 (1954), p. 288f.

"Leon Battista Alberti, Bericht über die vom Zentralinstitut für Kunstgeschichte in München veranstaltete wissenschaftliche Arbeitstägung (7. – 9. März 1960)," *Kunstchronik* (December 1960), p. 337f.

Lewis, S., "Function and Symbolic Form in the Basilica Apostolorum at Milan," *Journal of the Society of Architectural Historians* 28, no. 2 (1969), p. 83f.

Lotz, W., "Michelozzos Umbau der SS. Annunziata in Florenz," *Mitteilungen des Kunsthistorischen Instituts in Florenz* 5 (1940), p. 402f.

————, "Das Raumbild in der Italienischer Architekturzeichnung der Renaissance," *Mitteilungen des Kunsthistorischen Instituts in Florenz* 7 (1956), p. 193f.

————, "Zu Hermann Vischers d. J. Aufnahmen italienischer Bauten," *Miscellanea Bibliotecae Herzianae* (Munich, 1961), p. 65f.

————, "Notizien zum Kirchlichen Zentralbau der Renaissance," *Studien zur Toskanischen Kunst, Festschrift für Lüdwig Heinrich Heydenreich* (Munich, 1964), p. 157f.

Luporini, E., *Brunelleschi: Forma e Ragione* (Milan, 1964).

MacDonald, W., *Roman Architecture* (New Haven, 1965).

MacDougall, E. B., "Nicholas V's Plan for Rebuilding St. Peter's, the Vatican Palace and the Borgo," A.M. thesis, New York University, 1955).

————, rev. of T. Magnuson, *Studies in Roman Quattrocento Architecture, Art Bulletin* 44 (1962), p. 67f.

Magnuson, T., *Studies in Roman Quattrocento Architecture* (Rome, 1958).

Mancini, G., *Vita di Leon Battista Alberti*, 2d ed. (Florence, 1911).

Manetti, A., *The Life of Brunelleschi*, ed. H. Saalman, trans. C. Enggass (University Park, Pa., 1970).

Marani, E., and C. Perina, *Mantova: Le Arti*, vols. 2 and 3 (Mantua, 1961–1965).

Masini, L., "La Vita e l'Arte di Filippo Juvarra," *Atti della Società Piemontese di Archeologia e Belle Arti* 9, no. 2 (1920), p. 197f.

Matteucci, V., *Le chiese artistiche del mantovano* (Mantua, 1902).

Mazzoldi, L., *Mantova: La Storia*, 3 vols. (Mantua, 1959–1963).

Milesi, R., "Mantegna und die Reliefs der Braut-Truhe Paola Gonzagas," *Festschrift Rudolf Egger*, vol. 3 (Klagenfurt, 1954), p. 382f.

Morrovalle, F. da, *Loreto nell'Arte* (Genoa, 1964).

*Mostra Iconografica Gonzaghesca, Catologo delle Opere* (Mantua, 1937).

Muhlmann, H., "Albertis St.-Andrea-Kirche und das Erhabene," *Zeitschrift für Kunstgeschichte* 32 (1969), p. 153f.

Nerlius, A., *Breve Chronicon Monasterii Mantuani Sancti Andreae Ord. Benedict. ab Anno MXVII usque ad MCCCCXVIII*, in L. A. Muratori, *Rerum Italicarum Scriptores*, vol. 24 (Milan, 1738), p. 1071f.

Nivolaria, P. de, *Opusculum de sanguine Jesu Christi, qui est Mantuae* (1489), MS in Biblioteca Comunale, Mantua.

Norberg-Schulz, C., "Le ultime intenzioni di Alberti," in *Acta ad archaeologiam et artium historiam pertinentia*, vol. 1, ed H. P. L'Orange and H. Torp (Oslo, 1962), p. 131f.

Orioli, P., *Foglie e Spighe . . . I dipinti candelabri nella Basilica di S. Andrea di L. B. Alberti in Mantova* (Mantua, 1900).

Ozzola, L., *Il Museo d'Arte Medievale e Moderna del Palazzo Ducale di Mantova* (Mantua, s.d. [after 1949]).

Paatz, W., *Die Kirchen von Florenz*, 6 vols. (Frankfurt, 1941–1955).

Paccagnini, G., *Mantova: Le Arti*, vol. 1 (Mantua, 1960).

————, *Andrea Mantegna, Catologo della Mostra di Mantova* (Venice, 1961).

Pacchioni, G., "La cupola di S. Andrea a Mantova e le Pitture di Giorgio Anslemi," *Bolletino d'Arte* 13 (1919), p. 60f.

Pastor, L. von, *The History of the Popes*, vols. 3 and 4 (London, 1894).

Patzak, B., *Die Villa Imperiale bei Pesaro* (Leipzig, 1908).

Pelati, P., *La Basilica di S. Andrea* (Mantua, 1952).

Perina, C., *La Basilica di S. Andrea in Mantova* (Mantua, 1965).

Peroni, A., "La struttura del S. Giovanni in Borgo di Pavia e il problema delle coperture nell'architettura romanica lombarda," *Arte Lombarda* 14, no. 1 (1969), p. 21f.; and 14, no. 2 (1969), p. 63f.

Pinelli, A., and O. Rossi, *Genga Architetto* (Rome, 1971).

Pommer, R., *Eighteenth Century Architecture in Piedmont* (New York, 1967).

Pope-Hennessy, J., *Italian Renaissance Sculpture* (New York, 1958).

————, *Catalogue of Italian Sculpure in the Victoria and Albert Museum*, vol. 1 (London, 1964).

Posner, K. W.-G., rev. of F. da Morrovalle, *Loreto nell' Arte*, *Art Bulletin* 50, no. 1 (1968), p. 108f.

Procacci, U., "Cosimo de' Medici e la Costruzione della Badia Fiesolana," *Commentari* 19 (1968), p. 80f.

Quintavalle, A. C., *Prospettiva e ideologia, Alberti e la cultura del sec. XV* (Parma, 1967).

Ragghianti, C. L., "Tempio Malatestiano," *Critica d'Arte* 71 (1965), p. 23f.; and 74 (1965), p. 27f.

Ricci, C., *Il Tempio Malatestiano* (Milan and Rome, 1924).

Rimini, Città di, *Sigismondo Pandolfo Malatesta e il suo tempo* (Vicenza, 1970).

Ritscher, E., "Die Kirche S. Andrea in Mantua," *Zeitschrift für Bauwesen* 49 (1899), pp. 1f., 181f.

Romanini, A. M., *L'Architettura Gotica in Lombardia*, 2 vols. (Milan, 1964).

Saalman, H., "Filippo Brunelleschi: Capital Studies," *Art Bulletin* 40 (1958), p. 113f.

———, "Early Renaissance Architectural Theory and Practice in Antonio Filarete's Trattato di Architettura," *Art Bulletin* 41 (1959), p. 103f.

———, rev. of E. Luporini, *Brunelleschi, Forma e Ragione*, *Art Bulletin* 48, nos. 3–4 (1966), p. 442f.

Sabatini, A., "La Chiesa della SS. Annunziata di Firenze prima della reconstruzione michelozziana," *Rivista d'Arte* 22 (1940), p. 229f.

Sanpaolesi, P., *Brunelleschi* (Milan, 1962).

———, "Il tracciamento modulare e armonico del S. Andrea di Mantova," *Arte Pensiero e Cultura a Mantova nel Primo Rinascimento in Rapporto con la Toscana e con il Veneto*, Atti del VI Convegno Internazionale di Studi sul Rinascimento, *1961* (Florence, 1965), p. 95f.

Schiavi, A., *Il restauro della chiesa di S. Sebastiano di Leon Battista Alberti in Mantova* (Mantua, 1932).

Schivenoglia, A., *Cronaca di Mantova di Andrea Schivenoglia da MCCCCXLV al MCCCCLXXXIV*, in *Cronisti e documenti storici lombardi inediti*, ed C. D'Arco (Milan, 1857), pp. 16f.

Serra, L. *L'Arte nelle Marche, il periodo del Rinascimento* (Rome, 1934).

Sinding-Larsen, S., "Palladio's Redentore, a Compromise in Composition," *Art Bulletin* 47 (1965), p. 419f.

———, "Some Functional and Iconographical Aspects of the Centralized Church in the Italian Renaissance," in *Acta ad archaeologiam et artium historiam pertinentia*, vol. 2, ed. H. P. L'Orange and H. Torp (Rome, 1965), p. 203f.

Spencer, J., *Filarete's Treatise on Architecture* (New Haven, 1965).

Stegmann, C. von, and H. von Geymüller, *Die Architektur der Renaissance in Toscana*, 11 vols. (Munich, 1885–1908; English ed., New York, n.d.).

Suida, W., on Alberti in *Thieme-Becker*, vol. 1 (1907), p. 206f.

Susani, G., *Nuovo prospetto delle pitture sculture ed architetture di Mantova e de' suoi contorni* (Mantua, 1818).

Taucci, R., *La Chiesa e il Convento della SS. Annunziata di Firenze e il loro ampliamento fino alla metà del secolo XV* (Florence, 1942).

Theuer, M., *Albertis Zehn Bücher über die Baukunst* (Vienna, 1912).

Tibaldi, U., *La Divina Armonia di S. Andrea* (Verona, 1955).

Tigler, P., *Die Architekturtheorie des Filarete* (Berlin, 1963).

Timofiewitsch, W., *La Chiesa del Redentore* (Vicenza, 1969; English ed., University Park, Pa., 1971).

Urban, G., "Zum Neubauprojekt von St Peter unter Papst Nikolaus V," *Festschrift für Harald Keller* (Darmstadt, 1963), p. 131f.

Valentiner, W. R., "The Florentine Master of the Tomb of Pope Pius II," *Art Quarterly* 21 (1958), p. 117f.

Vasari, G., *Le vite de' piu eccellenti pittori, scultori ed architettori*, ed. G. Milanesi (Florence, 1878–1885).

Venturi, A., *Leon Battista Alberti* (Rome, 1923).

———, *Storia dell'arte italiana*, vol. 8, pt. 1 (Milan, 1923).

Verheyen, E., "Jacopo Strada's Mantuan Drawings," *Art Bulletin* 49 (1967), p. 62f.

Viti, P. V., *La Badia Fiesolana* (Florence, 1956).

Volta, L. C., *Compendio cronologico-critico della storia di Mantova* (Mantua, 1807–1838).

Wasserman, J., *Ottavio Mascarino and his Drawings in the Accademia Nazionale di San Luca* (Rome, 1966).

Westfall, C. W., rev. of J. Gadol, *Leon Battista Alberti*, *Art Bulletin* 53, no. 4 (1971), p. 526f.

White, J., *Art and Architecture in Italy, 1250–1400* (Baltimore, 1966).

Wittkower, R., *Architectural Principles in the Age of Humanism*, 3d ed. (London, 1962).

Zevi, B., on Alberti in *Encyclopedia of World Art* (London, 1968), vol. 1, p. 188f.

Zupellari, G. C., *Mutamenti e fatti avvenuti in Mantova nella prima metà del secolo XIX* (Mantua, 1865).

Zurko, E. R. de, "Alberti's Theory of Form and Function," *Art Bulletin* 39 (1957), p. 142f.

# Index

# Illustrations

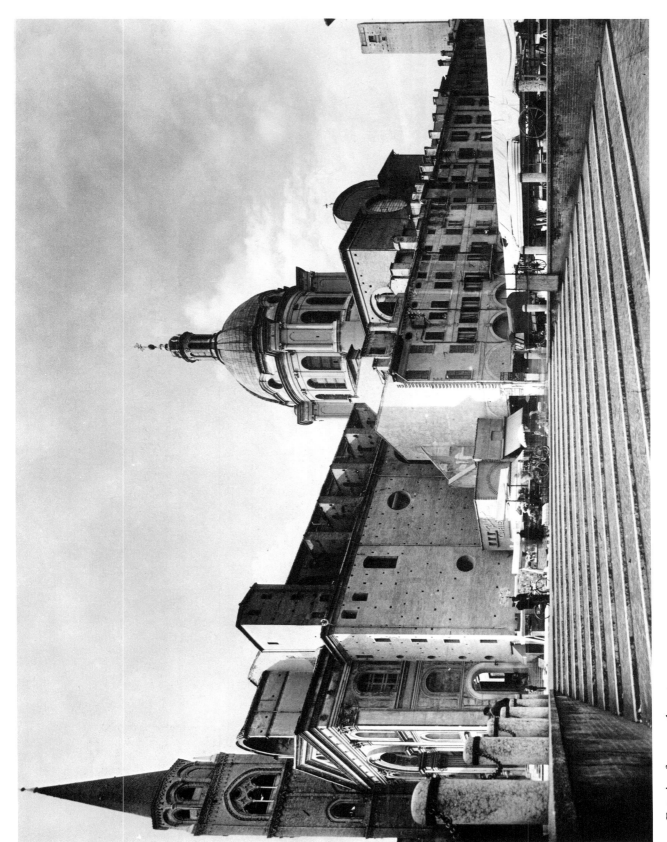

1. Exterior from southwest

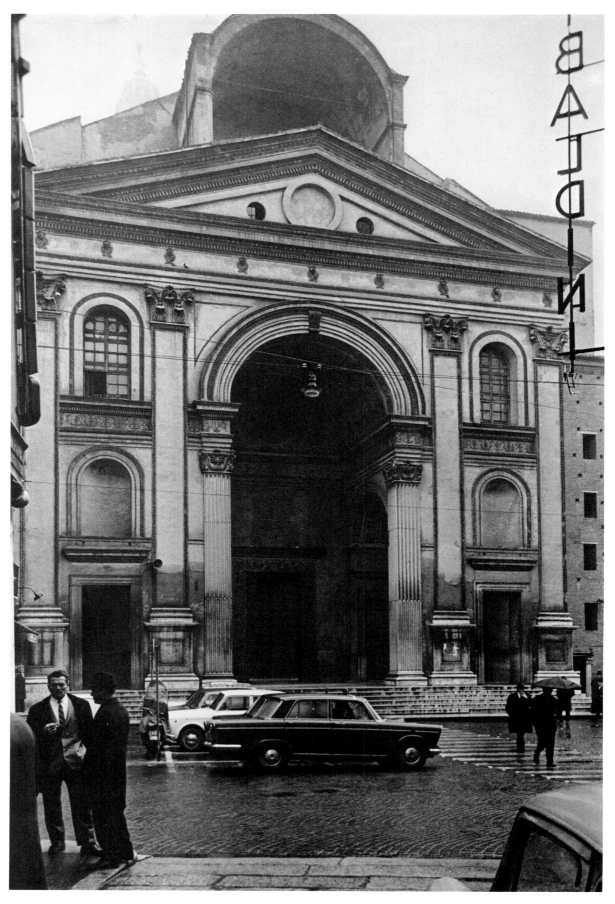

2.  West porch

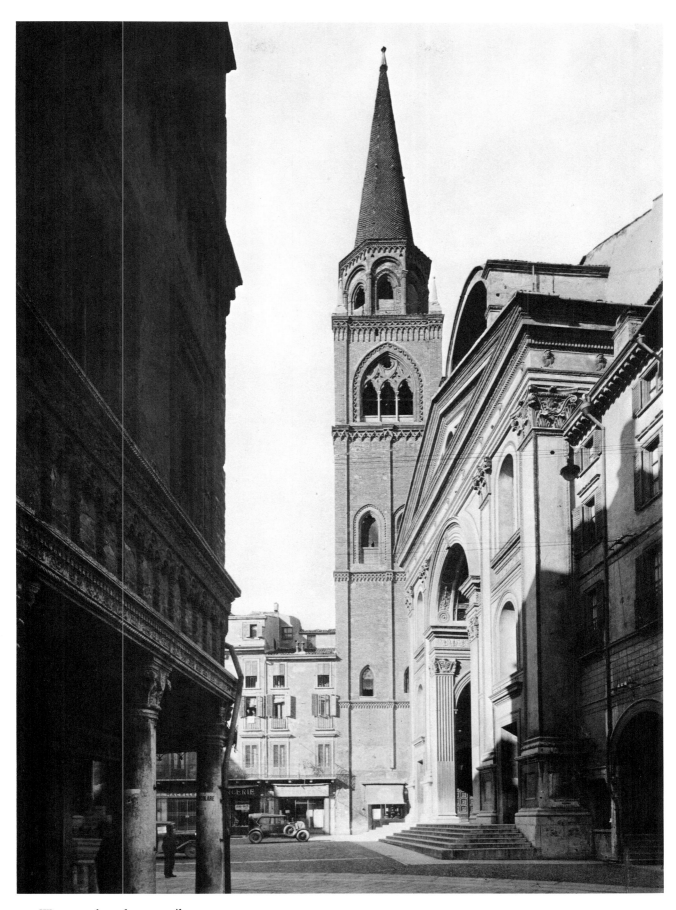

3. West porch and campanile

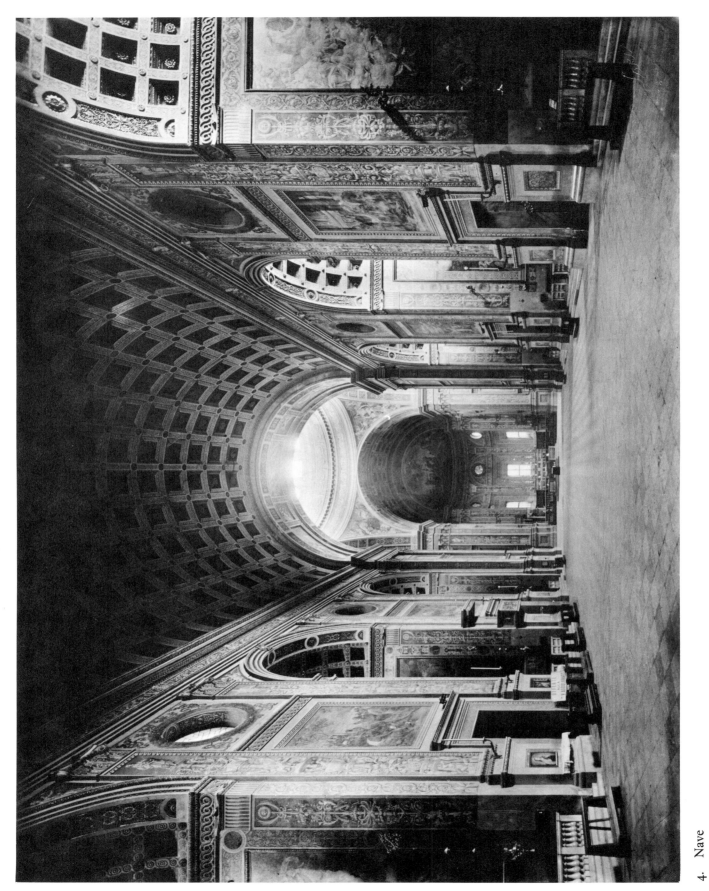

4. Nave

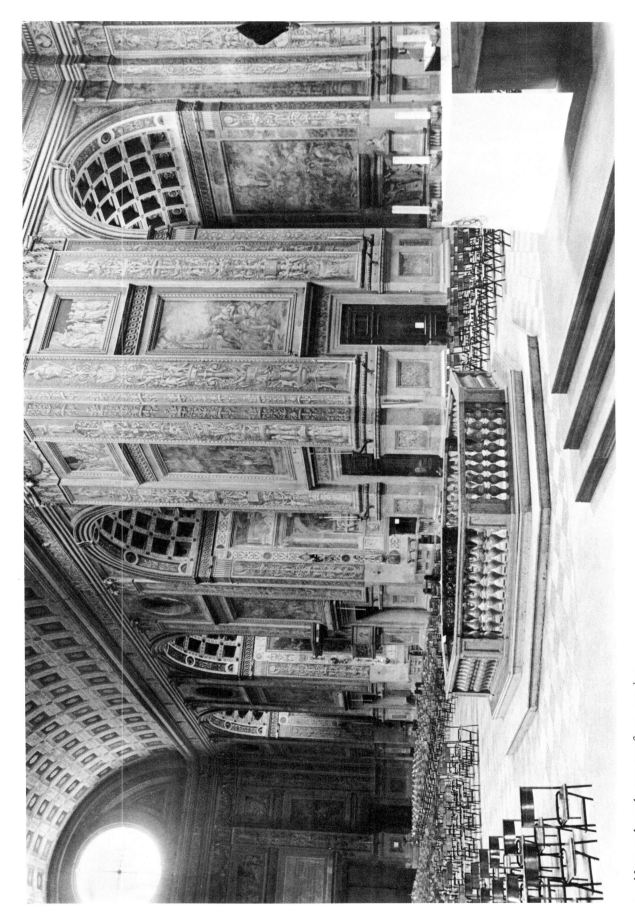

5. Nave and north transept from crossing

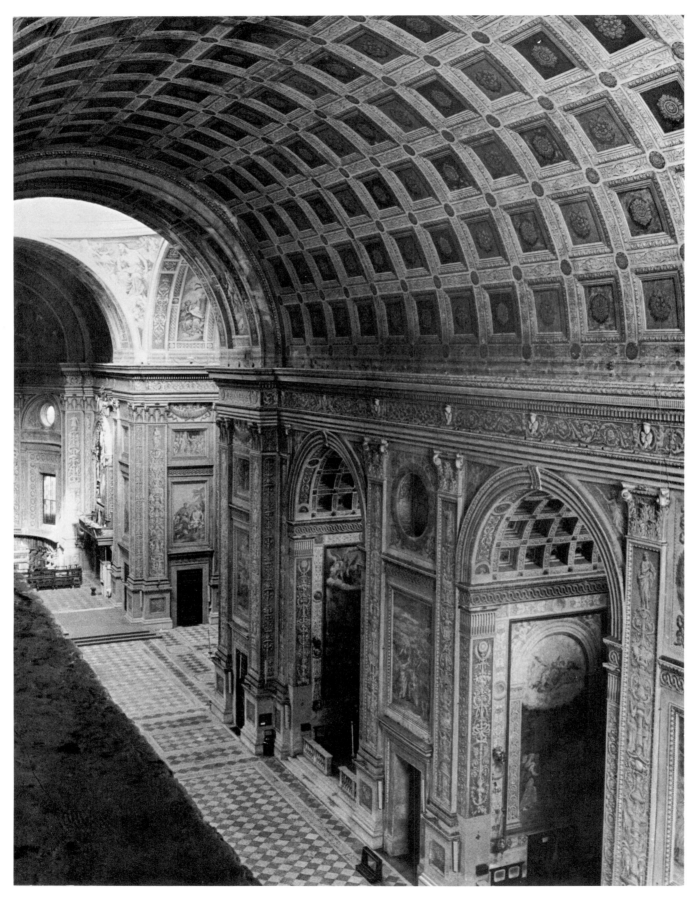

6. South wall of nave

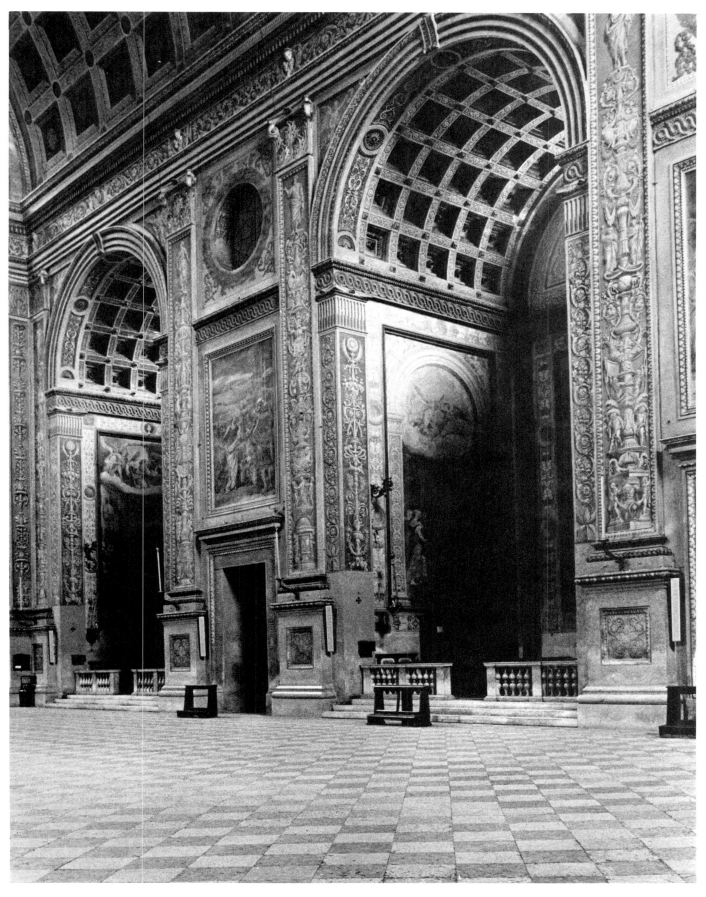

7.   South wall of nave, detail

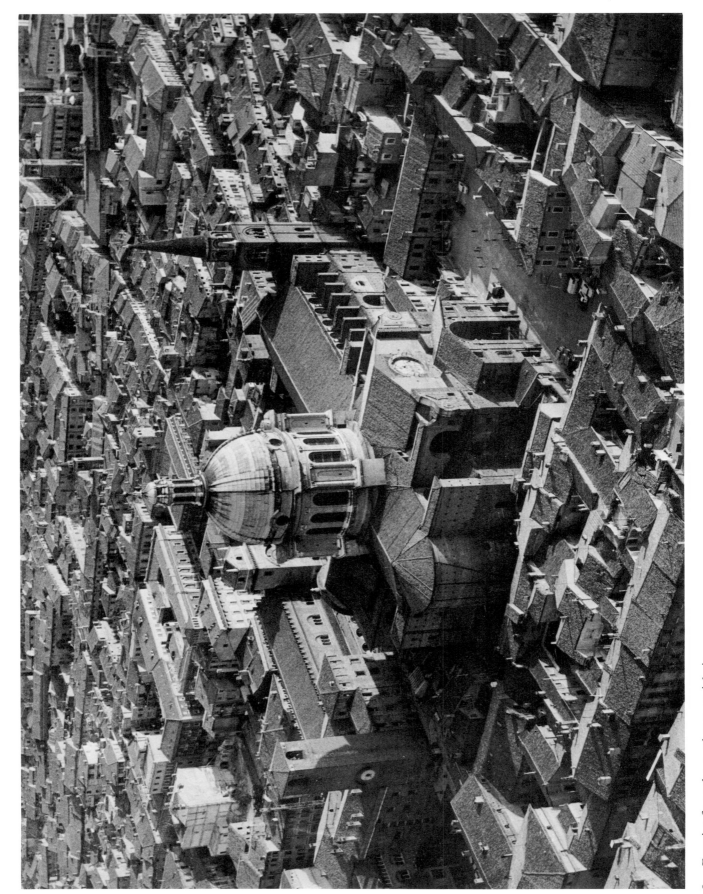

8. Exterior from the northeast, aerial view

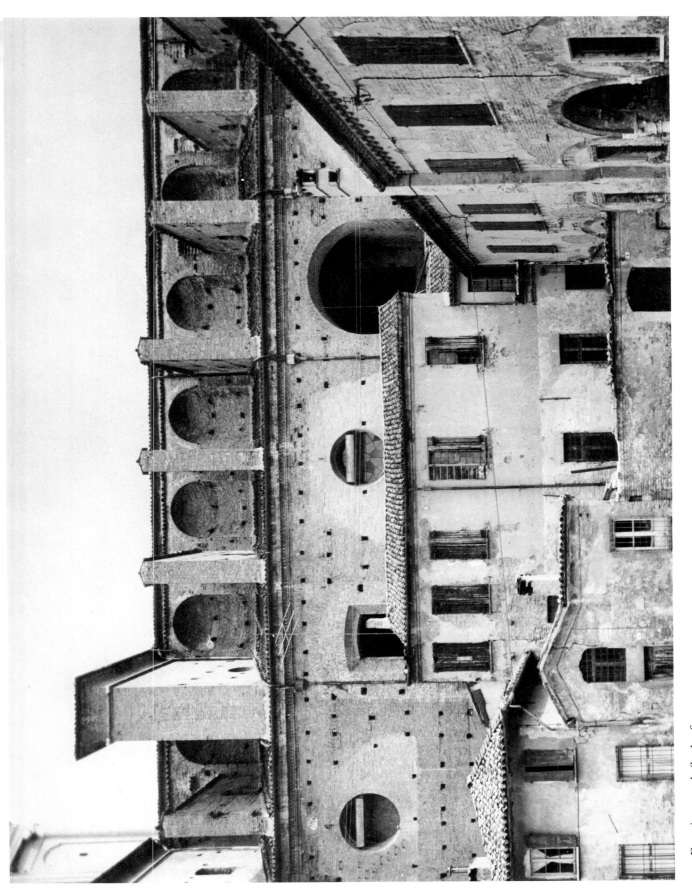

9.  Exterior, north flank of nave

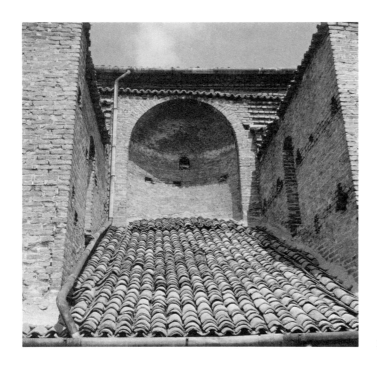

10. Exterior, niche along nave vault, south flank

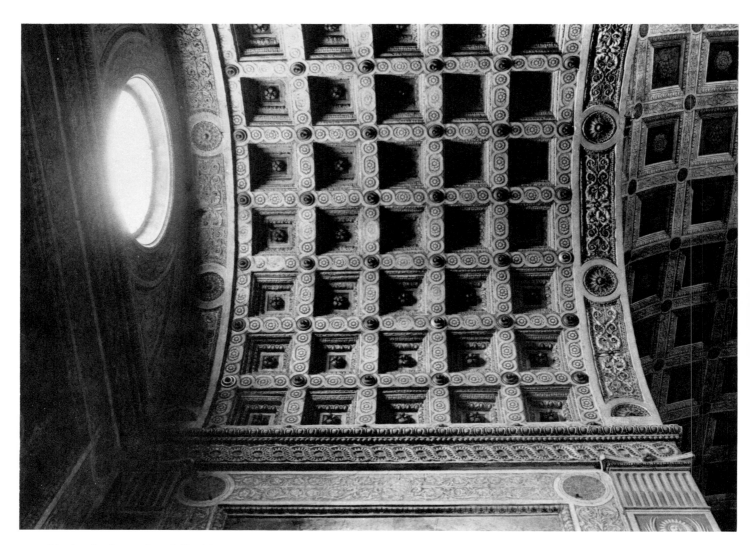

11. Vault of a large chapel flanking nave

12. Letter from L. B. Alberti to Lodovico Gonzaga

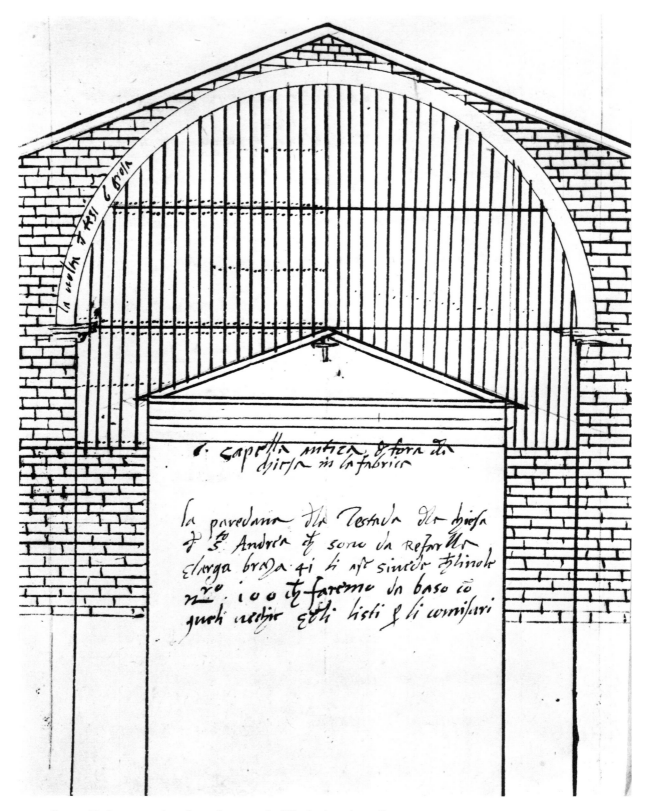

13.  Cesare Pedemonte, drawing of east end of S. Andrea in 1580

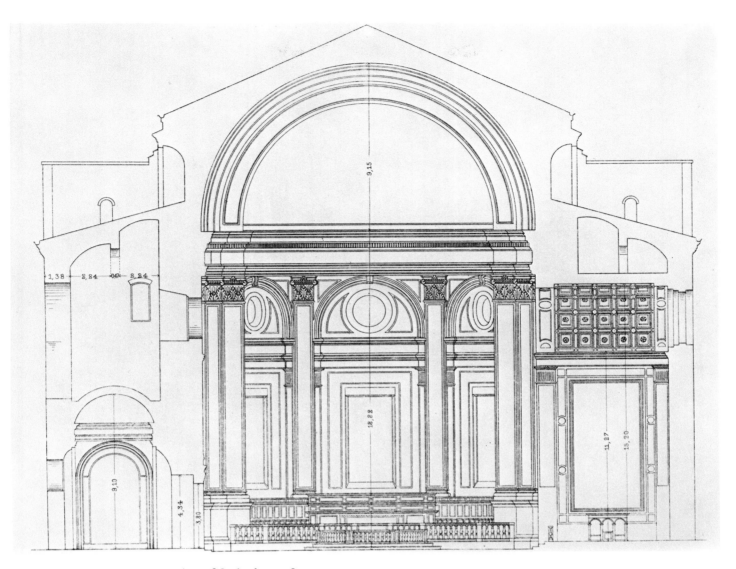

14.   Ernst Ritscher, cross section of S. Andrea, 1899

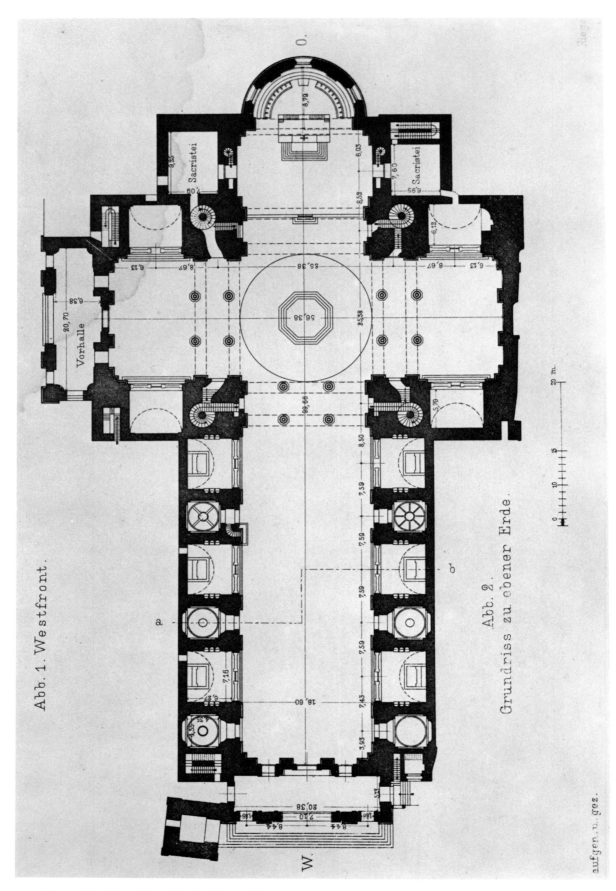

15.   Ernst Ritscher, plan of S. Andrea, 1899

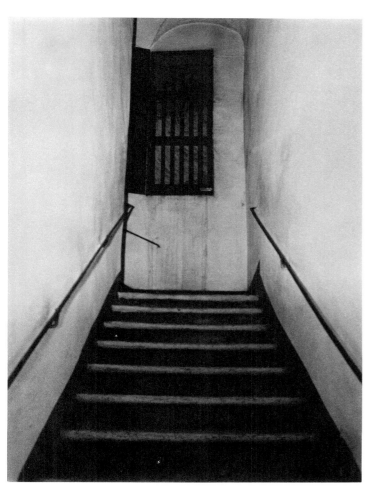

16. Stairway to crypt in southwest crossing pier

17. Walled-up oculus in northwest crossing pier

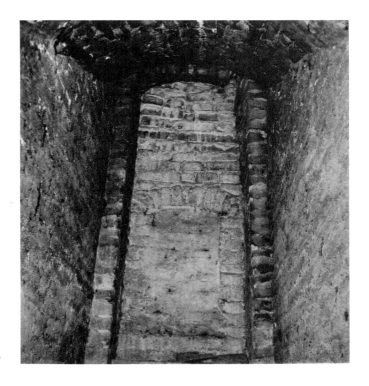

18. Walled-up opening in northwest crossing pier

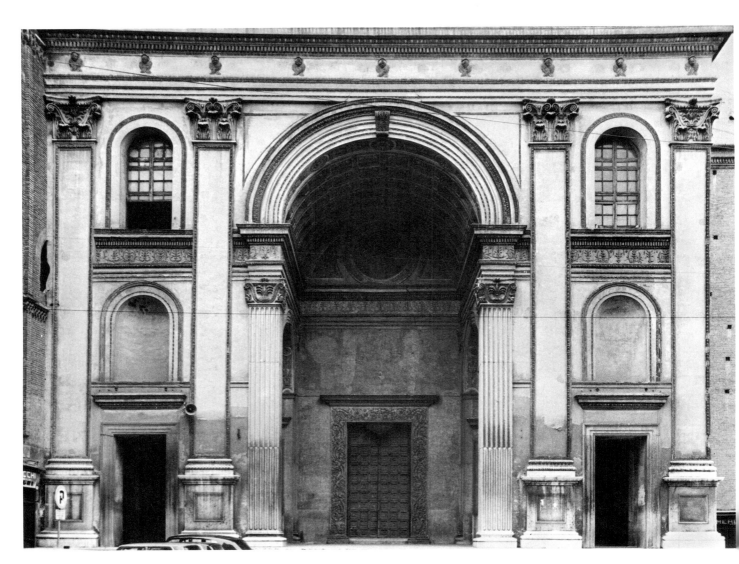

19. West porch, detail

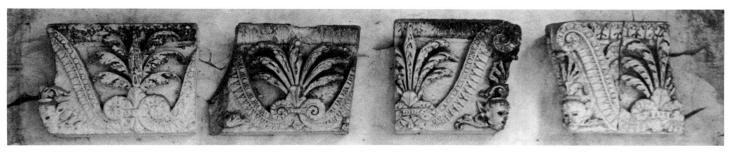

20.   Four fragments of capitals from the small order of the west façade, S. Andrea

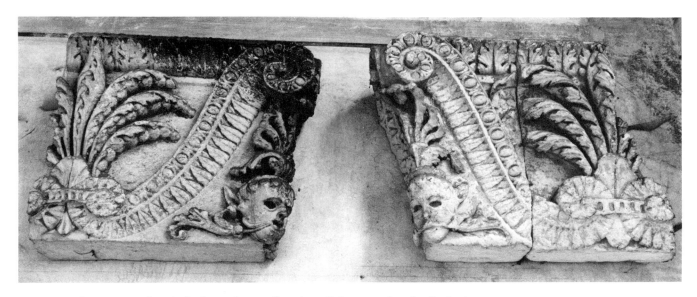

21.   Two fragments of capitals from the small order of the west façade, S. Andrea

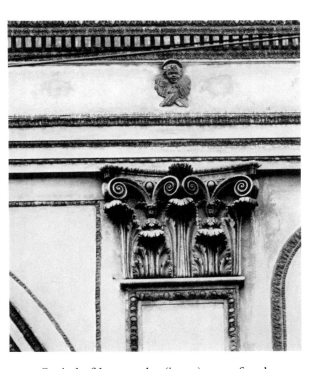

22.   Capital of large order (inner), west façade

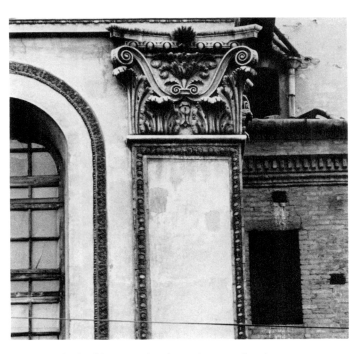

23.   Capital of large order (outer), west façade

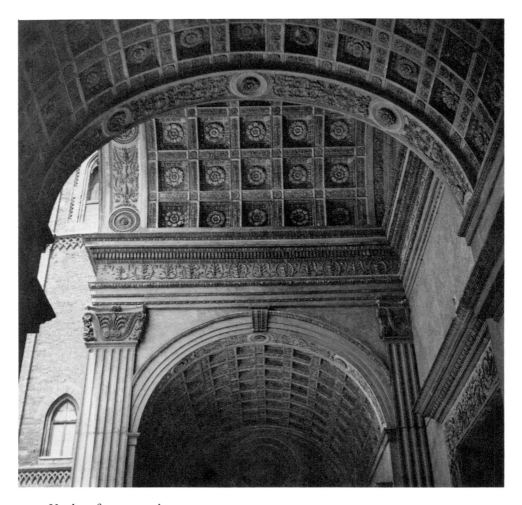

24. Vaults of west porch

25. Base of large order, west façade

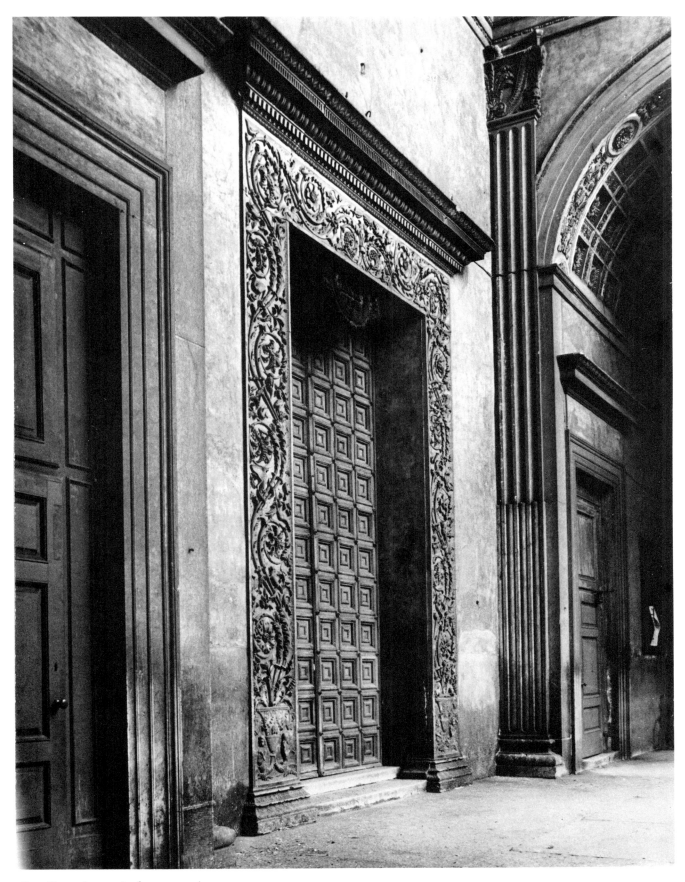

26. Central portal of west porch

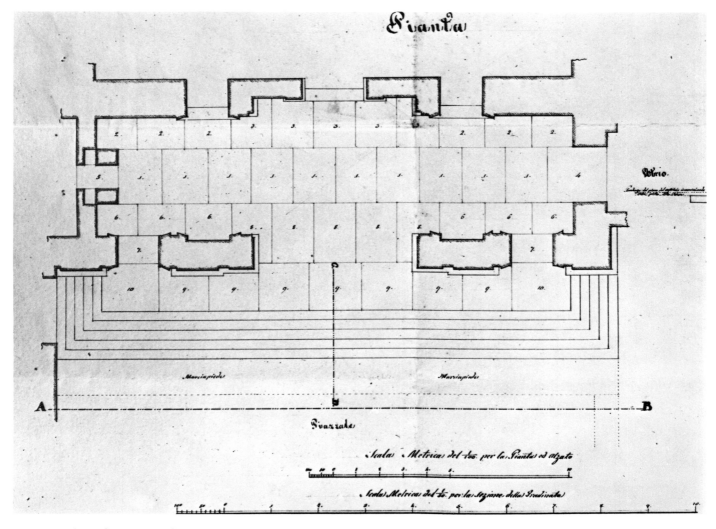

27.   Drawing of pavement for west porch, S. Andrea, c. 1830

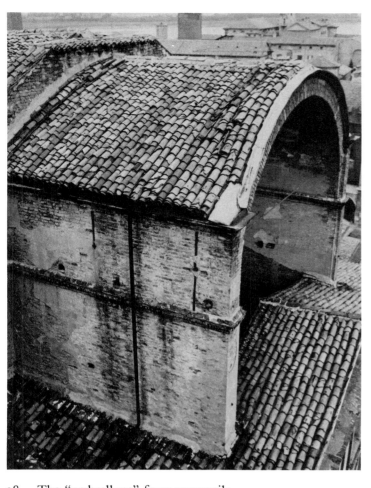

28.   The "ombrellone" from campanile

29.   North rising wall of "ombrellone"

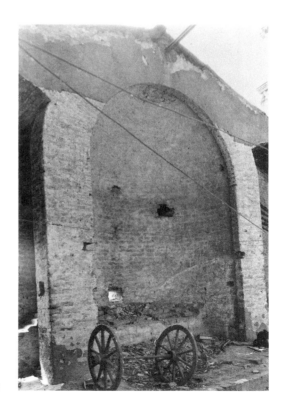

30.   Niche behind center of pediment of west façade

31. Inscription in central vault of north porch

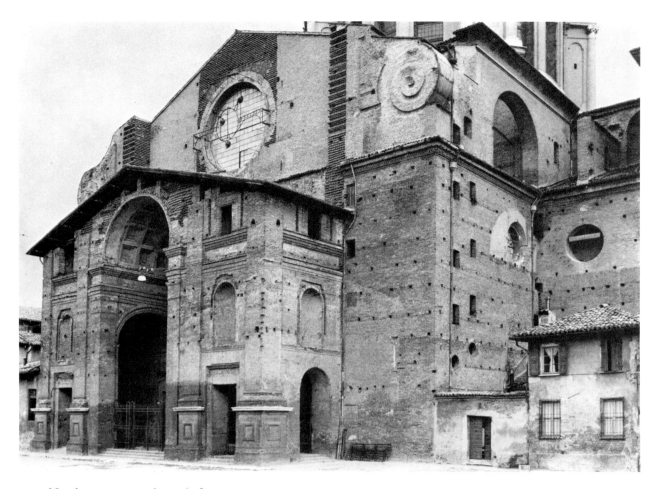

32.   North transept and porch from west

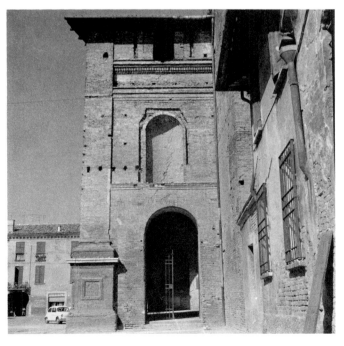

33.   Exterior of west side of north porch

34.   Juncture of nave and north transept

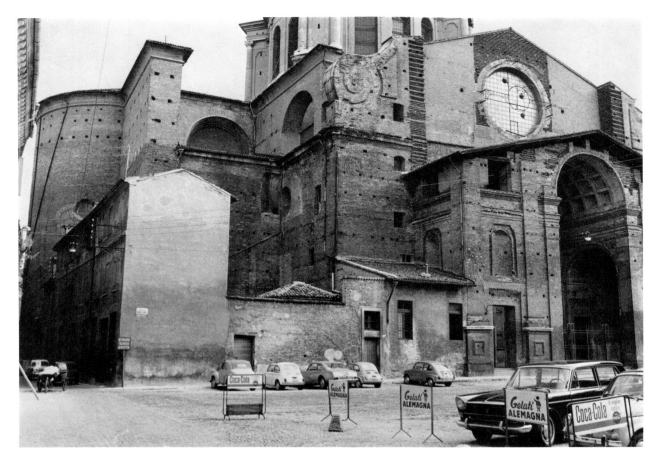

35. North transept and porch from east

36. Exterior walls of south sacristy and apse

37. Exterior walls of apse and north sacristy

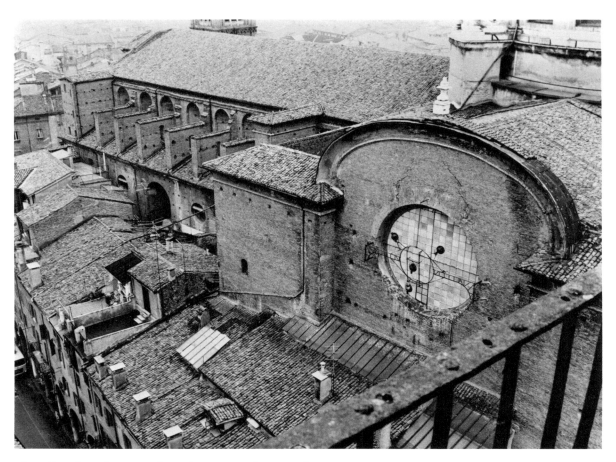

38. Exterior of nave and south transept from southeast

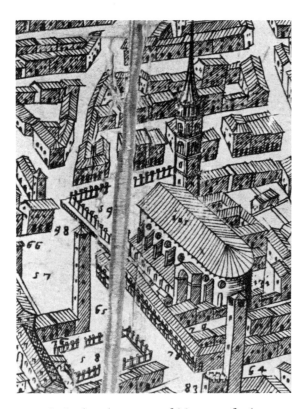

39. S. Andrea in a map of Mantua of 1625

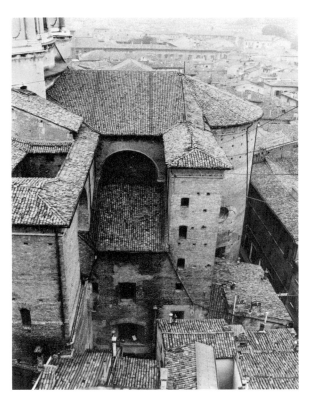

40. Exterior of south transept and choir from south

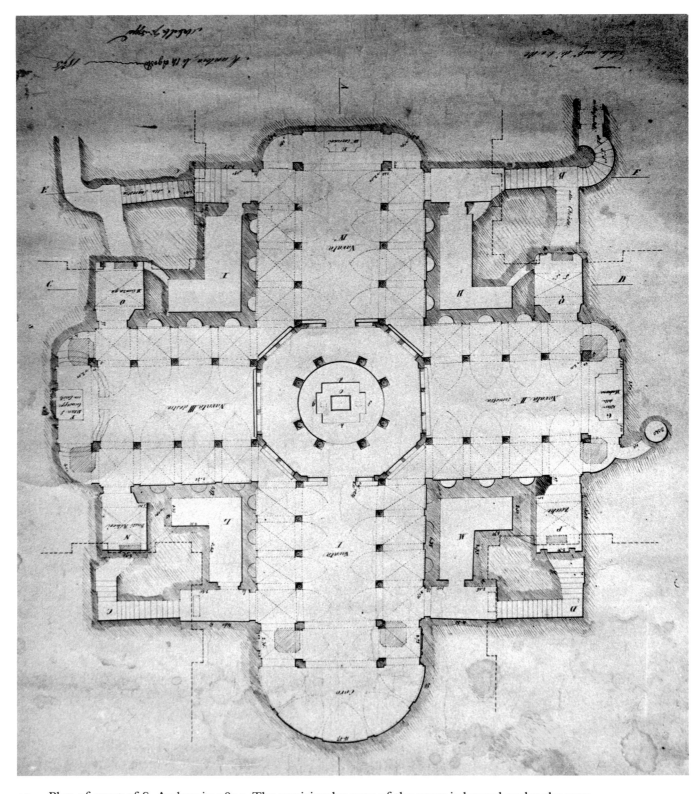

41. Plan of crypt of S. Andrea in 1875. The semicircular apse of the crypt is located under the nave

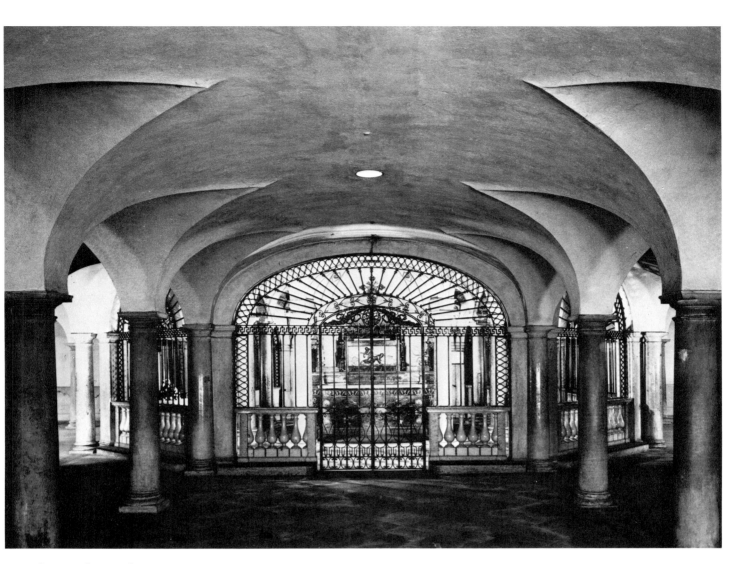

42.   Center of crypt from west arm

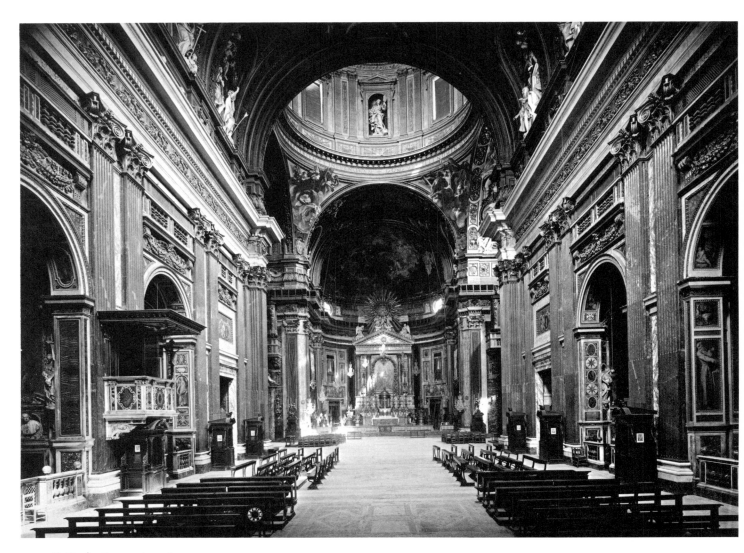

43. Il Gesù, Rome, interior

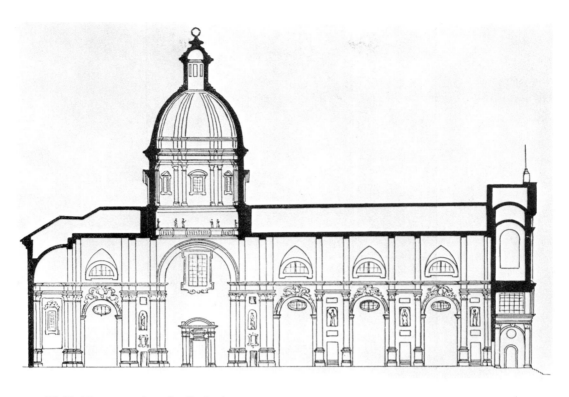

44. Giulio Torre, project for S. Andrea

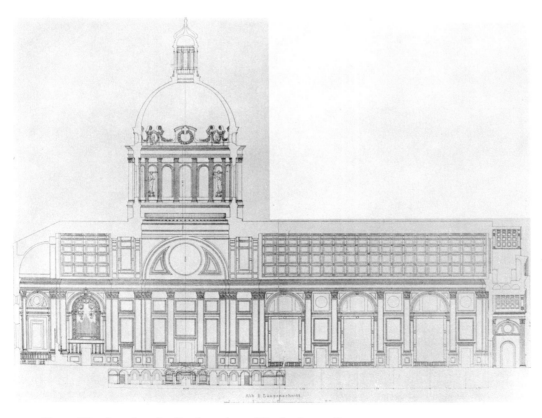

45. Ernst Ritscher, longitudinal section of S. Andrea, 1899

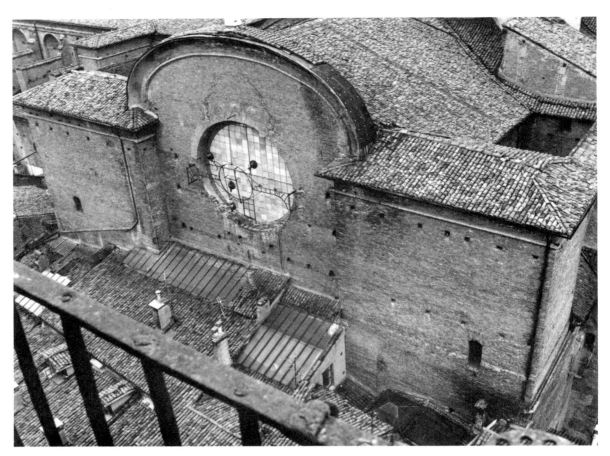

46. South transept, exterior

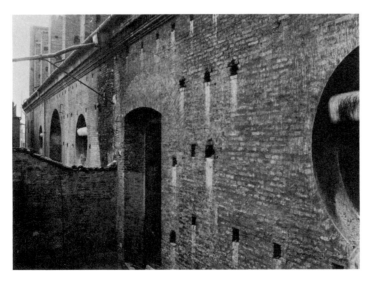

47. Exterior of south flank of nave, looking west
from south transept

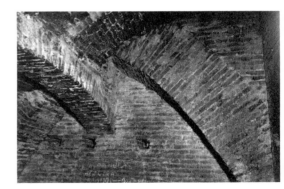

48. Upper left, diaphragm arch supporting
fifteenth-century ramping vaults. To right
and left of diaphragm, larger arches added
around 1700. Photo taken above barrel
vault of Chapel of St. Longinus—last
chapel on right from entrance. Wall in
background separates Longinus Chapel
from small chapel directly to west

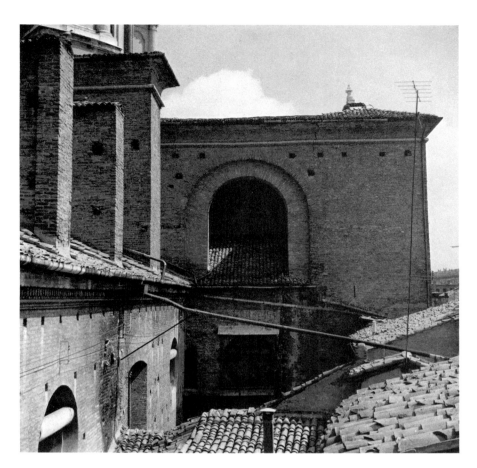

49.  Exterior of nave and south transept from west

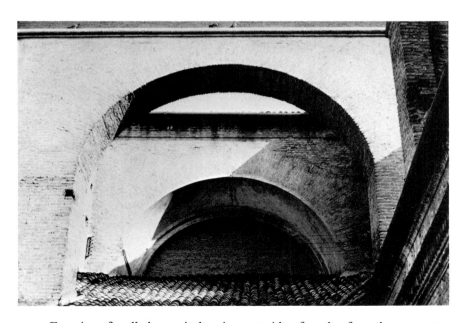

50.  Exterior of walled-up window in west side of vault of north transept

51. West wall of nave, exterior, showing present oculus and, below it, walled-up remains of rectangular window of 1702

52. Walled-up niche in west wall of nave, from exterior

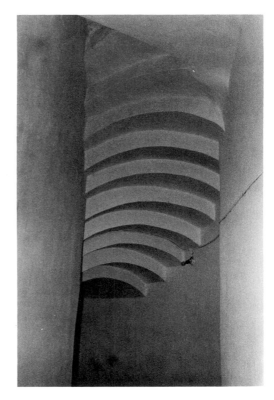

53. Vault of passage through northeast crossing pier from north transept to sacristy, from sacristy

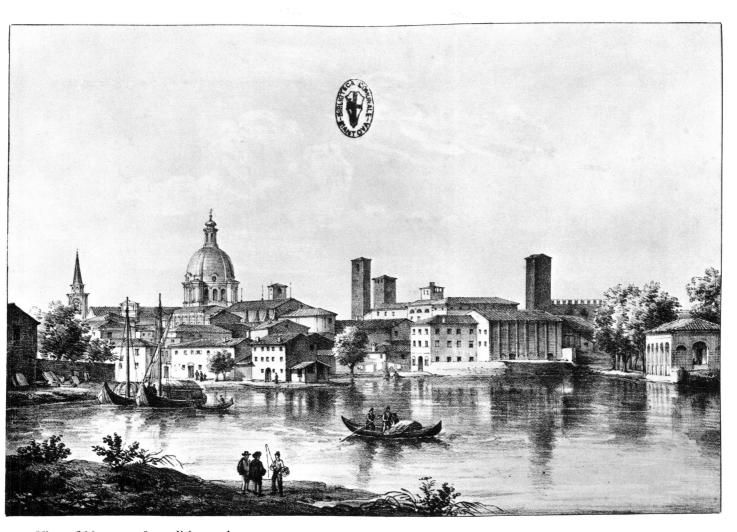

54.   View of Mantua, 1830s, lithograph

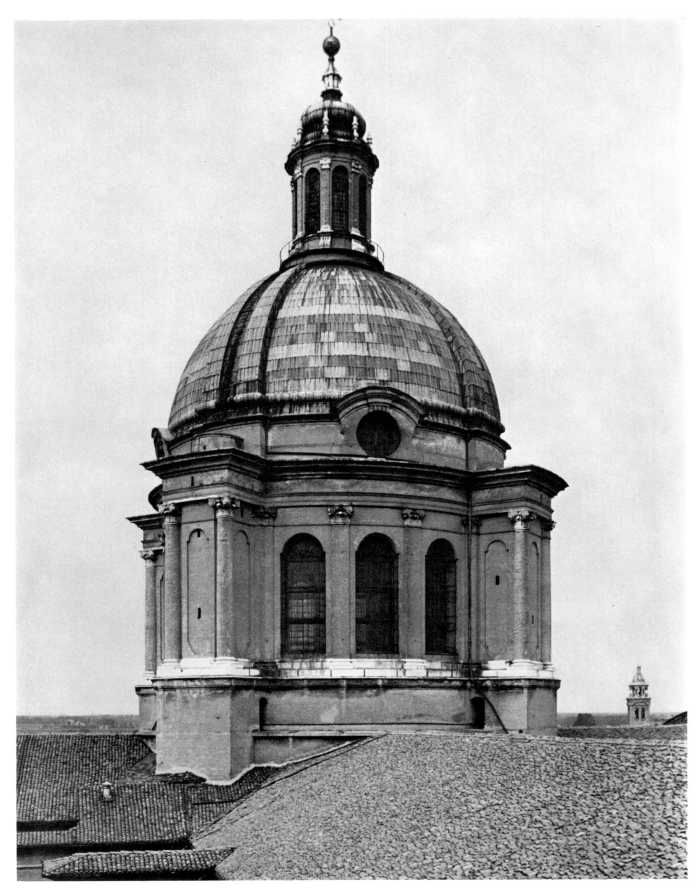

55. Dome from campanile

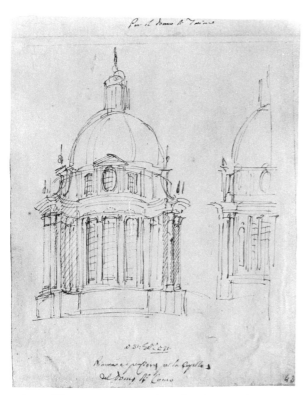

56. Filippo Juvarra, project for dome of Cathedral of Como, 1731

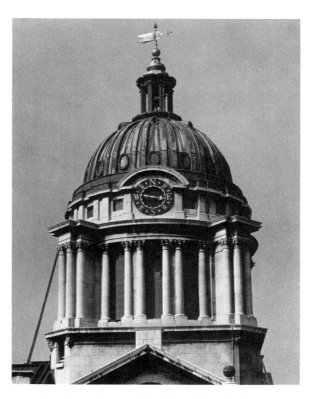

57. London, Greenwich, Royal Hospital, east dome, Queen Mary Block

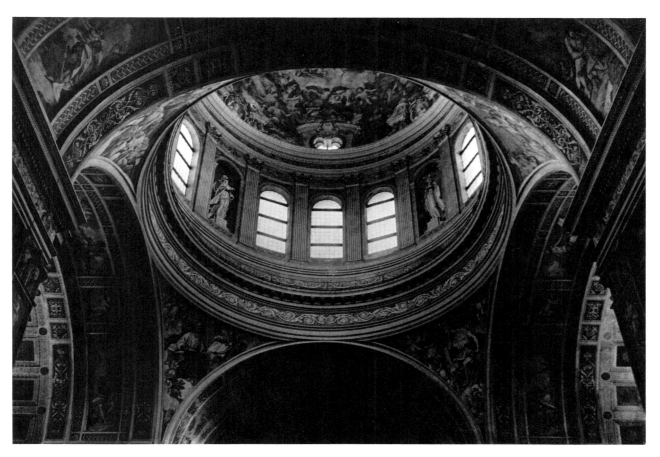

58. Interior of dome

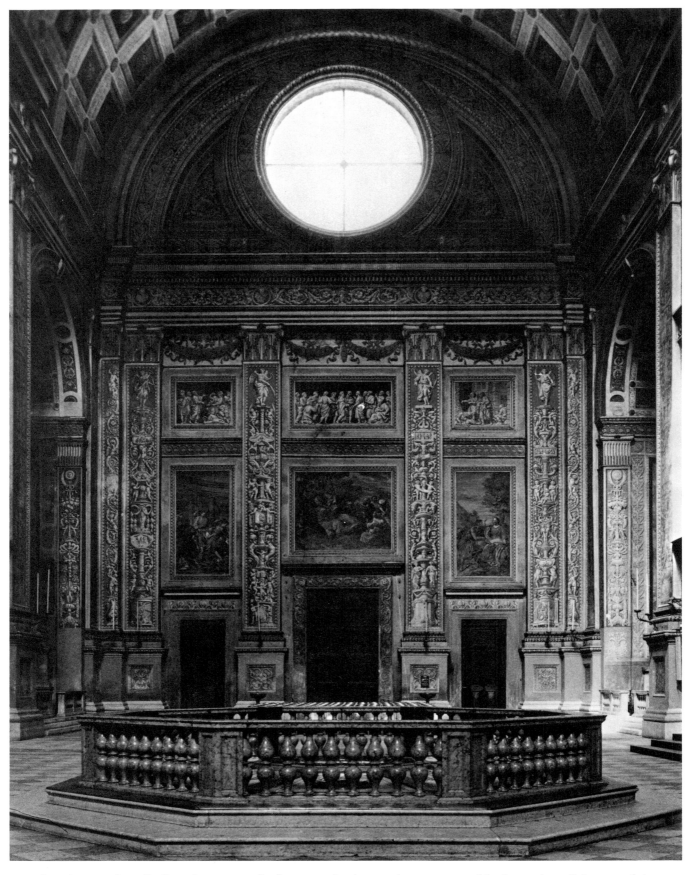

59.    Interior, north wall of north transept. In foreground, nineteenth-century marble decoration of the top of the dome of the crypt

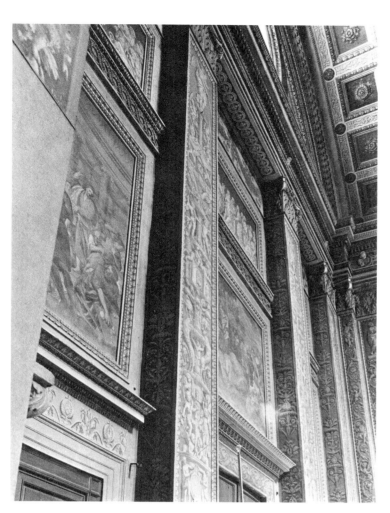

60. Raking view of inner face, north wall of north transept

61. Paolo Pozzo, project for lunettes at ends of nave and transept arms, S. Andrea, 1782

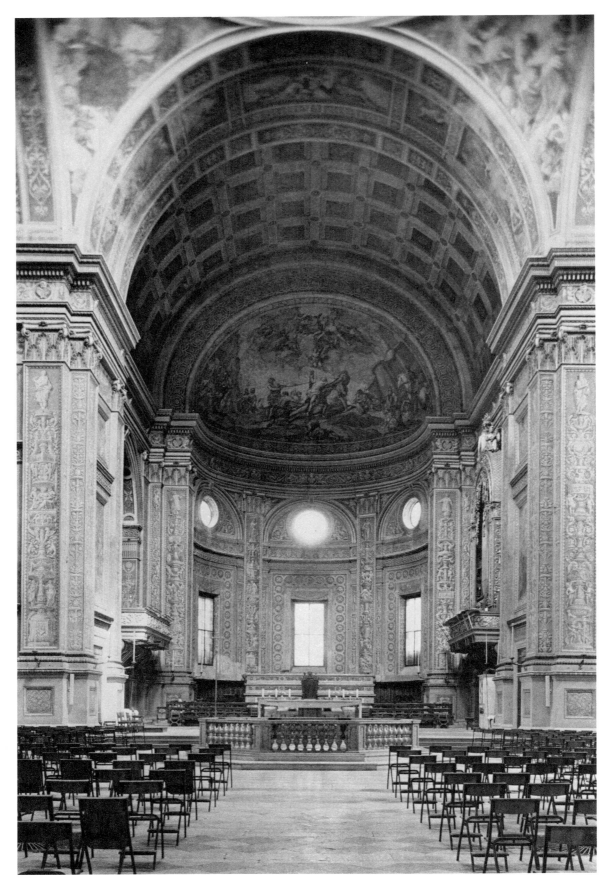

62.  Choir, interior

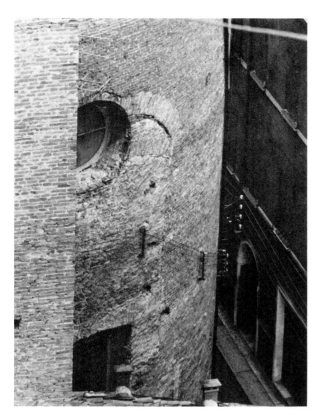

63. Exterior of apse from south, showing three phases of apse window

64. Exterior of south flank of west porch. Oculi to right light interior staircase

65. Interior, base of a pilaster of large order of nave

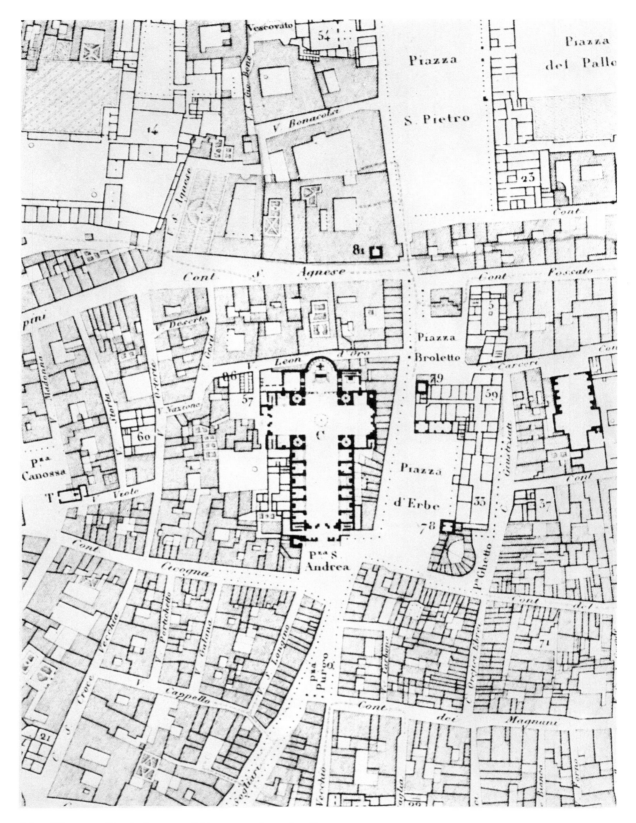

66.   Giuseppe Ranieri, map of Mantua, 1831, detail

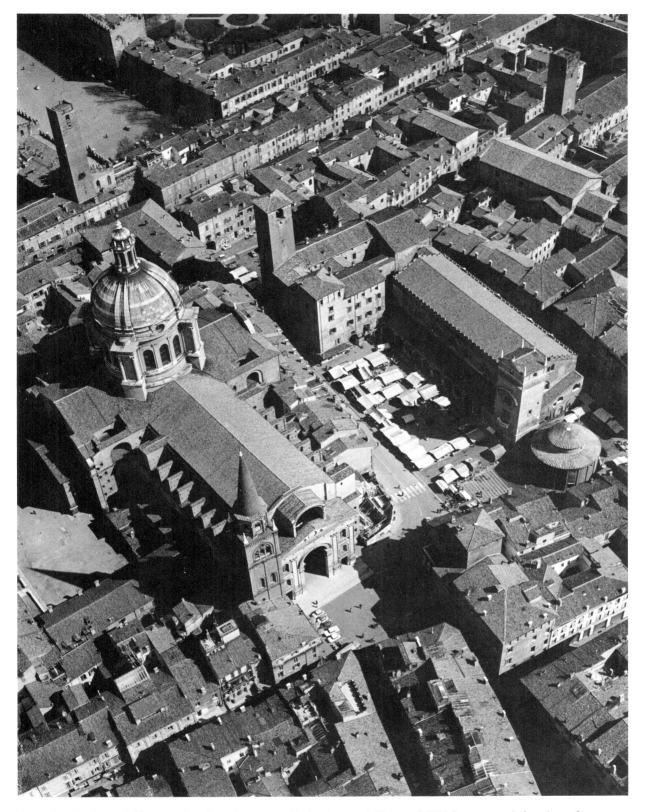

67.  Aerial view of Mantua showing, in center, S. Andrea and Piazza dell'Erbe; upper left, edge of Palazzo Ducale

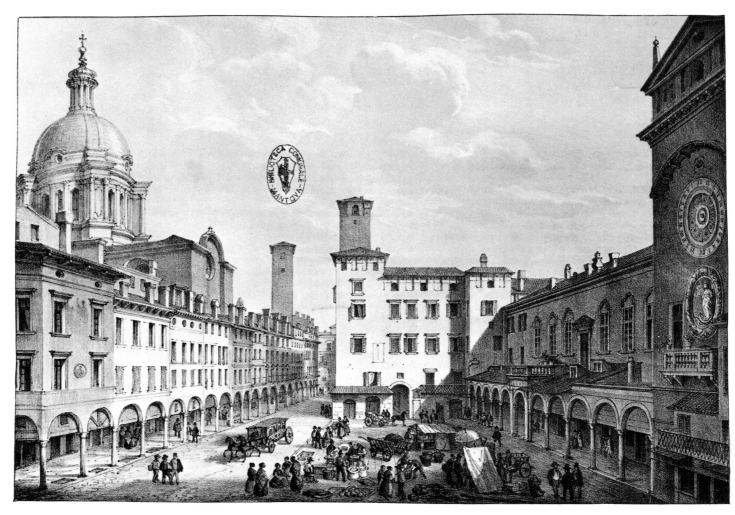

68. Piazza dell'Erbe, Mantua, in a lithograph of the 1830s. From left to right: S. Andrea, Palazzo del Comune, Palazzo della Ragione, Torre dell'Orologio

69.  South transept from Piazza dell'Erbe

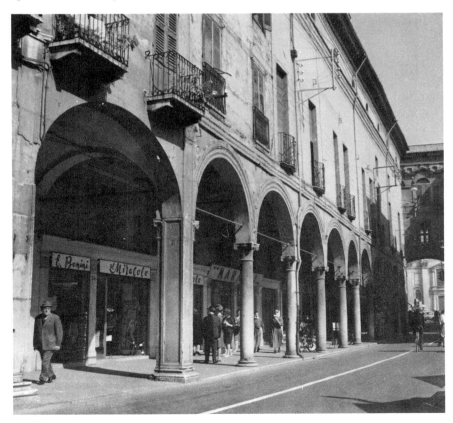

70.  Portico along Piazza Broletto, Mantua. At extreme left, pilasters mark
entrance into Vicolo Leon d'Oro

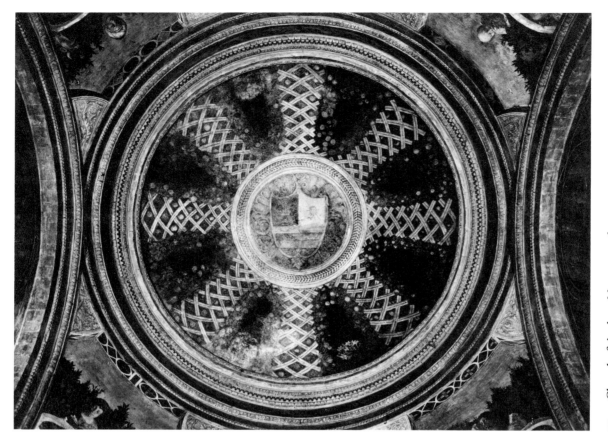

72. Chapel of Andrea Mantegna, dome

71. Chapel of Andrea Mantegna

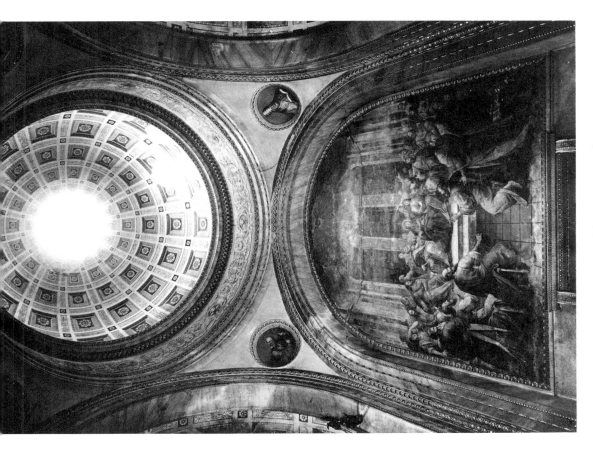

74. Cathedral, Mantua, Cappella dell'Incoronata, dome

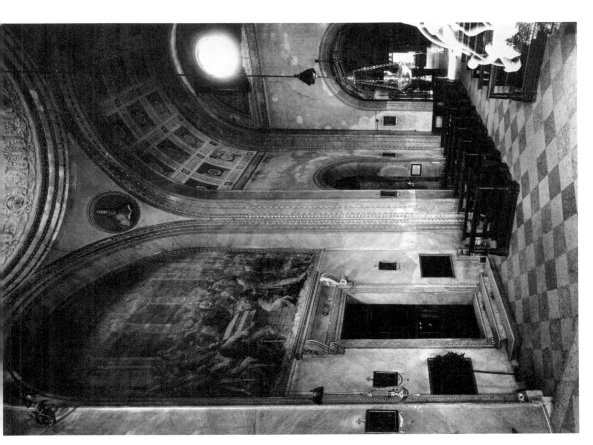

73. Cathedral, Mantua, Cappella dell'Incoronata, interior

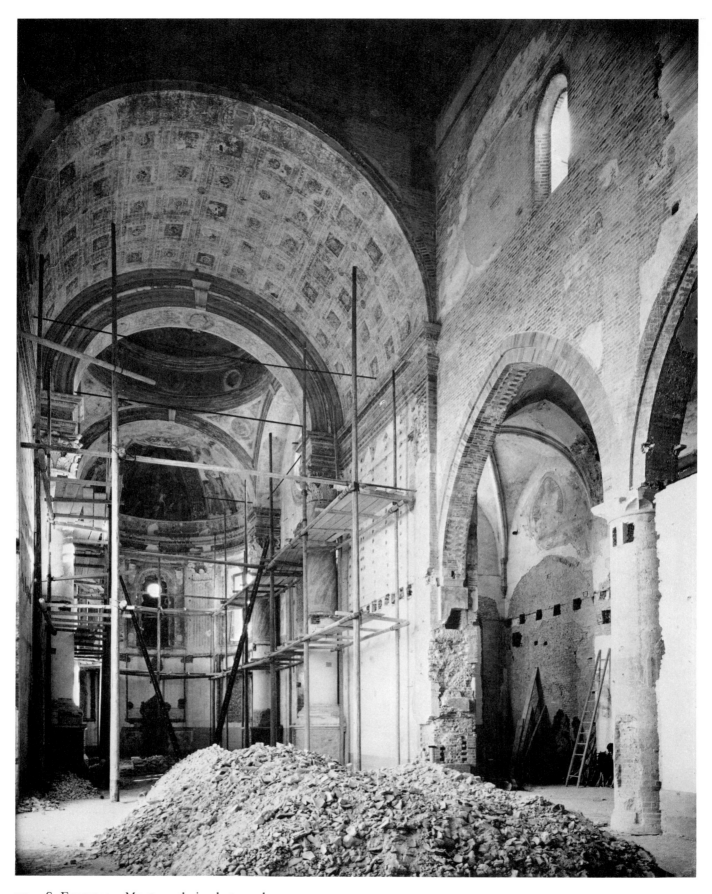

75.   S. Francesco, Mantua, choir, destroyed

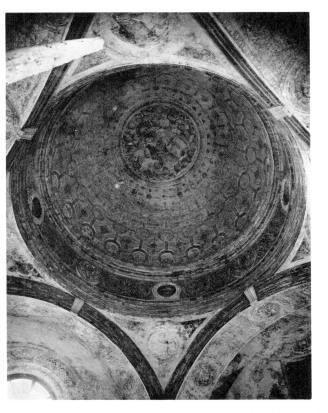

77.   S. Francesco, Mantua, apse vault, destroyed

76.   S. Francesco, Mantua, dome over choir, destroyed

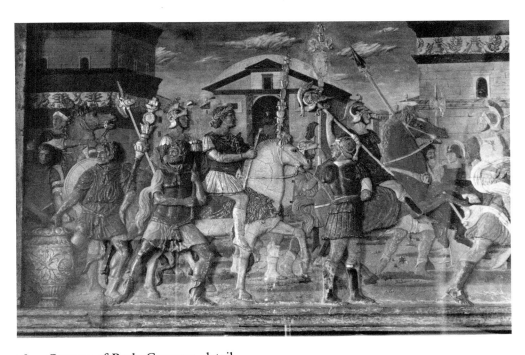

78.   Cassone of Paola Gonzaga, detail

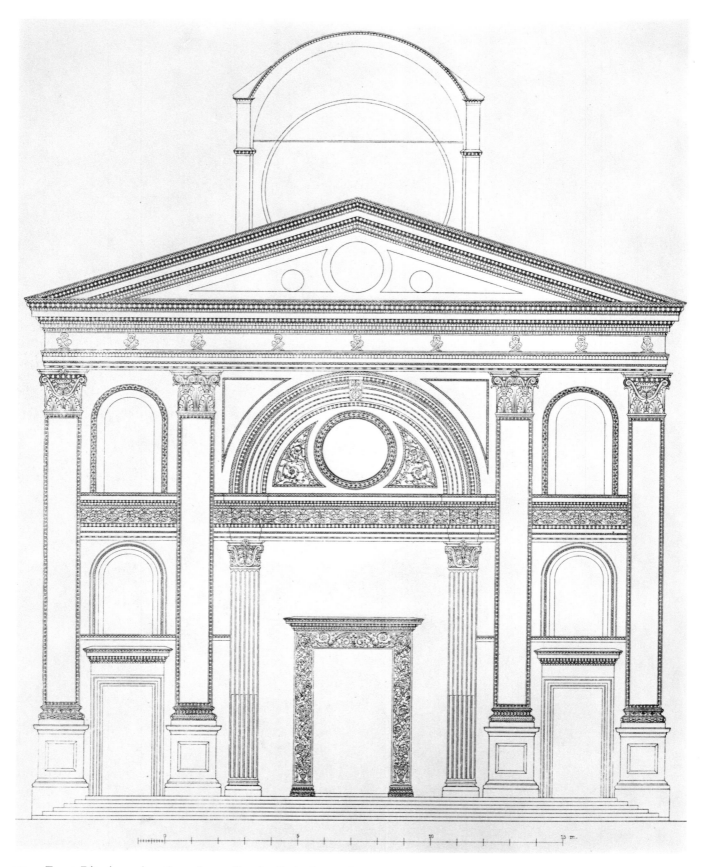

79.   Ernst Ritscher, elevation of west façade, S. Andrea, 1899

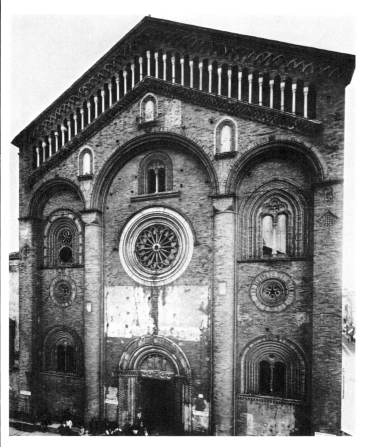

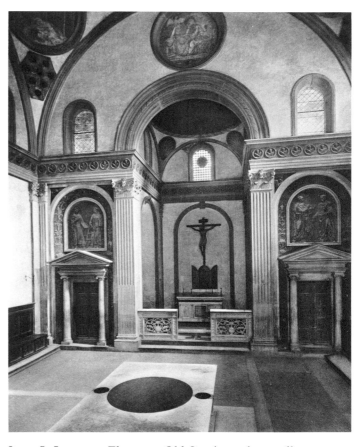

80.   Cathedral, Crema, façade

81.   S. Lorenzo, Florence, Old Sacristy, altar wall

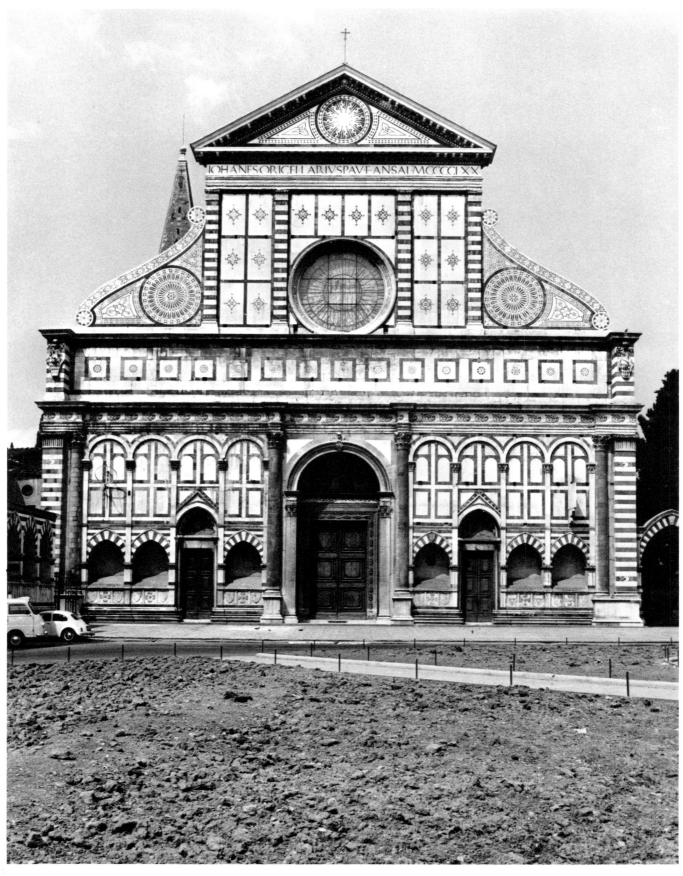

82.   S. Maria Novella, Florence, façade

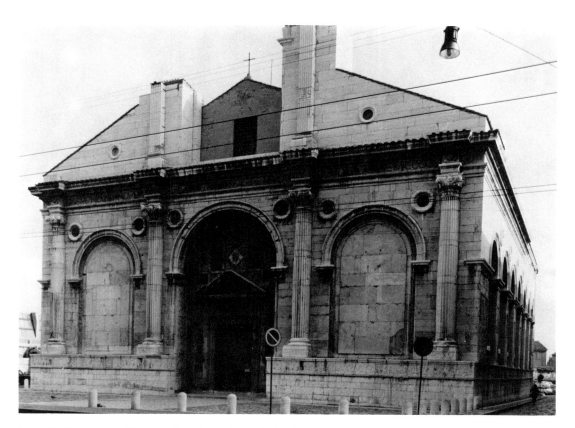

83.   S. Francesco, Rimini, façade and south flank

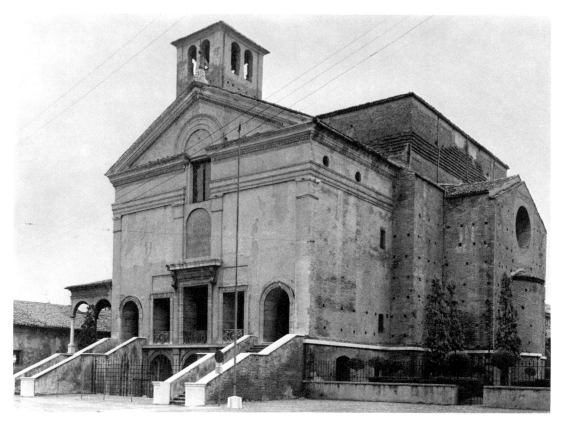

84.   S. Sebastiano, Mantua, façade and south flank

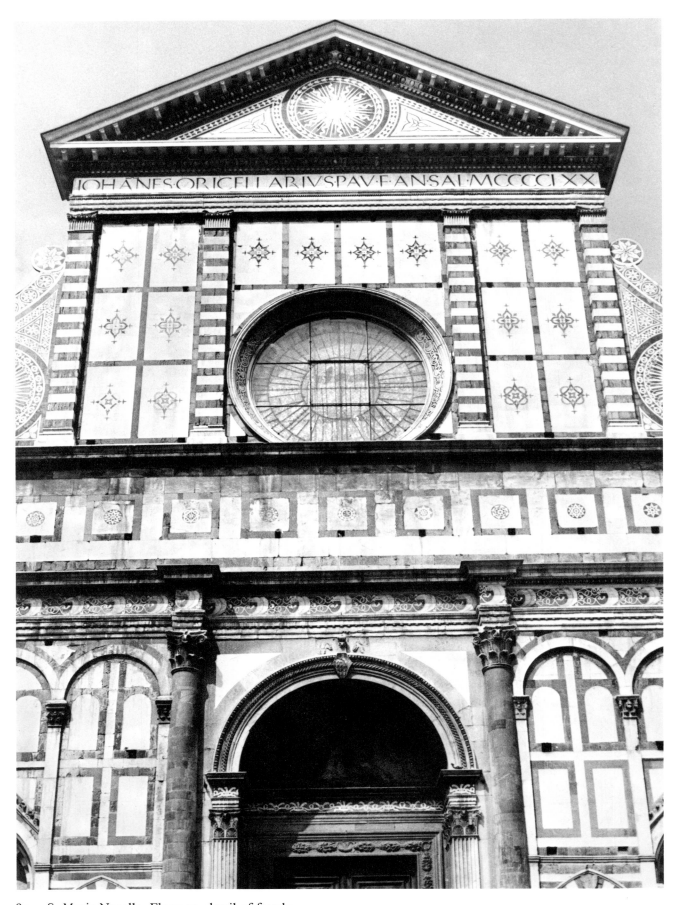

85. S. Maria Novella, Florence, detail of façade

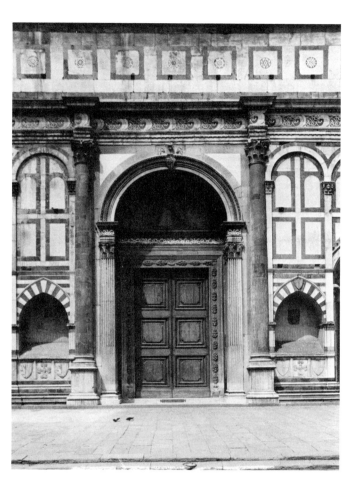

86.   S. Maria Novella, Florence, central portal     87.   S. Francesco, Rimini, central portal

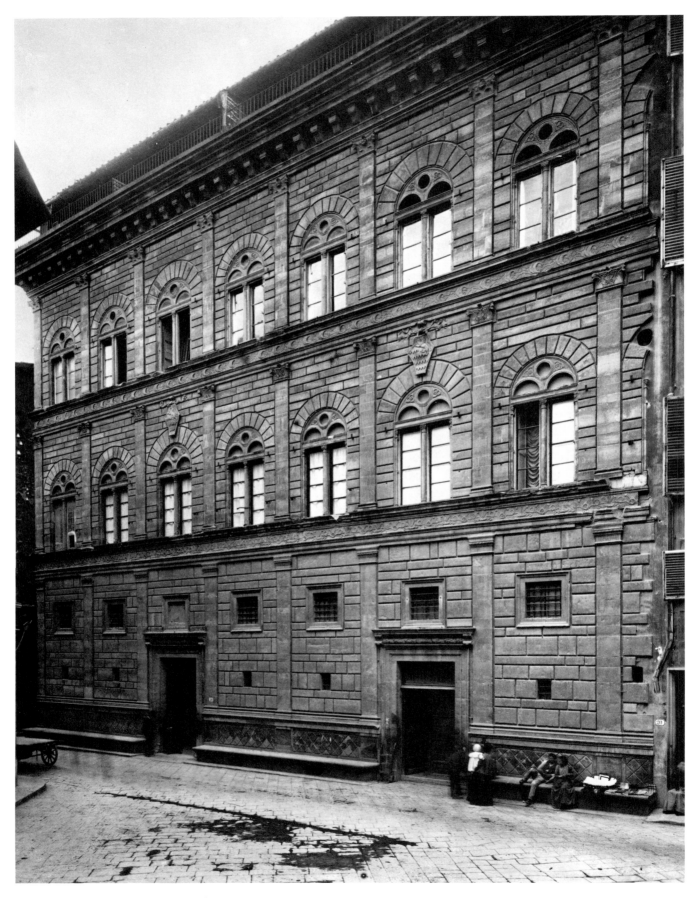

88.   Palazzo Rucellai, Florence, façade

89. Palazzo Rucellai, Florence, façade, right portal

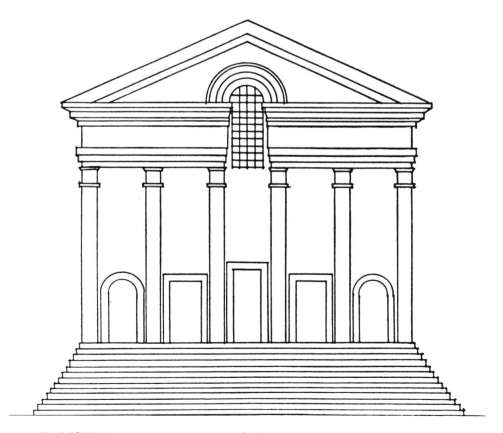

90. Rudolf Wittkower, reconstruction of Alberti's project of 1460 for façade of S. Sebastiano, Mantua

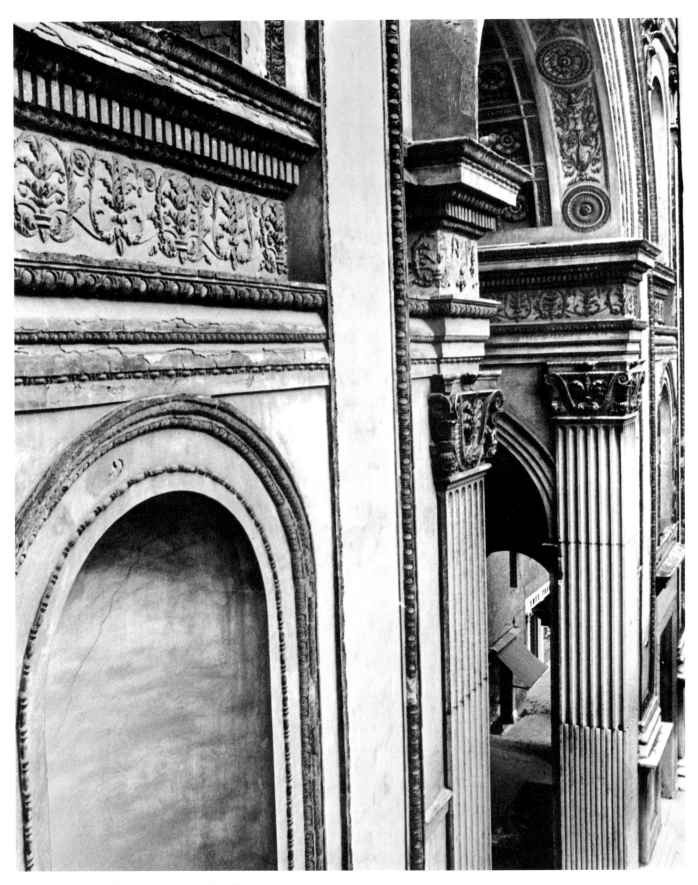

91. West porch from campanile, detail

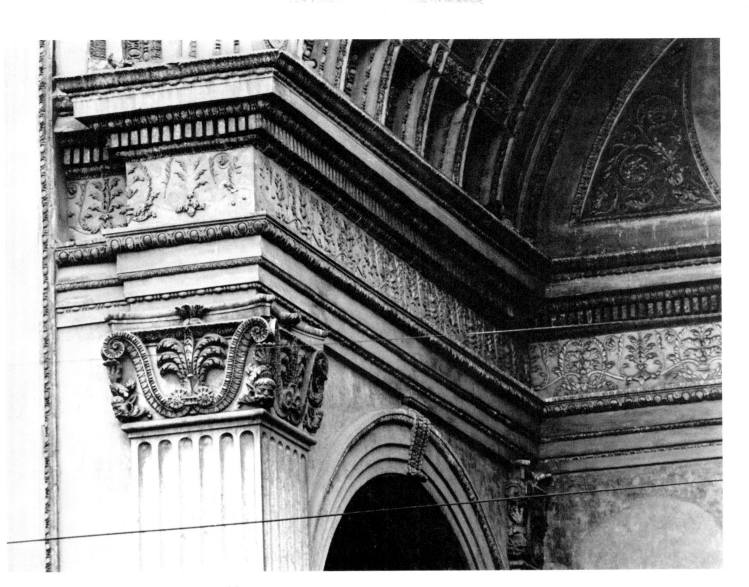

92.   West porch, entablature in central bay

93.   Badia, Fiesole, façade

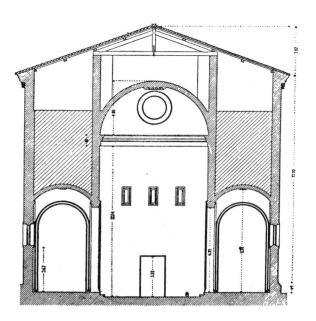

94.   Badia, Fiesole, cross section

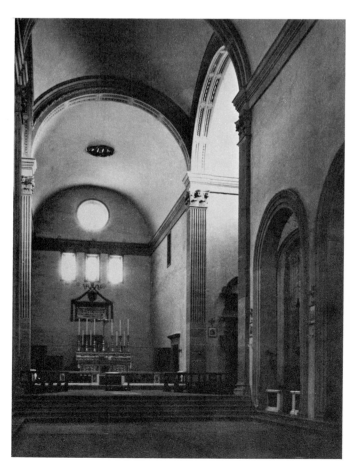

95.   Badia, Fiesole, nave, crossing and choir

96. Nave from choir

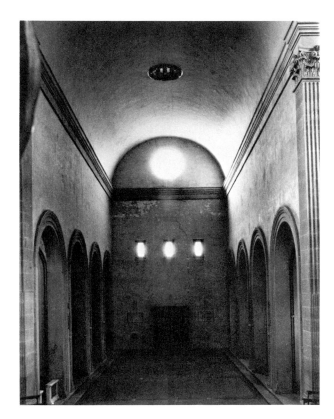

97. Badia, Fiesole, nave from choir

98. S. Francesco, Rimini, north flank

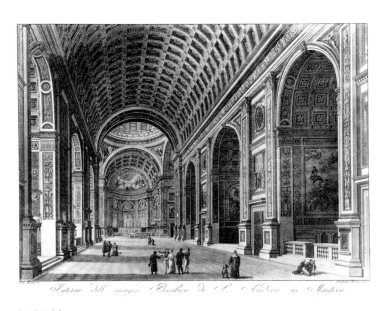

99. F. L. Montini, interior of S. Andrea, etching and aquatint

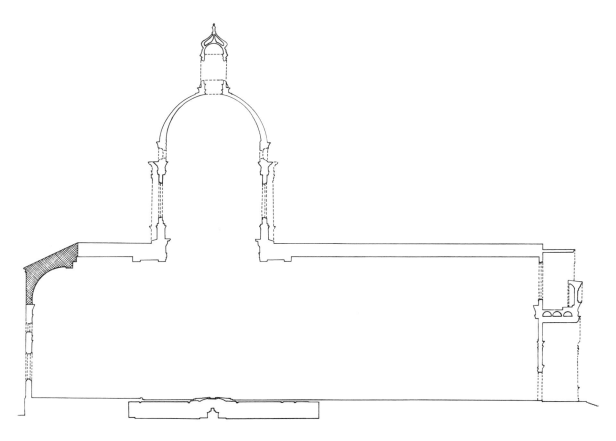

Fig. 1    Longitudinal section of S. Andrea (after Ritscher)

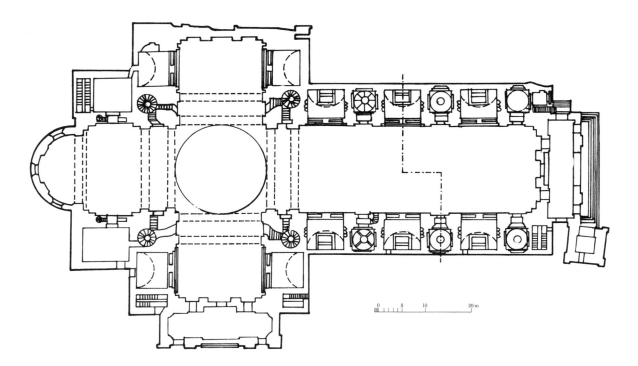

Fig. 2.    Plan of S. Andrea (after Ritscher)

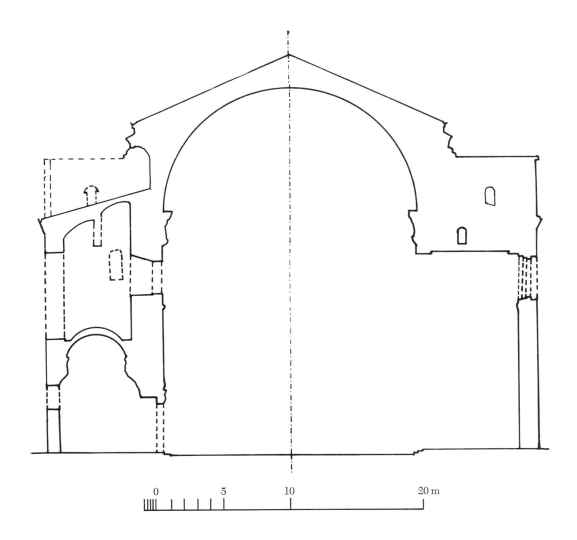

Fig. 3.    Cross section of S. Andrea (after Ritscher)

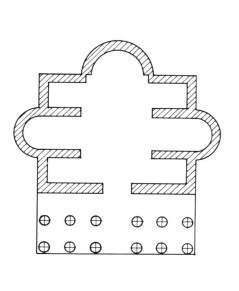

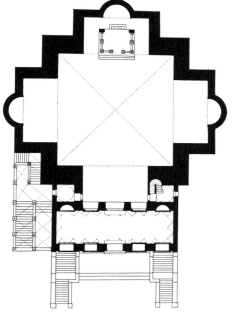

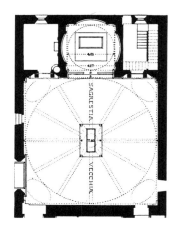

Fig. 4. Richard Krautheimer, reconstruction of Alberti's *templum etruscum*

Fig. 5. S. Sebastiano, Mantua, plan of upper church (from Schiavi)

Fig. 6. S. Lorenzo, Florence, Old Sacristy, plan (from Stegmann-Geymüller)

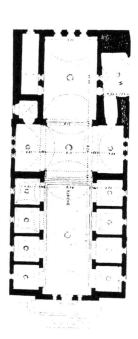

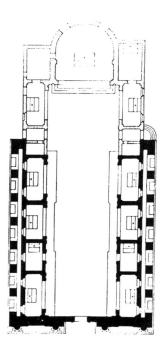

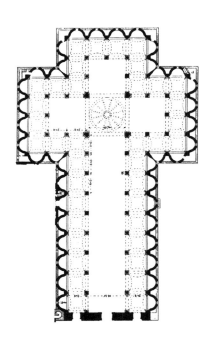

Fig. 7. Badia, Fiesole, plan (from Stegmann-Geymüller)

Fig. 8. S. Francesco, Rimini, plan

Fig. 9. S. Spirito, Florence, plan (from Stegmann-Geymüller)

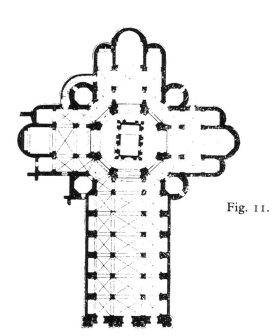

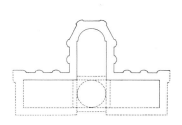

Fig. 11. St. Peter's, Rome, reconstruction of the Nicholas V project for new crossing, transepts, and choir (from Magnuson)

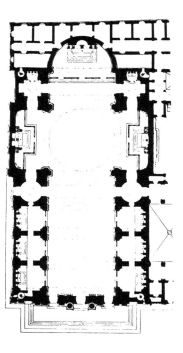

Fig. 10. S. Casa, Loreto, plan

Fig. 12. Il Gesù, Rome, plan

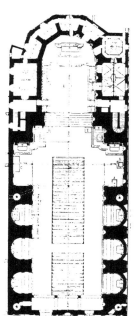

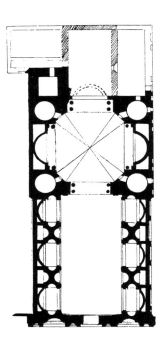

Fig. 13. St. Michael's, Munich, plan

Fig. 14. S. Giovanni Battista, Pesaro, plan (from Serra)